Temptation Transformed

Temptation Transformed

The Story of How the Forbidden Fruit Became an Apple

AZZAN YADIN-ISRAEL

The University of Chicago Press
Chicago and London

The University of Chicago Press, Chicago 60637
The University of Chicago Press, Ltd., London
© 2022 by The University of Chicago
All rights reserved. No part of this book may be used or reproduced in any manner whatsoever without written permission, except in the case of brief quotations in critical articles and reviews. For more information, contact the University of Chicago Press, 1427 E. 60th St., Chicago, IL 60637.
Published 2022
Printed in the United States of America

31 30 29 28 27 26 25 24 23 22 1 2 3 4 5

ISBN-13: 978-0-226-82076-7 (cloth)
ISBN-13: 978-0-226-82212-9 (e-book)
DOI: https://doi.org/10.7208/chicago/9780226822129.001.0001

Library of Congress Cataloging-in-Publication Data

Names: Yadin-Israel, Azzan, author.
Title: Temptation transformed : the story of how the forbidden fruit became an apple / Azzan Yadin-Israel.
Description: Chicago : University of Chicago Press, 2022. | Includes bibliographical references and index.
Identifiers: LCCN 2022004670 | ISBN 9780226820767 (cloth) | ISBN 9780226822129 (ebook)
Subjects: LCSH: Bible. Genesis—Criticism, interpretation, etc. | Apples—Religious aspects. | Temptation in the Bible. | Eden. | Apples in art. | Temptation in art.
Classification: LCC BS1237 .Y33 2022 | DDC 222/.1106—dc23/eng/20220209
LC record available at https://lccn.loc.gov/2022004670

♾ This paper meets the requirements of ANSI/NISO Z39.48-1992 (Permanence of Paper).

To my teachers:
At Berkeley, the Hebrew University, and Cleveland Heights High School

To my teachers
At Bar-Ilan, The Hebrew University and Cleveland Heights High School

That the Forbidden fruit of Paradise was an Apple, is commonly beleeved.
THOMAS BROWNE, *Pseudodoxia Epidemica* (1658)

Contents

List of Illustrations xi
Introduction: The Curious Case of the Apple 1

1. The Missing Apple — 4
2. A Bad Latin Apple — 12
3. The Iconographic Apple — 28
4. The Vernacular Apple — 63

Conclusion: A Scholarly Reflection — 79

Acknowledgments 85
Appendix: Inventory of Fall of Man Scenes 89

Early Christian, Byzantine, and Carolingian	90
France before 1250	91
France after 1250	93
Germany, England, and the Low Countries before 1250	95
Germany, England, and the Low Countries after 1250	98
Italy and Spain before 1250	102
Italy and Spain after 1250	103

Abbreviations 107
Notes 111
Bibliography 153
Index 175

Color plates follow page 76

Illustrations

Plates

I. Anonymous, fresco, 320–340
II. Anonymous, *Receptio Animae* Sarcophagus, ca. 330
III. Anonymous, Moutier-Grandval Bible, ca. 840
IV. Workshop of Master of Jacques de Besançon, Book of Hours, 1500–1515
V. Anonymous, stained glass, 12th century
VI. Anonymous, illuminated manuscript, 1250–1299
VII. Willem Vrelant, Book of Hours, 1460–1463
VIII. Albrecht Dürer, *Adam and Eve*, 1507
IX. Michelangelo, *Fall of Man*, 1512
X. Giulio Clovio, Farnese Book of Hours, 1546
XI. Jan van Eyck, Ghent Altarpiece, 1432
XII. Anonymous, plinth pane, 1666–1669

Figures

3.1. Anonymous, Junius-Bassus Sarcophagus, 359 30
3.2. Anonymous, sarcophagus, 330–335 31
3.3. Anonymous, sarcophagus of the Tomb of St. Clair, 400–432 32
3.4. Anonymous, fresco, 320–360 33
3.5. Anonymous, fresco, 375–385 34
3.6. Anonymous, sarcophagus, 145–150 35
3.7. Anonymous, mosaic, 475–525 36

3.8. Anonymous, ivory box, 11th–12th century 37
3.9. Gislebertus, portal lintel relief, 1120–1135 39
3.10. Anonymous, capital, 1080–1099 40
3.11. Anonymous, nave capital, 1120–1132 41
3.12. Anonymous, capital, 1000–1135 42
3.13. Anonymous, capital, 12th century 43
3.14. Anonymous, Caedmon Genesis, 1000 46
3.15. Meister HL, carving, 1520–1530 48
3.16. Anonymous, *Speculum humanae salvationis*, 1375–1399 49
3.17. Anonymous, Salerno Antependium, 1084 51
3.18. Lorenzo Maitani, relief, 14th century 52
3.19. Antonio Rizzo, sculpture, 1476 53
3.20. Lorenzo Ghiberti, panel, 1452 54
3.21. Albrecht Dürer, engraving, 1504 55
3.22. Giovanni della Robbia, glazed terracotta, ca. 1515 56
3.23. Anonymous, illuminated manuscript, 976 57
3.24. Anonymous, illuminated manuscript, 11th century 58
3.25. Anonymous, capital, late 12th century 59
3.26. Anonymous, illuminated manuscript, 1542 61
4.1. Hans Brosamer, Luther Bible, 1550 77
c.1. Anonymous, cupola mosaic, 13th century 81
c.2. Raffaele Garrucci, *Storia della arte cristiana*, vol. 2, pl. 96.1 82
c.3. Anonymous, fresco, 4th century 83

Maps

1. Early Christian, Byzantine, and Carolingian 38
2. France before 1250 44
3. France after 1250 45
4. England, Germany, and the Low Countries before 1250 50
5. England, Germany, and the Low Countries after 1250 50
6. Italy and Spain before 1250 60
7. Italy and Spain after 1250 60

INTRODUCTION

The Curious Case of the Apple

The Bible contains many mysteries, but the identity of the forbidden fruit, it seems, is not one of them. It is, by common consent, an apple, an identification that has freighted the apple with symbolic meaning like no other fruit. From Roz Chast's *New Yorker* cartoon of the serpent temptingly informing Eve that "it's a Honeycrisp!" to the feminine hands cradling a cardinal red apple on the cover of Stephenie Meyer's *Twilight*, the apple is everywhere the symbol of forbidden knowledge and temptation.

Of course, common consent is not proof that the Book of Genesis intended an apple. In fact, there are compelling reasons to assume otherwise. The apple does not appear in the Fall of Man narrative, nor anywhere else in the Hebrew Bible, undoubtedly because the grafting technique essential to apple cultivation was not known in ancient Israel.[1] Furthermore, the ascent of the apple is relatively recent; for centuries, the preferred forbidden fruits were the fig and the grape, along with other less prominent species. How, then, did the apple become the most popular forbidden fruit?

This book aims to answer that question. Chapter 1 surveys the ancient Jewish and Christian sources depicting the forbidden fruit: the Hebrew Bible and its ancient translations (the Greek Septuagint, Latin Vulgate, and Aramaic Targums); biblical pseudepigrapha such as the Book of Enoch; and rabbinic and early Christian biblical commentaries. Two important conclusions emerge: these works do not mention the apple, and they do identify other fruit species as the forbidden fruit—primarily the grape and the fig. The enduring popularity of these fruits is significant because one of the striking aspects of the apple's ascent is the way it reshaped the entire forbidden-fruit landscape, eradicating species that had peacefully coexisted for centuries.

Chapter 2 questions the reigning theory that links the apple's rise to an accident of the Latin language, namely, that it designates both "evil" and "apple" with the word *malum*. The logic seems compelling: the forbidden fruit caused the Fall of Man, introducing death into the world—a terrible *malum* ("evil") if ever there was one. What fruit, then, would medieval scholars who read and interpreted the Bible in Latin consider better suited to the role than the *malum* ("apple")? This hypothesis ("the *malum* hypothesis") centers on the Fall of Man narrative in Genesis 3, but claims additional support from Song of Songs 8:5, a verse whose Latin translation can be interpreted as referring to Eve's corruption under an apple tree.

However, there is scant evidence for the *malum* hypothesis. Medieval commentaries on Genesis and Song of Songs 8:5 almost never refer to the two meanings of *malum*, and many scholars contend (or imply) that the forbidden fruit was a fig, including Saint Augustine, Alcuin of York, and Thomas Aquinas. Moreover, the Christian allegorical reading of the Song of Songs regularly associated the apple with Christ—not the cause of original sin, but its salvation. Most significantly, the Latin authors are unaware of any tradition identifying the forbidden fruit with the apple. Thus, a mystery: not only do the Latin sources not support the *malum* hypothesis, they force us to grapple with the questions of where and when the apple tradition first appeared.

To answer these questions, chapter 3 explores the rich iconographic tradition of the Fall of Man. Drawing on nearly five hundred Fall of Man scenes, the chapter demonstrates that the apple is virtually absent before the twelfth century. Then, the apple begins to appear in French Fall of Man scenes and quickly becomes the dominant forbidden fruit, rapidly supplanting figs, grapes, and all other species. Something similar occurs in England, Germany, and the Low Countries, though the apple appears slightly later and its spread is more gradual. Italy, however, remains loyal to the fig for centuries, with leading Italian artists depicting the forbidden fruit as a fig well into the sixteenth century. These findings prompt three questions: Why did the apple appear in twelfth-century France? Why was its spread so irregular—a quick ascent in England and Germany, but not in fig-friendly Italy? And why, in the regions that embraced the apple, was there such a disparity between the forbidden fruits of the artists and those of the Latin commentators?

Chapter 4 answers these questions. Here, I argue that while scholars have sought to explain the apple's rise in theological terms, it was actually an unintended consequence of two distinct historical developments: a series of semantic shifts and the proliferation of Fall of Man narratives in the European vernaculars. Words that meant "fruit" in early French, English, and German later came to denote the apple, and, consequently, sources that used these

words to designate the forbidden fruit were interpreted as referring to a forbidden apple.

I have tried throughout to make my argument as accessible as possible. Foreign-language quotations appear in English translation, with the original passage reproduced in the endnotes when necessary for my analysis.[2] I have also simplified some of the foreign terms, citing Latin nouns and adjectives in the nominative and standardizing the spelling of vernacular terms. The terms France, England, and the like today designate modern nation-states that are substantially different from corresponding medieval political entities. I have retained this terminology nonetheless, but intend it primarily in a linguistic sense, that is, France is the region where (one of the varieties of ancient) French was spoken, and similarly for England, Germany, and so on.[3] All dates are CE (née AD), unless otherwise noted.

Like any broad and vigorously interdisciplinary study, this book entails some risk. I do not claim to have a full command of the Latin commentary tradition, medieval Christian iconography, or European vernacular languages and their literatures—even though each of these fields plays a critical role in my argument. I undoubtedly commit errors both of omission and of commission. Yet I believe such risks are justified when they allow us to solve historical riddles that would otherwise elude us.

1

The Missing Apple

Ancient Jewish and Christian Sources

The biblical Fall of Man narrative appears in the second and third chapters of the Book of Genesis. God creates Adam and places him in the Garden of Eden, enjoining him to eat of all the trees save for the Tree of Knowledge of Good and Evil and the Tree of Life. God then creates Eve as Adam's companion, and they "were both naked, and were not ashamed" (Gen 2:25).[1] This idyll, alas, is short-lived. The serpent promptly enters, and successfully entices Eve to eat the fruit of the Tree of Knowledge. She then gives the fruit to Adam, who eats as well. Immediately, "the eyes of both were opened, and they knew that they were naked; and they sewed fig leaves together and made loincloths for themselves" (Gen 3:7). The account is concise, just two verses for the divine prohibition (Gen 2:16–17) and seven for the human transgression (Gen 3:1–7).

The Book of Genesis does not identify the offending fruit, calling it *peri*, the generic Hebrew word for "fruit."[2] The major ancient translations of the Bible follow suit. The Greek Septuagint has *karpos*, "fruit,"[3] as do the two ancient Latin translations (*fructus*).[4] The earliest Aramaic translation, *Targum Onkelos*, likewise uses a generic Aramaic term for "fruit."[5] Neither the Book of Genesis nor its earliest translators, then, identify the species of the forbidden fruit. As often happened, ancient commentators took biblical silence as an invitation to fill in the lacuna.[6] As we will now see, none thought to identify the fruit as an apple. Instead, we find two major interpretive traditions, that of the grape and that of the fig.

The Grape Tradition

Outside of Genesis, the earliest account of the Garden of Eden is found in 1 Enoch, a Jewish apocalyptic text, parts of which date as far back as the third

century BCE. At its center stands Enoch, the biblical character who met an unusual end: "Enoch walked with God; then he was no more, because God took him" (Gen 5:24).[7] On the authority of this verse, later readers understood Enoch to have ascended to heaven, where he was shown apocalyptic visions and given knowledge of divine secrets. According to the "Book of the Watchers," the earliest component of 1 Enoch, while in Paradise Enoch saw a tree

> in height like the fir, and its leaves like (those of) the carob, and its fruit like the clusters of the vine—very cheerful; and its fragrance penetrates far beyond the tree. Then I said, "How beautiful is the tree and how pleasing in appearance." Then Gabriel, the holy angel who was with me, answered, "This is the tree of wisdom from which your father of old and your mother of old, who were before you, ate and learned wisdom. And their eyes were opened, and they knew that they were naked, and they were driven from the garden." (1 Enoch 32:5–6)[8]

This tree is an amalgam: as tall as a fir tree, with round carob-like leaves, and fruit—the forbidden fruit—that resemble a cluster of grapes. The author eschews clear botanical terms (the components of the tree are only *like* familiar plants), but describes the forbidden fruit as most closely resembling the grape.

Another heavenly-ascent text in the grape tradition is the first-century CE Greek Apocalypse of Baruch, also known as 3 Baruch, which survives in Greek and Church Slavonic recensions.[9] Baruch, the scribe of the biblical prophet Jeremiah, ascends to heaven and learns that different angels planted fruit trees in the Garden of Eden: Michael the olive, Gabriel the apple, Uriel the nut, Raphael the quince, and Satanael the grapevine. When Baruch asks to see "the tree through which the serpent led Eve and Adam astray," his angelic guide responds, "[It is] the vine, which Satanael planted" (3 Baruch 4:8).[10] Here, once again, the forbidden fruit is the grape.

The grape is also the source of Adam and Eve's sin in a third heavenly-ascent narrative, the Apocalypse of Abraham, a work dating to the first or second century CE.[11] In it, Abraham narrates his ascent to heaven, where he witnesses the Fall of Man:

> And I saw there a man very great in height and terrible in breadth . . . entwined with a woman who was also equal to the man in aspect and size. And they were standing under a tree of Eden, and the fruit of the tree was like the appearance of a bunch of grapes of vine. And behind the tree was standing, as it were, a serpent in form . . . and he was holding in his hands the grapes of the tree and feeding the two whom I saw entwined with each other. (Apocalypse of Abraham 23:5–8)[12]

This scene captures the drama of the Fall of Man, with the serpent feeding Adam and Eve the forbidden fruit, a grape.

None of these works explains why the forbidden fruit is a grape, though 3 Baruch offers a possible clue in its vehement denunciation of the grape because of its association with wine. For

> men drinking insatiably the wine which is begotten of it make a transgression worse than Adam, and become far from the Glory of God, and commit themselves to the eternal fire. . . . Through the calamity of wine come into being all [these]: murders, adulteries, fornications, perjuries, thefts, and such like." (3 Baruch 4:16–17)[13]

Perhaps antipathy to wine makes grapes the forbidden fruit; perhaps it is the numerous biblical pronouncements against wine and drunkenness—some specific to the priesthood (Lev 10:9) and others more general (Prov 23:20–21). The role wine plays in the sexual impropriety of Noah (Gen 9) and Lot (Gen 19) may also have contributed to the identification of the grape as the forbidden fruit in these heavenly-ascent sources.

Rabbinic sources also name the grape as the forbidden fruit, generally with the support of biblical prooftexts. The Book of Deuteronomy likens the Israelites to corrupt vines that produce poisonous wine: "Their vine comes from the vine-stock of Sodom, from the vineyards of Gomorrah; their grapes are grapes of poison, their clusters are bitter; their wine is the poison of serpents, the cruel venom of asps" (Deut 32:32–33). Sifre Deuteronomy, a third-century rabbinic commentary, preserves a midrashic tradition attributed to Rabbi Nehemiah that links this verse to the Fall of Man:

> "Their wine is the poison of serpents": Rabbi Nehemiah applied [the verse] to the nations of the world: you are certainly of the vine of Sodom and of the planting of Gomorrah. You are the disciples of the primeval serpent that caused Adam and Eve to go astray. (Sifre Deuteronomy §323)[14]

According to Rabbi Nehemiah, then, the "nations of the world," that is, the gentiles, are disciples of the serpent from Genesis 3. Since this midrash develops from the biblical phrase "Their wine is the poison of serpents," the implication is that the serpent led Adam and Eve astray with the fruit of the vine.

A later rabbinic commentary on the Book of Leviticus links the forbidden fruit to the grape on the basis of Proverbs 23:32: "Do not look at wine when it is red, when it sparkles in the cup and goes down smoothly. At the last it bites like a serpent, and stings (*mafrish*) like an adder." The Hebrew verb *mafrish*, which generally means "to distinguish or divide," is here a technical term for secreting poison. The rabbinic interpretation, perhaps made in ignorance of

the specialized meaning, maintains the word's primary sense and interprets the verse as an allusion to the Fall of Man:

> Just as the adder divides (*mafrish*) between death and life, so too wine divided (*hifrish*) between Adam and Eve, on the one hand, and death, on the other. As Rabbi Yehuda ben Ilai said, The tree from which Adam ate was of grapes. (Leviticus Rabbah 12.1)[15]

The Babylonian Talmud preserves yet another instance of the grape tradition, though this one is not anchored in scripture. "Rabbi Meir said: That tree from which Adam ate was a vine, for nothing but wine (*yayin*) brings wailing (*yelalah*) to man (*adam*)."[16] Rabbi Meir acknowledges the suffering that can follow alcoholic consumption, and plays on the phonetic similarity between the Hebrew words *yayin* ("wine") and *yelalah* ("woe," "cry of woe"). At the same time, the phrase "Nothing else but wine brings woe to man," possibly a folk saying that circulated in his time, is the basis for a clever pun. The English *man* in the phrase "brings wailing to man" renders the Hebrew word *adam*, which means both "man" and "the first man, Adam." Playing on the semantic ambiguity of *adam*, Rabbi Meir reads the statement "Wine brings woe to man" as evidence that wine—the grape—brought woe to Adam.

Several early Christian authors also championed the grape tradition. When Noah emerges from the ark after the flood, he is "the first to plant a vineyard" (Gen 9:20). Commenting on this verse, Origen states plainly that the vineyard "was the fruit of the Tree of Knowledge of Good and Evil."[17] The grape is also linked to the forbidden fruit in the theology of the Severians, an early Christian community whose teachings Epiphanius, the bishop of Salamis, deemed heretical. He characterizes the Severians as Gnostics who believe that God is located in the highest heaven. The devil, who governs the created world, was "cast down to earth by the power above, and having come down and being in serpentine form, was smitten with desire and copulated with the earth as with a woman, and from the seed he shed the vine sprouted."[18] Epiphanius offers only a partial summary of Severian theology, but it can be reasonably inferred that the grapes that sprouted as a result of the devil's copulation with the earth were the forbidden fruit.

The grape tradition enjoyed remarkable longevity. Centuries after the grape was first identified as the forbidden fruit, the great twelfth-century Bible scholar Andrew of St. Victor listed the grape as one of two fruits commonly associated with the Fall of Man (alongside the fig). This tradition, he writes, is based on the verse "The parents have eaten sour grapes, and the children's teeth are set on edge" (Jer 31:29).[19] In Andrew's interpretation, the grape-consuming parents are Adam and Eve, and the children are humanity,

who must pay for the parents' sin. The grape tradition was particularly durable in Slavic literature, where it appears as late as the eighteenth century.[20] I will say more about these sources in the following chapters, but for now turn to survey the fig tradition.

The Fig Tradition

The fig was at the center of the second major forbidden fruit tradition in antiquity. Immediately after eating the forbidden fruit, Adam and Eve realize they are naked and cover themselves with fig-leaf aprons. Though the Book of Genesis never identifies the fig as the forbidden fruit, a clear exegetical logic sustains the fig tradition: if Adam and Eve were standing by the fig tree when they sinned, this was likely the tree whose fruit they consumed.

Perhaps the most important source for the fig tradition is the *Life of Adam and Eve*, an account of Adam, Eve, and their children's lives after the expulsion from Eden.[21] The *Life of Adam and Eve* enjoyed great popularity, with surviving versions in Greek, Latin, Armenian, Georgian, Slavonic, and the western European vernaculars. Most scholars date the *Life of Adam and Eve* to between the third and seventh centuries, while acknowledging that it draws on earlier sources.[22] Here is Eve's first-person account of the Fall:

> [The serpent] climbed the tree, and sprinkled his evil poison on the fruit.... And I bent the branch toward the earth, took of the fruit, and ate.... I looked for leaves in my region so that I might cover my shame, but I did not find any from the trees of Paradise, since while I ate, the leaves of all the trees of my portion fell, except (those) of the fig tree only. And I took its leaves and made for myself skirts; *they were from the same plants of which I ate*. (*Life of Adam and Eve* 19:3–20:5)[23]

The authenticity of the italicized phrase is the subject of debate. Johannes Tromp points out that it is found in only five manuscripts, which descend from a common source, suggesting that "the passages present in these manuscripts, but absent from all others, are additions made to the text."[24] Jan Dochhorn, by contrast, includes the phrase in his German edition of the *Life of Adam and Eve* on the grounds that it is found in the Armenian and Georgian versions.[25] I side with Tromp in this dispute, but for the present purposes, the question is not critical: if the phrase is original, it testifies to the antiquity of the fig tradition; if it is a later interpolation, it testifies to the fig tradition's ongoing vitality.[26]

Another apocryphal work in the fig tradition is the *Testament of Adam*, a Syriac work redacted by Christian editors most likely in the late third

century.[27] There are three recensions of this work, including one in which Seth, Adam's son, inquires about the identity of the forbidden fruit. Adam responds: "The fig, my son, was the gate by which death entered into me and my posterity."[28] Additional evidence for the fig tradition in late antique Christianity comes from a statement attributed (perhaps misattributed) to Theodoret, the fifth-century bishop of Cyrrhus, in northern Syria. The use of fig leaves for aprons, he says, makes it "undeniable that the tree [of knowledge] was a fig."[29]

Besides the sources endorsing the fig and vine, we also have indirect statements that attest to the vitality of these traditions. Methodius of Olympus (d. 311), the bishop of Olympus, in southern Turkey, and later of Tyre, composed a treatise on chastity that touches on the forbidden fruit:

> The power that is set against us always tries to imitate the outward forms of virtue and righteousness, not to encourage their practice, in truth, but for the purpose of hypocritical deceit. . . . Thus he would like to be taken for a fig tree or a vine and bring forth sweetness and joy, transforming himself in "an angel of light," beguiling many with a façade of piety.[30]

Methodius is not explicit on this point, but he is generally—and plausibly—understood to be referring to the fig and the vine as the established forbidden fruits. The Cappadocian Father Gregory of Nyssa (d. 395) confirms the prevalence of the fig narrative even as he rejects the notion that the forbidden fruit was a natural species: "I am persuaded that the tree of which it was forbidden to eat (Gen 2:17) was not, as some have asserted, a fig tree or any other fruit-bearing tree. For if the fig tree was a death-dealer in those days, it would not be perfectly edible now."[31] Along with the grape, then, the fig can rightly be characterized as one of the presumptive forbidden fruit species prior to the rise of the apple tradition.[32]

Other Traditions

Despite their popularity as forbidden fruits, grapes and figs were hardly the only fruit species to bear that designation. An early rabbinic commentary on Genesis aggregates the views of several rabbis on this question:

> What was the tree whereof Adam and Eve ate? R. Meir said: It was wheat, for when a person lacks knowledge people say, "That man has never eaten bread of wheat." . . . R. Judah the son of R. Ilai said: It was grapes, for it says, "their grapes are grapes of poison, their clusters are bitter" (Deut 32:32). . . . R. Abba of Acco said: It was the citron, as it is written, "So when the woman saw that the tree was good for food" (Gen 3:6). Consider: go forth and see, what tree is

it whose wood can be eaten just like its fruit? and you find none but the citron. R. Jose said: They were figs. . . .[33] R. Azariah and R. Judah b. R. Simon in the name of R. Joshua b. Levi said: Heaven forfend [that we should conjecture what the tree was]! The Holy One, blessed be He, did not and will not reveal to man what that tree was.[34]

The vine and grape are anchored in familiar scriptural arguments, and the citron too is buttressed by a biblical prooftext, though it is not clear why it is particularly suited to the verse.[35] Irrespective, it is evident that the rabbis admit various potential species as the forbidden fruit and that the apple is conspicuously absent from this list.[36]

The Coptic Nag Hammadi writings, also known as the "Gnostic Gospels," suggest yet another fruit. The treatise "On the Origin of the World," which dates from the third or fourth century, offers a creation narrative that incorporates elements from the Book of Genesis, some radically reworked.[37] During the creation of the world, a hermaphroditic Eros appears, causing the blossoming of the grapevine, which is associated with creation, since "those who drink of it conceive the desire of sexual union." After the grapevine, "a fig tree and a pomegranate tree sprouted up from the earth, together with the rest of the trees," and then Paradise is created with the tree of eternal life and the tree of knowledge. The former's "leaves are like those of the cypress [and] its fruit is like a bunch of grapes," while the latter's "are like fig leaves" but "its fruit is like a good appetizing date."[38] The grape, then, is the fruit of the Tree of Life (or at least the species most like it), while the forbidden fruit is the date.

Additional fruits could be adduced. The pomegranate appears occasionally in written sources, and enjoys significant presence in medieval Fall of Man iconography. A Syriac Quran commentary lists various candidates for the forbidden fruit, among them the familiar wheat, grapes, and figs, but also a newcomer, the banana.[39] The historical fate of these fruits varies. Some were associated with the forbidden fruit for many centuries; others appear only briefly, then vanish. Taken in aggregate, however, they reveal a rich and variegated discourse surrounding the identity of the forbidden fruit.

The apple is almost completely absent from this discourse. I found one explicit invocation of the apple in the "Mysteries of Saint John the Apostle and Holy Virgin," a Coptic heavenly-ascent treatise preserved in a single manuscript. In it, the apostle John ascends to Paradise and sees the Tree of Knowledge, whose fruit, he reports, "was a kind of apple."[40] An earlier, Byzantine Greek source may suggest a connection between the apple and the forbidden fruit.[41] Cyril of Scythopolis, a sixth-century Palestinian monk, composed a series of hagiographies of elder monks, including Sabas the Sanctified. Once,

Sabas was working in the garden and wished to eat a beautiful apple, but abstained because "beautiful to look at and ripe to eat was the fruit (*karpos*) that caused my death through Adam."[42] Sabas hurls the apple to the ground and vows to abstain from apples the rest of his life.[43] Neither Cyril nor Sabas states that the forbidden fruit was an apple, and it is possible that other beautiful fruits would have recalled the beauty of the fruit that tempted Eve. The text, moreover, distinguishes between the apple (*mēlon*) and the forbidden fruit (*karpos*). Still, the episode suggests some affiliation between the two. While the "Mysteries of Saint John" and Cyril of Scythopolis's monastic hagiography have a place in any account of the forbidden fruit in antiquity, it must be emphasized that these works were historical isolates, exerting only limited influence on later works and wholly divorced from the apple tradition that extends to the present day.

My argument thus far has been largely *ex silentio*; the apple is conspicuously absent. However, the ancient sources also provide explicit evidence that the apple was not the forbidden fruit. We saw above that in 3 Baruch, Baruch is told that Gabriel planted the apple and Satanael the forbidden fruit, indicating that the apple is one of the trees that God encourages Adam to eat (Gen 2:16). In addition, while Philo's position (discussed in note 31, above) is part of his broad commitment to allegorical interpretation, he explicitly excludes the apple as a candidate for the Tree of Knowledge.[44] The apple, then, is not only missing from the list of candidates for the forbidden fruit—it is on occasion cited as *not* being this fruit.

Conclusion

This chapter reveals the variety of ancient forbidden fruits—the fig, the grape, the citron, the wheat shaft, and the date, among others—and demonstrates the startling absence of the apple. The absence is not absolute; at least one text identifies the forbidden fruit as an apple, and another suggests as much. But these scattered references do not constitute a sustained apple tradition. How, then, did the apple, essentially undocumented in antiquity, become the de facto forbidden fruit? And why did other fruits commonly identified as the forbidden fruit lose that association?

2

A Bad Latin Apple

> Some have been so bad Prosodians, as from [Latin *malum* ("apple")] to derive the Latine word *Malum* ["evil"] because that fruit was the first occasion of evill.
>
> THOMAS BROWNE

Sir Thomas Browne, the great seventeenth-century English polymath, devoted his considerable talent to rooting out misconceptions. His magnum opus, *Pseudodoxia Epidemica: or, Enquiries into Very Many Received Tenets and Commonly Presumed Truths* (also known as *Vulgar Errors*), surveys and refutes hundreds of views held as truths in his day. The work is structured thematically, with books devoted to errors on different topics (minerals, animals, geography, and so on). Book 7, which is devoted to errors "deduced from the History of holy Scripture," opens with an examination of the view that the forbidden fruit was an apple.[1] Browne considers this an error because Scripture does not identify the species of the Tree of Knowledge and because other fruits are identified as the forbidden fruit.[2] The error, he speculates, may be due to what he calls the generic quality of the apple (that is, its ability to stand in for any fruit), and he adds that some authorities justify the apple through the two meanings of the Latin word *malum*: "apple" and "evil."[3] This explanation derives primarily from the Fall of Man narrative—original sin was the ultimate *malum* ("evil deed")—though Browne also mentions that Song of Songs 8:5 is adduced as support for this view, for reasons that will be discussed in detail below.

The same argument, based on the same verses, remains popular today, as we find scholars regularly invoking the homonymity of Latin *malum* as the historical origin of the apple tradition. Indeed, this explanation has become received wisdom, regularly referred to without supporting citation or reference. Such discussions are, unsurprisingly, most common in biblical studies. Ziony Zevit, who recently published a detailed reexamination of the Fall of Man narrative, writes that the apple tradition "arose because of the assonance between the Latin words for wrongdoing, *malum*, and apple, *malus*."[4] Victor P.

Hamilton avers that "the time-honored tradition that identifies the fruit as an apple may have originated due to the common sound in Latin *malus*, 'evil,' and *malum*, 'apple.'"[5] Both Zevit and Hamilton echo Gerhard von Rad's influential Genesis commentary, which claims that identifying the forbidden fruit with the apple "derives from Latin Christianity and may be occasioned by the association *malus* ('bad')–*malum* ('apple')."[6] Yet the religious and cultural importance of the Fall of Man narrative has extended the reach of the *malum* hypothesis well beyond biblical studies, as we find references to it in religious studies, art history, theater studies, and elsewhere.[7] While there have been dissenting voices, no other interpretation has gained wide acceptance, making the *malum* hypothesis *the* explanation for how apples became the popular forbidden fruit.[8]

The *malum* hypothesis has great intuitive appeal. It is elegant and seems to explain why the apple tradition is unknown in Hebrew, Aramaic, or Greek. In addition, its advocates claim significant historical support. For one, Latin authors recognized the ambiguity of *malum* as early as the fourth century. Rufinus (344–411), a contemporary of Jerome, was an important translator of Greek patristic writings into Latin, including Origen's commentary on the Song of Songs, a work that "set the tone of the medieval genre of Song of Songs exegesis."[9] In Song of Songs 2:3, the female speaker likens her male lover to an apple tree: "As an apple tree among the trees of the woods, so is my beloved among the young men." When translating this verse as part of Origen's commentary, Rufinus notes that the fruit should be rendered *malum* in Latin, but refuses to do so "lest the simpletons, on account of the similarity of the phrases, assume that the apple tree (*arbor mali*) is an evil tree (*arbor mala*), so named for its evil quality."[10] To avoid this ambiguity, Rufinus simply transliterates the Greek *mēlon*: "We say *arbor meli*, admittedly employing the Greek word, but one that is better known to the simpletons than Latin *mali*. For it is better that we offend grammarians than place a stumbling block in the explanation of the truth."[11] Rufinus's testimony is of limited historical value, as he does not state that anyone *has* interpreted *malum* in Song of Songs 2:3 as "evil," and neither Origen nor Rufinus connects the fruit of Song of Songs 2:3 with the forbidden fruit. All the same, Rufinus is an early example of the *malum-malum* ambiguity.

If Rufinus acknowledges the possibility of interpreting the *malum*, "apple," as evil, later Latin interpreters realize this possibility. Brian Murdoch writes that the forbidden fruit "is as firmly an apple in Cyprian of Gaul or in Avitus as it is in Milton."[12] The Cyprian to whom Murdoch refers is a Christian poet active in the first decades of the fifth century who composed a versified version of the Bible, though only the Heptateuch survives.[13] Cyprian describes

God's prohibition of the forbidden fruit thus: "Do not be afraid to pick those fruits that are lawful. . . . But beware lest by chance you pick an apple that is harmful (*malum noxale*)."[14] While not an obvious play on words, the phrase *malum noxale* may be intended to evoke the two meanings of *malum*: a harmful apple prohibited by God, and a harmful evil. Avitus, Cyprian's younger contemporary and the bishop of Vienne (in Gaul), composed *De spiritualis historiae gestis*, a poetic retelling of biblical history. In it, Avitus plays openly on the two meanings of *malum*, relating how the serpent picked "an apple (*malum*) from the deadly tree," which Eve accepted because she was "perversely gullible" (*male credula*).[15] Murdoch also mentions Geoffrey of Vinsauf, the early thirteenth-century author of *Poetria Nova*, a popular handbook on poetic technique, who laments that the "taste of the apple (*malum*) was the general cause of evil (*malum*)."[16] To this list, we may add Geoffrey's contemporary, Petrus Riga, whose *Aurora* was "one of the most popular and widely circulated books of the Middle Ages."[17] Riga teaches that Eve "picked an apple (*malum*) from the tree . . . and from that was evil (*malum*) born."[18] Armed with these examples, Murdoch concludes that the association of "the non-biblical apple" with "the tree of knowledge, a pun on the Latin word for 'evil', has established itself very thoroughly indeed."[19]

Still, Murdoch's list of authors merits scrutiny. First, because Cyprian and Avitus are historically marginal authors whose influence on later exegetes was decidedly limited, while Geoffrey of Vinasuf and Petrus Riga, though undeniably popular, wrote when the apple tradition was already established.[20] Considering the secure status Murdoch claims for the apple, one would expect to find more prominent authors cited. Furthermore, it is not clear that all these authors in fact associate the forbidden fruit with the apple. Avitus unquestionably refers to the forbidden fruit as *malum*, punning on the two senses of the Latin word, but he also describes Adam and Eve, *prior to the Fall*, "plucking red *mala* from a green branch."[21] What is the meaning of *mala* (the plural form of *malum*) here? At this point in the biblical narrative, God has already distinguished the prohibited Tree of Knowledge from all the other trees of which Adam and Eve may freely eat (Gen 2:16–17). This means the *mala* they are eating are permitted, and not the same type of fruit as the forbidden *malum*. Clearly, Avitus is using *malum* in the less common but still well-known sense of "fruit" rather than "apple."[22] I have not found evidence that Cyprian uses *malum* in this generic sense, but the geographic and chronological proximity of the two authors means the possibility cannot be discounted. Finally, the leap from two fifth-century authors (Cyprian and Avitus) to two thirteenth-century authors (Vinsauf and Riga) does not

bespeak chronological continuity. To the contrary. Rather than demonstrate the existence of an unbroken Latin apple tradition, the sources Murdoch cites call into question whether such a tradition even exists.

Genesis

Despite the immense wealth of Latin writing on the Fall of Man, the corpus presents several challenges for the present inquiry.[23] For one thing, Latin authors do not generally refer to the forbidden fruit as *malum*, preferring *fructus* ("fruit"), *cibus* ("food"), or *pomum* ("fruit, tree fruit"). As we saw in chapter 1, the Vulgate employs *fructus* in its translation of Genesis 3, so it is no surprise that later authors retain this terminology. *Cibus* is a generic term that means "food, nutriment," in both classical and ecclesiastical Latin.[24] It is not clear why some Latin authors employ *cibus* for the forbidden fruit, but the practice goes back to the fourth century at least and is present in some of the most important Latin writers of the time. Jerome uses it figuratively to describe the serpent tempting him with the "forbidden food" of sexuality;[25] Ambrose calls the forbidden fruit the *incontinentiae cibus*, the "food of incontinence, wantonness";[26] and Augustine employs *cibus* in his massively influential *Literal Commentary on Genesis*.[27] With this pedigree, it is no surprise that later writers follow suit.[28]

By far the most common Latin word for the forbidden fruit is *pomum*.[29] In classical Latin, the term means "a fruit tree" or "a fruit, specifically an orchard fruit,"[30] and this is its sense in the Vulgate as well. For example, when on the third day of creation, God commands that the earth "put forth vegetation: plants yielding seed, and fruit trees of every kind on earth that bear fruit with the seed in it" (Gen 1:11), the Vulgate renders "fruit trees" *lignum pomiferum*, trees that bear *poma*.[31] In Leviticus 19:23 God instructs the Israelites to "plant all kinds of trees for food," which the Vulgate translates "trees bearing *poma*" (*ligna pomifera*). And when God warns Israel to follow the divine ordinances lest "the trees of the land shall not yield their fruit" (Lev 26:20), it is *poma* that the Vulgate's trees will withhold.[32] Augustine employs *pomum* (alongside *cibus*) in his literal commentary on Genesis, saying of the forbidden fruit, "We must assume that the fruit (*pomum*) on that tree was similar to the fruits (*poma*) of other trees, which our first parents had tasted and found harmless."[33] Many prominent medieval authorities adopted *pomum*, among them Rupert of Deutz, Hugh of St. Victor, and Thomas Aquinas. The term became so common that the Latin phrases *pomum vetitum*, *pomum interdictum*, and *pomum prohibitum*—all meaning "forbidden fruit"—are found throughout

Medieval Latin writing (see the sources in note 29, above). *Pomum* also appears in apocryphal texts such as the Latin *Life of Adam and Eve* and the *Post Peccatum Adae*.[34]

As for *malum*, prior to the twelfth century there is almost no mention of the apple as forbidden fruit beyond the sources already discussed, a pronounced absence given the frequent discussions of *malum*, "evil," in the context of the Fall of Man.[35] Already the third-century Christian poet Commodian writes that "the fruit (*pomum*) having been tasted, death entered the world," and in the same paragraph speaks of "those who worship forbidden (*vetitos*) gods and the evil (*mala*) joys of life."[36] In the space of a few lines, Commodian invokes the forbidden fruit, speaks of a divine prohibition, and uses the word *malum*. However, the forbidden fruit is a *pomum*, God prohibits idols, and *malum* is the adjective "evil." Remigius of Auxerre (ninth-century France) writes of the *inobedientiae malum* of the Fall, a phrase that could mean "the apple of disobedience," though here it does not; the contrast between this phrase and *obedientiae bonum*, "the good of obedience," demonstrates Remigius's *malum* is "evil."[37] The same disjuncture between *oboedientiae bonum* and *inoboedientiae malum* appears in the Genesis commentary of Andrew of St. Victor (twelfth-century France).[38] Arnold of Bonneval, Andrew's contemporary, writes of the *malum concupiscientiae* ("apple/evil of desire"): as soon as Adam ate of the forbidden fruit, "in that very place man felt what he had not felt before; he felt the evil of desire (*malum concupiscientiae*), and the itching of rebellious limbs";[39] this is, then, another occurrence of *malum*, "evil." Later in the same passage, Arnold asserts that Eve was in an uncorrupted state "prior to her tasting the fruit (*pomum*) by the evil (*malum*) of pride."[40] Alan of Lille (twelfth-century France) writes that it was "only through God's prohibition that it was bad (*malum*) to eat the fruit (*pomum*) . . . indeed to eat the fruit (*pomum*) was generally good; but through the prohibition of God it became bad (*malum*)."[41] Passage after passage, then, set the forbidden fruit and the Latin word *malum* in close proximity; the play on words is ripe for the taking. Yet, the forbidden fruit remains *pomum* or *cibus*, not *malum*.

I noted in chapter 1 that 3 Baruch counted the apple among the licit trees in the Garden of Eden, a rare explicit contradiction of the apple tradition. A similar passage appears in the work of Bernard of Clairvaux (1090–1153), the leading figure of Cistercian monasticism and the abbot of Clairvaux Abbey.[42] His commentary on the Song of Songs describes Adam's life in Paradise prior to the Fall in the following terms: "His dwelling was in Paradise, he spent his days in the midst of delights. His food the sweet-smelling apples (*odoriferis . . . malis*), his bed the flowering bank."[43] Bernard is not concerned here

with the Fall of Man as such, but Adam's prelapsarian apples indicate that Bernard does not endorse the apple tradition.

The ongoing absence of the apple represents a grave difficulty for the *malum* hypothesis: without *malum*, there can be no play on the two meanings of *malum*.[44] It also raises a second concern: irrespective its origin, what evidence exists for an apple tradition in the Latin commentaries? The question is of particular salience given the stark contrast between the absent apple and the fig, which maintains a prominent presence throughout the Middle Ages and, in some regions, into the Renaissance. Augustine, a decisive figure in this respect, explicitly associates the fig with Adam and Eve's transgression and with sexual desire.[45] The former is evident in Augustine's interpretation of John 1:48, part of the Gospel of John's account of Jesus's disciple, Philip, as he attempts to recruit a man named Nathanel to Jesus's ministry. Though skeptical at first, Nathanel agrees to meet Jesus, who immediately characterizes him as "an Israelite in whom there is no deceit" (Jn 1:47). Taken aback, Nathanel asks how Jesus knows him, and Jesus responds: "I saw you under the fig tree, before Philip called you" (Jn 1:48). In his *Tractates on the Gospel of John*, Augustine inquires after the meaning of the fig and locates it in two other biblical verses. One is the New Testament account of Jesus coming hungry from Bethany and "seeing in the distance a fig tree in leaf, he went to see whether perhaps he would find anything on it. When he came to it, he found nothing but leaves, for it was not the season for figs. He said to it, 'May no one ever eat fruit from you again'" (Mk 11:12–14; parallel at Mt 21:18–22). Augustine's second scriptural fig is the Fall of Man narrative. From the juxtaposition of these two, Augustine concludes that leaves of the fig are "understood as sins," and that Nathanel was seated "under the fig tree, as under the shadow of death"—that is, under the shadow of human mortality introduced into the world by Adam and Eve's sin.[46]

Elsewhere, Augustine links the fig to sexuality in his commentary on Jesus's parable of the budding fig tree: "Then the sign of the Son of Man will appear in heaven.... From the fig tree learn its lesson: as soon as its branch becomes tender and puts forth its leaves, you know that summer is near. So also, when you see all these things, you know that he is near, at the very gates" (Mt 24:30–33). The lesson of Jesus's parable is clear: the imminent advent of the messianic Son of Man is as inevitable as the blooming of the fig before summer. However, Augustine does not interpret thus, arguing instead that the fig tree symbolizes "the human race, because of the itching of the flesh."[47] In this passage, and others like it, Augustine insists that the fig tree stands for sin and/or sexual desire, and relates it to the Fall of Man.[48] Though he

does not outright state that the forbidden fruit was a fig, Augustine strongly implies this is the case.

Many later medieval authors follow Augustine's example, either implying or asserting that the fig is the forbidden fruit. The *Liber de ordine creaturarum* ("Book of the Order of Creatures"), a work traditionally attributed to Isidore of Seville but now thought to have been composed in Ireland between 655 and 675,[49] recognizes that "it is not at all clear from what species of tree Adam ate." Still, the author states, the circumstantial evidence is compelling: "Immediately after sinning [Adam] covered his nakedness with the leaf of a fig tree (Gen 3:7), the only tree Jesus cursed when he was in the flesh—not long before he accepted death on account of the fault of Adam."[50] Roughly contemporary with the *Liber de ordine creaturarum* is the Bible commentary of Theodore, bishop of Canterbury, and his companion Hadrian, two scholars who came to England with a deep knowledge of Mediterranean exegetical traditions. Theodore (602–690) was born in Tarsus (near the southern coast of present-day Turkey), spoke and read Syriac, and most likely received his education in Antioch. Less is known of Hadrian's life, but he was Amazigh (Berber) and probably educated in North Africa.[51] Commenting on Genesis 2:9, the first mention of the Tree of Knowledge, Theodore and Hadrian write that in the Garden of Eden there was "one fig tree" and that the Lord "cursed *it* especially in the gospel, and none other, since the first sin was committed through it."[52]

Like Theodore and Hadrian, Alcuin of York (d. 804), one of the leading scholars of the Carolingian court, explicitly identifies the fig as the forbidden fruit. In *Questions and Answers on Genesis*, a treatise written as a dialogue between a disciple and his teacher, he writes:

> Question: Why did they, when they were troubled, have recourse to fig leaves?
> Answer: Because they lost the glory of simple chastity, they took refuge in the double excitement of lust. That is why the Lord Jesus said to Nathanael, "when you were under the fig tree, I saw you" (John 1:48), that is, when you were under the fig tree of original sin, I saw you through mercy, and therefore I came down to deliver you.[53]

The teacher's answer incorporates Augustine's characterization of the fig as inherently tied to lust, as well as the intertextual connection to John 1, and pushes it further when the teacher speaks of it as "the fig tree of original sin." For Alcuin, too, the forbidden fruit was unquestionably a fig.

The fig tradition continued to flourish into the High Middle Ages. No less an authority than Thomas Aquinas links the fig with the sin of Adam and Eve: "In the mystical sense, the fig tree signifies sin: both because we find a

fig tree ... being cursed, as a symbol of sin (Mt 21:19); and because Adam and Eve, after they had sinned, made clothes from fig leaves."[54] For Aquinas, as for his predecessors, the fig-leaf aprons do not signify Adam and Eve's newfound shame, but rather identify the fig as a symbol of sin and, at least implicitly, as the source of original sin. Meister Eckhart (1260–1328), the most prominent German theologian of his time, cites the fig-leaf aprons as proof that Adam and Eve ate a fig, and quotes a poem (otherwise unknown) that refers to the fig as an enemy that struck or betrayed us.[55] Some of the best-known medieval exegetes, then, were partisans of the fig.

A less known but fascinating fig passage occurs in the work of Rodericus Ximenez de Rada, archbishop of Toledo from 1209 until his death in 1247. In his *Breviarium historie catholice*, a survey of world history that takes the biblical narrative as its starting point, de Rada acknowledges that Scripture does not expressly identify the forbidden fruit. All the same, he argues, there are grounds for concluding it was a fig: it is the most savory of fruits (and so "good for food," per Genesis 3:6), and Adam and Eve used fig leaves for their aprons. De Rada then provides a biblical prooftext (of sorts): "And the Song of Songs states, '*Under the fig tree I saw you*, there your mother was corrupted, there was violated she who gave birth to you,' that is, Eve."[56] The italicized phrase diverges from the standard text of the Vulgate both in the species of the tree and in the action of the speaker: as we will see below, the biblical verse speaks of the apple tree, not the fig, under which "I *awakened* you," not "*saw* you." This wonderful variant is the result of de Rada grafting Jesus's words to Nathanel in John 1:49 ("I saw you under the fig tree") onto Song of Songs 8:5 ("Under the apple tree I awakened you").[57] Though any reconstruction is necessarily speculative, the underlying logic appears to be as follows: the forbidden fruit is a fig, so if the tree of Song of Songs 8:5 is associated with the Tree of Knowledge, it too must be a fig. If this is correct, de Rada's statement reflects just how deeply the fig had insinuated itself into the theological discourse surrounding the forbidden fruit.

At least one (vernacular) source describes the fig tradition as a matter of ecclesiastic instruction, the Middle High German romance *Tristan*, by Gottfried von Strassburg (d. 1210). While lamenting the prevalent disobedience of women, the author cites the case of Eve and the forbidden fruit, adding that the "priests tell us that it was the fig-tree."[58] Gottfried offers no further information regarding the precise nature or geographic scope of this instruction. Nonetheless, his comment indicates that, at least in some regions, the association of the forbidden fruit with the fig was standard church instruction.

Several commentators report on the various forbidden fruit traditions without championing any one, and here too the fig is regularly cited but the

apple is not. Peter Abelard, the celebrated twelfth-century theologian, writes in his *Commentary on the Six Days of Creation (Hexameron)* that while Scripture does not provide definite evidence, "nonetheless it appears to some that [the forbidden fruit] was a fig," though the Jews, he adds, identify it with the grape.[59] His contemporary Hugh of St. Victor also testifies to the existence of a fig tradition,[60] as does Hugh's disciple, Andrew of St. Victor, in a passage adduced in chapter 1: "Some say that the forbidden tree was a fig, since 'they sewed fig leaves'; others a vine—for it is written 'The parents have eaten sour grapes, and the children's teeth are set on edge' (Jer 31:29)."[61] Petrus Comestor refers to but does not endorse the fig tradition in his wildly influential *Historia Scholastica*, noting that "because of [the fig-leaf aprons], certain individuals claim that [the fig] was the forbidden tree,"[62] and later scholars echo these words.[63] Nicholas of Lyra (French, ca. 1270–1349), the leading Bible commentator of his day, writes: "*And they sewed fig leaves together*, from this the Jews say that the fig was the tree whose fruit they ate."[64] The agnosticism of these exegetes makes their testimony more compelling. They have no theological skin in the game, so were the apple tradition known to these authors, they would have included it. Since it was not, they did not. All of which is in keeping with the testimony of the Latin commentaries on Genesis as a whole: not only do they contain no evidence for the *malum* hypothesis; the apple tradition itself is absent.

The Song of Songs

The Fall of Man narrative is the primary biblical source for any discussion of the forbidden fruit, but like the "bad Prosodians" Thomas Browne attacked more than three centuries ago, contemporary scholars also cite Song of Songs 8:5. The verse merits close analysis. The New Revised Standard Version has the following: "Under the apple tree I awakened you. There your mother was in labor with you; there she who bore you was in labor."[65] However, it was the Vulgate that served as the basis for medieval Christian commentary, and its translation differs considerably: "Under the apple tree, I raised thee up. There thy mother was corrupted. There she was deflowered who bore thee."[66]

Though different in several respects, both the NRSV and the Vulgate translate the Hebrew fruit *tapuaḥ* as "apple," an identification modern Bible scholars generally reject (the apricot has emerged as a more likely candidate).[67] The botanical identity of the *tapuaḥ* is crucial for understanding the original meaning of the Song of Songs, but the *malum* hypothesis rests on the Latin of the Vulgate, which was, de facto, *the* Bible of medieval Europe. It is the Vulgate's translation of Song of Songs 8:5 that makes the verse amenable to a Fall of

Man interpretation, since the corrupted mother was readily identified with Eve, the first mother of humanity. The sin of Eve would then be committed "under the apple tree," a view that resonates with the ambiguity of the Latin phrase *sub arbore malo*, "under the apple tree" or "under the evil tree."[68] James Snyder summarizes the significance of Song of Songs 8:5 to the *malum* hypothesis as follows: "Since *sub arbore malo* was read as either 'under the apple tree' or 'under the evil tree,' the association with Eve and the forbidden fruit was a most fitting one."[69]

I want to state at the outset that even though Genesis 3 is the principal site of forbidden fruit commentary, it is in the medieval commentary tradition on Song of Songs 8:5 that we find evidence for the *malum* hypothesis. Anselm of Laon (d. 1117), a French theologian and exegete, is best known today for his role in the creation of the *Glossa Ordinaria*, an anthology of commentaries that became "the ubiquitous text of the central Middle Ages."[70] He is also the author of a number of biblical commentaries, including one on the Song of Songs, the *Enarratio in Canticum Canticorum*, which was published in Paris in 1550 and reprinted in the *Patrologia Latina*.[71] For centuries, scholars considered this a singular witness to Anselm's Song of Songs commentary, until Jean Leclercq published an influential essay demonstrating that there are, in fact, two other versions—a long commentary and an abridgment of this long commentary.[72] The key finding for the present discussion is that all three versions connect Song of Songs 8:5 to the Fall of Man. Both the *Enarratio* and the long commentary gloss "under the apple tree" (*sub arbore malo*) as "the sin committed under the *arbore malo*, that is, the sin of the first parent," and assert that the Cross was made of the wood of this tree.[73] The abridged commentary adopts the same exegetical approach, with a unique and important addition: "Under the apple tree—under the eating of the apple (*sub comestione mali*)."[74] Here we have an unequivocal affirmation that Adam and Eve sinned by eating an apple.

Knowing what we know about Anselm of Laon, we can readily imagine how the rest of the story unfolds: Anselm included this interpretation in the *Glossa Ordinaria* to Song of Songs, and as the *Glossa* gained popularity, it carried the seeds of the apple tradition to every corner of Latin Europe. Alas, none of this occurred. The *Glossa Ordinaria* does not incorporate the abridged commentary's "under the eating of the apple" gloss. In fact, it does not connect the tree of Song of Songs 8:5 to the Fall of Man, offering instead an ecclesiological interpretation (a symbolic account of the history of the church), in which "there your mother was corrupted" refers to the Synagogue, the figurative "mother" of the Church, and "under the apple tree" symbolizes the Cross, which the Jews failed to embrace:

I awakened you: I recalled you to faith in the passion which was a deed of great good will, because by that same tree your mother [the Jews] was inwardly blinded, and consequently said "his blood be upon us and upon our children" (Mt 27:25). *There your mother was corrupted*: as punishment for the same crucifixion; *violated*: by the outward vengeance of Titus and Vespasian.[75]

The forbidden fruit is nowhere to be found. So, while Anselm equates original sin with eating an apple, this assertion does not reach a wide readership and, as a consequence, does not play a meaningful role in the emergence of the apple tradition.[76]

Over half a century later, Gilbert of Foliot, the bishop of London, provides another reference to the apple in his commentary on the Song of Songs 8:5: "They say that the forbidden tree, of which man, while in Paradise, was commanded to abstain, was an apple."[77] Like the Genesis commentators surveyed at the end of the previous section, Foliot notes the existence of a forbidden fruit tradition without endorsing it. He also does not refer to the two meanings of *malum*, so the grounds for the apple identification remain unclear. Still, Foliot's comment is significant in that it is the first indication of something resembling an apple tradition ("They say . . ."). But what is its historical significance? Like Anselm's apple interpretation, it was never published and survives in a single manuscript, suggesting only a minimal impact on later readers.[78]

If Anselm's and Foliot's apple comments did not exert discernible influence on contemporary and subsequent readers, might they nonetheless have been harbingers of a shift toward interpreting Songs of Songs 8:5 as evidence the forbidden fruit was an apple? In a word, no. The overwhelming majority of commentaries on this verse do not cite the two meanings of *malum*, nor do they identify the apple as the forbidden fruit. In fact, the opposite is the case. The apple of Song of Songs was closely associated with Christ—symbol of salvation, not transgression—an interpretive tradition rooted in verse 2:3, where the female beloved likens her lover to an apple tree: "As an apple tree (*sicut malum*) among the trees of the woods, so is my beloved among young men." Read in the allegorical key that pervaded the medieval Christian understanding of the Song of Songs, the Church is praising Christ by likening him to an apple tree. This reading is found at least as early as Saint Ambrose, in the fourth century:

> Wounds are what Christ received; what he gives in return is sweet fragrance. From the tree of the Cross hangs the fruit, fruit that the Church tastes and so cries out, "His fruit was sweet to my palate" (Song of Songs 2:3). To learn what this fruit is, read on, "As an apple tree among the trees of the woods, so is my beloved among young men." (Song of Songs 2:3)[79]

Building on the language of Song of Songs 2:3, Ambrose invokes two images that will recur in later commentaries: the apple tree is the Cross and its fruit—Christ.[80]

Many commentators affirm that the Cross was made of the wood of an apple. For Venerable Bede, the early eighth-century English scholar, Song of Songs 2:3 proves that "the apple tree most aptly depicts the wood of the holy Cross."[81] Alcuin presents this conclusion in the context of verse 8:5: "'Under the apple tree': Under the tree of the Cross."[82] Similar glosses of "under the apple tree" as "under the Cross" or "under the wood of the Cross" are quite common.[83]

The symbolic connection of Christ and the apple is also quite common. The twelfth-century Spanish Augustinian Martin of Leon states that the apple tree of Song of Songs 8:5 "represents nothing other than the sacred Cross that sustained that very apple, namely Christ."[84] Alan of Lille, Martin's French contemporary, declares that the Cross is called an apple tree because "it bears that glorious apple."[85] Such was the salvific force of the apple tree, that some scholars identified it with the Tree of Life, as when Robert of Tombelaine, an eleventh-century Benedictine monk, glosses Song of Songs 2:3, "This very tree is indeed the tree of life."[86] Strictly speaking, nothing could be further from the Tree of Knowledge.

Might the Christ-apple symbolism be compatible with the claim that the forbidden fruit was an apple? After all, Christian theologians as far back as Tertullian and Jerome posited a salvific symmetry between original sin and salvation: Christ remedies Adam, Mary remedies Eve, and the Cross remedies the Tree of Knowledge.[87] Perhaps, then, the redemptive force of the apple is paralleled by the apple's role in the Fall. This is a plausible suggestion, but one not borne out by the commentaries on Song of Songs 8:5. In fact, many commentators resist identifying the apple with the forbidden fruit, even when situating the verse in the context of the Fall of Man. In some cases, this is simply a matter of terminological difference. Honorius Augustodunensis (or Honorius of Autun; 1080–1154),[88] a widely read theologian about whose life almost nothing is known, interprets Song of Songs 8:5 as an account of Christ's death *sub arbore malo*, glossed as "under the wood of the Cross." Through this act, Honorius writes, humanity atoned for the actions of its mother, Eve, who "ate of the forbidden fruit," in Latin—the forbidden *pomum*.[89] Honorius draws a clear distinction: the *malum*, "apple," is the redemptive fruit, while the fruit that occasioned the Fall of Man is a *pomum*, "fruit." The Cistercian Geoffrey of Auxerre (1115–1194) likewise distinguishes the apple tree (*arbor malus*) that provides the wood of the Cross and on which hangs Christ, from the fruit that tempted Eve, "the noxious *pomum*."[90] Another Cistercian, Thomas of Perseigne (d. 1190), opposes "the tree of the Cross, which [the Song of Songs]

designates by the apple (*malum*)" to "Adam's fruit (*pomum*) of damnation."[91] These sources are highly significant. Advocates of the *malum* hypothesis could not ask for a more favorable theological setup, with the apple (*malum*) of Song of Songs 8:5 juxtaposed to the forbidden fruit. Nothing would be more natural—*if* the apple were associated with the forbidden fruit—than to identify the forbidden fruit with the apple. Yet all three theologians insist that the *malum*, "apple," is firmly rooted on the side of redemption (Christ, the Cross), while the Fall of Man occurred as a consequence of a *pomum*, "fruit."

A number of authors introduce the Fall of Man into their interpretation of the Song of Songs, but not the forbidden fruit. Apponius, one of the earliest Christian commentators on the Song of Songs (tentatively dated to the seventh century), glosses "under the apple tree" as "the one sleeping under the power of the devil, that is, the tree of death,"[92] an allusion to the Tree of Knowledge. But he does not pursue this line of argument, rather adopting an ecclesiological interpretation according to which the awakening mother symbolizes the conversion of the Jews to Christianity.[93] For Haimo of Auxerre, a ninth-century French Benedictine, the apple of Song of Songs 8:5 is not the forbidden fruit but rather the redeemer of humanity "from the deceit of original sin and from the power of the devil."[94] For the twelfth-century Benedictine Wolbero of Cologne, Song of Songs 8:5 speaks of Eve, who, "seduced and violated, persuaded the man and both took of the forbidden tree," but the verse's apple is the wood of the Cross.[95] These authors do not use the *malum/pomum* distinction, but they emphatically separate their lapsarian interpretation of verse 8:5 from the claim that its apple tree was the Tree of Knowledge.

Some authors go further still, structuring their interpretations in a way that precludes connecting the apple of Song of Songs 8:5 with the forbidden fruit. John of Mantua, a late eleventh-century Italian monk, interprets the tree as a symbol of the Cross and the beloved's awakening as the transition from a state of fallenness to redemption in Christ. The passage invokes the salvific symmetry discussed above: the Tree of Knowledge yielded the food (*cibus*) of death and dejection; the apple tree, that is, the Cross, yielded the food (*cibus*) of life and redemption.[96] John then offers a second interpretation (*aliter exponere*) of verse 8:5, namely, as "the tree by which Adam was dominated," a tree "seen as evil and sweet on account of the pleasure of gluttony."[97] There are two clear issues here. First, what John of Mantua presents as distinct exegeses could quite naturally be viewed as complementary elements of a single reading that posits a correspondence between the Tree of Knowledge and the Cross (the salvific symmetry): the beloved awakens redeemed under the apple tree that symbolizes the Cross, the very Cross that redeemed

humanity from the transgression of the apple tree—the Tree of Knowledge. Second is the unnatural and jarring description of the Tree of Knowledge as "evil and sweet" (*malus et dulcis*). Both, I believe, are intended to repudiate the identification of the Tree of Knowledge with the apple of verse 8:5. By framing his reading of the verse as consisting of two discrete interpretations, John of Mantua represents the salvific symmetry as concerned with *cibus*, "food": the *cibus* of the Tree of Knowledge is redeemed by the *cibus* of the Cross. Considering that Song of Songs explicitly identifies the tree in question as an apple tree, and that it would be quite natural to posit a symmetry between the *malum* of the Tree of Knowledge and the *malum* that is the Cross, the separation of the two interpretations, and the use of *cibus* in the first, bespeak a resolute resistance to the identification of the forbidden fruit with the apple. So too the odd description of the Tree of Knowledge as "evil and sweet" (*malus et dulcis*). Juxtaposing *malus* and *dulcis* locks *malus* into the adjectival sense of "evil," and precludes reading it as a noun—"apple tree." In other words, John of Manuta's first interpretation understands the *malus* of verse 8:5 as an apple, but *only insofar as it is identified with Christ and the Cross*. In the second interpretation, which interprets the tree of verse 8:5 with the Tree of Knowledge, *malus* means only "evil," not "apple." The result is a commentary contorted by its determination to repudiate any reading that identifies the forbidden fruit with the apple.[98]

I want to conclude this section as I did the preceding, with a passage from Nicholas of Lyra. Lyra regularly incorporated Hebrew Bible scholarship into his commentaries, and his discussion of Song of Songs 8:5 is a case in point:[99]

> Under the apple tree (*sub arbore malo*), that is, by virtue of your holy Cross and passion.... You must also realize that the word *malo* is not an adjective, as some think, explaining this as a reference to the tree which was forbidden to Adam and Eve, because in Hebrew, instead of two words *arbore malo*, there is only one word, *punica*, which refers to a pomegranate tree. The former explanation comes from ignorance of idiomatic Hebrew.[100]

Like Rufinus nearly a millennium before him, Nicholas of Lyra is aware of the possibility of interpreting *sub arbore malo* as "under the evil tree," and like Rufinus, he rejects it. Yet he does so on different grounds, which require some elaboration. As noted above, the Hebrew of Song of Songs 8:5 places the beloved "under the *tapuaḥ*," a fact Lyra considers doubly significant. First, the Hebrew noun *tapuaḥ* abolishes the ambiguity of Latin *malum*, which can now no longer be interpreted as the adjective, "evil." Second, Lyra takes *tapuaḥ* to denote a *malum punicum*, a pomegranate. Setting aside the accuracy of this translation,[101] Lyra's two claims provide important insights into the

contemporary understanding of the forbidden fruit. The first indicates that Lyra knows of an exegetical tradition that equates the fruit of Song of Songs 8:5 with the forbidden fruit, and he rejects it as incompatible with the Hebrew text: it is possible to interpret the Latin phrase *arbore malo* adjectivally ("evil tree"), but the Hebrew original does not support this reading. Those who claim the tree of verse 8:5 is the Tree of Knowledge are mistaken. Lyra then asserts that the Hebrew *tapuaḥ* is a pomegranate. Key to the present discussion is the argument that Lyra does *not* make. Namely, he does not argue that the identity of the *tapuaḥ* as a pomegranate gainsays the identification of the forbidden fruit with the apple. In other words, he attacks those who erroneously link the tree of 8:5 and the Tree of Knowledge (on the grounds that Hebrew *tapuaḥ* cannot mean "evil"), but he does not attack those who erroneously identify the forbidden fruit as an apple (on the grounds that it means "pomegranate," an error he could also attribute to "ignorance of idiomatic Hebrew"). The most natural explanation for this omission is that Nicholas of Lyra, the greatest Christian Bible scholar of the fourteenth century, is not aware of the claim that the forbidden fruit was an apple. More than a century after Anselm of Laon and Gilbert Foliot wrote their commentaries, Nicholas of Lyra joins a long list of exegetes either unaware of or opposed to the notion that the apple tree of Song of Songs 8:5 is the Tree of Knowledge and the apple, the forbidden fruit.

Conclusion

This chapter began under the assumption that medieval Latin authors knew and endorsed the apple tradition, and it remained only to ascertain whether the homonymy of Latin *malum* was its cause. This assumption, however, did not withstand the textual evidence. The apple tradition is almost nonexistent in Latin commentaries on Genesis 3. Cyprian of Gaul refers to the forbidden fruit as apple in fifth-century Gaul,[102] as do Petrus Riga and Geoffrey of Vinsauf some seven centuries later. In the interim, however, we find a vibrant fig tradition whose witnesses include the greatest figures of medieval Christendom—Augustine, Alcuin, Thomas Aquinas, and many more. The apple hardly fares better in the commentary tradition on Song of Songs 8:5. It is attested in two commentaries of marginal historical significance, each of which survives in single, unpublished manuscripts. Aside from these, we find either silence or efforts to avoid linking the apple tree of Song of Songs 8:5 with the Tree of Knowledge. Rather than confirm or refute the *malum* hypothesis, the findings of this chapter signal the need for a fundamental rethinking of the task at hand. We cannot explain the origins of the apple tradition until

we have located it, and so we are faced with a new question: Where and when is the apple consistently identified as the forbidden fruit? To address this question, the next chapter adopts a different disciplinary approach and examines the iconographic depictions of the forbidden fruit. Perhaps the visual sources will speak where the literary sources have been frustratingly silent.

3

The Iconographic Apple

> Although the account of the Fall of Man in Gen. 3 does not mention any particular fruit ... the fruit has always been regarded as the apple.
>
> THE OXFORD DICTIONARY OF
> CHRISTIAN ART AND ARCHITECTURE, 2013

In 1966, J. B. Trapp lamented that "there is no satisfactory account of the iconography of the Fall." More than half a century later, these words still hold true, especially with regard to the identity of the forbidden fruit.[1] Scholarship abhors a vacuum, and in the absence of a widely accepted account of the forbidden fruit's iconography, statements to the effect that "the fruit has always been regarded as the apple" proliferate despite being gross mischaracterizations of the historical evidence.[2] As I show in what follows, the apple, in fact, played no meaningful role in the Fall of Man iconography until its first sustained appearance, in twelfth-century France. From there, the apple tradition spread to England, Germany, and the Low Countries, but found a less receptive environment in Italy and Spain. Of course, it is not always possible to identify the forbidden fruit securely in every work, and reasonable viewers may disagree. Such disagreements, however, tend to be of minor import: whether a forbidden fruit is a pomegranate or a generic fruit does not impact the core argument concerning the absence of an apple tradition prior to the twelfth century. The argument of this chapter is based on analysis of hundreds of Fall of Man scenes across a variety of media: paintings, manuscript illuminations, column capitals, stained-glass windows, and more, only a small fraction of which could be included in this book.[3] However, I have provided both a series of maps that graphically represent the iconographic landscape as fully as possible and an appendix that offers an inventory of the works. In addition, the images (or links to the images) are available on the book's companion website: https://treeofknowledgeart.com/.

Before the Apple: Early Christian to Carolingian Art

The two most important media for early Christian art are catacomb frescoes and engraved sarcophagi, Rome being the chief source of both. The Fall of Man is a common motif in these media, with the fig tradition enjoying a commanding presence.[4] Fortunately, fig leaves have a distinct morphology—they are wide and consist of three to five distinct lobes—making it easier to identify the Tree of Knowledge as a fig even when the forbidden fruit is either not represented or indistinct. The catacombs preserve numerous Fall of Man scenes where the Tree of Knowledge has clearly discernible fig leaves, as we see in the well-preserved fresco in cubiculum XIII of the Catacombs of Marcellinus and Peter (plate I). Figs are also found in arcosolium III in the Catacombs of Marcellinus and Peter, and in Rome's Coemeterium Majus.[5] While not all catacomb Fall of Man scenes include botanically identifiable Trees of Knowledge, every identifiable tree is a fig.

The fig tradition is dominant in Christian sarcophagi as well.[6] These works exhibit a thematic diversity mirroring the iconographic plasticity of the early Christian conceptions of the Fall of Man. Three of the best-known sarcophagi of fourth-century Rome differ markedly in their artistic representation of the Fall. The Junius Bassus Sarcophagus represents Adam and Eve standing on either side of the Tree of Knowledge, staring off in forlorn recognition of their fallenness (fig. 3.1);[7] in the Dogmatic Sarcophagus they are on either side of Jesus, in a scene known as the assignment of the tasks;[8] and the Cyriaca Sarcophagus depicts them plucking the fruit from the tree. Each of these sarcophagi offers a different visual interpretation of the Fall of Man, but one element is constant: the tree is a fig. In fact, the Tree of Knowledge is a fig in almost every sarcophagus that has a botanically identifiable forbidden fruit: some thirty fig exempla in Rome, some of which were exported to other parts of the Roman Empire (see fig. 3.2, from Spain), with additional attestations in Naples, Syracuse, and Verona, as well as Roman Gaul.

The fig tradition did not hold absolute sway. A fourth-century sarcophagus from Lucq-de-Béarn, in southwestern France, depicts a tree with large leaves and Eve holding a fruit whose botanical identity is not clear. Another fourth-century French sarcophagus, from the Tomb of St. Clair in Toulouse, depicts Eve holding a large round fruit (fig. 3.3).[9]

The one critical exception is the Fall of Man scene of the *Receptio Animae* sarcophagus, created in Rome 330–340 CE, perhaps in the same workshop that produced the Dogmatic Sarcophagus (plate II).[10] The sarcophagus was exported to Spain, and is today located in the minor basilica of the Church of Santa Engracia in Zaragoza. The visual idiom of the scene is familiar: Adam and Eve stand on either side of the Tree of Knowledge, Eve holds the

FIGURE 3.1. Anonymous, Junius Bassus Sarcophagus, 359. Vatican City, Basilica of St. Peter. Credit: @Genevra Kornbluth.

forbidden fruit in her right hand, Adam's index and middle finger extend in the oration gesture, and the serpent is entwined around the trunk of the tree. The uniqueness of the *Receptio Animae* lies with its forbidden fruit, clearly an apple, based on its size, the sharp indentation at the base of the stalk, and the bite Eve has taken of hers. This is the only definite representation of an apple on early Christian sarcophagi, and it would be easy to dismiss it as an iconographic isolate. Yet we know that at some future point, the apple becomes the forbidden fruit par excellence. Does the *Receptio Animae* herald this change, the first Fall of Man scene that eventually gave rise to the apple tradition?

This is an intriguing possibility, but all evidence points against it. In all probability, the *Receptio Animae*'s apple imagery is a reflection of the iconographic norms of the surrounding pagan culture. Indeed, art historians have long recognized that early Christian iconography is bound up with the visual idiom of pagan art—not surprising for a nascent tradition emerging in the context of a prestigious and firmly established artistic tradition. In its earliest iterations, Christian visual identity was not sundered from its pagan surroundings.[11] As Jaś Elsner notes, fourth-century Rome was "poised between

THE ICONOGRAPHIC APPLE 31

worlds, where 'pagan' and 'Christian' served not as a mutually exclusive antithesis . . . but rather as a rich complex of options through which the identities of Rome's inhabitants could be expressed," and this "mixture of visual (and other) discourses speaks of a culture of Christian and pagan assimilation and easy interchange."[12]

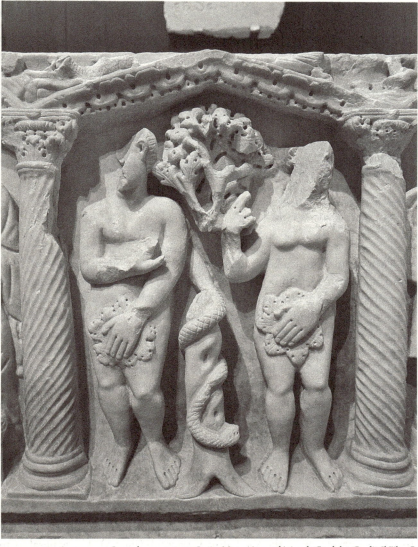

FIGURE 3.2. Anonymous, Sarcophagus, 330–335. Spain, Museo Arqueológico de Cordoba. Credit: Jl FilpoC, CC BY-SA 4.0, via Wikimedia Commons (https://creativecommons.org/licenses/by-sa/4.0/legalcode).

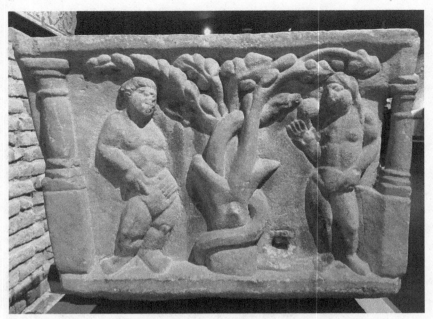

FIGURE 3.3. Anonymous, Sarcophagus of the Tomb of St. Clair, 400–432. Toulouse, Musée Saint-Raymond. Credit: Musée Saint-Raymond, public domain, via Wikimedia Commons (https://creativecommons.org/licenses/by-sa/4.0/legalcode).

This "assimilation and easy interchange" found various expressions: Christian patronage of pagan art,[13] the intermingling of distinctly Christian and pagan motifs,[14] and, most relevant to the present analysis, a shared visual idiom employed for both pagan and Christian scenes.[15] That is, certain biblical scenes were patterned after established imagery from Greek and Roman mythology: Jonah and Endymion (a shepherd whose beauty caused the moon-goddess Selene to fall in love with him), Christ and Orpheus, and others.[16] The most important of these for our purposes is the striking iconographic similarity between the Fall of Man and the eleventh labor of Hercules: taking the golden apples from a tree planted in the Garden of the Hesperides and guarded by the serpent Ladon.[17] The parallels with Genesis 3—the picking of a forbidden fruit, a garden that belongs to a god, and the presence of a serpent—are obvious.[18] Small wonder, then, that the Fall of Man and Hercules in the Garden of the Hesperides are represented in a visually similar fashion, as the two scenes from the Roman catacombs demonstrate: the Fall of Man scene from the St. Peter and St. Marcellinus Catacombs (fig. 3.4) and the fresco of Hercules from the Via Latina Catacomb (fig. 3.5). The general form of the tree, the representation of the serpent, and the positioning of the figure

to the right of the tree—Hercules and Eve, respectively—are all remarkably alike. Neither scene depicts the fruits themselves, but Hercules holds apples (or apple-like fruit).[19] The *Receptio Animae* most probably belongs to this class of Christian art, as its portrayal of Adam and Eve reaching for the fruit echoes depictions of Hercules (e.g., in the Velletri Sarcophagus; fig. 3.6).[20] This interpretation finds support in the subsequent trajectory of the Fall of Man iconography. As pagan influence ebbed and Christian art developed its own visual conventions, no other early Christian works depicted the forbidden fruit as an apple; the *Receptio Animae* is a unique exemplar.

The few fourth- and fifth-century Fall of Man scenes outside the catacombs and sarcophagi affirm the diversity of the forbidden-fruit traditions, as well as the commanding presence of the fig. A fourth-century glass bowl

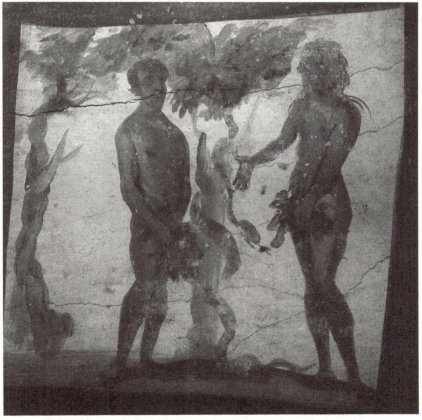

FIGURE 3.4. Anonymous, fresco, 320–360. Rome, Catacombs of Marcellinus and Peter, cubiculum XXX. Credit: Courtesy of the Pontifical Commission for Sacred Archaeology.

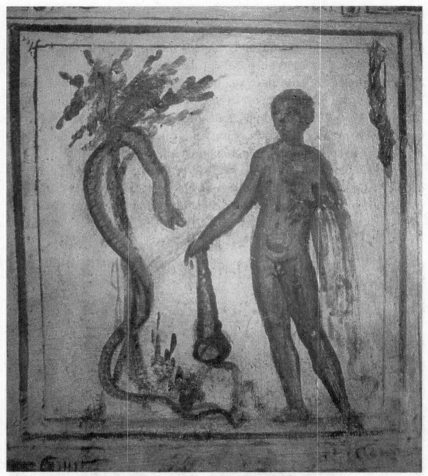

FIGURE 3.5. Anonymous, fresco, 375–385. Rome, Via Latina Catacombs, cubiculum N (PCAS). Credit: Courtesy of the Pontifical Commission for Sacred Archaeology (PCAS).

from Cologne has an unidentifiable tree, with leaves shaped like a nearby wheat stalk; a coffin plaque from Trier, roughly contemporary with the Cologne bowl, depicts a tree that resists clear identification—perhaps a fig. The Trees of Knowledge on two fourth-century gold glasses from Rome appear to be figs, but here too it is hard to be certain, while a late fifth- or early sixth-century mosaic from northern Syria depicts the forbidden fruit as a fig (fig. 3.7). The fig, then, is the dominant but not the sole forbidden fruit.

The Fall of Man is not a common theme in Byzantine art,[21] though it does feature prominently in a series of illuminated Byzantine Octateuchs.[22] The

most important of these are the eleventh-century Bible in the Laurentian Library in Florence, the twelfth-century Bible housed in the Seraglio Library in Istanbul, and the thirteenth-century Greek codex in the Vatican Library. In the Florentine scene, the tree is not naturalistic—it borders on decorative—making botanical identification impossible. The Seraglio and Vatican Fall of Man scenes are almost identical, depicting Eve's tempter as a four-legged creature, the serpent before God punished it by removing its legs ("On your belly you shall go and dust you shall eat"; Gen 3:14). These Octateuchs consist

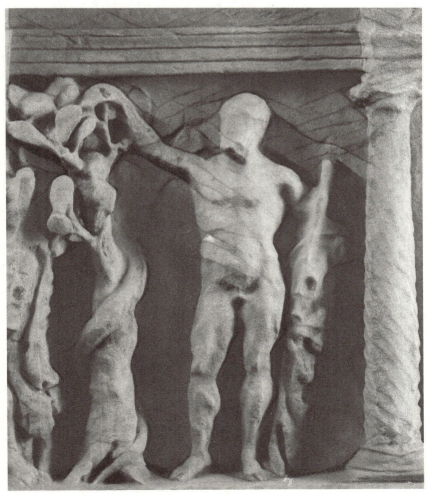

FIGURE 3.6. Anonymous, sarcophagus, 145–150. Velletri, Museo Civico di Velletry. Credit: Gibon Art/Alamy Stock Photo.

of a sequence of images corresponding to the biblical narrative: the serpent tempting Eve, Adam and Eve conversing, and the commission of the sin. The first and third scenes include the Tree of Knowledge, but its botanical identity is unclear.[23] Other Byzantine works that represent the Fall of Man include an eleventh- or twelfth-century casket produced in Constantinople and now

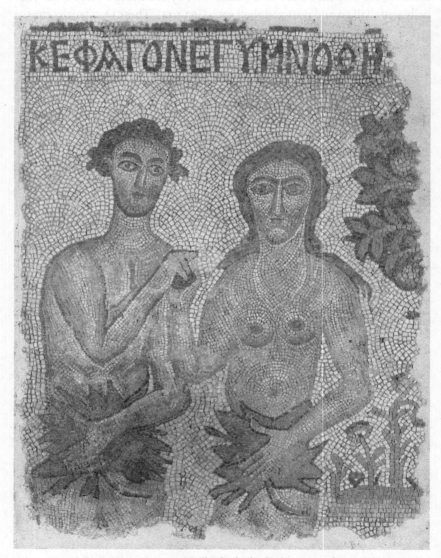

FIGURE 3.7. Anonymous, mosaic, 475–525. Cleveland, Cleveland Museum of Art. Credit: Public domain, via Cleveland Museum of Art.

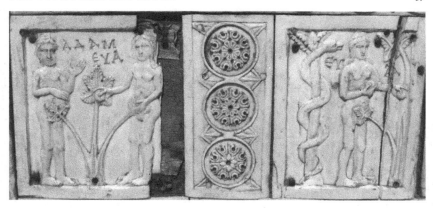

FIGURE 3.8. Anonymous, ivory box, 11ᵗʰ–12ᵗʰ century. Cleveland, Cleveland Museum of Art. Credit: Cleveland Museum of Art Daderot, CC0, via Wikimedia Commons (https://creativecommons.org/public domain/zero/1.0/legalcode).

housed in Reims; two contemporary ivory boxes with Fall of Man scenes (fig. 3.8); and an eleventh- or twelfth-century manuscript of Marian homilies by the monk Jacobus Kokkinibaphos. None portrays the forbidden fruit as an apple. A late ninth-century collection of John Chrysostom's sermons depicts Adam holding a red fruit with a visible calyx: a pomegranate.[24]

The Fall of Man motif does appear regularly in illuminated Bibles. The earliest surviving illuminated Bible is the Vienna Genesis—twenty-four folios of the Genesis Septuagint from sixth-century Syria. The fruits of the Tree of Knowledge are faded, but Trapp suggests they are pomegranates.[25] Illuminated Bibles became increasingly important during the Carolingian reforms, which saw Charlemagne appoint Alcuin abbot of the monastery of St. Martin in Tours in 796, transforming it into a major center of illuminated-manuscript production.[26] The first Touronian Bible with a Genesis frontpiece (ca. 840) was the Moutier-Grandval Bible (plate III), followed closely by the Vivian Bible, and the Bamberg Bible. The wide and distinctly shaped leaves of the Tree of Knowledge in all three mark it as a fig.[27] In the Bible of San Paolo fuori le Mura, commissioned by Charles the Bald, the Tree of Knowledge is not a fig, but neither is it an apple. This burst of Carolingian Fall of Man iconography does not, then, materially alter the picture: aside from the *Receptio Animae*, the apple is absent (map 1).

The Apple Tradition

The early Christian works discussed above concur with the written sources examined in chapter 2. They exhibit several fruit species, the fig enjoys pride of

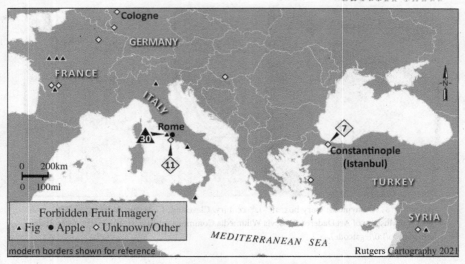

MAP 1. Early Christian, Byzantine, and Carolingian. The fig tradition was dominant in Italy. It is an open question whether the sarcaphogi found in France were produced there, but they appear as French on the map. The lone attestation of the apple is the *Receptio Animae*. Map credit: Michael Siegel, Rutgers Cartography, 2021.

place, and the apple is an afterthought; they offer no hint of a sustained apple tradition. What, then, motivated later artists to introduce a new species, and why did it so quickly and thoroughly displace the fig and all other fruit species?

The initial step toward answering these questions is to establish when the apple tradition first appeared, but before doing so, two iconographic issues must be addressed. One is what to do with round, apple-sized forbidden fruit that lacks distinguishing morphological characteristics. As always, context is key. Prior to the emergence of the apple tradition, such images cannot be securely counted as apples, since they may well be meant as generic "fruit," and not a particular species. If, however, apple iconography is dominant in a particular region, the identification of the fruit as apples becomes more plausible. Artists working in such a milieu were likely familiar with forbidden apples and could use round, apple-sized fruit as shorthand for that species, while artists wishing to avoid this identification would take pains to distinguish the forbidden fruit from the apple.[28]

The other issue involves images I classify as apples that to modern eyes may appear to be oranges. I identify them as apples for two reasons. First, edible oranges were not common in Europe during the period under discussion: "Before 1500, European orange growers mainly grew Bitter Oranges."[29] These inedible varieties would scarcely be associated with a tempting fruit that was "good for

food" and eaten directly off the tree. It was not until Portuguese traders brought sweet orange trees to Europe from India in the early sixteenth century that the edible orange became popular.[30] Second, the yellow and orange color of this forbidden fruit functions as a visual allusion to the "golden apple," which has its roots in the classical tradition but came to be incorporated into Christian Fall of Man iconography.[31] In a number of works, the depiction of the golden apple is unmistakable (plate IV).[32] Bearing these points in mind, we can survey the landscape of medieval Fall of Man iconography.

France

Artistic traditions are never static, and the French Fall of Man iconography exhibits thematic variety. Works differ regarding the placement of Adam and Eve relative to the Tree of Knowledge, the presence or absence of fig-leaf aprons, the depiction of the serpent with a female (or, rarely, male) face;[33] and Adam's gesture toward his throat. Some works break dramatically with the dominant iconographic norms. Gislebertus of Autun, a twelfth-century Romanesque sculptor, represents Eve floating like a medieval precursor of Chagall's airborne figures (fig. 3.9); a fourteenth-century manuscript depicts Adam and Eve fully dressed; and a fifteenth-century illumination has Eve in full courtly dress, with the serpent, a dragon, at her feet.[34] For the most part, however, eleventh- and twelfth-century artists adhere to the iconographic

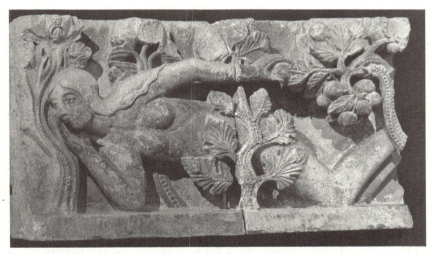

FIGURE 3.9. Gislebertus, portal lintel relief, 1120–1135. Autun, France, Cathedral of Saint Lazare, now Musée Rolin. Credit: Morio60, CC BY-SA 2.0, via Wikimedia Commons (https://creativecommons.org /licenses/by-sa/2.0/legalcode).

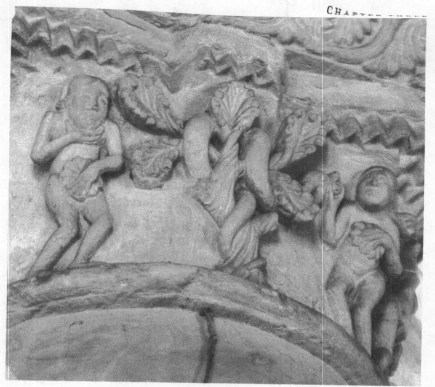

FIGURE 3.10. Anonymous, capital, 1080–1099. Airvault, France, Saint Pierre Church. Credit: @Jean Marie Sicard.

norms of earlier Christian art—various species of forbidden fruit, with the fig enjoying greatest prominence.

Let us imagine an early thirteenth-century Benedictine monk from the Church of St. Pierre in Aulnay de Saintonge in western France, forty-five miles inland from the port of La Rochelle. He is undertaking a pilgrimage to Rome, with a stop at Amiens, north of Paris, to see the great cathedral under construction there, a month's journey on foot, all told. His first stop is at Airvault, just north of Aulnay. He is, of course, familiar with the forbidden fruit on the capital of his own church, an apple-sized but indeterminate round fruit,[35] so he notes with interest that at Airvault the tree is a fig (fig. 3.10). When he reaches Amiens he finds that the fruit is a grape, as it is at his next stop, the Abbey of Saint-Denis in the northern suburbs of Paris. Grapes recur at the Abbey of Sainte-Madeleine in the Burgundian town of Vézelay, along with a second Fall of Man scene in which Eve offers Adam a pomegranate (figs. 3.11 and 3.12). The famed Cluny Abbey, a week's journey to the south,

again has grape clusters, while the church of the nearby town of Neuilly en Donjon depicts Adam and Eve standing together between two identical trees that lack botanical characteristics. Less than a hundred miles away, a fresco in the church at Saint Jean des Vignes depicts the serpent passing to Eve a small black fruit, apparently an olive.[36] The pomegranate appears again in the church at St. Paul de Varax, north of Lyon, while the priest's last two stops before crossing into Italy belong to the fig tradition: a church at Tarascon, and the Cathedral (now Church) of St. Trophime in Arles.

While in Arles, our pilgrim strikes up conversation with a local priest, and mentions the variety of forbidden fruit species he witnessed on his journey. The priest, who happens to be learned, is not surprised, and remarks that he has seen most of these species in manuscript illuminations. A featureless round fruit in a Beatus Fall of Man, a fig in a Latin Bible, and a likely pomegranate in the Anchin Bible.[37] The forbidden fruit, the pilgrim and priest conclude, is as various—if not more so—than other elements of the Fall of Man iconography.

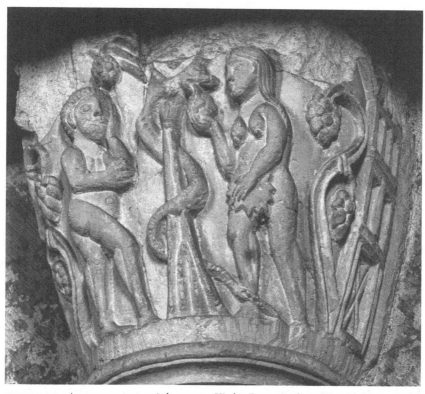

FIGURE 3.11. Anonymous, nave capital, 1120–1132. Vézelay, France, Basilique Sainte Madeleine. Credit: @Jean Marie Sicard.

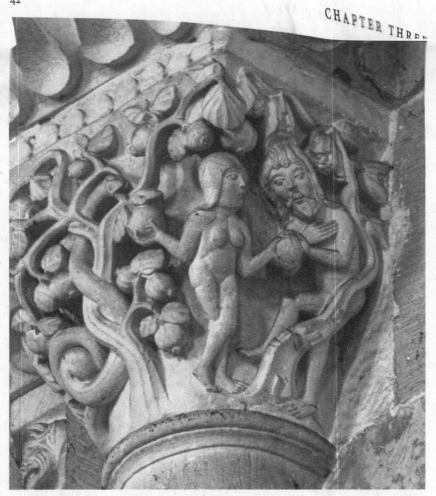

FIGURE 3.12. Anonymous, capital, 1000–1135. Vézelay, France, Basilique Sainte Madeleine, capital 93. Credit: @Jean Marie Sicard.

In addition to the species listed above, a keen observer would recognize a tentative newcomer: the apple. An illustrated psalter (1180–90) from the Church of St. Fuscien in northern France shows Adam about to eat a round fruit with what appears to be an apple stem, and the forbidden fruit on the capital at the south side of the St. Pierre Church in Airvault displays the distinctive cleft (stamen) of the apple (fig. 3.13).[38] The novelty of these images is noteworthy, but are they significant? As we saw with Cyprian of Gaul and the Laon Song of Songs commentary, an isolated cluster of apples does not necessarily constitute the beginnings of the apple tradition.

Except that in this case it does. These twelfth-century images are harbingers of a sweeping change that upends established iconographic norms, as the apple quickly evolves from one option among several to the dominant forbidden fruit, displacing the grape, the pomegranate, and even the venerable fig. The change occurs quite suddenly and across media. Red, round, apple-sized forbidden fruit appear on stained-glass windows of thirteenth-century cathedrals at Chartres, Amiens, Auxerre, and Le Mans (plate V), among others. Illuminated manuscripts overwhelmingly represent the forbidden fruit in this manner, some even displaying the white pulp of the bitten apple (plate VI). Stone carvings also adopt this new idiom, as we see in the reliefs at Sainte-Chapelle in Paris and St. Etienne in Auxerre. In the centuries that follow, the apple becomes ubiquitous: of some twenty-five fourteenth-century Fall

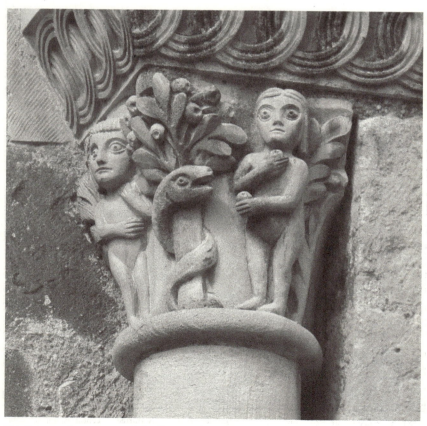

FIGURE 3.13. Anonymous, capital, 12ᵗʰ century. Airvault, France, Saint Pierre Church. Credit: @Béatrice Delepine, 2014.

of Man scenes, the vast majority are likely apples,[39] and in the fifteenth and sixteenth centuries, the apple's dominance increases.

Accustomed as we are to thinking of the forbidden fruit as an apple, it is difficult to appreciate the significance of the shift that occurred in twelfth-century France. It represents a dramatic break with the iconographic tradition of the time: for the first time in centuries, a new forbidden fruit is introduced into the Christian visual lexicon. No less important, the apple fundamentally altered the assumption that different species of forbidden fruit could coexist. Though the fig tradition had previously enjoyed pride of place, grapes and pomegranates remained viable artistic options for centuries. With the ascent of the apple, competing species disappear almost completely, and

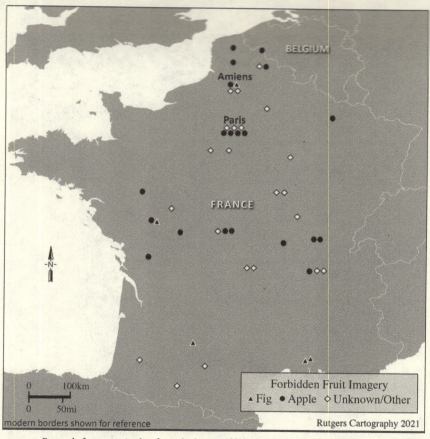

MAP 2. France before 1250. Apples, from the late twelfth and early thirteenth centuries, appear along with figs and other species (grapes, pomegranates, and more). Map credit: Michael Siegel, Rutgers Cartography, 2021.

THE ICONOGRAPHIC APPLE

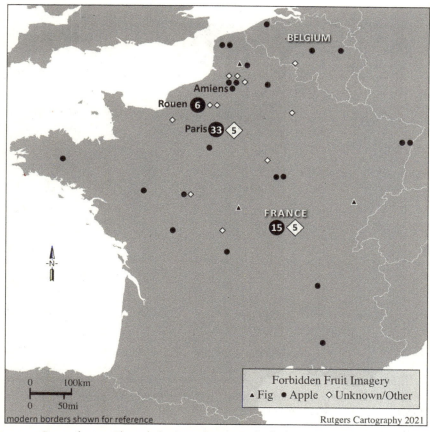

MAP 3. France after 1250. The apple dominates the iconographic landscape. Map credit: Michael Siegel, Rutgers Cartography, 2021.

the earlier iconographic biodiversity cedes to an apple monoculture. From this point on, apples are the de facto forbidden fruit, with pomegranates, grapes, and figs quietly exiting the French iconographic tradition, just as they would soon exit the iconography of other regions (maps 2 and 3).

England

The rise of the apple to a position of iconographic dominance, so swift and dramatic in France, begins slightly later and unfolds more gradually in England. Prior to the Norman Conquest in 1066, English iconography was part of the broader artistic and literary Anglo-Saxon engagement with the Hebrew Bible.[40] Early Anglo-Saxon illustration was rarely figural, and the missionary emphasis

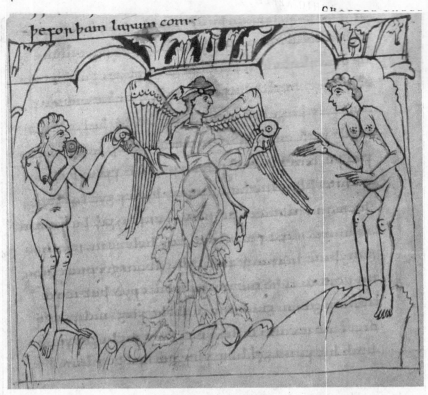

FIGURE 3.14. Anonymous, Caedmon Genesis, 1000. Oxford, Bodleian Library, MS Junius 11, fol. 31. Credit: Bodleian Libraries, Oxford University.

on the New Testament resulted in few depictions of Genesis narratives. The first Fall of Man scenes appear in the late tenth- or early eleventh-century Junius 11 manuscript, a work containing an Old English paraphrase of Genesis, within which is embedded an Old English adaptation of an Old Saxon poem about Adam and Eve's Fall (known as Genesis A and Genesis B, respectively).[41] The illustration has Adam and Eve standing to the left of the Tree of Knowledge as Eve hands Adam the forbidden fruit. To Adam's left is an angel, the devil in disguise. The forbidden fruit is round but does not resemble a particular species so much as Eve's breasts—a visual allusion to the sexual dimension of the Fall (fig. 3.14). Other round forbidden fruits appear, inter alia, in the strikingly original illumination of Ælfric of Eynsham's late tenth-century Hexateuch translation and the twelfth-century Walsingham Bible, whose red fruit may be apples.[42] Overall, however, the English Romanesque that emerged following the

Norman Conquest tended toward a highly stylized idiom that eschewed naturalistic depictions of the Tree of Knowledge and its fruit.[43]

By the middle of the thirteenth century, nearly a century after they first appear in France, apples begin to populate the English iconographic landscape. A biblical miscellany from the second half of the thirteenth century and a 1265 illuminated Bible from Oxford are among the earliest examples.[44] Not coincidentally, both hew closely to the French iconographic norms, such as representing the serpent with a woman's head. Initially, the apple is not as dominant in England as it is in France. Figs still appear in thirteenth- and early fourteenth-century manuscripts, as well as in statues such as the north choir capital of the Ely Cathedral in southeastern England. Some artists render the forbidden fruit as small and round; others eschew botanical realism altogether. Nonetheless, starting in the second half of the thirteenth century, the apple becomes the dominant forbidden fruit in English iconography.[45]

Germany and the Low Countries

The iconographic dynamics of Germany and the Low Countries are quite similar to those of England.[46] Fall of Man scenes from the tenth to the twelfth century display a familiar mix of figs, pomegranates, and other fruits. The fig adorns an early eleventh-century ivory book cover from Metz and a capital in the Notre Dame cathedral in Maastricht, while the pomegranate is found in psalters from Belgium and southern Germany. Many Fall of Man scenes depict generic round fruit, some apple-sized, as in the Bernward doors of the Hildesheim Cathedral,[47] the prayerbook of Hildegard of Bingen, and a thirteenth-century Book of Hours; in other representations it is smaller, closer in size to an egg.[48]

What differentiates the fig, the pomegranate, the apple-sized fruit, and the smaller fruit is not their starting point—all are present in German Fall of Man iconography throughout the thirteenth century—but their subsequent fate. The fig makes a brief and intriguing return in the boxwood carving of the early sixteenth-century artist Meister HL (fig. 3.15), but otherwise plays no meaningful role in Germany and the Low Countries.[49] The pomegranate is likely the forbidden fruit of the late fourteenth-century Freiburg Cathedral and the fourteenth- or fifteenth-century Bremen Cathedral, but is not widely attested. The small, round fruit fades from view as well. The apple, by contrast, gradually becomes the default forbidden fruit. Round red or orange fruit appears in several thirteenth-century illuminations,[50] and becomes preeminent in the fourteenth century and beyond (plate VII). It is the fruit

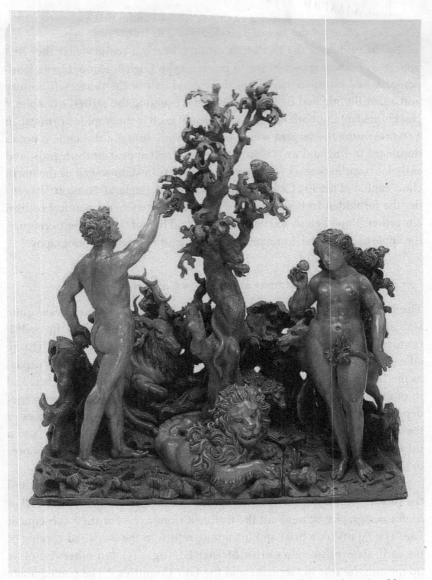

FIGURE 3.15. Meister HL, carving, 1520–1530. Freiburg im Breisgau, Germany, Augustiner Museum. Credit: Hans-Peter Vieser; CC BY 4.0, via Augustiner Museum. (https://creativecommons.org/licenses/by/4.0/legalcode).

of choice for lighthearted illustrations of the *Speculum humanae salvationis* (fig. 3.16) and somber stained-glass windows, for elaborate altar decorations, and in countless other Fall of Man scenes throughout the fourteenth and fifteenth centuries.[51]

Nowhere is the apple's dominance more apparent than in the works of the northern masters, several of whom revisit the theme of the Fall of Man time and again. Hugo van der Goes's 1479 "Fall of Man" places Eve at the center of the composition, with the viewer's eye drawn to her outstretched left arm as it picks an apple. Three years later, Hieronymus Bosch offers an interpretation of the Fall of Man in the "Last Judgment" Triptych, a topic he would revisit a quarter century later in the Haywain Triptych—both part of the apple tradition. Dürer depicts the apple repeatedly, including in his famous 1504 engraving (see fig. 3.18, below) and his 1507 painting *Adam and Eve* (plate VIII).[52] No artist engaged the theme of the Fall as intensively as Lucas Cranach the Elder, who produced dozens of paintings on the theme; in all of them, an apple tempts Eve.[53] The apple is also the fruit of choice in the fifteenth-century Fall of Man scenes in *The Illustrated Bartsch*, a collection of European old master prints starting from 1420.[54] As in France and England, then, Germany and the

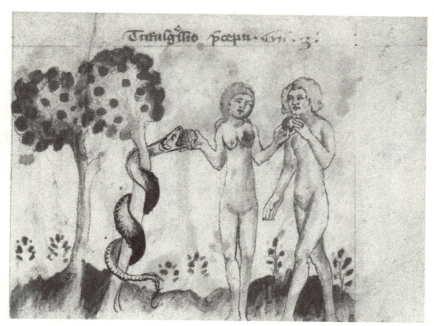

FIGURE 3.16. Anonymous, *Speculum humanae salvationis*, 1375–1399. London, British Library, MS Harley 3240, fol. 5r. Credit: The British Library Board, Harley 3240, fol. 5r.

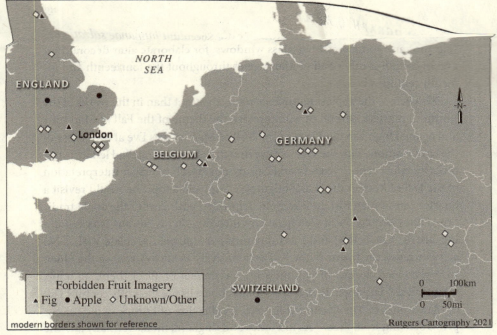

MAP 4. England, Germany, and the Low Countries before 1250. The apple tradition is still inchoate. Map credit: Michael Siegel, Rutgers Cartography, 2021.

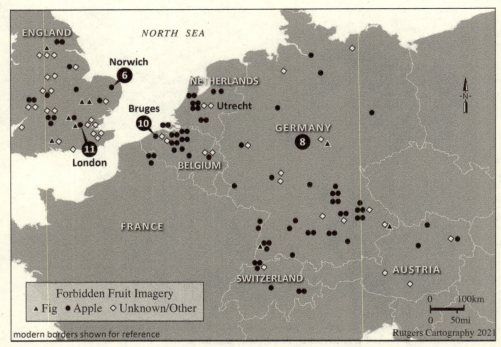

MAP 5. England, Germany, and the Low Countries after 1250. The iconographic landscape displays the apple's rapid propagation and the subsequent marginalization of other fruit species. Map credit: Michael Siegel, Rutgers Cartography, 2021.

Low Countries witness the earlier iconographic variety replaced by a single dominant fruit, the apple (maps 4 and 5).

The Limits of the Apple Tradition: Italy and Spain

The apple's journey from obscurity to triumph has followed similar lines in the regions examined thus far, but Italy complicates this narrative. During the eleventh and twelfth centuries, Italian iconography is consistent with that of other parts of western Europe. The fig features prominently, appearing in a ninth-century Fall of Man fresco in the southern city of Matera, an eleventh-century mosaic in the Otranto Cathedral in Pantaleone, the Salerno Antependium (fig. 3.17), and elsewhere. In some cases the forbidden fruit is botanically indeterminate (for example, in the capital relief in the San Zeno cathedral in Verona), but apples are nowhere to be found.

In later centuries, however, Italy breaks with the dynamic established by other European regions in that its forbidden fruit iconography does not change. Though not wholly absent, the apple's presence is tentative. One apple appears in the thirteenth century (a Padua Bible medallion), and a few more in the fourteenth (Giusto de'Menabuoi's Baptistery of St. John and a

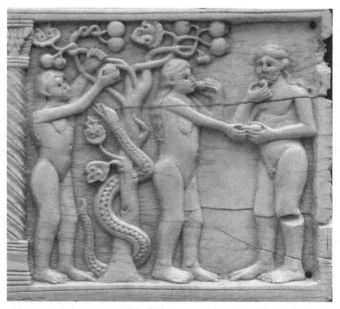

FIGURE 3.17. Anonymous, Salerno Antependium, 1084. Salerno, Italy, San Matteo Diocese Museum. Credit: Kunsthistoriches Institut in Florenz, Max-Planck-Institut.

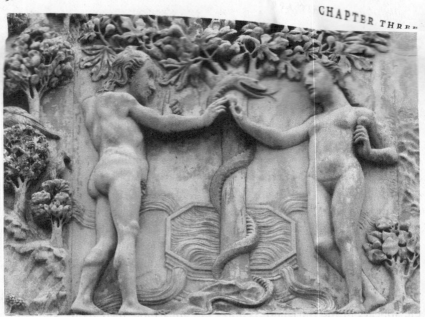

FIGURE 3.18. Lorenzo Maitani, relief, 14th century. Umbria, Italy, Orvieto Duomo. Credit: Georges Jansoone, Creative Commons 3.0, via Wikimedia Commons (https://creativecommons.org/licenses/by-sa/3.0/legalcode).

manuscript of Nicholas of Lyra's Genesis *Postilla*). In the fifteenth century apples appear in the Mirandola Book of Hours, Michele di Matteo's "The Dream of the Virgin," and Andrea Mantegna's 1496 Madonna of Victory altarpiece in Mantua. It was not until the middle of the sixteenth century, however, long after the apple was securely established in other parts of Europe, that it became a fixture of Italian iconography; a shift exemplified, inter alia, in Giulio Clovio's Farnese Hours and paintings by Tintoretto and Titian. Prior to this shift, Italy's apple yield was so poor that one could scarcely speak of an apple tradition.[55]

The fig, in contrast, continues to bloom, forming an Italian tradition that "begins with the ancient Christian sarcophagus art and passes through the medieval period, reaching its apex in the Renaissance."[56] The presence of the fig in major twelfth-century works is to be expected.[57] But rather than recede in the face of the apple's advance in the centuries that follow, the Italian fig goes from strength to strength. In fact, fig iconography is so common that one could argue that it enjoys the same level of dominance in the fourteenth and fifteenth centuries that the apple does in France (figs. 3.18 and 3.19). Remarkably, the fig achieves the greatest visibility in the early sixteenth century, when it appears

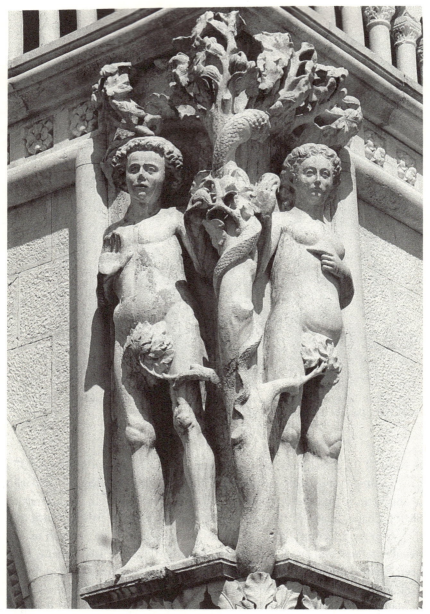
FIGURE 3.19. Antonio Rizzo, sculpture, 1476. Venice, Italy, Doge Palace. Credit: Jean-Pol Grandmont, CC BY 4.0, via Wikimedia Commons (https://creativecommons.org/licenses/by/4.0/legalcode).

FIGURE 3.20. Lorenzo Ghiberti, panel, 1452. Florence, Italy, *Gates of Paradise*, Baptistery of San Giovanni. Credit: Public Domain, via Wikimedia Commons.

in some of the best-known Renaissance masterpieces, including Albertinelli's *Creation and Fall of Man*, the Stanze di Raffaello and the Loggia di Raffaello in the Vatican, and the best-known Fall of Man scene of all, Michelangelo's Sistine Chapel (plate IX). Indeed, the fig remains a viable artistic choice into the seventeenth century, for example, in Domenichino's two versions of *The Rebuke of Adam and Eve*. It bears noting that some Italian artists appear to have been aware of the apple tradition and visually thematized the priority of the fig. Both Masolino da Panicale's fresco in the Brancacci Chapel and Ghiberti's Fall of Man panel on the San Giovanni Baptistery doors (fig. 3.20) depict the fig as the Tree of Knowledge with a proximate apple tree, as if to acknowledge the existence of the apple tradition while polemically endorsing the fig.

The obvious question here is, Why did the apple tradition fail to take root in Italy in same way it did in France, England, and Germany? I will address this question in the following chapter. For now, I want to call attention

THE ICONOGRAPHIC APPLE

to two points. First, essentially all the representations of the apple originate in northern Italy: Padua, Bologna, Milan, Mantua, and Venice.[58] The only possible exception is Giulio Clovio's Farnese Hours, which he produced in Rome, although Clovio himself was in many ways a northern artist: he came from Croatia and was intimately familiar with the artistic idiom to northern Europe from early on.[59] This familiarity is, in fact, evident in the Farnese Hours' Fall of Man scene, which is modeled after Dürer's 1504

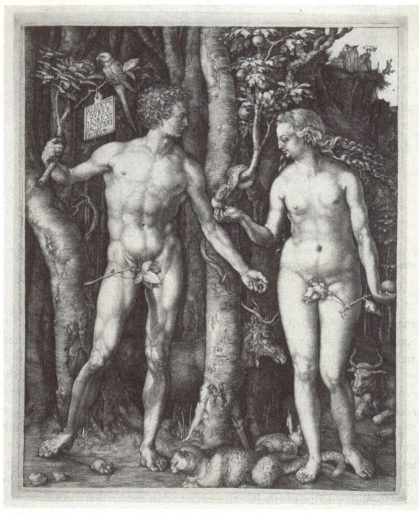

FIGURE 3.21. Albrecht Dürer, engraving, 1504. New York, Metropolitan Museum of Art. Credit: Public domain, via New York Metropolitan Museum (https://www.metmuseum.org/art/collection/search/336222).

FIGURE 3.22. Giovanni della Robbia, glazed terracotta, ca. 1515. Credit: Public domain, via Walters Art Museum (https://art.thewalters.org/detail/35961//).

engraving—right down to the apple (plate X). The concentration of Italian apple iconography in the north speaks to the powerful influence German and Low Countries artists exerted on the region, and particularly on Venice, which maintained important commercial and economic ties with its northern neighbors.[60] Northern art was greatly esteemed by Venetian collectors, and Italian artists spent extended periods in the Low Countries and southern Germany.[61] It is not surprising, then, that apple iconography migrated south of the Alps and found a home in northern Italy. What is surprising is that the iconographic migration was unidirectional. Venice was, after all, an important artistic center in its own right, yet we do not find figs that crossed the Alps from Italy to the north. It is also curious that the northern influence was so clearly demarcated within Italy. The work of northern artists, and of Dürer in particular, was known and admired throughout Italy: Why did their Fall

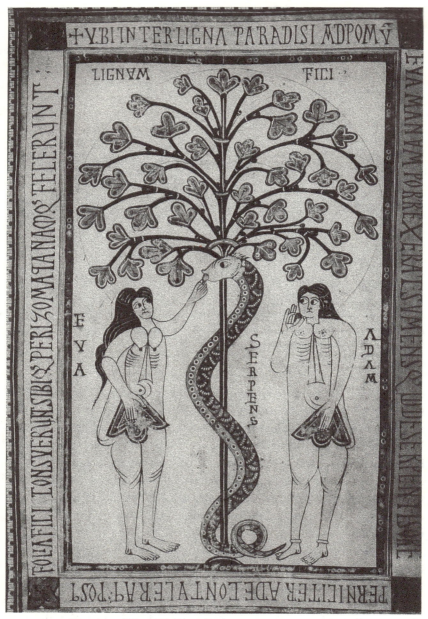

FIGURE 3.23. Anonymous, illuminated manuscript, 976. El Escorial Library, Bibl. de S. Lorenzo el Real, Codex Vigilano, fol. 17r. Credit: HeritagePics/Alamy Stock Photo.

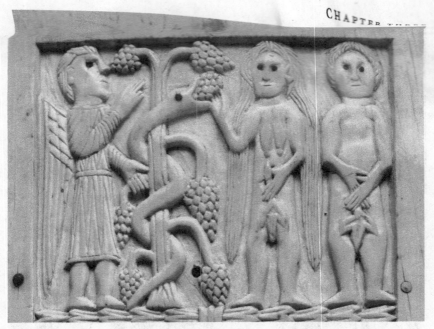

FIGURE 3.24. Anonymous, illuminated manuscript, northern Spain, 11th century. Saint Petersburg, Hermitage Museum. Credit: @Genevra Kornbluth.

of Man scenes not produce a single Florentine apple? An interesting case in this regard is Dürer's 1504 engraving of the Fall of Man (fig. 3.21), which was plainly the model for the Florentine Giovanni della Robbia's glazed terracotta Fall of Man (fig. 3.22). But della Robbia introduces two changes: the serpent has a female head, and the forbidden fruit is not an apple, but a fig. Why did northern Italian artists not embrace this simple solution and maintain the Italian fig tradition? These issues complicate the picture in Italy, and any compelling historical explanation of the rise of the apple tradition will need to address them as well.

The second point is that Italy is not a unique case. The situation in Spain is similar to Italy's, as the apple enjoys only a modest iconographic presence. It appears in three illuminated manuscripts from the devoutly cosmopolitan court of King Alfonso X, and once or twice each in the fourteenth, fifteenth, and sixteenth centuries.[62] The fig appears in several works, including the Beatus of Liebana (fig. 3.23)[63] and the Ripoll Bible, as do the grape (figs. 3.24 and 3.25) and pomegranate. The forbidden fruit is most commonly a round specimen with no botanical markers. In sum, Spain, like Italy, has no apple tradition to speak of (maps 6 and 7).

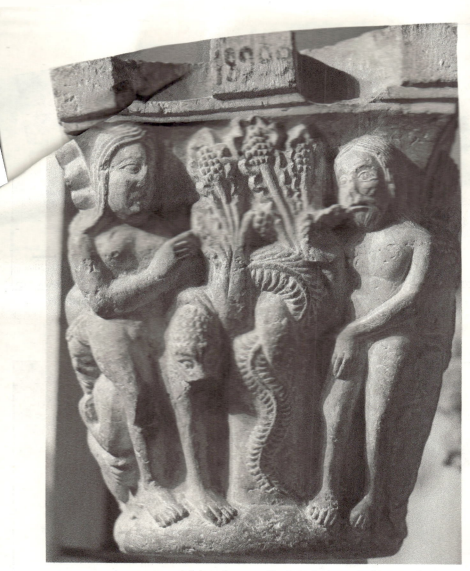

FIGURE 3.25. Anonymous, capital, late 12th century. Northern Catalunya. Credit: Musée de Cluny—Musée national du Moyen Âge, public domain, via Wikimedia Commons.

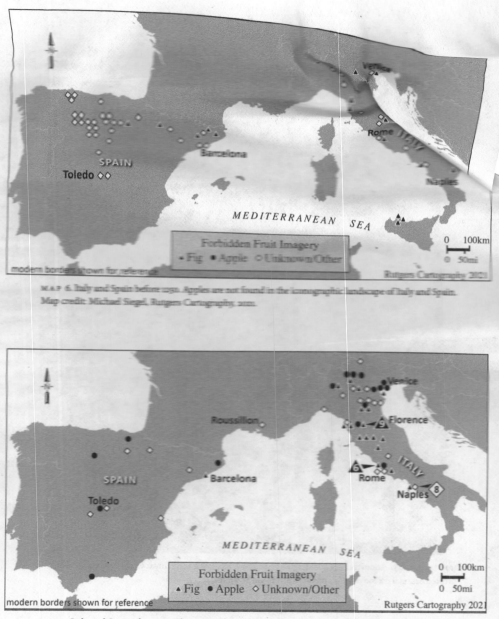

MAP 6. Italy and Spain before 1250. Apples are not found in the iconographic landscape of Italy and Spain. Map credit: Michael Siegel, Rutgers Cartography, 2021.

MAP 7. Italy and Spain after 1250. The one apple in Rome is Clovio's Farnese Hours, which could well be considered northern. Three of the late Spanish apples are from the court of Fernando X. (Roussillon was part of the Crown of Aragon during the first half of the fifteenth century.) Map credit: Michael Siegel, Rutgers Cartography, 2021.

FIGURE 3.26. Anonymous, illuminated manuscript, 1542. Novgorod, Russia, Library of the Holy Synod 997, fol. 1240r. Credit: Florentina Badalanova Geller.

Conclusion

An exhaustive study of forbidden fruit iconography would extend beyond the geographic limits of this chapter. Martina Horn recently published a rich and detailed study of the Adam and Eve scenes in the churches of Crete, including an early fifteenth-century Fall of Man scene where the forbidden fruit is likely an apple.[64] The grape tradition maintains a strong presence in Slavic art (fig. 3.26), a testament to the vitality of the Greek patristic sources discussed in chapter 1.[65]

A fuller study would also address in detail iconographic phenomena that do not bear directly on the emergence of the apple tradition: a cluster of fourteenth-century Neapolitan Bibles that depict the Tree of Knowledge as a date palm;[66] a late fifteenth-century Parisian illustration in which Adam and Eve eat a ripe mango;[67] the citron in Jan van Eyck's Ghent Altarpiece (plate XI);[68] the paucity of apples in Slavic art (plate XII), and more. My focus, however, is the ability of the art-historical sources to provide what the written sources could not—a record of the apple tradition's initial appearance and subsequent spread. *Why* the apple tradition appeared remains, at this point, an open question, but the findings of this chapter allow us to reformulate our questions in a historically nuanced manner. Why did the apple tradition emerge in twelfth-century France? What accounts for its rapid propagation in England and Germany, but the continued dominance of the fig in Italy? And how do we explain the chasm between the iconographic and written sources—that dozens of Parisian illuminated manuscripts depict apples, but Nicholas of Lyra, a professor at the Sorbonne, knew nothing of this tradition? These questions guide us as we turn to the final chapter.

4

The Vernacular Apple

The principal question to arise from the previous chapter is, Why does the apple tradition first emerge in twelfth-century France? To date, scholarship has failed to recognize this historical development, so there is no secondary literature on the subject. Over the course of many conversations and exchanges with colleagues, however, I have repeatedly heard the suggestion that the apple tradition first appeared as the result of the fruit's popularity in France. This explanation has strong intuitive appeal and may even claim support from the peculiar history of European apple cultivation. I will discuss it briefly, before offering an alternative argument.

Apple trees are self-incompatible, that is, the apple blossoms of one tree require pollination from another apple tree. Left to their own devices, then, new apple trees will not produce the same apples as those that provided their seeds. Farmers can combat this generational inconsistency by grafting a shoot from the parent tree onto the rootstock of the descendant, thus ensuring the offspring will be true to stock. This technique was familiar to Roman farmers,[1] but declined in the early Middle Ages, and with it apple cultivation. Grafting was revived in the twelfth century by the monks of the Cistercian order, with dramatic consequences: "In twelfth-century Europe, the expansion of the Cistercian order of monks . . . renewed the cultivation of apples across the continent."[2] Did these developments provide the initial impetus for the apple tradition?

It seems not. For one, rumors of grafting's death have been greatly exaggerated. Hrabanus Maurus, the archbishop of Mainz, writes in the ninth century, "Wild trees produce bitter and sterile fruits if left to themselves, but when they have been grafted fatten into the most sweet fruitfulness."[3] In addition, a Carolingian guide to estate management prescribes the cultivation

of "various kinds of apple trees, various kinds of pear trees, various kinds of *plum trees, sorb, medlar*, chestnut and peach, etc.," and even identifies distinct apple cultivars ("gozmaringa, geroldinga, crevedella, spirauca," and more).[4] Grafting may not have been widely practiced, but the technique was known in some circles, and apples remained a constant albeit diminished presence throughout the medieval period. They were not a twelfth-century novelty.

A more fundamental difficulty is that the assumptions underlying this hypothesis are untenable. Medieval artists operated under significant cultural and religious constraints because of the need for financial and, often, ecclesiastical patronage. It is quite unlikely, then, that an artist might note an increase in apples in the local produce market and simply abandon the venerable fig, grape, or pomegranate for the iconographically unprecedented apple. Moreover, the implied causal connection between local agriculture and iconographic conventions is tenuous at best: though figs and grapes do not grow in cold climates, they figured prominently in the medieval iconography of Germany and Russia, respectively. Conversely, pears were common in France but never associated with the forbidden fruit.[5] Finally, even if an artist were inspired by their local produce market, this would not explain the disappearance of the fig, the grape, and the other fruit species. In sum, the appearance of the apple tradition cannot be explained as a function of market forces.

To understand the rise of the apple, we must turn our gaze away from the orchards of Europe and focus instead on two historical developments. One is linguistic. The Old French word *pom* designated "fruit" at one point, but later came to mean "apple." The other is literary—the proliferation of vernacular Fall of Man narratives in both written and oral media. In the section that follows, I focus on the semantics of Old French *pom*, first tracing the shift from "fruit" to "apple," then trying to determine, to the extent possible, when this shift occurred. I then turn to examine the importance of the word *pom* in Old French Fall of Man narratives. The initial argument of this chapter is that Old French authors regularly used *pom* in its earlier sense, "fruit," to designate the forbidden fruit, but as the meaning of *pom* changed, "forbidden *pom*" came to be understood as a "forbidden apple." It is at this point that the apple tradition was born. The chapter's second argument is that the uneven diffusion of the apple tradition corresponds to variations in the vernacular semantics of various regions.

Semantic Shift: From *Fruit* to *Apple*

As we have seen, *pomum*, "a fruit, specifically an orchard fruit,"[6] was the most common Latin word for the forbidden fruit. The Old French *pom* is the direct

etymological descendant of *pomum* and initially retained the Latin word's meaning, but by a process known as "semantic narrowing," it gradually took on the narrower sense of "apple."[7] Such shifts are a regular feature of linguistic change, but in this case there is likely a specific cause, namely, Old French's reluctance to adopt Latin *malum*, "apple," because of its phonetic similarity to the taboo *malum*, "evil." The result was that *pom* "entered into a competition with the classic name for the apple, *malum* . . . and supplanted it."[8] Of course, the semantic change was gradual and varied from region to region, and for a period, the word had both a broad and a narrow meaning: "fruit" and "apple."[9]

Pom, "fruit," is prominent in Old French Bible translations, where it commonly and unsurprisingly renders the Vulgate's *pomum*. As noted in chapter 2, in the Vulgate of Genesis 1:11 God commands the earth to "put forth . . . fruit trees [that are] *pomum* bearing (*pomiferum*)"; in the Old French Genesis, the trees are "*pom* bearing."[10] The broad meaning is also evident in an Anglo-Norman translation of the Song of Songs, where the pomegranate (Song 4:3) is called "that fruit (*poume*) with much grain,"[11] and "choice fruits" (Song 4:16) are called *le frut dé pumes*, "the produce of the fruit tree."[12] *Pom* also functions as a generic term in the names of many fruits, including *pom de cedre*, "cedar cone," *pom de ciprés*, "cypress cone," *pom de pin* "pine cone," and *pom de terre*, which denotes a variety of plants, including earthnut, cyclamen, and mandrake.[13]

Identifying the narrow sense of *pom*, "apple," is a challenge, since every apple is a fruit, so it is difficult to ascertain when *pom* refers to the species apple and not to fruit generally. When the eleventh-century *Song of Roland* refers to Roland holding a red *pom*, is this a red apple or a red fruit?[14] Only under certain conditions does the narrow sense become evident: that is, when *pom* glosses Latin *malum*, "apple," or when it is part of a list of fruit species. The former occurs in marginal glosses to Adam of Balsham's twelfth-century epistolary study of uncommon Latin words, the *Oratio de utensilibus*.[15] The latter is found in, for example, the popular French poem *Roman de la Rose* (ca. 1230), which refers to "fruit trees, bearing quinces, peaches, nuts, chestnuts, apples (*pomes*) and pears."[16] Similarly, the Anglo-Norman decree of King Edward II (r. 1307-27) commands that records be kept of "apples (*pomes*), pears, cherries, and other fruit said fruitier will purvey."[17] But when precisely did this narrow meaning gain wide currency? The first part of *Roman de la Rose* was composed in the first third of the thirteenth century, so at least some authors were using *pom* in the sense of "apple" at that time. Is it possible to determine when this narrow meaning became dominant?

Dating the Semantic Shift of *pom*

Though it is difficult to pin down the narrow meaning of *pom*, and consequently difficult to date its emergence as the dominant sense of the word, it may be possible to glean insight from the semantics of its direct ancestor, Latin *pomum*. We have already seen this word means "fruit," and that it occurs in the phrase "fruit-bearing trees" (*lignum pomiferum*), in Genesis 1:11. It should be emphasized that the meaning of *pomifermum* was self-evident to Latin commentators for many centuries. The verse's plain meaning was unproblematic to centuries of Latin commentators, from Isidore of Seville in seventh-century Spain, through Bede, Hugh of Saint Victor, Peter Comestor and many others.[18] It is surprising, then, to find a detailed discussion of the term in Peter Abelard's *Hexameron* (discussed briefly in chapter 2). In his comments on Genesis 1:11, Abelard explains to his readers that *pomiferum* refers to "fruitful trees" (*arbores fructuosas*), since *pomum* "should clearly be understood as a generic term, standing for all fruit trees."[19] From a classical Latin perspective, Abelard's explanation itself stands in need of explanation: of course, *pomiferum* means "fruitful." This is both the word's plain lexicographic sense and its obvious meaning in the context of Genesis 1. Why, then, does Abelard explain it? Because he is addressing readers for whom *pomum* no longer means "fruit," but rather, "apple," and who are therefore perplexed that God commanded the earth to bring forth trees that are *pomiferum*, specifically "apple bearing." To them Abelard explains: *pomum* can mean "fruit."[20] This passage in Abelard's *Hexameron*, composed in Paris in the 1130s, offers a critical clue to the changing semantics of *pomum*, and the rise of the meaning "apple."[21]

Other interpreters of Genesis 1:11 continue this line of argument. Robert Grosseteste, the celebrated English philosopher and theologian, writes a century later that "the fruit of every kind of tree is understood under the name *pomum*,"[22] and the great German theologian and mystic Meister Eckhart explains to his early fourteenth-century readers of Genesis 1:11 that "it ought to be noted that *pomum* is a general name for all fruit."[23] Eckhart then expands on this point as follows: "*Pomum* stands for all soft fruit, whether it be a pear, a *pomum*, or indeed even a fig." This is potentially confusing—how can *pomum* denote a category of fruit that includes the *pomum*? Why does Eckhart not circumvent the difficulty by referring to generic fruit as *pomum* (as the plain meaning of Genesis 1:11 requires), and use *malum*, "apple," when enumerating the various fruit species? The most plausible answer is that he would have done so, had *malum*, "apple," retained any currency among his readers. That it does not indicates how thoroughly *pomum* had displaced *malum* as the term for "apple."

Not all instances of *pomum*, "apple," involve Genesis 1:11. One of the chapters in Alexander Neckam's (1157–1217) encyclopedic *De natura rerum* is titled *De pomis et piris* ("On Apples and Pears"); in classical Latin it would have been *De malis et piris*.[24] The Franciscan scholar Petrus Iohannis Olivi (1248–98) interprets the *malus*, "apple tree," in Song of Songs 2:3 thus: "*Malus* is a genus of fruit-bearing tree, which produces round fruit. . . . Simply stated, [the word] more properly stands for *pomum*."[25] Olivi assumes the reader does not know the botanical meaning of *malus*, "apple tree," but will recognize *pomum*. At Song of Songs 8:5 Olivi simply writes: "Under the *arbore malo*, that is: the *pomo*."[26] Thomas of Perseigne, the twelfth-century French Cistercian whose commentary on the Song of Songs I discussed in chapter 2, has a suggestive slip of the pen. He alludes to Song of Songs 2:3 with the phrase *sicut pomum* instead of *sicut malum*.[27] It seems he knew that the verse referred to an apple tree, and unreflectively employed what was for him the standard Latin term for "apple."

Additional sources could be adduced, but I hope the point is clear.[28] The semantic narrowing of *pomum* from "fruit" to "apple" was an established fact for some authors by the twelfth century. Two points deserve emphasis. First, *pomum* did not mean "apple" in Medieval Latin as a whole. Many authors maintain the classical Latin distinction between *pomum*, "fruit," and *malum*, "apple,"[29] while others employ *pomum* in both the broad and narrow senses in the same composition.[30] Second, the scholars who use *pomum*, "apple," generally do not do so because they are unaware of the classical meaning of the word. Their deep familiarity with the Vulgate, the Latin Fathers, and classical Latin sources ensured their familiarity with *pomum*, "fruit." More often than not, their concern was that their readers would take *pomum* to mean "apple," and, starting with Abelard in early twelfth-century Paris, they labored to prevent that error.

Why did Latin *pomum* come to mean "apple"? For living languages, semantic change is a constant—words are forever shifting meanings.[31] But the case of Medieval Latin is different, as it was taught in a school setting that emphasized faithful adherence to earlier, venerated linguistic forms, a controlled environment that minimized semantic change. Moreover, the specific shift in question is implausible. First, because there already is a Latin term for "apple"—*malum*—there is no linguistic need for *pomum* to take on the same sense. Second, as Abelard and other commentators on Genesis 1:11 make clear, the shift leads to confusion concerning the plain sense of *pomum* in the Vulgate, making it unlikely teachers of Medieval Latin would want to introduce this disruptive new meaning. Why, then, did the change come about? The answer lies in the impact of vernacular languages on the Latin of the day. As

Michael Herren argues, though Latin wielded tremendous influence on the European vernaculars, "it must be borne in mind that influences worked in both directions," and vernaculars introduced new forms and meanings into Latin as well. Medieval Latin, in other words, was in a state of continuous contact with the vernacular of each region, and was influenced by it.[32]

Scott Gwara's study of Ælfric Bata's *Colloquia* (Latin study aids for monastic pupils mastering spoken Latin) offers a fascinating example of this dynamic.[33] Gwara demonstrates that the Latin of the *Colloquia* mirrors linguistic features of Old English, including semantic borrowing or calquing.[34] Gwara discusses the Latin phrases *radere foras* and *secare foras*, whose literal translations, "shave outside" and "cut outside," are nonsensical in classical Latin, but comprehensible in light of the Old English prefix *for/fore*, which is used with verbs of cutting to denote completion. That is, the phonetic similarity of Latin *foras* to Ælfric Bata's native Old English *for/fore* caused him to "import" the Old English structure into Latin and place *foras* alongside verbs of cutting and shaving.[35]

The influence of vernaculars on Latin is of principal importance because it offers the most plausible explanation for the semantic narrowing of Latin *pomum* from "fruit" to "apple." That is, once Old French *pom* came to mean "apple," it restructured the semantics of Latin *pomum* in the same manner. "It is hardly surprising," David Trotter writes, "that certain elements of the vernacular should begin to creep into written Latin,"[36] and *pom-pomum* is an especially likely candidate given the phonetic similarity, semantic proximity, and etymological kinship of the two words, all of which inclined native speakers of Old French to assume the words shared the same meaning too.[37] If so, Abelard's need to explain the meaning of *pomum* in Genesis 1:11 reflects not only on the semantics of Latin, but also, indirectly, on the semantics of Old French *pom*. By the early twelfth century, *pom*, "apple," was so firmly established, that French-speaking readers of Latin projected it onto Latin *pomum*. The Latin commentaries on Genesis 1:11, then, identify early twelfth-century France as a terminus post quem, a time by which "apple" was a widespread and likely dominant sense of Old French *pom*. This linguistic development is a critical component in the rise of the apple tradition, but its significance lies in the impact it had on audiences of vernacular Fall of Man narratives, narratives to which we now turn.

The Old French Fall of Man

In 813, Charlemagne, nearing the end of his life, convened the Council of Tours, with the aim of reforming Christian lay education. To that end, the

council called on parish priests to address the faithful in the Latin of the countryside and in German (*rustica romana lingua aut theotisca*), a demand of twofold significance: it indicates that speakers of *rustica romana* did not understand standard ecclesiastical Latin,[38] and it bespeaks a commitment to lay scriptural instruction in the vernacular. Charlemagne's advocacy of lay preaching did not bear fruit for the simple reason that parish clergy were not up to the task, linguistically: "The average clergyman would find it hard to understand a homily, written in normal Latin, well enough to reproduce or paraphrase it in the vernacular for his parishioners."[39] Still, the commitment to lay scriptural instruction persisted, and the eleventh and twelfth centuries saw a period of steady growth in lay literacy, and with it the growth of a market for biblical literature in the vernacular.[40] Such works included Bibles, psalters, and devotional and liturgical texts that contained scriptural citations. No less important than the canonical Bible (and for most medieval Christians indistinguishable from it) was the complex of apocryphal works, prose paraphrases, and poetic reworkings of Scripture that Brian Murdoch has called the medieval popular Bible.[41] The most important of these works, the *Life of Adam and Eve*, was discussed in chapters 1 and 2; others include Herman de Valenciennes's twelfth-century *Histoire de la Bible*, a biblical epic, and Guyard Desmoulins's late thirteenth-century *Bible historiale*, an Old French translation of Peter Comestor's *Historia Scholastica* and one of the most popular works of the time.[42] The first full vernacular Bible translation in western Europe was the Old French Bible, also known as the Thirteenth-Century Bible.[43]

Despite the relative increase in lay literacy, most medieval Christians remained illiterate and received their ecclesiastical teachings through rudimentary vernacular instruction that was initially limited to "simple matters of faith and elements of correct moral action."[44] (Sermons dealing with Scripture were reserved for monastic settings).[45] The Church reforms crystallized in the Third Lateran Council of 1179 brought about a professionalization of the parish priesthood, including the production of preaching handbooks containing vernacular sermons.[46] As a result, by the end of the twelfth century, vernacular preaching had "shifted its emphasis from preaching that was largely monastic and clerical to the needs of popular audiences,"[47] needs increasingly understood in terms of biblical instruction.[48] The establishment of the Franciscan and Dominican orders, which included preaching as part of the apostolic life (*vita apostolica*), further aided the spread of vernacular preaching after the early thirteenth century.[49]

Another medium of oral scriptural instruction was medieval theater, a significant educational source for unlettered Christians.[50] The twelfth-century *Jeu d'Adam*, the first work of French theater, is an Anglo-Norman account

of the Fall of Man whose pedagogic role for vernacular audiences is widely recognized. As Charles Mazouer writes, "To stir and instruct the broader Christian public, it was necessary to employ its language."[51] By the twelfth century, then, there existed a robust ecosystem of Old French Bible instruction, including various written sources for the literate, and oral preaching and theater for the unlettered.

The vernacular sources employ various terms to refer to the forbidden fruit. Some, including several Old French Bible translations, hew closely to the language of the Vulgate, using the Old French words descended from *fructus* (e.g., *fruit*).[52] In most vernacular Fall of Man narratives, however, Adam and Eve eat a forbidden *pom*. This is true across genres and styles: an anonymous Psalms commentary from ca. 1163;[53] Evrat's twelfth-century translation of Genesis;[54] Herman de Valenciennes's *Histoire de la Bible* (twelfth century);[55] a compilation of the miracles of the Virgin by Gautier de Coincy (thirteenth century);[56] the Old French translation (early thirteenth century) of Honorius Augustodunensis's *Elucidarium*;[57] the *Bible anonyme*;[58] the *Histoire ancienne* (early thirteenth century);[59] the poetry of Marie de France, the earliest known female poet of Old French (twelfth century);[60] and the twelfth-century play *Jeu d'Adam*.[61] The Fall of Man, and with it the *pom*, also appeared in many nonbiblical works. *Le roman de Renart le contrefait*, a satirical French poem composed by an anonymous cleric around 1320, informs its readers that it was "on account of pride and sinfulness that Adam ate the *pom*."[62] The first French adaptation of Ovid's *Metamorphoses*, the *Ovide Moralisé* (also ca. 1320), refers to Adam and Eve's "bite of the bitter *pom*."[63] The list goes on. As a result, Bible scholars,[64] devotees of edifying poetry,[65] women preparing for monastic life,[66] and laypeople aspiring to spiritual betterment[67]—all encountered the forbidden fruit (whether in written or oral texts) as a *pom*. It is true that, except in rare cases, it is impossible to determine whether the authors of these (written or oral) texts intended *pom* to mean "fruit" or "apple."[68] What is clear is that once "apple" became the dominant sense of *pom*, the various Old French accounts of the Fall of Man communicated a clear and simple lesson: Adam and Eve were tempted by an apple.[69]

We are now in a position to answer the principal question—why did the apple tradition (as found in iconography of the Fall of Man) appear in twelfth-century France? It did so because of the conjunction of semantic change (*pom* comes to mean "apple") and the spread of vernacular Fall of Man narratives that referred to the forbidden fruit as a *pom*. This explanation resolves a number of otherwise intractable difficulties, including why the apple, of all fruits, became the de facto forbidden fruit, when it does not appear in the Fall of Man narrative, carries no negative connotation in the Hebrew Bible, and

symbolized Christ for many medieval authors. In fact, the emergence of the apple tradition was not driven by scriptural or theological considerations; it was the unintended result of a biblically indifferent historical process.[70]

We can also understand why the apple appeared with the force it did, effortlessly vanquishing other species that were more venerable and more scripturally justified—chief among them the fig. Who would endorse the fig or the grape, when the *Bible historiale*, the *Jeu d'Adam*, and (Evrat's translation of) the Book of Genesis itself all speak of the forbidden fruit as an apple? The self-evidence of the apple tradition, the fact that for later readers it was the explicit instruction of Scripture and church authorities, explains the apple tradition's dramatic advance and the retreat of all other species before it.

Finally, the vernacular semantics hypothesis explains the disjunction between the iconographic sources and the contemporary Latin Bible commentaries. Artistic production is, in important respects, a vernacular enterprise. To be sure, patrons, including ecclesiastical patrons, were involved in the artistic production, sometimes dictating to the artists certain aspects of the work. Most artistic programs, however, were limited to matters of theme and composition; details such as the species of the forbidden fruit were often left to the artist.[71] In this sense, artists enjoyed significant freedom to shape scenes in accordance with their own understanding—an understanding that was decidedly vernacular.[72] Artists were trained from an early age as apprentices to established artists; typically, they did not study Latin, to say nothing of the Latin commentary tradition.[73] They knew Scripture from vernacular sources: sermons, plays, and, for the literate, vernacular Bible translations and adaptations. Consequently, Old French–speaking artists adopted the apple while contemporary Latin commentators did not.

Vernacular Semantics and the Diffusion of the Apple Tradition

What of the irregular diffusion of the apple tradition? As we saw in chapter 3, the iconographic apple rapidly established itself in England, Germany, and the Low Countries, but struggled to gain purchase in Italy, where the fig tradition blossomed for centuries. To be sure, the diffusion of the apple tradition is partially due to general cultural contact. France enjoyed remarkable prestige during the centuries under discussion, and French illuminated manuscripts and other works of art that circulated throughout Europe introduced the apple tradition into new territories. The same is true for literary transmission, for, as Margriet Hoogvliet has demonstrated, "texts written in French were frequently read in parts of present-day Belgium, Luxembourg, Switzerland, and the British Isles, northern Italy, and Germany."[74] Hoogvliet further shows

that biblical works circulated among laypeople and non-elites, in which case the texts would have introduced the apple tradition to broad swaths of the population.[75] But while French art and literature were significant factors, vernacular semantics played a major role.

Medieval French exerted massive influence on English and German. Following the Norman Conquest in 1066, French (that is, Anglo-Norman) became the language of the English royal court, the legal system, the aristocracy, and the church administration. Over time, it spread to increasingly wider social circles. Scholars differ on the social dynamics underlying this linguistic diffusion, but it was unquestionably broad and linguistically impactful.[76] The most significant linguistic impact was the "general . . . adoption of French words in every province of life and thought."[77] At the same time, French affected English vocabulary less visibly, by reshaping the meaning of native English words to align with French counterparts, that is, by calquing.[78] For instance, English did not incorporate the Old French phrase *par cœur*, but rather the corresponding "by heart" (of identical meaning). French *avant la main* yielded "beforehand," *venir a chief*, "to come to a head," among many other examples. Some calques did not produce new phrases, but rather reshaped the meaning of existing words or phrases. For example, the Old English word *stede*, the ancestor of today's *stead*, meant "place" and occurred in the phrase *in-stede*, "on that spot, there." Under the influence of *en lieu de* (literally, "in place of"), the semantics of the English phrase shifted to the still-current meaning of *instead* ("as a substitute").[79] French language and culture exerted tremendous influence on German too, including through the introduction of French words, and considerable calquing.[80]

I emphasize French's influence on English and German because it likely explains the fact that they too witnessed a semantic narrowing of "fruit" to "apple." In Middle English, the word that underwent the shift was *appel*, initially a generic term for "fruit."[81] When the mid-twelfth-century *Old English Herbarium* speaks of *æpples* "that are called *malum granatum*," that is, pomegranates, *æpples* clearly means "fruit."[82] This is also the operative meaning in John Wycliffe's 1382 translation of Genesis 1:11: Let the earth bring forth *appil tre makynge fruyt bi his kynde* ("*appil* tree making fruit by its kind").[83] The broad sense of *apple* has a long afterlife in scholars' English, for example, the 1968 article on apple symbolism in classical sources in which *apple* denotes "the apricot, quince, citron, peach, and most other fruits, except nuts, in addition to the genuine apple."[84] The narrow sense, *appel* in the sense of "apple," which can only be discerned in lists of fruit species and the like, shows itself as early as the thirteenth century, when the *South English Legendary*, a verse anthology of the lives of biblical figures and saints, refers to *applene*

and peoren and notes ("apples and pears and nuts").[85] Other sources mention the "apple and pear," including the *Oath Book of Colchester* (fourteenth century),[86] and an early gardening treatise from the fifteenth century.[87]

The Middle High German *apfel* (pl. *epfel* or *öpfel* with many variants) likewise meant "fruit" and later became "apple."[88] A thirteenth-century medical treatise counsels readers suffering from premature graying to create a balm of wine, vinegar, and "the *epfel* of the cypress tree."[89] Konrad of Megenberg's fourteenth-century *Buch der Natur* ("Book of Nature") refers to the *öpfel* of the cedar, of the orange tree, and of the pomegranate tree, and describes the diet of monkeys as consisting of *öpfel und nüz* ("fruit and nuts").[90] A fifteenth-century Latin-German glossary, the *Liber ordinis rerum*, translates Latin *testa* ("shell, peel") as *apfelschal*, "the shell of a fruit," and Latin *pulpa* ("flesh") as *das best an dem appel*, "the best [part] of the fruit."[91] In the first German Bible (ca. 1466), fruit trees of Genesis 1:11 are *óphelbaum*, "óphel trees."[92] The narrow meaning, "apple," is found in Hildegard of Bingen's *Physica* (ca. 1150), which lists the medicinal qualities of various fruit trees, including the pear (*birbaum*), the nut (*nuszbaum*), and the *affaldra*, "apple tree";[93] the 1276 municipal code of the city of Augsburg prohibits the sale of "fruit (*obez*) . . . be they pears or apples (*ephel*) or stone fruit";[94] and a recipe in the fourteenth-century *Das Buch von guter Speise* ("The Book of Good Food") instructs the reader to "take roasted pears and tart apples (*epfele*) and chop them small."[95] The aforementioned *Buch der Natur*, a witness to the broad sense of the word, also uses the narrow when it pairs the *apfel* with the pear.[96]

It is worth noting that the apple was one of several fruits introduced into Britain by the Romans, along with the "pear, plum, cherry, walnut, fennel, dill and cabbage."[97] Almost all these fruit names come from Latin, while "apple" is a non-native fruit with a native name.[98] The German names for these plants are also nearly all Latin, while *Apfel* is Germanic.[99] The receptivity of English and German to the Latin names of so many plants, but not the *malum*, is another indication that this Latin word was rejected because of its similarity to the taboo *malum*, "evil." The resulting gap—a fruit in need of a name—made Middle English and Middle High German susceptible to the semantic influence of *pom*, causing *appel* and *apfel* to adopt the narrow sense they have to this day.[100]

We see, then, that the semantic development of *appel* and *apfel* was similar to that of *pom* in Old French. Notably, these terms were also akin to *pom* in serving as standard designators of the forbidden fruit.[101] *Appel* goes back at least as far as the "Saxon Genesis," a ninth-century Old Saxon poem, with later occurrences in Middle English homilies, monastic writings, Scholastic essays, biblical apocrypha, and literary works.[102] In Middle High German too,

the forbidden fruit was regularly identified as an *apfel* in oral and written sources alike.[103] While some of the authors undoubtedly intend *appel* or *apfel* in the broad sense of "fruit,"[104] the narrow sense eventually became dominant and then self-evident, and the apple became the dominant and then self-evident forbidden fruit. The transition was not as rapid as in France, nor as complete.[105] Still, the semantics of *appel* and *apfel*, and the regular appearance of these words in vernacular Fall of Man narratives (along with the influence of French art and literature), established the apple as the forbidden fruit throughout northern Europe by the second half of the thirteenth century.[106]

The apple faltered in Italy and Spain because the linguistic landscape was different. The Italian and Spanish words for "apple"—*mela* and *manzana*, respectively—did not originally denote "fruit," later undergoing a semantic narrowing to "apple": *mela* descends from Latin *malum*, *manzana* from Latin *(malum) matianum*, "Matian apple," which already in Isidore of Seville's time was "the *malum* proper."[107] Since they never meant "fruit," it stands to reason that *mela* and *manzana* did not denote the forbidden fruit early on, an assumption borne out by the textual evidence to which we now turn, beginning with the Catalan and Castilian sources.

There are few vernacular Catalan and Castilian Bibles, because of the Spanish Inquisition's hostility toward vernacular Bible translations.[108] Among the Catalan sources, the only complete Hebrew Bible translation, the Peirsec Codex, describes Eve picking a fruit (*fruyt*), as does the partial Colbert Codex—both dating from the fifteenth century.[109] In the twelfth-century *Homilies d'Organyà*, the oldest surviving literary text in Catalan, the devil tempts Adam and Eve with the forbidden *pom de paradis*.[110] A survey of medieval Catalan sources, however, indicates that *pom*, like its Latin ancestor, means "fruit," not "apple": a 1340 Catalan translation of Gregory the Great's *Dialogues* renders the Latin *fructifera*, "fruit bearing," as "trees bearing *poms*"; the fifteenth-century Valencian poet Ausiàs March writes that if a man cuts the roots of a tree, both the branch and the *pom*—that is, the fruit—decay; and the Peiresc Codex uses *pom* to describe the locust consuming the greenery and the *poms*, "fruit," of Egypt.[111] (The word *poma* means "apple" in Old Catalan, but it does not appear in the context of the forbidden fruit.)

Castilian vernacular Bibles also survived only in small numbers—"the result of inquisitorial pressure"[112]—and they uniformly refer to the forbidden fruit as a *fruto*,[113] as does Alphonso X's *General estoria*, a universal history written in Old Castilian, the first part of which was composed before 1270.[114] Castilian translations of Song of Songs 8:5 refer to the tree as a *mançano*, "apple tree,"[115] so there is no linguistic link between it and the Fall of Man. Gonzalo de Berceo (d. before 1264), the first Castilian poet known to posterity

by name, describes a pilgrim's respite in a bucolic valley that is clearly patterned after the biblical paradise—four rivers run through it, like the four rivers of Eden, and it is populated with lush groves containing pomegranates and figs, pears and apples.[116] Though this is not a description of the Garden of Eden proper, if de Berceo knew of a tradition linking the forbidden fruit and the apple, it is unlikely he would have included the apple among the life-sustaining trees in his Edenic valley. A vernacular sermon preserved in a fifteenth-century manuscript, moreover, refers to the forbidden fruit as *pomo*, "fruit," rather than *manzana*.[117] I did find a single reference to the forbidden apple: Alfonso X's *Cantigas de Santa Maria*, composed during the third quarter of the thirteenth century, describe Adam tasting the apple (*da maçãa que gostou*).[118] However, Alfonso X was a cosmopolitan king who was fluent in French and intimately familiar with French art and literature. According to some scholars, Alfonso personally translated the *Gran conquista de ultramar* ("Great Overseas Conquest"), an account of the Crusades, from French, and he commissioned a translation of the French *History of the Holy Grail*.[119] The *Cantigas*' apple, then, testifies to Alfonso's encounter with the French apple tradition, not to an apple tradition native to Spain.[120] Aside from the *Cantigas*, the apple does not play a role in the medieval written sources of Spain, whether Catalan or Castilian.

In Italy, as in Spain, there were few vernacular translations of the Hebrew Bible, since early Italian translators focused on the New Testament.[121] It is only in the fourteenth century that we find translations of Genesis, all of which refer to the forbidden fruit with cognates of Latin *fructus*: the late fourteenth-century *Bibbia istoriata padovana* (*fructo* and *fruto*),[122] the Pentateuch translation of Ghinazzone da Siena (*frutto*),[123] and Nicolo Malermi's 1471 Bible translation (*fructo*).[124] But this is not the whole story. We saw in chapter 3 that the Fall of Man iconography of northern Italy includes a significant number of apples, because of the close economic and cultural contact between the Italian north and the cultural centers of southern Germany and the Low Countries. I noted, however, that cultural contact fails to explain why the iconographic influence ran only north to south, why it did not make an impression farther south in Italy, and why northern Italian artists did not alter the fruit species (as Giovanni della Robbia had done). The answer to these questions lies in the linguistic makeup of the different regions of Italy, and the fact that northern Italy witnessed its own semantic narrowing.

The unification of Italy and the establishment of Tuscan as the national standard have obscured the country's earlier linguistic diversity. During the period under discussion, northern Italy was home to a variety of Milanese vernacular dialects, as well as the vernaculars of Lombardy, Piedmont,

Emilia-Romagna, and the Veneto region (the so-called Lombard-Venetian koine).[125] Today, these are referred to as "Italian dialects," as though they were variants of Tuscan. From a historical-linguistic perspective, however, this designation is baseless: they developed independently of Tuscan, and some even belong to different linguistic branches of Romance (Lombard, for example, is a Gallo-Romance language, like French).[126] For our purposes, the most important linguistic difference between the northern languages and Tuscan involves the meaning of *pomo*. This word appears in a number of Tuscan sources in reference to the forbidden fruit. For example, Giordano da Pisa (1255–1311), a Dominican theologian whose homilies are among the earliest works preserved in Tuscan, states that Adam "sinned by eating the *pomo*,"[127] and a commentary on the *Inferno* written by a Florentine contemporary of Dante's refers to "the forbidden *pomo*."[128] In these cases, *pomo* means "fruit," the basic sense of *pomo* in Tuscan at the time and since. The first Italian (sc. Tuscan) dictionary, the *Vocabolario degli Accademia della Crusca* (first edition, 1612), defines *pomo* as "the fruit of any tree" (*il frutto d'ogni albero*), citing supporting passages from Dante, Boccaccio, and other Tuscan writers.[129]

Not so in Italy's north, where *pomo* means "apple." Pietro da Barsegapè, a thirteenth-century poet who composed a Lombard sermon on Genesis, speaks of *pere e pome*, which can only mean "pears and apples";[130] Antonio Beccari, a fourteenth-century poet from Ferrara, writes *di pome e di pere*, "of pears and apples";[131] and Malermi, who was Venetian, renders Song of Songs 8:5 "under the *pomo* tree I awoke you."[132] In short, Latin *pomum* narrowed in the northern Italian vernaculars to mean "apple," just as it did in French, and with similar results: "forbidden *pomo*" was understood as "forbidden apple." The phrase could have occurred in earlier strata of the northern Italian vernaculars written prior to the semantic narrowing, in Tuscan texts such as the Dante commentary, or in other accounts of the Fall of Man.[133] The intended sense of the word notwithstanding, northern readers encountering these texts after the semantic narrowing of *pomo* would have understood *pomo* to mean "apple."

The situation in Italy provides an outstanding demonstration of the correlation between linguistics and iconography. In northern Italy, where *pomo* meant "apple" in the local vernaculars, the apple tradition prospered; in Florence, where *pomo* meant "fruit," the fig tradition persisted virtually unchallenged. This correlation holds the key to the difficulties raised in our earlier discussion. The iconographic influence is asymmetric (the apple traveled south to Italy, but the fig did not travel north into southern Germany) because northern Italy was linguistically disposed toward a forbidden apple, while southern Germany was not linguistically disposed toward a forbidden fig.

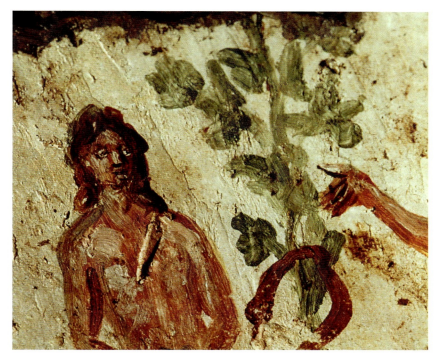

1. Anonymous, fresco, 320–340. Rome, Catacombs of Marcellinus and Peter, cubiculum XIII, arcosolium vault, back wall. Credit: Sonia Halliday Photo Library/Alamy Stock Photo.

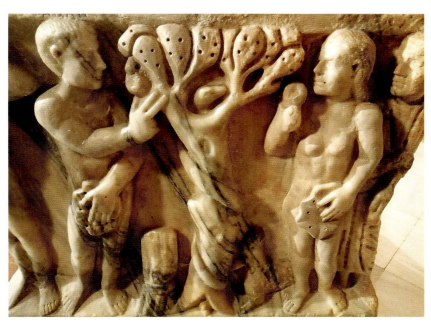

II. Anonymous, *Receptio Animae* Sarcophagus, ca. 330. Zaragoza, Spain, Church of St. Engracia. Credit: Antonio Mostalac Carrillo.

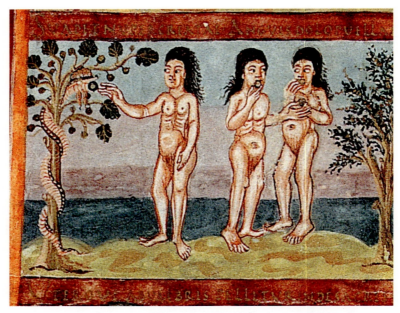

III. Anonymous, Moutier-Grandval Bible, ca. 840. London, British Library, Additional MS 10546, fol. 5v. Photo: British Library Board, BL Add. Ms 10546.

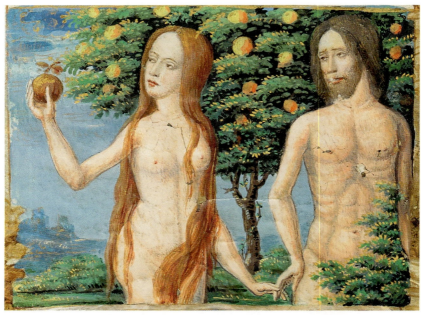

IV. Workshop of Master of Jacques de Besançon, Book of Hours, 1500–1515. Philadelphia, Free Library of Philadelphia, Lewis E 113, fol. 9v. Credit: Free Library of Philadelphia, Rare Book Department.

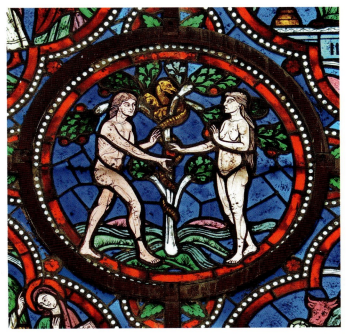

v. Anonymous, stained glass, 12th century. Le Mans, France, Cathedral of Saint Julien de Le Mans, window 106. Credit: Selbymay, CC BY-SA 3.0, via Wikimedia Commons (https://creativecommons.org/licenses/by-sa/3.0/legalcode).

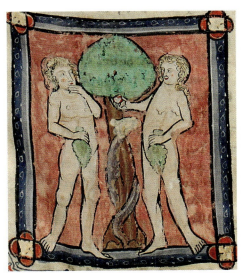

vi. Anonymous, illuminated manuscript, 1250–1299. Paris, Bibliothèque nationale de France, MS Arsenal 3516, fol. 4r. Credit: Bibliothèque nationale de France..

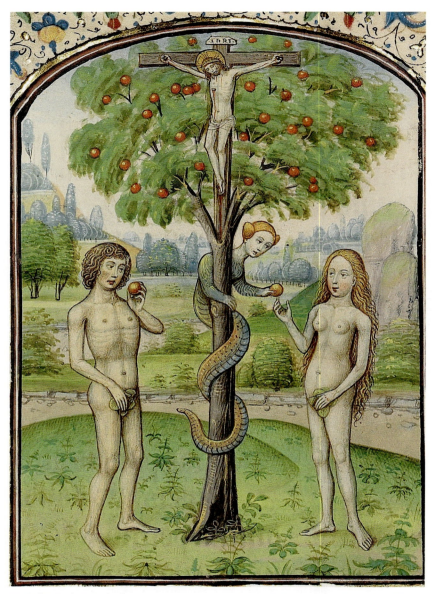

VII. Willem Vrelant, Book of Hours, 1460–1463. Los Angeles, John P. Getty Museum, MS Ludwig IX 8 (83. ML.104), fol. 137r. Credit: The Getty Museum.

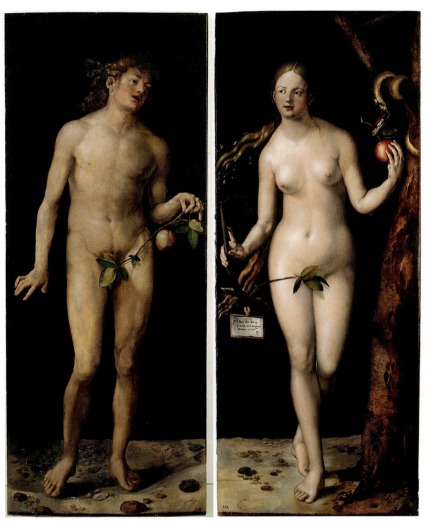

VIII. Albrecht Dürer, *Adam and Eve*, 1507. Madrid, Museo del Prado. Credit: Public domain, via Wikimedia Commons.

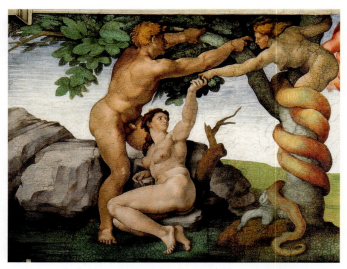

ix. Michelangelo, *Fall of Man*, 1512. Vatican City, Sistine Chapel. Credit: Sebastian Bergmann, CC BY-SA 2.0, via Wikimedia Commons (https://creativecommons.org/licenses/by-sa/2.0/legalcode).

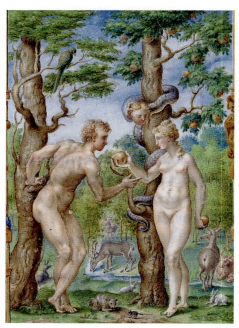

x. Giulio Clovio, Farnese Book of Hours, 1546. New York, Morgan M.69, fol. 27r. Credit: Public domain, via Wikimedia Commons.

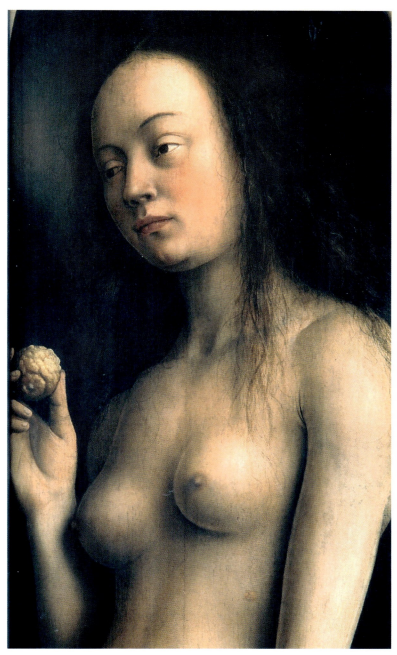

xi. Jan van Eyck, Ghent Altarpiece, 1432. Ghent, Belgium. Credit: Public Domain, via Wikimedia Commons.

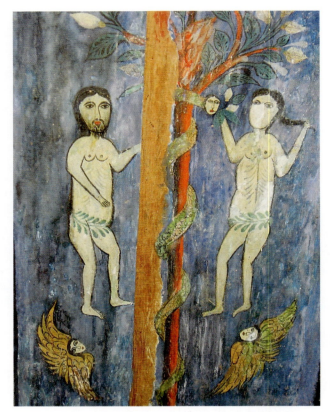
XII. Anonymous, plinth pane, 1666–1669. Arbanasi, Bulgaria, Church of St. Athanasius. Credit: Florentina Badalanova Geller.

This is also why the northern apple tradition did not extend farther south into Italy, even though the influence of Dürer and other northern masters was evident in those regions. Della Robbia emulated Dürer, but "tuscanized" the forbidden fruit. All of which is to say that the semantic narrowing that birthed the apple tradition in France also determined the limits of its diffusion. Regions whose word for "apple" once meant "fruit" were consistently more receptive to the apple; those whose words for "apple" did not, were more resistant.

Postscript: The Triumph of the Apple Tradition

From this point, the final victory of the apple tradition was a straightforward matter. In part, it was the result of art-historical and linguistic processes already underway. Once Venice supplanted Florence as the center of Italian art, and apple artists such as Titian and Tintoretto achieved prominence, all the major artistic centers of Europe belonged to the apple camp. And, over time, the narrow sense of *pomme*, *apple*, and *apfel* became the only sense, anachronistically transforming pre-shift occurrences of these words into unwitting witnesses to the apple tradition. But the apple also received outside help from Johannes Gutenberg and the inestimable cultural impact of the printing

FIGURE 4.1. Hans Brosamer, Luther Bible, 1550. Credit: Gibson Green / Alamy Stock Photo.

press. In the early sixteenth century, the world's major publishing houses were located in northern Europe, in Leipzig, Augsburg, Basel, Cologne, Nuremberg, Strasbourg, and Paris.[134] In Italy, printing "reach[ed] a genuinely industrial scale only in the city of Venice."[135] Many of the early books produced in these centers were Bibles that included illustrative prints, of which a "disproportionately large number . . . [were] devoted to the Fall from Grace in Genesis 3:6."[136] Leading northern artists such as Albrecht Dürer, Lucas van Leyden, Albrecht Altdorfer, Hans Baldung, and Lucas Cranach were active in this field—all champions of the apple tradition. Martin Luther, who was theologically committed to biblical illustrations, included them in his Bibles from the outset.[137] Early editions did not have a dedicated Fall of Man scene, but at least from the 1550 edition there was—an apple-tradition woodcut by Hans Brosamer (fig. 4.1). By this point, the apple tradition had been severed from its linguistic roots, and the revolutionary new medium of print disseminated forbidden apples to the farthest reaches of Europe and beyond.

CONCLUSION

A Scholarly Reflection

The study of the apple tradition—its genesis and its diffusion—resembles a detective novel centered on a wrongful conviction: though everyone assumes the guilty party has been identified, deeper investigation reveals them to be blameless, and another person, heretofore presumed innocent, is shown to be the true culprit. This reversal makes for a wonderful plot twist, but is problematic in a scholarly context, where mistaken propositions are expected to wither under critical scrutiny, not endure for centuries until they become received wisdom. That the historical origins of such a notable biblical symbol eluded rigorous analysis, and that the *malum* hypothesis enjoyed such staying power is remarkable, the more so given the poverty of the corroborating evidence. Literary sources consist of scattered references to the *malum*-apple in the writings of Cyprian of Gaul and (perhaps) Avitus of Vienne; two isolated passages in manuscript commentaries on the Song of Songs; and a few later *malum* puns that postdate the apple tradition itself. The iconographic harvest is poorer still: an isolated witness, Zaragoza's *Receptio Animae* sarcophagus, followed by more than half a millennium of silence. How did such a feeble explanation flourish for so long?

Part of the explanation lies in the ways the *malum* hypothesis speaks to assumptions that inform much of the academic study of religious traditions. For one, there is the notion that scholars can study "religion" (however we define that term) as a relatively autonomous field, unencumbered by the need to situate religious practices and discourses within a broader social and historical context. This leads to many vague statements about the symbolism of the apple in "Christianity" or "the West." A corollary is the assumption that scholars ought to explain religious phenomena by means of other religious phenomena. The *malum* hypothesis fits these assumptions well, since it explains

the apple in terms of a theological emphasis on the "evil," *malum*, of the Fall of Man. These assumptions turn out to be badly off the mark. The rise of the apple is the result of linguistic changes that take place outside the confines of religious discourse—an inadvertent result of developments unrelated to Genesis or human fallenness. The *malum* hypothesis is also consonant with the scholarly predilection for explanations anchored in high literary culture, at the expense of the vernacular. Some scholars were doubtless beguiled by the idea that a Latin play on words could fundamentally alter the literary and artistic representation of a key biblical motif. But here again, the historical truth lay elsewhere—not in Latin scriptoria, but in the lived reality of Europe's medieval vernaculars and their accounts of the Fall of Man.

Whatever its precise origins, the *malum* hypothesis has been perpetuated by a series of scholarly errors. Some are egregious, like *The Oxford Dictionary of Christian Art and Architecture*'s claim that "the [forbidden] fruit has always been regarded as the apple."[1] Similarly, *The Encyclopedia of the Bible and Its Reception* references "the apple exchanged by the serpent and Eve before the fig tree in Michelangelo's . . . Sistine Chapel," introducing an apple into a work firmly rooted in the fig tradition.[2] Or consider the Artstor caption for the Fall of Man mosaic at the San Marco Cathedral in Venice, where the Tree of Knowledge is unmistakably a fig: "Eve giving Adam the apple" (fig. c.1).[3] Similar errors are found in literary scholarship. Robert Applebaum, in an essay on Milton's apple, claims that the Vulgate's translation of the Fall of Man renders "the Hebrew word for fruit as *malum*, 'apple,' with a perhaps intentional pun on another pronunciation of *malum* . . . meaning 'evil.'"[4] The Vulgate, however, does not use *malum* to refer to the forbidden fruit—but *fructus*—so there is no pun, intentional or otherwise. Such statements put the proverbial carriage before the horse: the presence of the apple is first assumed, then imposed on the art-historical and textual evidence.

The apple insinuates itself in more subtle ways as well. Take Raffaele Garrucci's *Storia della arte cristiana*, a late nineteenth-century work that is now dated but was for generations an important resource for the study of Early Christian art.[5] Though admirable in many ways, the forbidden fruit drawings in Garrucci's *Storia* consistently represent apples where none exist.[6] Indeed, Garrucci goes to almost comical extremes in his sketch of the Fall of Man scene from the Cimitero di S. Gennaro in Napoli, representing Eve with an apple, which in fact is nothing more than a blemish in the fresco's plaster (figs. c.2 and c.3).[7] Garrucci did not set out to deceive his readers. To the contrary. Since he considered the identification of the forbidden fruit with the apple an established fact, the apple's inclusion was, in his eyes, the best

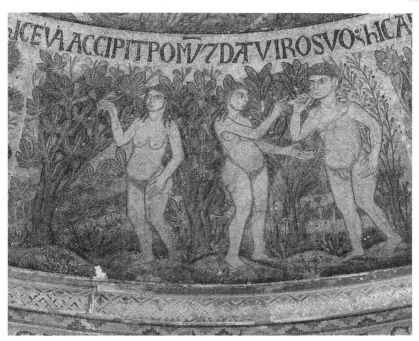

FIGURE C.1. Anonymous, cupola mosaic, 13th century. Venice, Italy, St. Mark's Cathedral. Credit: Art Resource.

possible historical reconstruction. In truth, however, he was perpetuating a view that ought to have been subjected to greater scrutiny.

It is translation above all that is responsible for sustaining errors surrounding the apple tradition. Modern translations of Latin Fall of Man narratives consistently render *pomum* as "apple," as do translations of Old French *pom*, Middle English *appel*, and Middle High German *apfel*. This despite the fact that "fruit" is an established—for some of these languages *the* established—meaning. As a result, English readers come across the apple in a range of sources: from Commodian's third-century Latin *Instructions*, to the late antique Aramaic Targum to the Song of Songs, and from the twelfth-century Anglo-Norman *Jeu d'Adam* to Middle English minstrel songs.[8] The phenomenon extends beyond explicit references to the Fall of Man. In *Purgatorio*, canto 27, Dante agrees to pass through a purifying fire to reach Beatrice, comparing himself to a child beguiled by a *pomo*, that is, "fruit," in (Tuscan) Italian. Nonetheless, scholars have argued that "the implied identification of Beatrice with an apple would appear to be a discordant one, because the

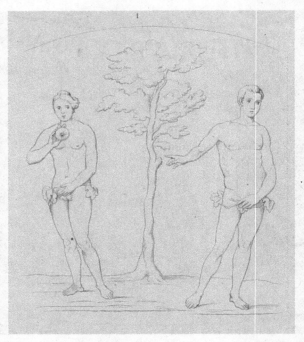

FIGURE C.2. Raffaele Garrucci, *Storia della arte cristiana*, vol. 2, pl. 96.1. Credit: Public domain.

forbidden fruit was the source of all human woe. How, then, could it be identified with Beatrice?"[9] But the assumption that *pomo* is an apple and therefore an allusion to the forbidden fruit cannot be justified on lexical grounds. Such examples could be multiplied many times over, but the ultimate result is the same. The mistranslations are mutually reinforcing, and cumulatively create the impression that the forbidden fruit was the apple across different regions and centuries.

Finally, part of the apple tradition's elusiveness lies in the inherently interdisciplinary nature of the investigation into its origins. The argument of this book unfolds over a series of studies in different scholarly disciplines, each necessary but none sufficient. The Latin commentaries on Genesis and the Song of Songs offer no support for the *malum* hypothesis: their authors are innocent of the notion that the forbidden fruit was an apple. But the Latin sources do not point us toward the answer. The Fall of Man iconography allows us to situate the appearance and diffusion of the apple tradition, but it tells us nothing about the historical *causes* of these developments. The semantic evolution of Old French explains the origin of the apple tradition, while the semantics of other European vernaculars shed light on its diffusion—but

A SCHOLARLY REFLECTION

there would be no cause to interrogate the sources this way without first determining the inadequacy of the *malum* hypothesis, and locating the appearance of the apple tradition in twelfth-century France. Only the combined study of these disparate fields allows us to uncover the apple tradition's roots and subsequent ramifications. This book, then, serves two functions. It is, first and foremost, an attempt to solve the riddle of the apple. But it is also, I hope, an illustration of the need for, and the promise of, interdisciplinary scholarship in the humanities.

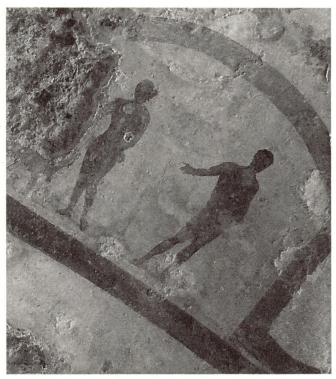

FIGURE C.3. Anonymous, fresco, 4th century. Naples, Italy, San Gennaro Catacombs. Credit: Archivio Fotografico Cooperativa La Paranza—Catacombe di Napoli.

Acknowledgments

It first occurred to me that the identity of the forbidden fruit might have a linguistic basis when I was a young assistant professor in the University of Minnesota's Department of Classical and Near Eastern Studies. My doctoral dissertation had focused on Hebrew and Aramaic texts, and while I had read Greek throughout graduate school, Latin had lain fallow for years. As a remedy, I set up weekly Latin readings with Aaron Poochigian, then a doctoral student in the department and today an accomplished translator and poet. We were reading book 2 of Augustine's *Confessions*, in which Augustine describes the theft of some pears, and shortly thereafter notes that the *poma* in question were beautiful (*pulchra erant illa poma; Confessions* 2.6). Under the sway of French *pomme*, I was momentarily confused—the fruit were explicitly pears, yet here Augustine refers to them as . . . apples? Aaron reminded me that *pomum* was a generic term for "fruit," and I wondered to myself whether this shift could have anything to do with the identification of the forbidden fruit with the apple. That question remained with me for more than a decade, until I began to collect scattered evidence and ultimately produce the argument of this book.

My primary academic training is in early rabbinic interpretation of biblical law (legal or halakhic midrash). This study, then, has taken me in new scholarly directions, and I am fortunate to have had generous and knowledgeable scholars to guide me along the way. I owe a special debt to friends and colleagues who read and commented on drafts of chapters: David N. Bell (Memorial University), Ari Geiger (Bar Ilan University), Scott Gwara (University of South Carolina), Hermann Haller (City University of New York), David Marsh (Rutgers University), Ann Matter (University of Pennsylvania), Jean-Claude Mühlethaler (Université de Lausanne), Pamela Patton (Princeton

University), Erik Thunø (Rutgers University), and Alessandro Vittori (Rutgers University). Each offered invaluable feedback, saving me from errors while sharing their insights. Paola Tartakoff read an early draft of the manuscript when it was at a critical point in the writing process, and her comments were profoundly helpful. David Biale, generous and supportive as always, read and commented on the entire manuscript. I am grateful to all. Other scholars graciously helped me navigate some of the textual and linguistic issues I encountered. John Dagenais (UCLA) assisted with Catalan; Alexander Kulik (The Hebrew University) with Slavic; Florentina Badalanova Geller with Slavic art; and David Brakke (The Ohio State University) with Coptic. Lisa Whitlock and Emmanuel Aprilakis, former and current doctoral students in classics at Rutgers, respectively, aided with the Latin sources. I thank Jim Morey (Emory) who sent me a copy of his transcription of the Middle English *Old Testament History* and Lena Struwe, a professor in the Department of Plant Biology at Rutgers, for her crash course in the genetics and biogeography of the apple. I further acknowledge the Rutgers students who assisted with various aspects of this project over the years: Aida Bahrami, Paris Downing, Becca McGinn, and Avi Sommer.

Jeremy Specland read the manuscript with a keen editorial eye, and Jesse Tisch pushed me to make the writing clearer and more accessible. I am indebted to both.

Michael Siegel, who heads the Rutgers Cartography Lab, created the wonderful maps in chapter 3 and was patient and helpful throughout the process.

A number of photographers generously shared their images for use in this book. Thanks to Painton Cowen, Béatrice Delepine, Genevra Kornbluth, and Jean Marie Sicard. I am thankful that this project has won me the acquaintance of Antonio Mostalac Carrillo of the University of Zaragoza, who personally photographed the *Receptio Animae* sarcophagus to my specifications. I further acknowledge the images provided by the Pontifical Commission for Sacred Archaeology, the German Archaeological Institute, the Kunsthistorisches Institut in Florenz (Max-Planck-Institut), and the photographic archive of the Cooperativa La Paranza—Catacombe di Napoli, as well as the many photographers who have placed their work in the public domain.

I am indebted to the many libraries that have invested incalculable time and effort digitizing their medieval and early modern holdings, thereby allowing scholars access to a previously unimaginable wealth of material. This book could not have been written without the efforts of the Bibliothèque nationale de France (whose online collection is exemplary), the Biblioteca Apostolica Vaticana, the British Library, the Bodleian Library, the Bayerische Staatsbibliothek, the Free Library of Philadelphia, the library of the University

of Heidelberg, and the Koninklijke Bibliotheek in The Hague, to name but a few. Many museums and scholarly organizations have also made their holdings available online—the Metropolitan Museum of Art, the British Museum, the Cleveland Museum of Art, the Getty Museum, the Walters Art Museum, and the Museo Arqueológico de Córdoba have all made substantial contributions to this book. The availability of these resources from afar is of particular importance for research conducted during the COVID-19 pandemic, when travel and *in situ* research have been curtailed.

I presented early versions of this study at the University of Florida, the University of Minnesota, Ben Gurion University, Haifa University, Tel Aviv University, Rutgers University, and Israel's Institute for Advanced Studies. I gratefully acknowledge the thought-provoking comments and questions from the scholars in audience. Special thanks to the friends and colleagues who extended the invitations: Nina Caputo, Bernard Levinson and Leslie Morris, Michal Bar-Asher Siegal, Moshe Lavee and Tsvi Kuflik, Ishay Rosen-Tzvi, Paola Tartakoff, and Elisheva Baumgarten and Debra Kaplan, respectively. Amit Miretzky created the maps that accompanied these early presentations.

I received both a research grant and a publishing subvention from the Rutgers Research Council. I gratefully acknowledge both.

Both my department chairs, Paola Tartakoff (Jewish Studies) and Jim McGlew (Classics), have been supportive of my work, even and perhaps especially when it has taken me in new and unexpected directions. My colleagues at Rutgers have offered continuous encouragement; Gary Rendsburg in particular has sent me innumerable Fall of Man images over the years. Heartfelt thanks to the three outside readers for their thoughtful and detailed responses, to Marian Rogers for her astute and attentive copyediting, and to Nathan Petrie, Michael Koplow, Kristin Rawlings, and Kyle Wagner, who have shepherded the manuscript along with great skill and dedication.

My greatest debt is to my family and to Hilit—always—above all.

This book is dedicated to my teachers, *sine qua non*.

APPENDIX

Inventory of Fall of Man Scenes

The works inventoried here are the basis for the maps and iconographic analysis in chapter 3. With the exception of material from Russia and Bulgaria, all works below are indicated by icons on the maps. Because of the large number of works included in this inventory, only the essential information about each is provided: medium, date, location. Where two locations are noted, the first is the place the work was created, and the second its current location. Full citations, links, and, when possible, the images themselves are available on this book's companion website: https://treeofknowledgeart.com/.

BAV: Vatican City, Biblioteca Apostolica Vaticana
BL: London, British Library
BnF: Paris, Bibliothèque nationale de France
Bodl: Oxford, Bodleian Library
BSB: Munich, Bayerische Staatsbibliothek
Getty: Los Angeles, John P. Getty Museum
KB: The Hague, Koninklijke Bibliotheek
KBR: Brussels, Koninklijke Bibliotheek van België
KhM: Vienna, Kunsthistorisches Museum
MM: The Hague, Museum Meermanno
MMA: New York, Metropolitan Museum of Art
Morgan: New York, Morgan Library and Museum
MPC: Vatican City, Museo Pio Cristiano
NYPL: New York, New York Public Library
ON: Vienna, Österreichische Nationalbibliothek
SB: Stadtmuseum Berlin
Walters: Baltimore, Walters Art Museum

Early Christian, Byzantine, and Carolingian

Fresco, Rome, 295–320, Catacombs of Marcellinus and Peter, cubiculum 14
Sarcophagus, Rome, 300–320, Museo Civico Archeologico, Rome
Sarcophagus, Rome, 300–322, Cemetery of Saints Marcus and Marcellianus, Rome
Sarcophagus, Rome, 300–324, Cemetery of St. Cyriaca, Rome
Sarcophagus, Rome, 300–324, Museo Nazionale Romano, Rome, front zone of sarcophagus
Sarcophagus, Rome, 300–324, MPC
Sarcophagus, Rome, 300–324, Cemetery of Saints Marcus and Marcellianus, Rome
Sarcophagus, Rome, 300–324, MPC
Cyriaca Sarcophagus, Naples, 300–325, Museo Nazionale, Naples
Mas d'Aire Sarcophagus, Rome, 300–325, Saint-Quitterie du Mas d'Aire, Aire-sur-L'Adour (Landes)
Sarcophagus, Rome, 300–332, MMA
Sarcophagus, Rome, 300–332, San Paolo fuori le mura, Rome
Sarcophagus, Rome, 300–332, MPC
Sarcophagus, Rome, 300–332, MPC
Sarcophagus, Rome, 300–349, Basilica di San Sebastiano, Rome
Fresco, Rome, 320–340, Catacombs of Marcellinus and Peter, arcosolium III vault
Receptio Animae Sarcophagus, Rome, 330, Church of St. Engracia, Zaragoza
Sarcophagus, Rome, 330–335, Museo Arqueologico, Cordoba
Dogmatic Sarcophagus, Rome, 325–349, MPC
Sarcophagus, Rome, 325–349, Musée de l'Arles antique
Fresco, Rome, 320–360, Catacombs of Marcellinus and Peter, cubiculum 30
Fresco, Rome, 320–360, Catacombs of Marcellinus and Peter, vault of arcosolium III, exterior wall
Adelphia Sarcophagus, Syracuse, Italy, 340, Museo Archeologico Regionale Paolo Orsi
Sarcophagus, Rome, 333–365, MPC
Sarcophagus, Rome, 333–365, MPC
Sarcophagus, Rome, 333–365, MPC
Fresco, Rome, 300–399, Nuova Cemetery, Via Latina, arcosolium lunette on right wall
Fresco, Rome, 300–399, Catacombs of Domitilla, cubiculum II, right arcosolium
Fresco, Rome, 300–399, Nuova Cemetery, Via Latina, left side of arcosolium lunette
Fresco, Rome, 300–399, Coemeterium Majus Catacomb, cubiculum II
Fresco, Rome, 300–399, Nuova Cemetery, Via Latina, cubiculum entrance wall
Sarcophagus of Aurelius, Rome, 300–399, Catacomb of Novatian
First Layos Sarcophagus, Rome, 300–399, Museo Federico Marés, Barcelona
Second Layos Sarcophagus, Rome, 300–399, Real Academia de la Historia, Madrid
Sarcophagus, Rome, 300–399, Museo Arqueológico Nacional, Madrid
Sarcophagus, Rome, 300–399, Dauphin Collection, Arles
Sarcophagus, 300–399, Rome, Capitoline Museum 396.1
Gold glass, Rome, 300–399, MPC

INVENTORY OF FALL OF MAN SCENES 91

Gold glass, Rome, 300–399, formerly at Czartoryski Museum, Cracow
Glass bowl, Cologne, Germany, 300–399, Römisch-Germanisches Museum, Cologne
Fresco, Pécs, Hungary, 300–399, Early Christian cemetery
Junius-Bassus Sarcophagus, Rome, 359, Basilica di San Pietro, Vatican City
Fresco, Rome, 350–399, Domitilla Catacombs, vault of arcosolium 77
Fresco, Rome, 350–399, Domitilla Catacombs, arcosolium exterior wall
Plaque, Trier, Germany, 350–399, Rheinisches Landesmuseum, Trier
Sarcophagus, Verona, Italy, 380–399, San Giovanni in Valle, Verona
Sarcophagus, Rome, 380–399, Musée de l'Arles antique
Sarcophagus, Rome, 380–420, Manosque, Cathedral of Notre Dame
Sarcophagus, Aquitaine, France, 400–432, Sarcophagus in Lucq-de-Béarn
Sarcophagus, Tomb of St. Clair, Aquitaine, France, 400–432, Musée des Augustins, Toulouse
Sarcophagus of Albane and Bertrance, Aquitaine, France, 466–499, Abbaye de Gellone, St. Guilhem le Désert
Mosaic, Syria, 400–599, Cleveland Museum of Art
Vienna Bible, Syria (?), 500–550, ON cod. theol. gr. 31, fol. 3r
Bamberg Bible, Tours, France, 834–843, Bamberg, Staatliche Bibliothek, Msc. Bibl. I (A.I.5), fol. 7v
Grandval Bible, Tours, France, 840, BL Add. 10546, fol. 5v
Vivian Bible, Tours, France, 845–851, BnF lat. 1, fol. 10v
Bible of San Paolo fuori le Mura, Rheims, France, 871, Rome, Library of San Paolo fuori le mura, frontpiece
Homilies of John Chrysostom, Constantinople, 875–899, National Library of Greece, MS 211, fol. 53r
Ivory box, Constantinople, 1000–1199, Walters
Casket, Constantinople, 1000–1199, Musée des beaux-arts, Reims
Catena to the Octateuch, Constantinople, 1050–1099, BAV gr. 747, fol. 22v
Octateuch, Constantinople, 1100–1149, Florence, Laurentian Library, Cod. Plut. 5.38, fol. 6r
Kokkinibaphos Master, *Homilies on the Virgin by James of Kokkinibaphos*, Constantinople, 1121–1150, BAV gr. 1162; fol. 35r
Kokkinibaphos Master, Octateuch, Constantinople, 1125–1150, Seraglio Library, Istanbul, Cod. 8, fol. 43v.
Octateuch, Constantinople, 1275–1299, BAV gr. 746, fol. 37v

France before 1250

Miscellany of early Christian authors, Moissac, 875–899, BnF lat. 2077, fol. 62v
Capital, Vézelay, 1000–1035, Basilique Sainte Madeleine
Capital, Deuil, 1000–1099, Church of Deuil
St. Severus Beatus, Gascony, 1036–1065, BnF lat. 8878, fol. 45r

Capital, St. Denis, 1000–1140, Abbey of St. Denis
Capital, Angers, 1050–1120, Le Ronceray Church
Capital, Airvault, 1080–1099, Saint Pierre Church
Capital, Cluny, 1090–1095, Musée d'Art et d'Archéologie
Capital, Ainay, 1080–1120, Church of St. Martin
Capital, Toulouse, 1100–1118, Basilica of St. Sernin, Miegeville
Capital, Chauvigny, 1100–1125, Church of Notre Dame
Lambert, illuminated manuscript, Liber Floridus, St. Omer, 1121, Ghent University Library 1125, fols. 231r–232v
Nave capital, Vézelay, 1120–1132, Basilique Sainte Madeleine
Capital, St. Paul of Varax, 1103–1150, Church of St. Paul of Varax
Gislebertus, portal lintel relief, Autun, 1120–1135, Cathedral of Saint Lazare, now Musée Rolin
Portal lintel relief, Andlau, 1130, L'Abbaye Sainte Richarde
Portal tympanum, Neuilly en Donjon, 1130, Church of St. Madeleine
Marchiennes Bible, Douai, 1125–1135, Douai, Bibliothèque municipale 1, fol. 1v
Capital, Aulnay de Saintonge, 1120–1149, Church of St. Pierre
Biblia Latina, 1126–1150, BnF lat. 10, fol. 3v
Fresco, Saint Plancard, 1140, Saint-Jean-de-Vigne
Frieze, Étampes, 1140–1155, Church of Notre Dame
Capital, Bourges, 1100–1199, Bourges Cathedral
Capital, Airvault, 1100–1200, Church of St. Pierre
Capital, Tavant, 1100–1199, Église de Tavant
Nave capital, Fleury, 1100–1199, Abbey Church of Fleury
Chess piece, 1140–1160, Louvre OA 3297
Anchin Bible, Douai, 1140–1160, Douai, Bibliothèque municipale, 2, fol. 7r
Capital, Saint Gaudens, 1100–1199, Collegiate Church of Saint Gaudens
Josephus's *Antiquitates judaicae*, Troyes, 1160, BnF lat. 8959, fol. 1v
Capital, Picardy, 1150–1175, Musée de Picardie
Frieze, Arles, 1160–1180, Saint Trophime Church
Statue, Verdun, 1150–1199, Notre Dame Cathedral
West portal tympanus, Tarascon, 1166–1199, St. Gabriel's Chapel
Psalter of Amiens, Saint Fuscien, 1180–1199, Amiens, Bibliothèque municipale 19, fol. 7r
Capital, Clermont-Ferrand, 1180–1199, Notre Dame du Port
Capital, Clermont-Ferrand, 1180–1199, Notre Dame du Port
Souvigny Bible, Cluny, 1200, Moulins, Bibliothèque municipale 1, fol. 4v
Stained-glass window, Chartres, 1210, Chartres Cathedral, w. 44-6, panels 16 and 18
Bible and *Vitae Sanctorum*, Saint Omer, 1200–1220, KB 76 F 5, fol. 2v sc. 1A
Stained-glass window, Bourges, 1210–1215, Bourges Cathedral, w. 13, panel 13
Stained-glass window, Soissons, 1220, Soissons Cathedral, window 102
Bible moralisée, Paris, 1225, ON 2554, fol. 2r

Capital, Amiens, 1220–1235, Cathedral of Notre Dame of Amiens
Psalter of S. Louis et Blanche de Castille, Paris, 1230, BnF Arsenal 1186, fol. 11v
Bible moralisée, Paris, 1225–1249, BL Harley 1527, fol. 18v
Stained-glass window, Lyon, 1235–1240, Lyon Cathedral, window 116
Bible moralisée, Paris, 1235–1245, Bodl 270b, fol. 7v
Psalter, Paris, 1240–1250, BnF lat. 10434, fol. 10r
Morgan Crusader Bible, Paris, 1244–1254, Morgan M.638, fol. 1v
Latin Bible, 1200–1299, BnF lat. 11, fol. 3r
Stained-glass window, Agnières, 1200–1299, St Vaast, w.0
Stained-glass window, Sens, 1200–1299, Sens Cathedral, w. 15
Stained-glass window, Tours, 1200–1299, Tours Cathedral, w. 207
Stained-glass window, Amiens, 1200–1299, Amiens Cathedral, w.27, panel C4
Stained-glass window, Reims, 1200–1299, Reims Cathedral, w. 115, north rose window
Stained-glass window, Auxerre, 1200–1299, Auxerre Cathedral, w. 11, panel 8 and w. 21, panel 4
Lyre Abbey Psalter, 1200–1299, BL Add. 16975, fol. 13r

France after 1250

Relief, Paris, 1236–1265, La Sainte-Chapelle
Acre Bible, France, 1250–1254, BnF Arsenal 5211, fol. 3v
Psalter Hours, Arras, 1246–1260, Morgan M.730, fol. 10r
Queste del graal, Artois, 1274, BnF fr. 342, fol. 127v
Bible, Paris, 1250–1300, KB 76 F 23, fol. 98r
Psalter Book of Hours, Liège, Belgium, 1250–1300, KB 76 G 17, fol. 3r
Illuminated manuscript, northern France, 1250–1299, BnF Arsenal 3516
Frieze, Bourges, Belgium, 1270–1280, Cathedral of St. Etienne
Thomas of Cantimpré, *De rerum natura*, northern France, 1276, BnF lat. 523A, fol. 2v
Jamb, Auxerre, 1270–1290, St. Etienne of Auxerre
Miscellany of Hebrew texts, northern France, 1277–1286, BL Add. 11639, fol. 520v
Bible, northeastern France, 1275–1299, Morgan M.969, fol. 173r
Roll, *Compendium Historiae*, Picardy, 1280–1299, Morgan M.367
North portal exterior, Rouen, 1281–1300, Cathedral Notre Dame
Stained glass, Strasbourg, 1200–1399, Strasbourg Cathedral, w. 17, panel D6
Missal of Corbie, Corbie, 1300–1310, Amiens, Bibliothèque municipale 157, fol. 128v
Apocalypse of St. John, Belgium, 1313, BnF fr. 13096, fol. 83r
North transept, Rouen, 1300–1330, Cathedral of Notre Dame
L'estoire del Saint Graal, northern France, 1316, BL Add. 10292, fol. 31v
Bible historiale, Paris, 1300–1335, BnF fr. 160, fol. 7v, 8r, 8v, 9r
Romance of Lancelot du Lac, 1320–1330, Bodl Rawl., Q. b. 6, fol. 349r
Bible historiale, Paris, 1325, Morgan M.322, vol. 1, fol. 13v
Bible historiale, Paris, 1320–1340, BL Yates Thompson 20, fol. 1r

Ovide moralisé, Paris, 1330, BnF Arsenal 5069, fol. 155r
Miroir historial, Paris, 1333, BnF fr. 316, fol. 40r
Quest de sant graal, Hainaut, Belgium, 1345, BnF fr. 122, fol. 259v
Jewish Antiquities, 1300–1399, BnF fr. 404, fol. 1r
Bible historiale, St. Omer, 1300–1399, BnF fr. 152, fol. 15r
Bible historiale, Paris, 1300–1399, BnF fr. 161, fol. 9v
Histoires bibliques, Saint Quentin, 1350, BnF fr. 1753, fol. 1v
Bible moralisée, Paris, 1345–1355, BnF fr. 167, fol. 3v
Bible historiale, Paris, 1350–1356, BL Royal 19 D II, fol. 8r
Bible historiale complétée, central France (Paris?), 1357, BL Royal 17 E VII, fol. 7v
Bible historiale, Paris, 1350–1375, Harvard Houghton Library, Typ 0555, fol. 9r
Breviary of Charles V, Paris, 1347–1380, BnF lat. 1052, fol. 207r
Histoire ancienne jusqu'à César, Paris, 1364, BnF fr. 246, fol. 1r
Grande Bible Historiale Complétée, Paris, 1371–1372, MM 10 B 23, fol. 10r
Antiphonal, Besançon, ca. 1380
Bible historiale, Paris, 1375–1400, BnF fr. 158, fol. 8r
Bible historiale moyenne complétée, Paris, 1375–1399, BnF fr. 2, fol. 8v
Bible, Paris or Troyes, 1390, NYPL Spencer 22, fol. 6v
Histoire universelle, 1390–1400, Morgan M.516, fol. 13r
Miroir historial, Paris, 1396, BnF fr. 312, fol. 30r
Cleres et nobles femmes, Paris, 1402, BnF fr. 12420, fol. 6v
Bible historiale, Chartres, 1411, BL Royal 19 D III, fol. 8v
Des Cas des nobles hommes et femmes, Paris, 1400–1424, BnF fr. 226, fol. 6v
Des Cas des nobles hommes et femmes, central France, 1400–1424, BL Royal 20 C IV, fol. 8r
Boucicaut Workshop, *Des Cas des nobles hommes et femmes*, Paris, 1413–1415, Getty 63, fol. 3r
Bible historiale, Paris, 1415, KBR 9001, fol. 26r
Bedford Hours, Paris, 1410–1423, BL Add. 18850, fol. 14r
Bible historiale, Bretagne, 1417, BnF fr. 163, fol. 5r
Bible historiale, Paris, 1400–1435, BnF fr. 3, fol. 8v
Bible historiale, Paris, 1400–1435, BnF fr. 9, fol. 9r
Lancelot Cycle, 1400–1435, Bodl Douce 215, fol. 31v
De Civitate Dei, Paris, 1400–1435, BnF fr. 21, fol. 29r
Des Cas des nobles hommes et femmes, Paris, 1425–1449, BnF fr. 235, fol. 7v
Speculum humanae salvationis, 1400–1499, BnF lat. 9586, fol. 3v
Champion of Women, *Des Cas des nobles hommes et femmes*, Carpentras, 1400–1499, Bibliothèque Inguimbertine 622, fol. 6v
Speculum humanae salvationis, Alsace, 1400–1499, BnF lat. 9585, fol. 7r
Miroir d'humaine salvation, France, 1450, BnF fr. 188, fol. 6v
Le Livre des hystoires du Mirouer du monde, Paris, 1400–1499, BnF fr. 328, fol. 1r
De proprietatibus rerum, Paris, 1400–1499, BnF fr. 22531, fol. 12r
Mare historiarum, Anjou, 1447–1455, BnF lat. 4915, fol. 24r

INVENTORY OF FALL OF MAN SCENES

De civitate Dei, Rouen, 1450–1474, BnF fr. 28, fol. 33r
Des Cas des nobles hommes et femmes, Paris, 1450–1474, BnF fr. 233, fol. 3r
Book of Hours, Rouen, 1460–1470, Morgan M.1160, fol. 27r
Roll, Arms of Gavre de Liedekerke, 1450–1461, Harvard Houghton Library, Typ 0041, fol. 1r
Quest del saint grail, Ahun, 1470, BnF fr. 116, fol. 657v
De civitate Dei, Paris, 1469–1473, BnF fr. 19, fol. 27r
Des Cas des nobles hommes et femmes, Paris, 1450–1499, BnF fr. 598, fol. 6v
Des Cas des nobles hommes et femmes, Paris, 1470–1480, Morgan M.342, fol. 8r
Queste del saint grail, Poitiers, 1480, BnF fr. 111, fol. 260v
Book of Hours, Rouen, 1479–1480, Morgan M.312, fol. 76r
Des Cas des nobles hommes et femmes, Tours, 1480, Morgan G.35, fol. 1r
Book of Hours, 1480–1485, Morgan M.677, fol. 48v
Legenda aurea, Paris, 1480–1490, BnF fr. 244, fol. 1r
Miroir de la salvation humaine, Bruges, Belgium, 1485, BnF fr. 6275, fol. 3v
Hours, Rouen, 1490, Morgan M.144, fol. 23r
Hours, Rouen, 1485–1499, Free Library of Philadelphia, Lewis E 123, fol. 22v
Compost et calendrier des bergers, Angers, 1493, Angers, BM impr. Rés. SA 3390, fol.1r
Book of Hours, Paris, 1490–1500, Morgan M.7, fol. 3r
Book of Hours, Paris, 1500, Morgan H.5, fol. 41r, 41v
Toison d'or, 1400–1599, BnF fr. 138, fol. 8r
Book of Hours, Paris, 1500, Morgan M.197, fol. 17v
Book of Hours, Rouen, 1500–1510, Morgan M.170, fol. 15r
Workshop of Master of Jacques de Besançon, Book of Hours, 1500–1515, Free Library of Philadelphia, Lewis E 113, fol. 9v
Book of Hours, Normandy, 1500–1524, Bodl Douce 72, fol. 15v
In Epistolam Joannis, 1540–1550, Morgan M.1124, fol. 1r
Bernard Salomon, *Biblia Sacra*, 1558, in *Icones historicae Veteris et Novi Testament* (Geneva: Samuel de Tournes, 1681), page 4

Germany, England, and the Low Countries before 1250

Caedmon Genesis, Canterbury, England, 1000, Bodl Junius 11, page 31
Old English Hexateuch, Canterbury, England, 1025–1049, BL Cotton Claudius B.IV, fol. 7r
St. Albans Psalter, St. Albans, England, 1125–1149, Hildesheim, St. Godehard Church, page 17
Walsingham Bible, Norfolk, England, 1100–1199, Chester Beatty Library W 022, fol. 8v
Font, Yorkshire, England, 1100–1199, Saint Mary's Church
Psalter of Geoffrey Plantagenet, northern England, 1100–1199, Leiden, Bibliotheek der Universiteit, BPL 76, fol. 8v

APPENDIX

Hunterian Psalter, England, 1170, University of Glasgow, Special Collections Hunter U.3.2. (229), fol. 7v
East Meon, Hampshire, England, 1150-1199, East Meon Church
Canterbury Psalter/Paris Psalter northern England, 1180-1190, BnF lat. 8846, fol. 1r
Golden Munich Psalter, Oxford, England, 1200-1210, BSB Clm. 835, fol. 8v
Psalter, Oxford, England, 1212-1220, Morgan M.43, fol. 7v
Psalter of Henry of Blois, Winchester, England, 1136-1299, BL Cotton Nero C IV, fol. 2r
The Taymouth Hours, England (London?), 1325-1349, BL Yates Thompson 13, fol. 2v
Opus Anglicanum Cope (lost), England, 1325-1349
The Bible of Robert de Bello, South-East England (Canterbury?), 1240-1253, BL Burney 3, fol. 5v
Bestiaire divin, England, 1250-1274, BnF fr. 14969, fol. 58v
Glazier Bible, Oxford, England, 1265, Morgan G.42, fol. 6r
Oscott Psalter, England (Oxford?), 1265-1270, BL Add. 50000, fol. 13r
Roll, *Compendium Historiae in Genealogia Christi*, South England, 1250-1299, BL Royal 14 B IX
Poetic Miscellany, England, 1250-1299, Morgan M.761, fol. 10r
Compendium Historiae in Genealogia Christi, Ramsey, England, 1250-1299, Morgan M.628, fol. 2r
Grandisson Psalter, Chichester, England, 1270-1280, BL Add. 21926, fol. 150v
Holland Psalter, England, 1270-1280, St. John's College, Cambridge K. 26, fol. 4r
Bible, England, 1266-1299, Bodl Auct. D.3.2, fol. 133r
Huth Psalter, Lincoln, England, 1275-1299, BL Add. 38116, fol. 9r
Queen Mary Psalter, London, England, 1200-1399, Cambridge University Library, Add. 4081, fol. 1r
Book of Hours, Cambridge, England, 1300, Walters W.102, fol. 28v
Cope of Daroca, England, 1300, Madrid, Museo Arqueológico Nacional
Ramsey Psalter, East Anglia or London, England, 1300-1310, Morgan M.302, fol. 1r
Psalter, York, England, 1300-1315, NYPL Spencer 002, fol. 2v
Peterborough Psalter, England (London?), 1299-1318, KBR 9961-62, fol. 25r
La lumiere as lais, England, 1300-1324, BL Royal 15 D II, fol. 2r
Queen Mary Psalter, England, 1310-1320, BL Royal 2 B VII, fol. 3v
Gregory the Great's *Moralia on Job*, Norwich, England, 1310-1320, Emmanuel College II. 1.1/112, fol. 195r
Carew-Poyntz Book of Hours, England, 1300-1360, Fitzwilliam Museum 48, fol. 14r
Holkham Bible Picture Book, London, England, 1327-1335, BL Add. 47682, fol. 4r
Choir Capital, Ely, England, 1338-1348, Ely Cathedral
Book of Hours, London, England, 1350, Rome, BAV Pal. lat. 537, fol. 37r
Omne Bonum, South-East England (London?), 1360-1375, BL Royal 6 E VI/1, fol. 2r
Speculum humanae salvationis, England, 1350-1399, BnF fr. 400, fol. 2r
Psalter-Hours, Oxford, England, 1380, Bodl Auct. D.4.4, fol. 24v
Historia Polychronica, Norwich, England, 1366-1399, BnF lat. 4922, fol. 2r
Almanac, England, 1366-1399, Bodl Rawl. D. 939, fol. 4r

INVENTORY OF FALL OF MAN SCENES

Ranulf Higden's *Polychronicon*, England, 1366–1399, Bodl Tanner 170, fol. 15v
Speculum humanae salvationis, Yorkshire, England, 1400, Morgan M.766, fol. 23v
Workshop of John Thornton of Coventry, stained-glass window, York, England, 1405–1408, York Minster, Great East Window
Compendium historiae in genealogia Christi (extracts), England, 1420–1430, Bodl Barlow 53 (R), membrane 1
John Lydgate's *Metrical lives of Saints Edmund and Fremund*, Bury St. Edumunds, England, 1434–1439, BL Harley 2278, fol. 1v
John Lydgate's *The Fall of Princes*, Suffolk, England (perhaps Bury St. Edmunds), 1450–1460, BL Harley 1766, fol. 11r
Roll, *Genealogy of the Kings of England*, England, 1460, KB 78 B 24
Roll, *Chronicle of the History of the World*, England, 1461, Free Library of Philadelphia, Lewis E 201
Genealogical chronicle of the Kings of England, England, 1461–1464, San Marino, CA, Huntington Library, HM 00264, fol. 1r
Genealogical Biblical and English history, England, 1467–1469, Bodleian e Musaeo 42, fol. 1v
Genealogical chronicle of the Kings of England from Adam to Edward IV, England, 1469–1470, Bodl Lyell 33, fol. 1v
John Lydgate's *Fall of Princes*, England, 1465–1475, Rosenbach Museum and Library 439/16, fol. 4r
John Lydgate's *Fall of Princes*, England, 1439–1500, Bodl 263, fol. 7r
Stained glass, Worcestershire, England, 1436–1499, Malvern Priory, South Choir Aisle (S.III)
Speculum humanae salvationis, London, England, 1489–1509, BL Harley 2838, fol. 4v
Physiologus, Liège, Belgium, 900–1049, KBR 10066-77, fol. 141v
Box for a Gospel Book, Germany, 900–999, Säckingen Cathedral
The Sacramentary of Bishop Abraham, Freisig, Germany, 984–994, BSB Clm. 6421, fol. 126r
Ivory book cover, Liège, Belgium, 1000–1020, Metz Municipal Museum
Bernward doors, Hildesheim, Germany, 1015, Hildesheim Cathedral
Marianus Scotus' *Chronicle*, Germany, 1000–1099, BAV Pal. lat. 830, fol. 37r
Bible, Lower Rhine, Germany, 1125–1149, BSB Clm. 14061, fol. 2v
Capital, Maastricht, Netherlands, 1100–1199, Notre Dame Cathedral
Bible of St. Mary de Parc, Belgium, 1100–1199, BL Add. 14788, fol. 6v
Bronze door, Magdeburg, Germany, 1152–1156, Novogrod, Cathedral of St. Sophia
Chalice, Lower Saxony, Germany, 1160–1170, KhM
Cornice, Baden-Württemberg, Germany, 1150–1199, Saint Martin
Dialogus de Laudibus Sanctae Crucis, Regensburg, Germany, 1170–1180, BSB Clm. 14159, fol. 1r
Prayerbook of Hildegard of Bingen, Trier, Germany, 1175–1180, BSB Clm. 935, fol. 4v
Herrade von Landsberg's *Hortus Deliciarum*, Alsace, 1167–1195, facsimile of lost 1164 manuscript, fol. 17b

Nicholas of Verdun, Klosterneuburg Altar, Austria, 1181, Abbey Church of Klosterneuburg
Millstatt Genesis, Austria, 1180–1220, Landesmuseum für Kärnten VI.19, fol. 11r
Passionary of Weissenau, Weissenau, Switzerland, 1200, Martin Bodmer Foundation, Cod. Bodmer 127, fol. 257r
Psalter, Tournai, Belgium, 1200, Morgan M.338, fol. 42r
Cross, Soest, Germany, 1200–1220, Santa Maria zur Höhe
Book of Hours, Bamberg, Germany, 1204–1219, Morgan M.739, fol. 9r
Facade relief, Schöngrabern, Austria, 1200–1249, Pfarre Maria Geburt
Psalter with calendar, Southwest Germany, 1235, BSB Clm. 11308, fol. 5r
Ceiling fresco, Hildesheim, Germany, 1225–1249, Church of St. Michael
Exterior relief, Münster, Germany, 1225–1264, Münster Cathedral
Stained glass, Marburg, Germany, 1245–1250, St. Elisabeth's Church, window 1, row 2

Germany, England, and the Low Countries after 1250

Ebstorf Map, Ebstorf, Germany, 1200–1299, destroyed
Psalter, southern Germany, 1250, Free Library of Philadelphia, Lewis E M 17:1, front
Augsburg Psalter, Augsburg, Germany, 1240–1260, Chester Beatty Library W.40, fol. 116r
Gospel Book, Seitenstetten, Austria, 1225–1275, Morgan M.808, fol. 196r
Grosbois Psalter-Hours, Liège, Belgium, 1261, Morgan M.440, fol. 16r
Hebrew Bible, Nördlingen, Germany, 1263, BSB Clm. 28169, fol. 5r
Fresco, Gurk, Austria, 1260–1270, Gurk Cathedral
Psalter, Upper Rhine, Germany, 1250–1300, Karlsruhe Lichtenthal 25, fol. 46r
Psalter, Freiburg, Germany (Diocese of Constance), 1250–1300, Stuttgart, SWB Cod. bibl. qt. 40, fol. 77v
Psalter-Hours, Liège, Belgium, 1275–1279, Huis Bergh 35 (225), fols. 1v–2r
Psalter-Hours, Liège, Belgium, 1280–1290, Morgan M.183, fol. 13r
Psalter, Utrecht, Netherlands, 1290, Morgan M.34, fol. 85r
Psalter, Munich, Germany, 1266–1299, BSB Clm. 8713, fol. 19v
Capital, Basel, Switzerland, 1185–1399, Basel Cathedral
Stained-glass window, Esslingen, Germany, 1300, Parish Church of St. Dionysius, Choir, window 1, row 2
Schocken Bible, Germany, 1300–1335, formerly Schocken Library 14840, fol. 1v
Stained glass, Alsace, 1340, Etienne Church, bay 102
Cross, Mecklenburg, Germany, 1300–1399, Doberan Church
Weltchronik, Regensburg, Germany, 1360, Morgan M.769, fol. 13r
Speculum humanae salvationis, Darmstadt, Germany, 1360–1370, Landesbibliothek 2505, fol. 8r
Speculum humanae salvationis, Southwest Germany or Alsace, 1350–1399, BL Harley 4996, fol. 4v

INVENTORY OF FALL OF MAN SCENES 99

Statue, Freiburg, Germany, 1350-1399, Freiburg Cathedral, northeast choir portal
Speculum humanae salvationis, Mainz, Germany, 1350-1399, BL Arundel 120, fols. 4v-5r
Fresco, Graubünden, Switzerland, 1350-1399, Church of St. George
Master of Rhäzüns, fresco, Grisons, Switzerland, 1350-1399
Bertram von Minden, altar, Hamburg, Germany, 1379-1383, Hamburg Kunsthalle Gallery
Speculum humanae salvationis, Germany or Switzerland, 1375-1399, BL Harley 3240, fols. 5r-5v
Weltchronik, Bavaria or Austria, 1375-1399, State Library of Upper Austria 472, fol. 17v
Historien Bibel, Germany, 1375-1400, Morgan M.268, fol. 2v
Speculum humanae salvationis, Nuremberg, Germany, 1380-1399, Morgan M.140, fol. 4v
Relief, Bremen, Germany, 1300-1499, Bremen Cathedral, choir stall
Master of the Berswordt Altar, altarpiece, Bielefeld, Germany, 1400, Neustädter Marienkirche
Dirc van Delft's *Duke Albrecht's Table of Christian Faith*, Utrecht, Netherlands, 1400-1404, Walters W.171, fol. 85v
Speculum humanae salvationis, Basel, Switzerland, 1410, BnF lat. 512, fol. 3v
Pol de Limbourg, *Très Riches Heures du duc de Berry*, Flanders, Belgium, 1411-1416, Musée Condé 65, fol. 25v
Giovanni da Udine's *Compilatio Historiarum*, Austria, 1420, Morgan M.192, fol. 1v
History Bible, Utrecht, Netherlands, 1430, KB 78 D 38 I, fol. 8v
Hans Acker, stained glass, Ulm, Germany, 1430, Besserer Chapel
Jan Van Eyck, Ghent Altarpiece, Ghent, Belgium, 1432
Bible, Vienna, Austria, 1435, Morgan M.230, fol. 5v
Book of Hours, Bruges, Belgium, 1425-1450, Lilly Library at Indiana University, Ricketts 117, fol. 19r
Hours of Catherine of Cleves, Utrecht, Netherlands, 1440, Morgan M.917/945, page 139
Bible History, Constance, Germany, 1445, NYPL MA 104, fol. 7r
Speculum humanae salvationis, Cologne, Germany, 1450, KB RMMW 10 B 34, fol. 2v
Speculum humanae salvationis, Germany, 1400-1500, KB RMMW 10 C 23, fol. 5v
Cover of Epistle Book, Cologne, Germany, 1400-1499, Kölner Domkirche 270
Egmont Breviary, Utrecht, Netherlands, 1400-1499, Morgan M.87, fol. 147r
Speculum humanae salvationis, Bruges, Belgium, 1440-1460, Morgan M.385, fol. 4v
Sarum Hours, Bruges, Belgium (?), 1436-1465, BL Harley 3000, fol. 92v
Bible, Zwolle, Netherlands, 1451, BL Royal 1 C V, fol. 4v
Miscellany, Augsburg, Germany, 1450-1460, Morgan M.782, fol. 8v
Book of Hours, Utrecht, Netherlands, 1455-1460, KB 135 E 40, fol. 32r
The Life of Christ, Germany, 1460, Fitzwilliam Museum 23, fol. 4v
Book of Hours, Bruges, Belgium, 1460, Rio de Janeiro, Biblioteca Nacional 50.1.001, fol. 57v

APPENDIX

Willem Vrelant, Hours use of Sarum, Bruges, Belgium, 1460–1463, Getty Ludwig IX 8 (83.ML.104), fol. 137r

Fortesque Hours, southern Netherlands (probably Bruges), 1460–1470

Illustrated Bartsch, Germany, 1473, vol. 80, fol. 15v

Hebrew Bible, Regensburg, Germany, 1465, BL Egerton 1895, fol. 6v

Speculum humanae salvationis, Flanders, Belgium, 1460–1470, Bodl Douce f. 4, fol. 5r

Southern German Old Testament, Regensburg, Germany, 1465, BL Egerton 1895, fol. 6v

Nicholas of Lyra's *Postilae Bibliae*, Bruges, Belgium, 1467, Morgan M.535, fol. 4v

Workshop of Diebold Lauber, Rudolf von Ems's *Joseph und Berlaam*, Hagenau, Alsace, 1469, Getty Ludwig XV 9 (83.MR.179), fol. 1v

Von synnrychen erluchten wyben, Ulm, Germany, 1474, NYPL Spencer 105, fol. 9v

Canterbury Hours, Belgium, 1475, Morgan M.254, fol. 114v

Giovanni da Udine's *Compilatio Historiarum*, Basel, Switzerland, 1476, Morgan M.158, fols. 1v and 24v

Stained-glass window, Tübingen, Germany, 1477, St. George Collegiate Church, window 2, row 7

Hugo van der Goes, painting, *The Fall of Man*, Brussels, Belgium, 1479, KhM

Book of Hours, Flanders, 1480, Amsterdam, Rijksmuseum KOG 29, fol. 121r

Hieronymus Bosch, painting, *The Last Judgment*, s-Hertogenbosch, Netherlands, 1482, Academy of Fine Arts, Vienna

Stained glass, Trier, Germany, 1466–1499, Church of St. Mary, Shrewsbury

Grimani Breviary, Bruges, Belgium, 1466–1499, Biblioteca nazionale marciana Lat. 1 99 = 2138, fol. 286v

Hans Memling, painting, *Altar of St. John*, Bruges, Belgium, 1485, KhM

Bernardinus Benali, *Supplementum chronicarum*, Zwettl, Austria, 1486, Codex Zwettlensis (Codex typicus I/129), fol. 15v

Bertold Furtmeyer, *Missal of Salzburg*, Regensburg, Germany, 1489, BSB Clm. 15710, fol. 60v

Tilman Riemenschneider, portal, Marienkapelle, Würzburg, Würzburg, Germany, 1491–1493, Museum für Franken

Hartmann Schedel, *Nuremberg Chronicle*, Germany, 1493, Cambridge University Library Inc.0.A.7.2[888], fol. 7v

Master of the Dark Eyes, prayerbook, Holland, Netherlands, 1490–1500, KB 135 E 19, fol. 31r

Albrecht Dürer, engraving, *Adam and Eve*, Nuremberg, Germany, 1504, MMA

Hans Wydyz, engraving, Freiburg im Breisgau, Germany, 1505, Historisches Museum Basel

Albrecht Dürer, painting, *Eve*, Nuremberg, Germany, 1507, Madrid, Museo del Prado

Gebetbuch des Claus Humbracht, Frankfurt, Germany, 1508, Goethe University, Frankfurt germ. oct 3, fol. 2v

Mabuse (Jan Gossaert), painting, *Adam and Eve*, produced during a visit to Italy, but artist based in Antwerp, Belgium, 1508, Thyssen-Bornemisza National Museum

INVENTORY OF FALL OF MAN SCENES 101

Hans Baldung, painting, *Eve*, Nuremberg, Germany, 1510, Hamburger Kunsthalle, Hamburg
Hans Baldung, painting, *Eve, the Serpent, and Death*, Germany, 1510, National Gallery of Canada
Prayerbook, Bruges, Belgium, 1500-1524, Princeton University, Garrett 63, fol. 8r
Albrecht Altdorfer, engraving, *Fall of Man*, Regensburg, Germany, 1513, Minneapolis Institute of Art
Hieronymus Bosch, painting, Haywain Triptych, s-Hertogenbosch, Netherlands, 1512-1515, Madrid, Museo del Prado
Ludwig Krug, relief, *Adam and Eve*, Nuremberg, Germany, 1514, SB
Meister IP, relief, *Adam and Eve*, Gotha, Germany, 1515, Schloss Friedenstein
Hans Holbein the Younger, painting, *Adam and Eve*, Basel, Switzerland, 1517, Kunstmuseum
Book of Hours, Bruges or Ghent, Belgium, 1500-1535, Bodl Douce 112, fol. 36r
Painting, *The Last Supper*, Antwerp, Belgium, 1515-1520, MMA
Meister HL, carving, *The Fall of Man*, Freiburg, Germany, 1520-1530, Augustiner Museum, Freiburg im Breisgau
Circle of Meister IP, relief, *The Fall of Man*, Passau, Germany, 1520-1530, Liebieghaus, Frankfurt am Main
Mabuse (Jan Gossaert), relief, *Adam and Eve*, Middleburg, Netherlands, 1525, Jagdschloss Grunewald, Berlin
Painting, *Adam and Eve*, Netherlands, 1500-1549, Gemäldegalerie Alte Meister, Dresden
Meister IP, relief, *Fall of Man*, Passau, Germany, 1520-1530, KhM
Lucas Cranach, painting, *Adam and Eve*, Wittenberg, Germany, 1526, Courtauld Institute of Art Gallery, London
Mabuse (Jan Gossaert), painting, *Adam and Eve*, Middleburg, Netherlands, 1527, SB
Statue, Vienna, Austria, 1530, Rijksmuseum, Amsterdam
Hans Baldung, painting, *Adam and Eve*, Strasbourg, France, 1531, Madrid, Museo Nacional Thyssen-Bornemisza
Workshop of Albrecht Altdorfer, painting, *The Fall of Man*, Regensburg, Germany, 1535, National Gallery of Art, Washington DC
Daniel Mauch, statue, *Adam and Eve*, Germany, 1535, Cleveland Museum of Art
Otto von Passau's *Die vierundzwanzig Alten*, Bavaria, Germany, 1540-1560, Princeton University, Garrett 134, fol. 3v
Medici Tapestries, *The Fall*, Flanders, Belgium, 1550, Accademia, Florence
Johann Brabender, statue, *The Fall of Man*, Germany, 1550, Münster, Museum für Kunst und Kultur
Missal, Flanders, Belgium, 1552, Morgan M.983, fol. 8r
Frans Floris, painting, *Adam and Eve*, Antwerp, Belgium, 1560, Ufizzi Gallery
Frans Floris, painting, *The Fall of Man*, Antwerp, Belgium, 1560, Malmö Art Museum
Philips Galle, engraving, *The Power of Women*, Haarlem, Netherlands, 1569

Cornelis van Haarlem, painting, *The Fall of Man*, Netherlands, 1592, Rijksmuseum, Amsterdam

Italy and Spain before 1250

Fresco, Matera, Italy, 800–899, Cripta del Peccato Originale
Capital, Alquezar, Spain, 800–899, Collegiate Church of Santa Maria Maggiore
Capital, Frómista, Spain, 800–899, Iglesia San Martin
León Bible of 960, León, Spain, 960, San Isidoro, fol. 15v
Bible of San Lorenzo, Rioja, Spain, 976, El Escorial Library, Codex Vigilano, fol. 17r
Facundus Beatus, León, Spain, 1047, Biblioteca Nacional Vitrina 14-2, fols. 10v and 63v–64r
Ripoll Bible, Ripoll, Spain, 1000–1099, BAV lat. 5729, fol. 5v
Roda Bible, Catalonia, 1000–1099, BnF lat. 6(1), fol. 6r
Ivory plaque, northern Spain, 1000–1099, Saint Petersburg, Hermitage Museum
Capital, Palencia, Spain, 1000–1099, Church of San Juan Bautista de Palencia
Reliquary of Saint Isidore, León, Spain, 1063, Real Colegiata de San Isidoro
Capital, Frómista, Spain, 1066, Church of Saint Martin
Monte Cassino Exultet Roll, Monte Cassino, Italy, 1075, BL Add. 30337, fol. 8r
Escorial Beatus, San Millán de la Cogolla, Spain, ca. 1000 or 950–955, Escorial, Biblioteca del Real Monasterio, Cod. & II.5, fol. 18r
Salerno ivories, Amalfi, Italy, 1084, San Matteo Diocese Museum, Salerno
Fresco, Venice, Italy, 1080–1099, Santa Maria Assunta
Capital, Loarre, Spain, 1080–1099, Church of Santa Maria
Ivory engraving, Amalfi, Italy, 1080–1120, SB
Bible, Umbria, Italy, 1100, Museo archeologico nazionale di Cividale del Friuli 1, fol. 6r
Silos Beatus, Santo Domingo de Silos, Spain, 1109, BL Add. 11695, fol. 40r
Fresco, Ceri, Italy, 1100–1120, Santa Maria Immacolata
Relief, Cremona, Italy, 1107–1117, Cremona Cathedral, west facade
Fresco, Maderuelo, Spain, 1123, Chapel of Vera Cruz, reproduced on canvas Museo del Prado
Giant Bible (Atlantic Bible), Todi, Italy, 1125, BAV lat. 10405, fol. 4v
Mosaic, Novara, Italy, 1125, Novara Cathedral, presbytery
Pantheon Bible, Umbria, Italy, 1125–1130, BAV lat. 12958, fol. 4v
Noccolò da Ficarolo and Guglielmus, relief, Verona, Italy, 1120–1138, San Zeno Maggiore, exterior facade
Bible of Santa Maria del Fiore, Tuscany, Italy, 1125–1149, Biblioteca medica laurenziana, Edili 125–126; I, fol. 5v
Wiligelmo, relief, Modena, Italy, 1100–1199, Duomo di Modena, Santa Maria Assunta, frieze
Mosaic, Palermo, Italy, 1140–1160, Palatine Chapel, nave
Fresco, Barcelona, Spain, 1100–1199, Museo Episcopal de Vic

Relief, Burgos, Spain, 1100–1199, Church of San Julián y Santa Basilisa de Rebolledo de la Torre
Capital, Asturias, Spain, 1100–1199, Church of San Nicolás de Bari
Capital, Lleida, Spain, 1150–1160, Santa Maria de Covet
Mosaic, Pantaleone, Otranto, Italy, 1163–1165, Cathedral of Otranto, presbytery floor
Burgos Bible, Burgos, Spain, 1150–1199, Burgos, Bibliotheca Provencial 846, fol. 12v
Capital, Barcelona, Spain, 1150–1199, Church of Santa Maria
Capital, Gerona, Spain, 1150–1199, Cathedral of Santa Maria
Fresco, Segovia, Spain, 1166–1199, Iglesia de San Justo y Pastor
Capital, Palencia, Spain, 1166–1199, Church of El Salvador de Pozancos
Capital, Cantabria, Spain, 1166–1199, Church of Santa María de Bareyo
Capital, northern Catalonia, 1166–1199, Cluny Museum of Medieval Art, Paris
Facade relief, Navarra, Spain, 1150–1220, Santa Maria la Real
Bonnanus of Pisa, bronze door, Pisa, Italy, 1186, Monreale Cathedral
Bonnanus of Pisa, bronze door, Pisa, Italy, 1186, San Ranieri Cathedral
Capital, Monreale, Italy, 1175–1200, Monreale Cathedral
Relief, Lodi, Italy, 1175–1199, Lodi Cathedral
Altar side table, Sagàs, Spain, 1175–1199, originally from the Church of Sant Andreu, Sagàs, now in the Solsona Museum
Sculpture, Lucca, Italy, 1180–1199, Cathedral of San Martino
Fresco, Rome, Italy, 1180–1199, San Giovanni a Porta Latina
Capital, Fornovo di Taro, Italy, 1200, Santa Maria Assunta
Wall mosaic, Monreale, Italy, 1100–1299, Cathedral of the Assumption
Capital, Palencia, Castile and León, Spain, 1175–1225, Hermitage of Santa Eulalia in the Barrio de Santa María of Aguilar de Campoo
Bible of San Millan de la Cogolla, San Millan de la Cogolla, Spain, 1200–1220, Madrid Real Academia de la Historia 2–3, vol. I, fol. 12v
Las Huelgas Beatus, Toledo (?), Spain, 1220, Morgan M.429, fols. 6v and 31v–32r
Cupola mosaic, Venice, Italy, 1200–1299, St. Mark's Cathedral
Capital, Palencia, Spain, 1166–1335, Ermita Santa Eulalia
Capital, Burgos, Spain, 1166–1335, Church of San Lorenzo de Vallejo de Mena
Capital, Asturias, Spain, 1200–1299, Church of San Juan de Amandi
Capital, Asturias, Spain, 1200–1299, Church of Santa María Magdalena de los Corros

Italy and Spain after 1250

Latin Bible, Naples or Genoa, Italy, 1260–1280, Free Library of Philadelphia, Lewis E 037, fols. 3v–4r
Relief, Perugia, Italy, 1277–1278, Fontana Maggiore
Cantigas de Santa Maria, Castille, Spain, 1280, Escorial Cod. T.I.1, fol. 88v
Relief, Arnolfo, Rome, Italy, 1285, San Paolo fuori le mura
Mosaic, Florence, Italy, 1250–1299, Baptistery of San Giovanni

Guido of Siena, *Treatise of the World's Creation*, Siena, Italy, 1275–1299, Biblioteca Comunale degli Intronati H.VI.31[3], fol. 92r.
Fresco, Torri di Sabina, Italy, 1250–1299, Santa Maria in Vescovio
Cantigas de Santa Maria, Toledo, Spain, 1290–1293, Florence, Biblioteca nazionale di Firenze B. R. 20, fol. 51r (two illustrations)
Bible, Padua, Italy, 1287–1300, Morgan M.436, fol. 4r
Cross of Constantine, Rome, Italy, 1300, San Giovanni in Laterano
Pacino di Bonaguida, panel, Florence, Italy, 1305–1310, Galleria dell'Accademia
Lorenzo Maitani, relief, Orvieto, Italy, 1310–1315, Duomo di Orvieto
Painting, Urriés, Spain, 1310–1330, Museo Diocesano de Jaca Huesca
Chronologia magna, Naples, Italy, 1328, BnF lat. 4939, fol. 8r
Speculum humanae salvationis, Bologna, Italy, 1320–1340, Biblioteca del Cabildo 10.8, fol. 4v
Ambrogio Lorenzetti, fresco, Siena, Italy, 1334, Chapel of San Galgano, Montesiepi
Anjou Bible (Andreas von Ungarn/Alife/Leuven Bible), Naples, Italy, 1340, Leuven University, Faculty of Theology Library 1, fol. 6r
Hamilton Bible, Naples, Italy, 1342–1345, Berlin, Kupferstichkabinett 78 E 3, fol. 4r
Histoire universelle, Genoa, Italy, 1300–1399, BnF fr. 9685, fol. 3r
Relief, Trento, Italy, 1300–1399, Crucifix Chapel, Cathedral San Vigilio
Painting, *Thirty Biblical Stories*, Verona, Italy, 1340–1360, Museo Civico di Castelvecchio
Nicolaus de Lyra's *Postilla litteralis in Genesim*, Mantua, Italy, 1300–1399, BnF lat. 364, fol. 5v
Turin Bible/Orsini Bible, Naples, Italy, 1300–1399, Biblioteca Reale, Turin varii 175, fol. 4r
Bible, Naples, Italy, 1300–1399, ON Codex Vindobonensis Palatinus 1191, fol. 4r
Bible moralisée, Naples, Italy, 1350, BnF fr. 9561, fol. 8v
Wall fresco, Emilia-Romagna, Italy, 1351, Pomposa Monastery
Robert von Tarent Bible, Naples, Italy, 1336–1365, Vat. lat. 14430A, fol. 14r
Planisio Bible, Naples, Italy, 1362, BAV lat. 3550/1, fol. 5v
Speculum humanae salvationis, Bologna, Italy, 1350–1399, Bibliothèque de l'Arsenal, Arsenal 593, fol. 4r
The Golden Haggadah, Barcelona, Spain (?), 1350–1374, BL Add. 27210, fol. 2v
Giusto de' Menabuoi, Fresco, Padua, Italy, 1375–1378, Baptistery of St. John
Book of Hours and Missal, Lombardy, Italy, 1380, BnF Smith-Lesouëf 22, fol. 89r
Breviari d'Amor, Gerona, Spain (?), 1375–1399, BL Yates Thompson 31, fol. 88r
Piero di Puccio, fresco, *Adam and Eve Cycle*, Pisa, Italy, 1389–1391, Camposanto Monumentale
Old Testament, Florence (?), Italy, 1396, Cambridge University Library, Add. 6685, fol. 2v
Statue, Venice, Italy, 1404, Doge's Palace
Fresco, Naturno, Italy, 1400–1420, Church of Saint Proclus
Fresco, Cori, Italy, 1411, Santissima Annunziata Church

INVENTORY OF FALL OF MAN SCENES

Ramón de Mur, Retable of Santa Maria de Guimeà, Tàrrega (?), Spain, 1410–1419, Museo Episcopal de Vic

Masolino da Panicale, fresco, Florence, Italy, 1427, Santa Maria del Carmine, Brancacci Chapel

Jacopo della Quercia, relief, Bologna, Italy, 1425–1428, Porta Magna of the Basilica of San Petronio

Michele di Matteo Lambertini, painting, *The Dream of the Virgin*, Bologna, Italy, 1435, Civic Museum, Pesaro

Lorenzo Ghiberti, gilded bronze tile, *Gates of Paradise*, Florence, Italy, 1425–1452, Baptistery of San Giovanni

Speculum humanae salvationis, Roussillon, Spain, 1430–1450, Bodl Douce 204, fol. 2r

Giovanni di Paolo, Siena, Italy, 1450, BL Yates Thompson 36, fol. 141r

Maso Finiguerra, drawing, *The Story of Adam and Eve*, Florence, Italy, 1450, Städel Museum, Frankfurt

Speculum animae, Valencia, Spain, 1400–1499, BnF esp. 544, fol. 4v

Hebrew Bible, Cremona, Italy, 1436–1465, BnF ital. 109, fol. 3r

Stained-glass window, Pisa, Italy, 1453–1454, Pisa Duomo, North XII Window

Circle of Baccio Baldini or of Maso Finiguerra, drawing, Florentine Picture Chronicle, Florence, Italy, 1470–1475, British Museum (1889,0527.1)

Illuminated antiphonary, Ferrara, Italy, 1475, Free Library of Philadelphia, Lewis E M 70:4

Compendium of rabbinic legal treatises, Ferrara (?), Italy, 1475, BL Harley 5717, fol. 5v

Mariano del Buono di Jacopo, *Piccolomini Breviary*, Lombardy, Italy, 1475, Morgan M.799, fol. 7v

Mino da Fiesole, relief, Rome, Italy, 1475–1478, Sacre grotte Vaticane, Vatican City

Prayerbook of Lorenzo de'Medici, Florence, Italy, 1485, BSB Clm. 23639, fol. 91v

Maestro de Salomón de Fromista, retable, Frómista, Spain, 1485, Museo de la Iglesia de San Pedro

Andrea Mantegna, painting, *Virgin of Victory*, Mantua, Italy, 1496, Louvre, Paris

Mirandola Book of Hours, Mantua or Ferrara, Italy, 1496 to 1499, BL Add. 50002, fol. 13r

Stone cross, Cruz de Humilladero, Spain, 1500, Ermita de San Isidro

Matteo del Nassaro, slate panel, Verona, Italy, 1501, Walters

Michelangelo, fresco, *Fall of Man*, Rome, Italy, 1508–1512, Sistine Chapel

Mariotto Albertinelli, painting, *Creation and Fall of Man*, Florence, Italy, 1509–1513, Courtauld Institute of Art, London

Giovanni della Robbia, glazed terracotta, *Fall of Man*, Florence, Italy, 1515, Walters

Raphael, fresco, *Fall of Man*, Rome, Italy, 1519, Loggia di Raffaello

Altarpiece, Oñati, Spain, 1533, Monasterio de Bidaurreta

Damian Forment, retable, La Rioja, Spain, 1537–1540, Catedral de Santo Domingo de la Calzada

Giulio Clovio, *Farnese Book of Hours*, Rome, Italy, 1546, Morgan M.69, fol. 27r

Raphael, fresco, *Fall of Man*, Rome Italy, 1509–1520, Stanze di Raffaello, Vatican
Jacopo Tintoretto, painting, *The Temptation of Adam*, Venice, Italy, 1550, Galleria dell'Accademia
Francesco Salviatii/de' Rossi, painting, *Original Sin*, Rome or Florence, Italy, 1550
Francesco Mosca, altarpiece statue, Pisa, Italy, 1563, Cathedral of Pisa
Titian, painting, *Adam and Eve*, Venice, Italy, 1570, Museo del Prado
Domenichino, *The Rebuke of Adam and Eve*, Rome, Italy, 1626, National Gallery of Art, Washington, DC

Abbreviations

AA: Arte e archeologia: Studi e documenti
AB: Aramaic Bible
ABMA: Auctores Britannici Medii Aevi
ACW: Ancient Christian Writers
AH: Analecta Hymnica Medii Aevi
AIL: Ancient Israel and Its Literature
ANF: Ante-Nicene Fathers
ANTS: Anglo-Norman Text Society
AO: Anecdota oxoniensia, Mediaeval and Modern Series
BCCT: Brill's Companions to the Christian Tradition
BLVS: Bibliothek des literarischen Vereins in Stuttgart
BSIH: Brill Studies in Intellectual History
BzOO: Byzanz zwischen Orient und Okzident
BZRP: Beihefte zur Zeitschrift für romanische Philologie
CCCM: Corpus Christianorum Continuatio Mediaevalis
CCSA: Corpus Christianorum, Series Apocryphorum
CCSG: Corpus Christianorum, Series Graeca
CCSL: Corpus Christianorum, Series Latina
CCT: Corpus Christianorum in Translation
CEJL: Commentaries on Early Jewish Literature
CF: Cistercian Fathers
CIM: Corpus of Illuminated Manuscripts
CL: Collection littéraire
CLO: Cahiers du Léopard d'or
CO: Collectio Oliviana
CPB: Corpus Biblicum Catalanicum
CPH: Catálogo de la predicación hispana
CS: Cistercian Studies
CSASE: Cambridge Studies in Anglo-Saxon England
CSEL: Corpus Scriptorum Ecclesiasticorum Latinorum

CSHA: California Studies in the History of Art
CSMLT: Cambridge Studies in Medieval Life and Thought
CUFSL: Collections des universités de France, Série latine
CWS: Classics of Western Spirituality
DB: Denkmäler der Buchkunst
DLW: Die deutschen und lateinischen Werke
DMH: Documents of Medieval History
DPLSM: De Proprietatibus Literarum, Series Maior
DTM: Deutsche Texte des Mittelalters
ECF: Early Church Fathers
EETS: Early English Text Society
EJL: Early Judaism and Its Literature
EMETS: Exeter Medieval English Texts and Studies
ES: Europa Sacra
FC: Fathers of the Church
FETS: French of England Translation Series
FT: Faux titre
GAG: Göppinger Arbeiten zur Germanistik
GAP: Guides to Apocrypha and Pseudepigrapha
GLMF: Germania Litteraria Mediaevalis Francigena
HA: Handbuch der Archäologie
HBR: Handbooks of the Bible and Its Reception
HMSAH: Studies in Medieval and Early Renaissance Art History
IMS: Illinois Medieval Studies
IR: Introduction to Religion
JACE: Jahrbuch für Antike und Christentum Ergänzungsband
JCI: Judentum Christentum und Islam
JTT: Judaica Texts and Translations
KS: Kernos supplément
LCL: Loeb Classical Library
LEC: Library of Early Christianity
LLMA: Lexica Latina Medii Aevi
LSLM: Lateinische Sprache und Literatur des Mittelalters
LWW: Library of the Written Word
MA: Moyen Âge
MAAP: Medieval Academy of America Publications
MAS: Middle Ages Series
MATM: Moyen Âge et temps modernes
MEL: Manuels et études linguistiques
METS: Middle English Text Series
MGH: Monumenta Germaniae Historica
MM: Millenio medievale
MRTS: Medieval and Renaissance Texts and Studies
MSNPH: Mémoires de la Sociéte néo-philologique à Helsingfors
MSR: Mélanges de science religieuse
MST: Mediaeval Sources in Translation

ABBREVIATIONS

MTU: Münchener Texte und Untersuchungen zur deutschen Literatur des Mittelalters
MUSC: Monografías de la Universidád de Santiago de Compostela
NBMA: Nouvelle bibliothèque du Moyen Âge
NCSRLL: North Carolina Studies in the Romance Languages and Literatures
NIBD: New International Bible Dictionary
NICOT: New International Commentary on the Old Testament
NIDB: New Interpreter's Dictionary of the Bible
OECT: Oxford Early Christian Texts
OHA: Oxford History of Art
OIP: University of Chicago Oriental Institute Publications
OSACR: Oxford Studies in Ancient Culture and Representation
OSP: Oxford Science Publications
OTL: Old Testament Library
OWDÜ: Origenes Werke mit deutscher Übersetzung
PBC: Patristic Bible Commentary
PG: Patrologia Graeca
PL: Patrologia Latina
PMS: Publications in Mediaeval Studies
PRF: Publications romanes et françaises
PRUL: Publications romans de l'Université de Leyde
PTS: Peregrina Translations Series
PV: Per Verba: Testi mediolatini con traduzione
PVTG: Pseudepigrapha Veteris Testamenti Graece
RMCS: Routledge Monographs in Classical Studies
RSMRC: Routledge Studies in Medieval Religion and Culture
RTTBS: Reformation Texts with Translation, Biblical Studies
SBLDS: Society of Biblical Literature Dissertation Series
SBLTCS: Society of Biblical Literature Text Critical Studies
SC: Sources chrétiennes
SGLG: Studia Graeca et Latina Gothoburgensia
SHCT: Studies in the History of Christian Traditions
SMC: Studies in Medieval Culture
SMI: Studies in Manuscript Illumination
SMMI: Studies in Medieval Manuscript Illumination
SpF: Spicilegium Friburgense
SS: Saecula Spiritualia
TAT: Thomas Aquinas in Translation
TBN: Themes in Biblical Narrative
TECC: Textos y estudios Cardenal Cisneros
TECCat: Textos i estudis de cultura catalan
TEG: Traditio Exegetica Graeca
TMLT: Toronto Medieval Latin Texts
TOE: Toronto Old English
TSAJ: Texts and Studies in Ancient Judaism
TSMAO: Typologie des sources du Moyen Âge occidental
TT: Temi e testi

TTH: Translated Texts for Historians
TUGAL: Texte und Untersuchungen zur Geschichte der altchristlichen Literatur
TuT: Texte und Textgeschichte
USML: Utrecht Studies in Medieval Literacy
VKAWA: Verhandelingen der Koninklijke Akademie van Wetenschappen te Amsterdam
VL: Vetus Latina
WGRW: Writings from the Greco-Roman World
WKF: Wiener kunstgeschichtliche Forschungen
WSATTC: Works of Saint Augustine: A Translation for the 21st Century
YJS: Yale Judaica Series
YMT: York Mediaeval Texts

Notes

Introduction

1. See Daniel Zohary, Maria Hopf, and Ehud Weiss, *Domestication of Plants in the Old World: The Origin and Spread of Domesticated Plants in Southwest Asia, Europe, and the Mediterranean Basin* (OSP; Oxford: Clarendon Press, 2012). According to these scholars, "the earliest reliable description of grafting in the Mediterranean basin was given by Theophrastus . . . who lived in Greece in the fourth century BC" (115). For a helpful survey of the apple's origins, cultivation, and cultural history, see Barrie E. Juniper and David J. Mabberley, *The Story of the Apple* (Portland, OR: Timber Press, 2006). On the botanical identity of the *tapuaḥ*, usually rendered "apple," see below, chapter 1.

2. I have not quoted Latin sources that are readily available to scholars, e.g., through Patrologia Latina.

3. The linguistic landscape of medieval and early modern Europe is exceedingly complex. Terms like "Old French" serve as an umbrella designation for a number of dialects and regional variants. I do not enter a detailed discussion of these matters except when they bear directly on my argument.

Chapter One

1. Bible passages are quoted from the New Revised Standard Version, except where otherwise noted.

2. The Masoretic Text of Genesis 3:6: ותרא האשה כי טוב העץ למאכל וכי תאוה הוא לעינים ונחמד העץ להשכיל ותקח מפריו ותאכל ותתן גם לאישה עמה ויאכל. Karl Elliger and Wilhelm Rudolph, eds., *Biblia Hebraica Stuttgartensia* (Stuttgart: Deutsche Bibelgesellschaft, 1998). For a discussion of the textual variants, see Ronald S. Hendel, *Text of Genesis 1–11: Textual Studies and Critical Edition* (Oxford: Oxford University Press, 1998), 44–45; and the proposed reading at 124–25.

3. The Septuagint, the first translation of the Bible, was produced by the Jewish community of Alexandria, Egypt, starting in the middle of the third century BCE. See Robert Hanhart, ed., *Septuaginta* (Stuttgart: Deutsche Bibelgesellschaft, 2006), which at Genesis 3:6 reads, καὶ εἶδεν ἡ γυνὴ ὅτι καλὸν τὸ ξύλον εἰς βρῶσιν καὶ ὅτι ἀρεστὸν τοῖς ὀφθαλμοῖς ἰδεῖν καὶ ὡραῖόν ἐστιν τοῦ κατανοῆσαι, καὶ λαβοῦσα τοῦ καρποῦ αὐτοῦ ἔφαγεν· καὶ ἔδωκεν καὶ τῷ ἀνδρὶ αὐτῆς μετ' αὐτῆς, καὶ ἔφαγον.

4. The two translations are the Vetus Latina and Jerome's Vulgate, the latter becoming the standard Bible of Latin Christendom. The Vetus Latina is preserved in two recensions—North African and European. At Genesis 3:6, the former reads, *Et vidit mulier quia bonum est lignum in escam et quia bonum est oculis ad videndum et cognoscendum et sumpsit fructum de ligno illo et manducavit*; and the latter, *Et vidit mulier quia bonum est lignum ad manducandum et quia gratum oculis ad videndum et speciosum est ad intuendum et accipiens de fructu eius manducavit*. Both recensions appear in Bonifatius Fischer, ed., *Genesis* (VL 2; Freiburg: Herder Press, 1951), 60–61. The Vulgate translates Genesis 3:6: *Vidit igitur mulier quod bonum esset lignum ad vescendum et pulchrum oculis aspectuque delectabile et tulit de fructu illius et comedit deditque viro suo qui comedit*. Robert Weber and Roger Gryson, eds., *Biblia Sacra Vulgata* (Stuttgart: Deutsche Bibelgesellschaft, 2007).

5. This translation was probably composed in the second or third century CE, but was edited and reworked in the centuries that followed. See Moses Aberbach and Bernard Grossfed, *Targum Onkelos to Genesis: A Critical Analysis Together with an English Translation of the Text* (New York: Ktav, 1982), 34–35: וחזת אתתא ארי טב אילנא למיכל וארי אסו הוא לעינין ומרגג אילנא לאסתכלא ביה ונסיבת מאביה ואכלת ויהבת אף לבעלה אמה ואכל.

6. The starting point of the survey that follows is Louis Ginzberg, *Legends of the Jews*, trans. Henrietta Szold (Philadelphia: Jewish Publication Society, 1909-38), 5:97n70. There is also a helpful if dated survey of nineteenth- and twentieth-century commentaries on the Fall of Man in Hans-Günter Leder, "*Arbor Scientiae*: Die Tradition vom paradiesischen Apfelbaum," *Zeitschrift für die Neutestamentliche Wissenschaft* 52 (1961): 156–89.

7. An accessible survey of this work can be found in George W. E. Nickelsburg, *1 Enoch 1: A Commentary on the Book of 1 Enoch, Chapters 1–36; 81–108* (Hermeneia; Minneapolis: Fortress Press, 2001), 1–70.

8. Nickelsburg, *1 Enoch*, 320. For an overview of the Tree of Knowledge in relation to other parts of the Book of Enoch and to other works found among the Dead Sea Scrolls, see Eibert J. C. Tigchelaar, "Eden and Paradise: The Garden Motif in Some Early Jewish Texts (1 Enoch and Other Texts Found at Qumran)," in Gerard P. Luttikhuizen, ed., *Paradise Interpreted: Representations of Biblical Paradise in Judaism and Christianity* (TBN 2; Leiden: Brill, 1999), 37–62.

9. For an overview of this work, see Alexander Kulik, *3 Baruch: Greek-Slavonic Apocalypse of Baruch* (CEJL; Berlin: De Gruyter, 2010), 11–33.

10. Kulik, *3 Baruch*, 187. In the Greek recension, the angel planting the vine is named Sammael.

11. On the date of the *Apocalypse of Abraham*, see R. Rubinkiewicz, trans., "The Apocalypse of Abraham," revised and annotated by H. G. Lunt, in James Charlesworth, ed., *The Old Testament Pseudepigrapha* (Garden City, NY: Doubleday, 1982-85), 1:683.

12. Alexander Kulik, *Retroverting Slavonic Pseudepigrapha: Toward the Original of the Apocalypse of Abraham* (SBLTCS 3; Brill: Leiden, 2005), 27.

13. Kulik, *3 Baruch*, 188.

14. Reuven Hammer, *Sifre: A Tannaitic Commentary on the Book of Deuteronomy* (YJS 24; New Haven, CT: Yale University Press, 1986), 336.

15. See Jacob Israelstam and Judah Slotki, trans., *Leviticus Rabbah* (London: Soncino, 1939), 4. Parallels are found in Numbers Rabbah 10.8 and Esther Rabbah 5.1.

16. Babylonian Talmud, Sanhedrin 70a-b.

17. Origen, *Selecta in Genesim* (PG 12.109), and see Karin Metzler, ed., *Origene: Die Kommentierung des Buches Genesis* (OWDÜ 1/1: Berlin: De Gruyter), 218, fragment E23. The Greek

has τοιοῦτος ἦν ὁ καρπὸς τοῦ ξύλου τοῦ γνωστοῦ καλοῦ καὶ πονηροῦ. The connection between the forbidden fruit and Noah's vine appears in later sources as well, including chapter 23 of *Pirkê de Rabbi Eliezer*, trans. Gerald Friedlander (New York: Bloch, 1916), 170.

18. Epiphanius of Salamis, *Panarion*, 3.45.1.5–8, in Philip R. Amidon, trans., *The Panarion of St. Epiphanius, Bishop of Salamis: Selected Passages* (New York: Oxford University Press, 1990), 164.

19. See Andrew of St. Victor, *Exposition on Genesis*, ed. Charles Lohr and Rainer Berndt (CCCM 53; Turnhout: Brepols, 1986), 36. The verse is 31:28 in the Masoretic text.

20. See Florentina Badalanova Geller, "*The Sea of Tiberias*: Between Apocryphal Literature and Oral Tradition," in *The Old Testament Apocrypha in the Slavonic Tradition: Continuity and Diversity*, ed. Lorenzo DiTommaso and Christfried Böttrich (TSAJ 140; Tübingen: Mohr Siebeck, 2011), 13–158, esp. 88–95. The works in question are the late tenth-century Bulgarian *Legend of the Holy Rood by Jeremiah the Priest*; a thirteenth-century Serbian recension of 3 Baruch; and an eighteenth-century version of the Slavonic apocryphal work *Sea of Tiberias*. Elsewhere, Geller has discussed the diversity of Slavic forbidden fruits. "As in the canonical biblical text, in Slavic folklore and apocryphal tradition this tree is usually unidentified. Still, some narratives indicate that it was a fig-tree, a grape-vine, or an apple tree." Geller, "South Slavic," in Eric Ziolkowski, ed., *The Bible in Folklore Worldwide* (HBR 1.1; Berlin: De Gruyter, 2017), 277. Geller's survey is focused on folklore traditions whose precise historical permutations are difficult to recover. See also the sources cited in Vatroslav Jagić, "Slavische Beiträge zu biblischen Apocryphen I: Die altkirchenslavischen Texte des Adambuches," In *Denkschriften der Kaiserlichen Akademie der Wissenschafter, Philosophisch-historische Classe*, vol. 42 (Vienna: F. Tempsky, 1893), 59.

21. As Brian Murdoch writes, "There is of course no such thing 'the apocryphal life of Adam and Eve'. What we have is a ramified tradition of Adamic apocryphal writings that has only recently been analyzed in detail." Brian Murdoch, *Adam's Grace: Fall and Redemption in Medieval Literature* (Cambridge: D.S. Brewer, 2000), 24.

22. For discussions of the *Life of Adam and Eve* as well as the broader set of writings that pertain to the fate of Adam and Eve after the expulsion, see Brian Murdoch and J. A. Tasioulas, *The Apocryphal Lives of Adam and Eve* (EMETS; Exeter: University of Exeter Press, 2002), 1–34; Marinus de Jonge and Johannes Tromp, *The Life of Adam and Eve and Related Literature* (GAP; Sheffield: Academic Press, 1997); and Michael Stone, *A History of the Literature of Adam and Eve* (EJL 3; Atlanta: Scholars Press, 1992).

23. M. D. Johnson, trans., *Life of Adam and Eve*, in James H. Charlesworth, ed., *The Old Testament Pseudepigrapha* (Garden City, NY: Doubleday, 1982–85), 2:279–81; emphasis added.

24. Johannes Tromp, *The Life of Adam and Eve in Greek: A Critical Edition* (PVTG 6; Leiden: Brill, 2005), 96.

25. Jan Dochhorn, *Die Apokalypse des Mose: Text, Übersetzung, Kommentar* (TSAJ 106; Tübingen: Mohr Siebeck, 2005), 351.

26. I favor Tromp's position on literary grounds. Eve's search for leaves to cover herself and the uniqueness of the fig, which alone among the trees of the Garden did not shed their leaves, suggest Adam and Eve did *not* make their aprons from fig leaves because they happened to be standing by a fig tree when they sinned. The overall force of the passage, then, implies that the fig was not the forbidden fruit.

27. S. E. Robinson, trans., *Testament of Adam*, in James H. Charlesworth, ed., *The Old Testament Pseudepigrapha* (Garden City, NY: Doubleday, 1982–85), 1:989–95.

28. Robinson, 994, note c. There are only two manuscript witnesses to this recension of the *Testament of Adam*, both composed in the early eighteenth century, so it is difficult to establish

the date of the "fig" insertion. See the discussion of the manuscripts in Stephen Edward Robinson, *The Testament of Adam: An Examination of the Syriac and Greek Traditions* (SBLDS 52; Chico, CA: Scholars Press, 1982), 45–51.

29. The passage appears in the Patrologia Graeca edition of Theodoret's *Questions on Genesis*, 2.28 (PG 80.125). However, neither the edition of Natalio Fernández Marcos and Angel Sáenz-Badillos, *Theodoreti Cyrenesis Quaestiones in Octateuchum* (TECC 17; Madrid: Consejo Superior de Investigaciones Cientificas, 1979) nor that of John Petruccione and Robert Hill, *The Questions on the Octateuch*, vol. 1, *On Genesis and Exodus* (LEC 1; Washington, DC: Catholic University of America Press, 2008) include it. I have been unable to locate the gloss in Françoise Petit, *Catenae Graecae in Genesim et in Exodum* (CCSG 15: Turnhout, Brepols 1986) or in her *La chaîne sur la Genèse: Édition intégrale, chapitres 1 à 3* (TEG 1; Louvain: Peeters, 1991). My thanks to John Petruccione for discussing this matter with me.

30. Methodius 10.5, *The Symposium: A Treatise on Chastity*, trans. Herbert Musurillo (ACW 27; London: Longmans, Green, 1958), 146. There follows an extended discussion of the duality of figs and vines, some being righteous, others deceitful.

31. Gregory of Nyssa, preface to the *Homilies on the Song of Songs*, trans. Richard A. Norris Jr. (WGRW 13; Atlanta: Society of Biblical Literature, 2012), 9. Philo of Alexandria precedes Gregory in rejecting the notion that Genesis refers to an identifiable tree, arguing that the entire Fall of Man narrative is an allegory: "To imagine that [God] planted vines and olive and apple and pomegranate trees or the like, would be serious folly." Philo, *On Noah's Work as a Planter*, 7.32, in *Philo*, trans. F. H. Colson and G. H. Whitaker (LCL 247; Cambridge, MA: Harvard University Press, 1988), 3:229.

32. I have not included Tertullian in my survey of the fig tradition. A number of scholars do so, citing *Against Marcion* 2.2 as evidence. However, this claim is based on a mistranslation popularized by the Ante-Nicene Fathers series. The Latin text reads, *nisi quod Adam nunquam figulo suo dixit*, which Peter Holmes, the Ante-Nicene Fathers translator, renders: "Except that Adam never said to his fig-tree . . ." (ANF 3.298). However, *figulo* derives from the verb *fingere*, "to shape, form," and means "potter" or "maker." See Ernest Evans's translation of this verse: "Even so, Adam never said to his Maker . . ." Tertullian, *Adversus Marcionem*, trans. Ernest Evans (OECT; Oxford: Clarendon Press, 1972), 91.

33. I have omitted a long parable involving the fig's willingness to clothe Adam and Eve.

34. Genesis Rabbah 15.7, Julius Theodor and Chanoch Albeck, *Midrasch Bereshit Rabba* (Jerusalem: Wahrmann, 1965), 1:139–41; English translation, H. Freedman, *Genesis Rabbah* (London: Soncino, 1939), 2:121–23. There are several parallels in later rabbinic sources, on which see Theodor and Albeck, 139.

35. Rather than a verse, the passage has a folk dictum linking knowledge and bread. Louis Ginzberg explains wheat as resulting from the phonetic similarity between the Hebrew words for "wheat" (*ḥiṭa*) and "sin" (*ḥeṭ*) (Ginzberg, *Legends of the Jews*, 5:97n70). I believe wheat is included because of the rabbinic principle of "measure for measure" (*middah ke-negged middah*), which holds that God metes out punishment corresponding to the crime. Since Adam's punishment is that "by the sweat of your face you shall eat bread" (Gen 3:19), the rabbis concluded that the transgression must have involved bread.

36. A similar list appears in the scholia of the thirteenth-century Syriac Orthodox scholar Bar Hebraeus: "Of those who understood [the Tree of Knowledge] physically, some said wheat was its fruit, since in the bread our Lord gave his body; and some of them (said) the grape, since in the blood (of the grape) he gave his blood; and some of them (said) flesh, since the skin of

the beasts which they killed they put on; and some of them (said) the fig, since they covered themselves with its foliage when they were ashamed of their nakedness." Martin Sprengling and William Creighton Graham, eds., *Barhebraeus' Scholia on the Old Testament: Genesis–II Samuel* (OIP 13; Chicago: University of Chicago Press, 1931), 21.

37. Hans-Gebhard Bethge, Bentley Layton, and the Societas Coptica Hierosolymitana, trans., "On the Origin of the World (II, 5 and XIII, 2)," in *The Nag Hammadi Library in English*, ed. James M. Robinson (San Francisco: HarperCollins, 1979), 170–89. The passage is discussed briefly in Alyssa Ovadis, "Abstraction and Concretization of the Fruit of the Tree of Knowledge of Good and Evil as Seen through Biblical Interpretation and Art" (master's thesis, McGill University, 2010), 55–56.

38. "Those who drink" and "a fig tree and a pomegranate tree" are from Bethge et al., "On the Origin of the World," §109, 178; "the tree of eternal life" and "leaves are like those of a cypress" and "leaves are like fig leaves" from §110, 179.

39. Max Grünbaum, *Neue Beiträge zur semitischen Sagenkunde* (Leiden: Brill, 1893), 64–65. The commentator rejects all on the grounds that Adam and Eve were spiritual beings in the Garden of Eden and did not consume physical fruit.

40. E. A. Wallis Budge, *Coptic Apocrypha in the Dialect of Upper Egypt* (London: Longmans, 1913), 249. The manuscript (British Museum Oriental 7026) has Greek and Coptic colophons. According to the former, the copy was completed in 1006, according to the latter in 1017, and see Budge's discussion at xxxii–xxxiii. My thanks to David Brakke (pers. comm.), who confirms that the Coptic word in question is normally translated "apple."

41. My thanks to Tzvi Novick, who brought this source to my attention.

42. Cyril of Scythopolis, *The Lives of the Monks of Palestine*, trans. R. M. Price (CS 114; Kalamazoo, MI: Cistercian Publications, 1991), 96. For the Greek text, see E. Schwartz, ed., *Kyrillos von Skythopolis* (TUGAL IV 49.2; Leipzig: J. C. Hinrichs, 1939), 88.

43. Cyril, *Lives of the Monks*, 96–97.

44. As we will see below, similar passages occur in Avitus of Vienne and Bernard of Clairvaux.

Chapter Two

1. Thomas Browne, *Pseudodoxia Epidemica* (London: Edward Dod, 1658), 419.

2. He mentions the grape, the fig, a fruit "not unlike the Citron," and another fruit that "Eastern Christians commonly [call] the Apple of Paradise." Browne, *Pseudodoxia Epidemica*, 419–20. The "apple of paradise" is generally identified with the banana.

3. Browne, *Pseudodoxia Epidemica*, 420–21. In classical Latin, *malum* originally denoted "most soft-skinned tree fruit; but later normally specifying an apple." *Oxford Latin Dictionary*, ed. P. G. W. Glare (Oxford: Oxford University Press, 1968), s.v. "mālum," 1069. The two senses of *malum* were originally distinguished by the length of the *a*, long *mālum*, "apple," short *mălum*, "evil." However, vowel length ceased to be a distinguishing marker in Latin from the second century CE, rendering the two words fully homonymous. See Veikko Väänänen, *Introduction au Latin Vulgaire* (MEL 6; Paris: Klincksieck, 1981), 29–74; and R. Anthony Lodge, *Le français: Histoire d'un dialecte devenu langue* (Paris: Fayard, 1993), 56–59.

4. Ziony Zevit, *What Really Happened in the Garden of Eden?* (New Haven, CT: Yale University Press, 2013), 170–71. Latin *malum* is the fruit of the apple tree; *malus*, the tree itself.

5. Victor P. Hamilton, *The Book of Genesis 1–17* (NICOT 1; Grand Rapids, MI: Eerdmans, 1990), 191.

6. Gerhard von Rad, *Genesis: A Commentary* (OTL; Louisville, KY: Westminster John Knox, 1973), 90.

7. In religious studies, see, for example, Beate Ego, "Adam und Eva in Judentum," in *Adam und Eva in Judentum, Christentum und Islam*, ed. Christfried Böttrich, Beate Ego, and Friedmann Eißler (JCI; Göttingen: Vandenhoeck & Ruprecht, 2011), 11 (I thank Tzvi Novick for bringing this passage to my attention); in art history, see James Snyder, "Jan Van Eyck and Adam's Apple," *Art Bulletin* 58 (1976): 511–15; in theater studies, see Dale Randall, "The Rank and Earthy Background of Certain Physical Symbols in *The Duchess of Malfi*," *Renaissance Drama* 18 (1981): 181. Many other examples could be adduced.

8. Among the dissenters, Karl Heisig claims that Carolingian poets, drawing on the symbolic valence of the apple in classical sources, introduced the apple into the Christian narrative of the Fall of Man; "Woher stammt die Vorstellung vom Paradiesapfel?," *Zeitschrift für die Neutestamentliche Wissenschaft* 44 (1953): 111–18. Hans-Günter Leder identifies the introduction of the apple tradition with Cyprian of Gaul (discussed below) in *"Arbor Scientiae."* Hilário Franco Júnior argues that fig symbolism gave way to apple symbolism "in parallel to the cultural process that saw the heart where previously there had been the liver"; "Between the Fig and the Apple: Forbidden Fruit in Romanesque Iconography," *Revue de l'histoire des religions* 223 (2006): 14. Finally, Ina Liphkowitz identifies the key motivation in the appearance of the apple tradition, the desire of Christian missionaries to subvert pagan religious norms: "How better to convert the pagans than by convincing them that their sacred fruit [the apple] didn't confer the immortality they believed it to, but, quite the contrary, lured them with false, dangerous, and sinful knowledge?" *Words to Eat By: Five Foods and the Culinary History of the English Language* (New York: St. Martin's Press, 2011), 51–52. None of these hypotheses explains why the apple tradition appeared where and when it did, or its diffusion pattern to other regions.

9. E. Ann Matter, *The Voice of My Beloved: The Song of Songs in Western Medieval Christianity* (MAS; Philadelphia: University of Pennsylvania Press, 1990), 34.

10. Luc Brésard, Henri Crouzel, and Marcel Borret, eds., *Origène: Commentaire sur le Cantique des Cantiques* (SC 376; Paris: Éditions du Cerf, 1992), 2:524–25. Origen's Greek original has been lost, but the Septuagint to Song of Songs 2:3 reads *mēlon*, Greek for "apple," and that is undoubtedly the word that Origen used in his commentary. Alan of Lille, a prominent French theologian and professor at the University of Paris, appears to share Rufinus's concern when, some eight centuries later, he writes: "Christ does not call his Cross an evil tree but rather an apple tree (*non malam, sed malum*)." Alan of Lille, *Elucidatio in Cantica Canticorum*, PL 210.105.

11. Brésard, Crouzel, and Borret, *Origène: Commentaire*, 2:524–25.

12. Brian Murdoch, *The Medieval Popular Bible* (Cambridge: D.S. Brewer, 2003), 16. Milton's work falls outside the purview of this study, but Murdoch is referring to, e.g., Satan's report to his demon subordinates that "by fraud I have seduc'd [Adam] . . . with an Apple," *Paradise Lost* 10.485–87. See also Jeffrey S. Shoulson, "The Embrace of the Fig Tree: Sexuality and Creativity in Midrash and in Milton," *ELH* 67 (2000): 873–903, especially 891–92, and the sources Shoulson cites there.

13. The Heptateuch consists of the Pentateuch with the Books of Joshua and Judges.

14. Cyprian of Gaul, *Genesis*, lines 65–70, in Carolinne White, trans., *Early Christian Latin Poets* (ECF; New York: Routledge, 2002), 102. Latin: *Ne trepidate simul licitos praecerpere fructus quos nemus intonsum ramo frondente creauit solliciti, ne forte malum noxale legatis*, in R. Peiper, ed., *Cypriani Galli Poetae Heptateuchos*, (CSEL 23; Vienna: Tempsky, 1881), 3–4, line 66. *Malum*, "apple," also occurs at line 77.

15. Avitus, *De spiritualis historiae gestis*, 2.210–13, in *The Poems of Alcimus Ecdicius Avitus*, trans. George W. Shea (MRTS 172; Tempe: Arizona State University Press, 1997), 84. Latin: *Ille . . . unum de cunctis letali ex arbore malum detrahit. . . . nec spernit miserum mulier male credula munus; sed capiens minibus pomum letale retractat*; Avitus, *The Fall of Man: De spiritualis historiae gestis libri I–III*, ed. Daniel J. Nodes (TMLT; Toronto: Centre for Medieval Studies, 1985), 38, lines 208–14. There is some debate surrounding *male credula*: Nicole Hecquet-Noti's translation has Eve believing the serpent "pour son Malheur," that is, "to her misfortune" or "to her detriment." See Nicole Hecquet-Noti, *Avit de Vienne, Histoire Spirituelle* (SC 444; Paris: Éditions du Cerf, 1999), 1:215. But on any interpretation, it is clear that Avitus is punning on the two meanings of *malum*.

16. Geoffrey of Vinsauf, *Poetria Nova*, trans. Margaret F. Nims (MST 49; Toronto: Pontifical Institute of Mediaeval Studies, 2010), 51. Latin: *Res mala! Res pejor aliis! Res pessima rerum! O malum! miserum malum! miserabile malum! Cur tetigit te gustus Adae? Fuit haec gustatio mali Publica causa mali*. Ernest Gallo, *The "Poetria Nova" and Its Sources in Early Rhetorical Doctrine* (DPLSM 10; The Hague: Mouton, 1971), 72, lines 1103–8. See Murdoch, *Adam's Grace*, 2 and 5.

17. Paul E. Beichner, "The Old French Verse *Bible* of Macé de la Charité, a Translation of the *Aurora*," *Speculum* 22 (1947): 227.

18. Paul E. Beichner, *Aurora Petri Rigae Biblia Versificata* (PMS 19; Notre Dame, IN: University of Notre Dame Press, 1965), 1:40. Latin: *Femina capta dolo discrepit ab arbore malum / Datque uiro; comedunt; nascitur inde malum*. Later, we find a reference to the apple in the versified commentary on the Song of Songs of Guillaume de Deguileville, a French Cistercian (fl. second quarter of the fourteenth century). Guillaume interprets Song of Songs 8:5 as a reference to Eve's introduction of death into the world by "tasting the apple with her evil mouth." Guillaume de Deguileville, *Super Cantica Canticorum*, paragraph 55, in *Lateinische Hymnendichter des Mittelalters*, ed. Guido Maria Dreves (AH 48; Leipzig: Riesland, 1905), 406. Latin: *Ibi sub illa arbore. . . . Corrupta est mater tua / malum gustans malo ore*.

19. Brian Murdoch, *Adam's Grace* (Cambridge: D.S. Brewer, 2000), 22. Note that Murdoch does not claim that the pun is the *source* of the apple's identification with the forbidden fruit.

20. The addition of the three Carolingian poets cited by Karl Heisig does not alter the picture, and see the following note.

21. Avitus, *De spiritulis historiae gestis*, 2.139; see Shea, *The Poems of Alcimus Ecdicius Avitus*, 183.

22. *Pace* Shea: "The happy young people [Adam and Eve] happened to be plucking red apples from a green branch." See also Heisig's admission that the ninth-century poet Milo of St. Amand's phrase *puniceum pomum* (Ludovicus Traube, ed., *Poetae latini aevi Carolini* [MGH; Berlin: Weidmann, 1896], 619, line 131) echoes Ovid's *puniceum pomum* ("pomegranate") in *Metamorphoses* 5.536, and the consequent possibility that *malum* elsewhere in St. Amand's work is an ellipsis for *malum punicum* or *malum granatum*, "pomegranate."

23. Helpful surveys of Latin commentaries on the Hebrew Bible include Ceslas Spicq, *Esquisse d'une histoire de l'exégèse latine au moyen âge* (Paris: Vrin, 1944); Charles Kannengiesser, *Handbook of Patristic Exegesis: The Bible in Ancient Christianity* (Leiden: Brill, 2004); Robert E. McNally, *The Bible in the Early Middle Ages* (Eugene, OR: Wipf and Stock, 2005); and Frans van Liere, *An Introduction to the Medieval Bible* (IR; Cambridge: Cambridge University Press, 2014).

24. See *Oxford Latin Dictionary*, s.v. "cibus," 312. For ecclesiastical use of *cibus*, see, e.g., the Vulgate's translation of Genesis 40:17 (Pharaoh's chief baker dreams he carries a basket containing "all sorts of . . . food [*omnes cibos*]"), Exodus 16:22 ("On the sixth day they gathered twice as

much food [*cibos duplices*]"), and Leviticus 11:34 ("Any food [*omnis cibus*] that could be eaten shall be unclean").

25. "Should I not weep, should I not groan, when the serpent invites me again to the forbidden food (*inlictos cibos*), when, in having driven me from the paradise of virginity, he wishes to clothe me in skins such as Elias cast upon the earth as he was returning to paradise?" Jerome, *Epistle* 22 (*Ad Eusotchium*), in *The Letters of St. Jerome*, trans. Charles Christopher Mierow (ACW 33; Westminster, MD: Newman Press, 1963), 1:149–50; Latin text: *Select Letters of St. Jerome*, trans. F. A. Wright (LCL 262; London: William Heinemann and G. P. Putman's Sons, 1933), 90.

26. Ambrose, "The Prayer of Job and David," Book 3, 4.10, in *Saint Ambrose: Seven Exegetical Works*, trans. Michael P. McHugh (FC 65; Washington, DC: Catholic University of America Press, 1972), 375; Latin text: Ambrose, *De interpellatione Iob et David*, ed. Karl Schenkl (CSEL 32; Vienna: Tempsky, 1897), 254.

27. According to Augustine, Eve may not have needed to persuade Adam to take the fruit, "since he saw that she was not dead from eating the fruit (*cibo*)"; Augustine, *The Literal Meaning of Genesis*, Book 11, chapter 31, trans. John Hammond Taylor (ACW 42; New York: Newman Press, 1982), 1:161.

28. Among the more prominent are the Venerable Bede in his commentary on Genesis 3:6 (quoting Augustine without attribution): Bede, *On Genesis*, trans. Calvin B. Kendall (TTH 48; Liverpool: Liverpool University Press, 2008), 127; Angelomus of Luxeuil, *Commentarius in Genesin*, PL 115.137; Rupert of Deutz, *Commentaria in Evangelium Sancti Johannis*, ed. Hrabanus Haacke (CCCM 9; Turnhout: Brepols, 1969), 339; Hugh of St. Victor, *De sacramentis christianae fidei*, PL 176.289; and Peter Cantor, *Glossae super Genesim: Prologus et Capitula 1–3*, ed. Agneta Sylwan (SGLG 55; Göteborg: Acta Universitatis Gothoburgensis, 1992), 49–50.

29. The following list, which is not exhaustive, aims to provide a sense of the chronological and geographic range of this usage. The listed sources refer to the *pomum* as *illicitum*, *vetitum*, or *prohibitum*, all of which mean "forbidden" (passages that I found through the Brepols "Library of Latin Texts" database are cited in accordance with the conventions of the database): Zeno of Verona (300–371; North African teacher and monk, became bishop of Verona) [Zeno of Verona, *Zenonis Veronensis Tractatus*, ed. Bengt Löfstedt (CCSL 21; Turnhout: Brepols, 1971), Book 1, Tractate 3, line 6]; Pope Gregory I, aka Gregory the Great (ca. 540–604; Rome) [*Sancti Gregorii Magni . . . in librum Primum Regum qui et Samuelis dicitur . . .* , PL 79.132—there is some debate among scholars as to whether this is an authentic work of Gregory the Great]; Hrabanus Maurus (776/784–856; German monk, archbishop of Mainz) [*Hrabani Mauri Expositio in Matthaeum*, ed. Bengt Lofstedt (CCCM 174; Turnhout: Brepols, 2000), Book 4, p. 362, line 52]; Paschasius Radbertus (785–865; French) [*Expositio in lamentationes Hieremiae, libri quinque*, ed. Beta Paulus (CCCM 85; Turnhout: Brepols, 1988), Book 2, line 1053]; Atto of Vercelli (9th–10th century Piedmont, Italy) [*Epistola prima ad corinthios, ad* 6:12, PL 134.342]; Petrus Damiani (1007–1072/73; Italian) [*Epistulae CLXXX*, ed. Kurt Reindel (MGH; Wiesbaden: Harrassowitz, 1988), 2:135]; Rupert of Deutz (1075–1129; Low Countries and Germany) [*De sancta trinitate et operibus eius*, ed. Rhabanus Maurus Haacke (CM 23; Turnhout: Brepols, 1972), 1598]; Hugh of St. Victor (1096–1141; Paris) [*De Sacramentis Christiane Fidei*, PL 176.291]; Hildegard of Bingen (1098–1179; German) [*Liber diuinorum operum*, ed. Peter Dronke and Albert Derolez (CCCM 92; Turnhout: Brepols, 1996), Part 3, Vision 4, Chapter 5]; Iohannes Beleth (fl. 1135–1182; French) [*Summa de ecclesiasticis officiis*, ed. Herbert Douteil (CCCM 41 and 41A; Turnhout: Brepols, 1976), Chapter 30, line 99]; Peter Lombard (1096–1160; Italian) [*Commentarius in Psalmos*, PL 191.60]; Petrus

Cellensis (1115–1183; French) [*Commentaria in Ruth* (CCCM 54; Turnhout: Brepols, 1983), First Commentary, part 3, line 1387]; Peter Cantor (d. 1197; French) [*Glossae super Genesim: Prologus et Capitula 1–3*, ed. Agneta Sylwan (SGLG 55; Göteborg: Acta Universitatis Gothoburgensis, 1992), 49–50]; William of Auvergne (1180/90–1249; French) [*Sermones de tempore*, ed. Franco Morenzoni (CCCM 230; Turnhout: Brepols, 2011), 534, line 28]; Stephen of Bourbon (1190/95–1261; French) [*Tractatus de diuersis materiis praedicabilibus*, ed. J. Berlioz, D. Ogilvie-David, and C. Ribaucourt (CCCM 124A; Turnhout: Brepols, 2015), 133, line 317]; Thomas Aquinas (1225–1274; Italian) [*Quaestiones disputatae de malo*, in *Quaestiones disputatae*, ed. R. Spiazzi et al., 2 vols. (Rome: Marietti, 1953), quaestio 4, articulus 6, argumentum 20; and *Summae theologiae*, ed. P. Cramello (Rome: Marietti, 1948), question 165, article 2]; Guillaume Durand (1230–1296; Italian) [*Rationale diuinorum officiorum (libri I–VIII)*, ed. Anselme Davril and Timothy M. Thibodeau (CCCM 140A; Turnhout: Brepols, 1998), Book 6, chapter 73, line 32]; Thomas à Kempis (1380–1471; Germany and the Netherlands) [*Sermones ad novicios regulares*, Sermon 19, in Thomas Kempis, *Opera Omnia*, ed. Michael Josef Pohl (Freiburg: Herder, 1902), 6.166].

30. *Oxford Latin Dictionary*, s.v. "pōmum," 1400. The broad sense is retained in the English word *pomology*, the branch of botany that studies fruit.

31. The Latin singular corresponds to the Hebrew ʿ*etz peri*. The Vulgate renders the second occurrence of fruit ("that bear fruit") with *fructus*. The Vulgate's use of *lignum* rather than the expected *arbor* is an example of the semantics of rabbinic Hebrew determining Jerome's understanding of biblical Hebrew. ʿ*Etz* is the standard biblical word for "tree," but in rabbinic Hebrew ʾ*ilan* is "tree," while ʿ*etz* comes to mean "wood." Jerome, then, translates the biblical ʿ*etz* (which should be *arbor*) in accordance with rabbinic semantics (*lignum*). I first heard this explanation in a graduate seminar of the late Haiim Rosén. I believe Rosén published an article on the topic, but I have not been able to locate it.

32. See also Exodus 10:15; Leviticus 27:30; Hosea 9:10 ("the first fruit of the fig tree"); and Amos 8:1–2.

33. Augustine, *The Literal Meaning*, trans. Taylor, 2:164.

34. *Pomum* is in the P recension of the *Life of Adam and Eve*, preserved in BnF lat. 3832, which is incorporated into Jean-Pierre Pettorelli and Jean-Daniel Kaestili, eds., *Vita Latina Adae et Evae* (CCSA 18–19; Turnhout: Brepols, 2012), 395. On *Post Peccatum Adae*, see Carolyn E. Jones, "*Cursor Mundi* and *Post Peccatum Adae*: A Study of Textual Relationships" (PhD diss., University of Miami, 1976), 70, line 85.

35. One must beware of false positives. The Cistercian John of Forde (1140–1214) writes of a *malum vetitum* in the context of the Fall of Man, but this is almost certainly an ellipsis of *malum punicum*, "pomegranate." In his exegesis of Song of Songs 6:6, which praises the beauty of the beloved whose "cheeks are like the bark [NRSV: halves] of a pomegranate (*malum punicum*)," John identifies the pomegranate with Christ: "The pomegranate . . . is plainly a fruit of the tree of life," for "in this fruit (*malum*) there is a complete redemption of the forbidden *malum* (*malum vetitum*) that was taken unrightfully (*male*)." John of Ford, *Sermons on the Final Verses of the Song of Songs*, trans. Wendy Mary Beckett (CF 41–47; Kalamazoo, MI: Cistercian Publications, 1983), 4:85. Latin: *In hoc malo mali uetiti male que usurpati unica redemptio est*, in E. Mikker and H. Costello, eds., *Iohannes de Forda, Super extremam partem Cantici canticorum sermones cxx* (CCCM 17; Turnhout: Brepols, 1970), Sermon 53, line 87. Any attempt to read *malum* as an apple must rely on the implausible claim that John of Forde employs *malum* in two senses in a single sentence, once to refer to a pomegranate and once to an apple. Rather, John of Forde is here drawing on the modest but enduring tradition that associates the pomegranate

with the forbidden fruit, just as Christ, the corrective, is so associated. Hanah Matis notes that the pomegranate's association with Christ's passion goes back at least to the eighth century; Matis, *The Song of Songs in the Early Middle Ages* (SHCT 191; Leiden: Brill, 2019), 41. For a survey of pomegranate symbolism in early Christian sources, see George Hardin Brown, "Patristic Pomegranates, from Ambrose and Apponius to Bede," in Katherine O'Brien O'Keefe and Andy Orchard, eds., *Latin Learning and English Lore: Studies in Anglo-Saxon Literature for Michael Lapidge* (TOE; Toronto and London: University of Toronto Press, 2005), 1:132–49. The Song of Songs plays an important role in this tradition, and several commentators identify the *malum* of vv. 2:3 and 8:5 with the pomegranate, on which see below, note 93.

36. Commodian, *Instructions*, 1.35; my translation. Latin: Jean-Michel Poinsotte, ed., *Commodien, Instructions* (CUFSL 392; Paris: Les Belles Lettres, 2009), 38, lines 15–16.

37. Remigius of Auxerre, *Expositio super Genesim*, ed. Burton Van Name Edwards (CCCM 136; Turnhout: Brepols, 1999), line 910. Latin: *Lignum scientiae boni et mali ex re futura nomen accepit, quia scilicet homo, postquam illud in cibum sumpsisset, sciret quae esset distantia inter oboedientiae bonum et inoboedientiae malum*. Note that Remigius refers to the forbidden fruit as *cibus*.

38. Andrew of St. Victor, *Expositio super heptateuchum In Genesim*, ed. Charles Lohr and Rainer Berndt (CCCM 53; Turnhout: Brepols, 1986), line 850. Latin: *Haec arbor scientiae boni et mali dicitur, quia fructu illius, ab homine contra praeceptum gustato, experiendo transgressor disceret, quid inter oboedientiae bonum et inter inoboedientiae malum esset*.

39. Arnold of Bonneval, *Tractatus de operibus sex dierum*, PL 189.1541–42.

40. Arnold of Bonneval, *Tractatus de operibus sex dierum*, PL 189.1542.

41. Alan of Lille, *Summa 'Quoniam homines,'* Book 2, tractate 5 (Glorieux, p. 28). See Palémon Glorieux, "La somme 'Quoniam Homines' d'Alain de Lille," *Archives d'histoire doctrinale et littéraire du moyen âge* 28 (1953): 357. Latin: *Sola Dei prohibitione malum fuit comedere pomum ... comedere enim pomum genere erat bonum*.

42. The order was founded in the village of Cîteaux, in eastern France, in 1098.

43. Bernard of Clairvaux, *On the Song of Songs II*, trans. Killian Walsh (CF 11; Kalamazoo, MI: Cistercian Publications, 1976), 168. Latin text from Bernard de Clairvaux, *Sermons sur le Cantique, III*, ed. Paul Verdeyen and Raffaele Fassetta (SC 452; Paris: Éditions du Cerf, 2000), 90–91.

44. A separate difficulty is the *malum* hypothesis's assumption that the forbidden fruit is evil. For while the outcome of Adam and Eve's actions was bad, there is a sustained interpretive effort to hold the fruit blameless, an effort tied to the exegetical need to avoid undermining the goodness of creation (Gen 1:31) and to a theological focus on disobedience as Adam and Eve's core transgression. Among the authors declaring the fruit blameless are Augustine: *De Genesi ad litteram* 8.6 (CSEL 28.1, 239–40); Bede: *On Genesis* (Kendall, 112–13); Martin of Leon, *Sermo Septimus (In Septuagesima II)*, PL 208.582; and Thomas Aquinas: *Summa Theologiae*, 1a, Part 1, Question 102, article 1, trans. Edmund Hill, OP (New York: McGraw-Hill and Eyre & Spottiswoode, 1963), 13:186–87. This view found its way into vernacular Bibles as well, as we see in a marginal note to the Old French Bible of Acre at Genesis 3:5 ("for God knows that when you eat of it your eyes will be opened, and you will be like God, knowing good and evil"), stating that the tree was not evil by nature. See Pierre Nobel, *La Bible d'Acre, Genèse et Exode* (CL; Besançon: Presses universitaires de Franche-Comté, 2006), 8.

45. See Vinzenz Buchheit, "Augustinus unter dem Feigenbaum (zu *Conf.* VIII)," *Vigiliae christianae* 22, no. 4 (1968): 257–71; and James J. O'Donnell, *Confessions III: Commentary on Books 8–13* (Oxford: Clarendon Press, 1992), 57.

46. Augustine, *Tractates on the Gospel of John, 1–10*, trans. John W. Rettig (FC 78; Washington, DC: Catholic University of America Press, 1988), 174.

47. Augustine, "Questions on the Gospels," Book 1, Question 39, in Boniface Ramsey, ed., *The Works of Saint Augustine: New Testament I and II*, trans. Ronald Teske (WSATTC I/15 and I/16; Hyde Park, NY: New City Press, 2014), 373.

48. See the sources cited in O'Donnell, *Confessions III*, 57. The fig tree plays a critical supporting role in the *Confessions*: Augustine is lying under a fig tree, in a state of despair over his inability to fully overcome the desires of his flesh, when he hears the voice calling *tolle lege*, "take it and read it" (*Confessions* 8.12.28–29).

49. See Marina Smyth, "The Seventh-Century Hiberno-Latin Treatise *Liber de ordine creaturarum*," *Journal of Medieval Latin* 21 (2011): 137–222. A survey of the attribution history of the treatise is found at 137–38.

50. *Liber de ordine creaturarum* 10.13; Smyth, 194. The author then goes on to describe how the curse *totam terram inficerat*, "infected the entire earth." The Latin verb *inficere*, "to infect," is an odd choice in the context of a curse and might play on the noun *ficus*, "fig." For the Latin text, see Manuel C. Díaz y Díaz, *Liber de ordine creaturarum: Un anónimo irlandés del siglo VII* (MUSC 10; Santiago de Compostela: la Universidád de Santiago de Compostela, 1972), 162.

51. See Bernhard Bischoff and Michael Lapidge, *Biblical Commentaries from the Canterbury School of Theodore and Hadrian* (CSASE 10; Cambridge: Cambridge University Press, 1994), 5–81.

52. Bischoff and Lapidge, *Biblical Commentaries*, 310–11; emphasis original.

53. Alcuin of York, *Questions and Answers on Genesis*, trans. Sarah van der Pas, in *Questions and Answers on Genesis: Augustine, Ambrosiaster, and Alcuin*, ed. John Litteral (PBC; CreateSpace Publishing Platform, 2018), 164. On Alcuin's use of the questions and answers genre, see E. Ann Matter, "Alcuin's Questions and Answers Text," *Rivista di storia della filosofia* 45 (1990): 645–56, with discussion of the Genesis text at 653–54.

54. Thomas Aquinas, *Commentary on the Gospel of John: Chapters 1–5*, trans. Fabian Larcher and James A. Weisheipl (TAT; Washington DC: Catholic University of America Press, 2010), 128.

55. Meister Eckhart, "Expositio libri Genesis," in *Die lateinischen Werke* I, trans. Konrad Weiss (Stuttgart: W. Kohlhammer, 1964), 352 (aprons) and 253 (poem).

56. Juan Fernández Valverde, ed., *Roderici Ximenii de Rada Breviarium Historie Catholice (I–IV)* (CCCM 72A; Brepols: Turnhout, 1992), 29–30; italic in the original for quoted biblical text. Latin: *Et in Canticis dicitur: Sub arbore fici vidi te; ibi corrupta ets mater tua; ibi violata est genitrix tua, Eva scilicet.*

57. Fernández Valverde, the editor of the *Corpus Christianorum* edition, provides a footnote (30) that refers the reader to Song of Songs 8:5, without noting de Rada's divergence.

58. Gottfried von Strassburg, *Tristan and Isolde*, trans. Francis G. Gentry (New York: Continuum, 1988), 235, lines 17948–49.

59. Peter Abelard, *Expositio in Hexameron*, ed. M. Romig and D. Luscombe (CCCM 15; Turnhout: Brepols, 2004), 90. Latin: *Quale autem hoc lignum fuerit in quo transgressi sunt, nulla definitum est scripture auctoritate. Nonnullis tamen visum est quod ficus fuerit. . . . Hebrei autem hoc lignum scientie boni et mali autumant vitem fuisse.* Half a millennium later, the English poet Thomas Peyton would echo Abelard's claim, writing that his Jewish contemporaries, or at least those "that Cabalists are cald [=called]," affirm that Adam's sin involved "nothing but the sweet delicious wine"; Peyton, *The Glasse of Time, In the First Two Ages* (London: Alsop, 1620), 36.

60. Hugh of St. Victor, *Adnotationes . . . in Genesim*, PL 175.42.

61. Andrew of St. Victor, *Exposition on Genesis*, 36. Latin: *Consuerunt folia ficus etc. . . . Lignum istud vetitum quidam ficum, quia folia ficus consuerunt, quidam vitem—pro eo, quod scriptus est: Patres coederunt uvam acerbam, et dentes filiorum obstupescunt"—fuisse aestimant.* Franco Júnior, "Between the Fig and the Apple," viii n28, claims that Andrew of St. Victor and Petrus Comestor identify the forbidden fruit with the fig, but in fact both authors merely state that there are those who do so.

62. Petrus Comestor, *Scholastica historia: Liber Genesis*, ed. A. Sylwan (CCCM 191; Turnhout: Brepols, 2005), 42 (*"Folia ficum": hinc quidam dicunt ficum fuisse arborem prohibitam*). "The *Historia* was one of the most popular books in the late Middle Ages; it is extant in many manuscripts and was one of the earliest works to be printed." James H. Morey, "Peter Comestor, Biblical Paraphrase, and the Medieval Popular Bible," *Speculum* 68 (1993): 8. Morey (8–9) lists translations into Saxon, Dutch, Old French, Portuguese, Czech, Castilian, Catalan, and Old Norse, all disseminating Comestor's fig-tradition testimony among their respective vernacular readers.

63. Petrus Cantor quotes Comestor verbatim on this point; Petrus Cantor, *Glossae super Genesim: Prologus et Capitula 1–3*, ed. Agnet Sylwan (SGLG 55; Göteborg: Acta Universitatis Gothoburgensis, 1992), 68.

64. Nicholas of Lyra, *Postilla super totam bibliam* (Venice, 1488), to Genesis 3:7; italic in the original for quoted biblical text. Latin: *Consuerunt folia ficus: ex hoc dicunt hebrei quod ficus erat arbor de cui fructus comederunt.*

65. This is the second stich of Song of Songs 8:5, preceded by "Who is that coming up from the wilderness, leaning upon her beloved?" For the sake of simplicity, I will refer to the passage beginning "Under the apple tree I awakened you . . ." as Song of Songs 8:5.

66. The translation is from the Douay-Rheims Bible, *The Holy Bible Translated from the Latin Vulgate* (Baltimore: John Murphy, 1914), 695–96.

67. "Uncertainty surrounds the exact species (fig, date, quince, citrus, apricot, apple), yet the most probable candidate is the apricot"; Deborah Appler, NIDB, s.v. "Apple," 1:209. See also NIBD, s.v. "Apricot," 796; Lytton John Musselman, *Figs, Dates, Laurel, and Myrrh: Plants of the Bible and the Quran* (Portland, OR: Timber Press, 2007), 51–53; Scott Noegel and Gary Rendsburg, *Solomon's Vineyard: Literary and Linguistic Studies in the Song of Songs* (AIL 1; Atlanta: Society of Biblical Literature, 2009), 116. Interestingly, there are a number of medieval Hebrew and Aramaic sources that equate the *tapuaḥ* with the citron (*'etrog*). The Aramaic Targum to the Song of Songs, usually dated to the seventh or eighth century, glosses Song of Songs 2:3 ("as a *tapuaḥ* among the trees of the woods"), "just as the citron (*'etroga*) is beautiful and is praised among ornamental trees" (translation: Jay C. Treat, "English Translation to the Aramaic Targum to Song of Songs," https://www.sas.upenn.edu/~jtreat//song/targum/). This meaning is also found in a number of medieval French rabbinic sources, including the Talmud commentary of Rabbenu Tam, the twelfth-century legal authority and grandson of Rashi (Shabbat 88a), and a late twelfth-century anonymous commentary on the Song of Songs from northern France that refers to the *tapuaḥ* of Song of Songs 2:3 as "the tree on which the citron (*etrog*) hangs." See Sara Japhet and Barry Dov Walfish, *The Way of Lovers: The Oxford Anonymous Commentary on the Song of Songs (Bodleian Library, MS Opp. 625)* (Commentaria 8; Leiden: Brill, 2017), 153, whose translation—"The apple is the tree whose fruit hangs from it"—is wrong. (I note in passing that the anonymous commentary is remarkable for its nonallegorical interpretation of Song of Songs as a dialogue between two actual lovers. To my knowledge, the only precedent for this approach is the Pelagian Julian of Eclanum, on whom see Matter, *The Voice of My Beloved*, 97–99). The *tapuaḥ* is also a citron in the commentary on Song of Songs preserved in the Florence,

Laurentian Library, MS Acquisiti e Doni 121, 16a–23a, discussed in Baruch Alster, "Human Love and Its Relationship to Spiritual Love in Jewish Exegesis on the Song of Songs" (PhD diss., Bar-Ilan University, 2006), 14–16. Alster identifies the author as a twelfth-century rabbinic scholar affiliated with the school of Rabbi Samuel ben Meir (Rashbam), another of Rashi's grandsons. My thanks to Baruch Alster for providing me with a copy of his dissertation. It may be pertinent that "during the twelfth and thirteenth centuries, the citron was described by the crusaders as 'Adam's Apple,' due [to] the narrowing on the upper part of some of the citron fruits that can resemble the bite of a human being." Rivka Ben-Sasson, "Botanics and Iconography: Images of the *Lulav* and the *Etrog*," Ars Judaica 8 (2012): 21.

68. In classical Latin, *arbor*, "tree," is feminine, so "under the apple tree" would be *sub arbore mala*. Medieval Latin authors, however, regularly took *arbor* to be grammatically masculine. As Hildegard König notes, "Die Verwendung von *arbor* als Maskulinum ist im übrigen mehrfach bezeugt." König, "*Vestigia antiquorum magistrorum sequi*: Wie liest Apponius Origenes?," *Theologische Quartel* 170 (1990): 132. The "evil tree" reading may also have been motivated by Jesus's analogy of false prophets to trees and their fruit in Matthew 7:17–18: "Every good tree bears good fruit, but the bad tree (*mala autem arbor*) bears bad fruit. A good tree cannot bear bad fruit, nor can a bad tree (*arbor mala*) bear good fruit."

69. Snyder, "Jan Van Eyck and Adam's Apple," 511–12.

70. Lesley Smith, *The "Glossa Ordinaria": The Making of a Medieval Bible Commentary* (Commentaria 3; Leiden: Brill, 2009), 1.

71. Anselmus Laudunensis, *Enarratio in Canticum Canticorum*, PL 162.1187–1228.

72. Jean Leclercq, "Le commentaire du Cantique des cantiques attribué à Anselme de Laon," *Recherches de théologie ancienne et médiévale* 16 (1949): 7–22. The long commentary is preserved in BnF lat. 568, fols. 1r–64v; the abridgment in BnF lat. 14801, fols. 1r–33r; the *Enarratio* is an amalgam of the abridgment and other sources. For a discussion of these manuscripts, and the complex manuscript history of Anselm's commentary, see Suzanne LaVere, *Out of the Cloister: Scholastic Exegesis of the Song of Songs, 1100–1250* (Commentaria 6; Leiden: Brill, 2016), 11–16. Today scholars question whether Anselm was the author of these commentaries in the strict sense of the term, since "the cathedral-school teaching of the twelfth century was part of a predominantly oral culture"; Alexander Andrée, "*Sacra Pagina*: Theology and the Bible from the School of Laon to the School of Paris," in Cédric Giraud, ed., *A Companion to Twelfth-Century Schools* (BCCT 88; Leiden: Brill, 2020), 275. See also the comments of Smith, *The "Glossa Ordinaria,"* 33, attributing the Song of Songs commentary to the circle of Anslem of Laon, but not necessarily to Anselm.

73. *Enarratio in Canticum Canticorum*, PL 162.1224 and BnF lat. 568, 61a. Latin: *Sub arbore malo. sub peccato primi parenti. . . . Sub arbore malo. sub precatione crucis cui brachui de malo illa arbore fuit*.

74. BnF lat. 14801, 34a: *Sub arbore malo. sub comestione mali*. I came across the same phrase in the Song of Songs commentary preserved in BnF lat. 33 (at fol. 76v), traditionally attributed to Stephen Langton. However, LaVere has already argued (*Out of the Cloister*, 16), on separate grounds, that the commentary should "be attributed to Anselm, or at least to his school at Laon."

75. Mary Dove, ed., *Glossa Ordinaria: In Cantica Canticorum* (CCCM 170; Turnhout: Brepols, 1997), 388–91; italic in the original for quoted biblical text. Interestingly, Dove translates *sub arbore malo* as "under the evil tree."

76. Cédric Giraud has noted that the success of the *Glossa Ordinaria* eclipsed Anselm's commentaries within the schools and the cloisters. Cédric Giraud, "*Lectiones Magistri Anselmi*, les

commentaires d'Anselme de Laon sur le Cantique des Cantiques," in I. van t'Spijker, ed., *The Multiple Meanings of Scripture: The Role of Exegesis in Early-Christian and Medieval Culture* (Commentaria 2; Leiden: Brill, 2008), 183.

77. Gilbertus Foliot, *Expositio in Cantica Canticorum*, PL 190.1298. Latin: *Dicunt enim vetitam illam arborem, a qua homo in Paradiso abstinere jussus est, malum fuisse.* The *malum* in this phrase cannot be an adjective ("They say that the forbidden fruit... was evil"), since the adjective *vetitam*, "prohibited," that modifies *arbor*, "tree," is feminine. Were *malum* the adjective "evil," it too would have been in the feminine (*malam*), but it is neuter—the apple. Ari Geiger has noted (pers. comm.) that any argument based on morphological endings is necessarily speculative, since these were often elided by the manuscript scribes, then reintroduced—sometimes incorrectly—by later scribes or by the editors of a print edition. I was not able to consult the sole manuscript of Foliot's commentary, BL Royal MS 2 E.vii.

78. Scholars previously held that there was a second manuscript (Walters 394), the two witnesses "perhaps indicating a limited influence"; Holt Montgomery, "Gilbert Foliot's Commentary on the Song of Songs" (master's thesis, University of North Carolina, Chapel Hill, 1974), 4. It has since been determined that the Walters manuscript is the work of Gilbert of Hoyland, leaving BL Royal 2 E.vii as the sole existing witness to Foliot's commentary—and diminishing its influence even further. See David N. Bell, "The Commentary on the Lord's Prayer of Gilbert Foliot," *Recherches de théologie ancienne et médiévale* 56 (1989): 80–101, esp. 84 and n25. I thank David Bell for his generous assistance on this point.

79. Ambrose, Homily 5 (*Hé*) to Psalm 118, in *Homilies of Saint Ambrose on Psalm 118 (119)*, trans. Íde Ní Riain (Dublin: Halcyon, 1998), 59.

80. Some later authors would justify the analogy in botanical terms, as when Alcuin and Gilbert of Stanford speak of the overarching excellence of the apple. Alcuin: "Just as the apple tree in sight, smell, and taste excels the forest trees, in this way Christ surpasses all holy men"; Rossana E. Guglielmetti, ed., *Alcuino: Commento al Cantico dei Cantici* (MM 53; Florence: SISMEL, Edizioni del Galluzzo, 2004), 123–24; Gilbert of Stanford: "[The apple is] a tree that produces the most pleasant fruit with regard to their appearance, their fragrance, and their flavor." Rossana Guglielmetti, ed., *Tractatus super Cantica Canticorum: L'amore di dio nella voce di un monaco del XII secolo* (PV 16; Florence: Edizioni del Galluzzo, 2002), 228. Bruno of Segni (1045–1125), an Italian prelate and bishop, invokes the apple's bloodlike redness: "The blood of Christ had the color and the appearance of this fruit"; Ruth Affolter-Nydegger, ed., *Der Hoheliedkommentar und die "Expositio de muliere forte" Brunos von Segni: Einführung, kritische Edition mit synoptischer Übersetzung und Kommentar* (LSLM 50; Bern: Peter Lang, 2015), 340.

81. Arthur Holder, trans., *The Venerable Bede: On the Song of Songs and Selected Writings* (CWS; New York: Paulist Press, 2011), 231.

82. Guglielmetti, *Alcuino: Commento al Cantico dei Cantici*, 174.

83. See, inter alia, Rupert of Deutz, *Ruperti Tuitiensis: Commentaria in Canticum Canticorum*, ed. Hrabanus Haacke (CCCM 26; Turnhout: Brepols, 1974), 162; Honorius of Autun, *The Seal of Blessed Mary*, trans. Amelia Carr (PTS 18; Toronto: Peregrina, 1991), 83; Robert of Tombelaine, *Expositio super Cantica Canticarum*, PL 79.541; Petrus Damiani, *Sancti Petri Damiani Sermones*, ed. Giovanni Lucchesi (CCCM 57; Turnhout: Brepols, 1983), 405, in the sermon "Beatae Columbae Virginis et Martyris Sermo Pauperculus" (drawing on the language of Haimo of Auxerre's commentary on Song of Songs 8:5, cited below, note 94); William of Newburgh, *Explanatio sacri Epithalamii in Matrem Sponsi*, ed. John Gorman (SpF 6; Freiburg: University Press, 1960), 341.

84. Martinus Legionensis, *Sermo Quartus In Natale Domini II*, §38, PL 208.546. (The same argument appears in his sermon *De Sancta Cruce*, PL 209.36).

85. Alan of Lille, *Elucidatio in Cantica*, PL 210.105.

86. Robert of Tombelaine, *Expositio super Cantica Canticarum*, PL 79.495. The commentary is misattributed to Gregory the Great in the Patrologia Latina, on which see Palémon Glorieux, *Pour revaloriser Migne: Tables rectificatives* (MSR 9; Lille: Facultés catholiques, 1952), 47.

87. Tertullian, *Against the Jews*, 13.19: "[The] hardness of this age has been plunged into profound error, and by the wood of Christ—that is, by his suffering—is freed through baptism in order that what once had been lost in Adam on account of wood, could be restored through the wood of the Christ"; Geoffrey D. Dunn, *Tertullian* (ECF; New York: Routledge, 2004), 99; Jerome on Galatians 3:14: "He hung on a tree so that by means of a tree he might erase the sin we had committed through the tree of the knowledge of good and evil"; *St. Jerome: Commentary on Galatians*, trans. Andrew Cain (FC 121; Washington D.C.: The Catholic University of America Press, 2010), 144.

88. His encyclopedic *Elucidarium* is discussed in chapter 4.

89. Honorius Augustodunensis, *Expositio in Cantica Canticorum*, PL 172.478–479.

90. Geoffrey of Auxerre, *Expositio in Cantica Canticorum*, ed. Ferruccio Gastaldelli (TT 19 and 20; Rome: Edizioni di storia e letteratura, 1974), 2:532–34. Latin: *Sub arbore malo. Ecclasiae dicitur universae, quae in prima matre Eva pomi noxialis morsu in morten corruit. . . . Arbor malus lignum crucis, in quo singularis saporis et odoris fructus pependit.*

91. Thomas of Perseigne, *Thomae Cisterciensis Monachi In Cantica Canticorum Eruditissimi Commentarii*, PL 206.808. On this commentary, see David N. Bell, "The Commentary on the Song of Songs of Thomas the Cistercian," *Citeaux: Commentarii cistercienses* 28 (1977): 5–25.

92. Apponius, *Commentaire sur le Cantique des Cantiques (Explanatio in Canticum Canticorum)*, ed. Bernard de Vregille and Louis Neyrand (SC 420, 421, 430; Paris: Éditions du Cerf, 1998), 3:269–70. Latin: *Sub arbore malo suscitaui te. Id est: sub potestate diaboli dormientem— quid est arbor mortis.*

93. Apponius is an idiosyncratic reader. He interprets the *malum* of Song of Songs 8:5 to mean "evil," not "apple," and identifies the *malum* of Song of Songs 2:3 as a pomegranate. Commenting on Song of Songs 2:3, "As an apple (*sicut malum*) among the trees of the forest," Apponius explains that this is a *malum granatum*, a pomegranate, which is the tree of life; Apponius, *Commentaire*, 3:332–35. Latin: *Sicut malum. . . . Id est pro loco arborem cum malum granatum Ecclesia appelavit, pro eo quod "arbor vitae" est.* Apponius is not the only scholar to identify the *malum* of Song of Songs with the pomegranate. Angelomus of Luxueil, a late ninth-century Carolingian scholar, echoes this claim; see the latter's comments on Song of Songs 2:3 in *Ennarationes in Cantica Canticorum*, PL 115.588; as does Nicholas of Lyra (see the passage discussed later in this chapter). The Wycliffe Bible translates the *malum* of Song of Songs 8:5 as the *pumgranate tre*, and the commentary on the earlier Wycliffe translation references an interpretive tradition that associated the fruit of Song of Songs 8:5 with the forbidden fruit: "Thus it is in Ebreu, tho summe doctours taken this unkunnyngly of the tre forebodun to Adam and Eue" (Thus it is in Hebrew, though some scholars ignorantly take this [to refer to] the tree forbidden to Adam and Eve). See Josiah Forshall and Sir Frederic Madden, eds., *The Holy Bible Containing the Old and the New Testaments with the Apocryphal Books in the Earliest English Versions Made from the Latin Vulgate by John Wycliffe and His Followers* (Oxford: Oxford University Press, 1850), 3:82–83. A rabbinic association of the *tapuaḥ* with the pomegranate is found in the *Yalquṭ Shimoni* passage cited below, note 101.

94. Henrike Lähnemann and Michael Rupp, eds. and trans., *Williram von Ebersberg Expositio in Cantica Canticorum und das "Commentarium in Cantica Canticorum" Haimos von Auxerre* (Berlin: De Gruyter, 2004), 258. The Patrologia Latina contains this commentary twice. Once it is attributed to Cassiodorus (ca. 485–ca. 585) (PL 70.1055–1106), and a second time to Haimo of Halberstadt (d. 853) (PL 117.295–358). In fact, the commentary is by Haimo of Auxerre, on which see Glorieux, *Pour revaloriser Migne*, 46 and 57; and Matter, *The Voice of My Beloved*, 119n65.

95. Wolbero of Cologne, *Commentaria vetustissima et profundissima super canticum canticorum Salomonis*, PL 195.1248–1249. The commentary is addressed to a commune of nuns.

96. Bernard Bischoff and Burkhard Taeger, eds., *Iohannis Mantuani In Cantica canticorum et de Sancta Maria tractatus ad comitissam Matildam* (SpF 19; Freiburg: Universitätverlag, 1973), 146. Latin: *Quam crucem vocat arborem, quia per arborem fuit casus vitae; sicut ex illa fuit cibus mortis et dejectionis, ita ex ista cibus vitae et elevationis. Arbor malus erat, quia odoriferi fructus ex ea pendebant.*

97. Bischoff and Taeger, *Iohannis Mantuani In Cantica canticorum*, 146. Latin: *Possumus hunc versum aliter exponere . . . sub arbore malo iacentem, scilicet cui dominabatur arbor Adae, quae per gulae delectationem malus et dulcis visa est; omnis enim homo sub illa per poenam existit, cui dominabitur peccatum originis.*

98. The approach of Hugh of St. Cher (d. 1263), a French Bible scholar who oversaw the first Bible edition with variant readings, is similar. Hugh distinguishes two readings of Song of Songs 8:5. In one, the apple tree is a symbol of Christ, but the context is ecclesiological: the corrupted mother is the Synagogue that Christ "awakens" by conversion. In the other reading, the verse alludes to the Fall of Man, but does not interpret the apple in this context. Indeed, he writes that Eve (the corrupted mother) lies "under the tree of the forbidden wood (or tree)" (*sub arbore ligni vetiti*), a convoluted phrase that avoids mention of the apple tree. *Opera Omnia in Universum Vetus & Novum Testamentum* (Venice, 1703), 3:137r. Latin: *Sub arbore malo:* [first interpretation] *Ecclesiae de Gentibus . . . de Synagoga ut fit haec arbor malus ipse Christus . . . vel ipsa Crux Christi. . . . Ibi corrupta est mater tua, id est synagoga . . .* [second interpretation] *sub arbore ligni vetiti corrupta est mater ejus . . . scilicet tam Eva.*

99. The Franciscan order, of which Nicholas of Lyra was a member, pioneered a Christian Hebraism aimed at recuperating the plain sense of Scripture. See Deeana Copeland Klepper, "Nicholas of Lyra and Franciscan Interest in Hebrew Scholarship," in Philip D. W. Krey and Lesley Smith, eds., *Nicholas of Lyra: The Senses of Scripture* (SHCT 90; Leiden: Brill, 2000), 289–311. Ari Geiger has discussed Nicholas of Lyra's use of Hebrew and of rabbinic interpretation in his biblical exegesis, showing that the Hebrew sources were used as tools both for understanding the plain sense of the text and for resolving exegetical difficulties. Ari Geiger, "A Student and an Opponent: Nicholas of Lyra and His Jewish Sources," in *Nicolas de Lyre: Franciscain du XIVe siècle*, ed. Gilbert Dahan (MATM 48; Paris: Institut d'études Augustiniennes, 2011), 167–203.

100. James George Kiecker, trans., *The Postilla of Nicholas of Lyra on the Song of Songs* (RTTBS 3; Milwaukee: Marquette University Press, 1998), 112–15. Latin: *Sub arbore malo, id est, per virtutem sanctae crucis et tuae passionis. . . . Et sciendum quod littera malo non est hic ajiectivum, ut credunt aliqui, exponent hoc de arbore vetita Ade et Eve, quia in Hebraeo pro istis duabus dictionibus, arbore malo, ponitur punica, quae significat malogranatum, ideo exposition illa procedit ex ignorantia idiomatis Hebraei*; Nicholas of Lyra, *Biblia cum postillis* (Venice: Franciscus Renner, 1482), vol. 2, *ad* Song of Songs 8:5. I have twice departed from Kiecker's translation. He renders *sciendum quod littera malo non est hic ajiectivum* as "You must also realize that the word 'apple' here is not an adjective," but Nicolas is not arguing that "apple" is not an adjective (how could it be?), but rather that

malum is not the adjective "evil" in the phrase *sub arbore malo*. Furthermore, Kiecker translates *pro istis duabus dictionibus, arbore malo, ponitur punica* as "Instead of two words 'apple tree,' there is only one word, 'red,' which refers to a pomegranate tree." Latin *punica* can mean "red" when it denotes the red dye associated with Phoenicia, but here it is an elliptical form of *malum punicum*, "pomegranate" (in the feminine because it is modifying the feminine noun *arbor*, "tree").

101. Lyra's claim may be based on a gloss to Song of Songs 2:3 in Rabbi Shimon of Frankfurt's medieval compilation *Yalqut Shimoni*: "As a *tapuaḥ* among the trees of the woods: even the vacuous among [the Children of Israel] are as full of commandments as a pomegranate," *Yalqut Shimoni* (Jerusalem: n.p., 1975), 2:1069. I thank Ari Geiger for calling this text to my attention.

102. Assuming *malum* denotes "apple" for him, and not "fruit," as it does for Avitus.

Chapter Three

1. J. B. Trapp, "The Iconography of the Fall of Man," in C. A. Patrides, ed., *Approaches to Paradise Lost: The York Tricentenary Lectures* (Toronto: University of Toronto Press, 1968), 223n1. Works that address some aspect of the iconography of the Fall include Sigrid Esche, *Adam und Eva: Sündenfall und Erlösung* (Düsseldorf: L. Schwann, 1957); Ernst Guldan, *Eva und Maria: Eine Antithese als Bildmotiv* (Graz: Bohlau, 1966); Bellarmino Bagatti, "L'iconografia della tentazione de Adamo ed Eva," *Liber Annus* 31 (1981): 217–30; Hans Martin von Erffa, *Ikonologie der Genesis: Die christlichen Bildthemen aus dem Alten Testament und ihre Quellen* (Berlin: Deutscher Kunstverlag, 1989); Vasiliki V. Mavroska, "Adam and Eve in the Western and Byzantine Art of the Middle Ages" (PhD diss., Johann Wolfgang Goethe University, 2009); Ovadis, "Abstraction and Concretization of the Fruit of The Tree of Knowledge of Good and Evil." The bibliography contains a list of the databases used to compile the images used in this chapter.

2. Tom Devonshire Jones, Linda Murray, and Peter Murray, eds, *The Oxford Dictionary of Christian Art and Architecture*, 2nd ed. (Oxford: Oxford University Press, 2013), s.v. "apple," 29.

3. This chapter does not examine scenes that either do not represent the Tree of Knowledge/forbidden fruit, or represent them in a way that does not allow for their botanical identification.

4. The importance of the fig in early Christian art and its historical longevity are discussed at length in Oswald Goetz, *Der Feigenbaum in der religiösen Kunst des Abendlandes* (Berlin: Mann, 1965). Goetz argues that the apple tradition emerged from the early Christian encounter with Greco-Roman myth ("[Der Apfel] muß aus dem griechisch-römischen Mythos in die frühchristliche Bildvorstellung gelangt sein," 25), even as his book documents the dominance of the fig tradition among those Christians who were in closest contact with pagan society.

5. A catalogue of biblical themes in catacomb frescoes can be found in Norbert Zimmerman, *Werkstattgruppen römischer Katakobenmalerei* (JACE 35; Münster: Aschendorff, 2002).

6. Important sources for the study of sarcophagi include the *Repertorium der christlichantiken Sarkophage* series: vol. 1, *Rom und Ostia*, ed. Friedrich Wilhelm Deichmann, compiled by Giuseppe Bovini and Hugo Brandenburg (Wiesbaden: Franz Steiner, 1967); vol. 2, *Italien mit einem Nachtrag Rom und Ostia, Dalmatien, Museen der Welt*, ed. Jutta Dresken-Weiland, compiled by Giuseppe Bovini und Hugo Brandenburg (Mainz: Philipp von Zabern, 1998); vol. 3, *Frankreich, Algerien, Tunisien*, ed. Brigitte Christern-Briesenick, compiled by Giuseppe Bovini und Hugo Brendenburg (Mainz: Philipp von Zabern, 2003); and the *Ikonographisches Register für das Repertorium christlich-antiken Sarkophage*, ed. Ulrike Lange and Brigit Kilian (Dettelbach: Roll, 1996). For a list of sarcophagi that depict the Fall of Man, see Guntram Koch, *Frühchristliche Sarkophage* (HA; Munich: Beck, 2000), 135–36.

7. See Elizabeth Struthers Malbon, *The Iconography of the Sarcophagus of Junius Bassus* (Princeton, NJ: Princeton University Press, 1990), especially 59–58. Malbon's discussion of the Fall of Man focuses on the scene's typological ties with the Daniel story.

8. Antonio Mostalac Carrillo has recently reinterpreted the "assignment of tasks" theme in the Dogmatic Sarcophagus, arguing that the scene does not depict the assignment of postlapsarian tasks, but rather the promise of Christ's continued presence with fallen humanity and of humanity's ultimate redemption. For a full discussion of this original and intriguing proposal, see Antonio Mostalac Carillo, "La iconografía del ciclo de Adán y Eva en el sarcófago de la receptio animae de la basílica menor de Santa Engracia (Zaragoza)," in *Miscelánea de estudios en homenaje a Guillermo Fatás Cabeza* (Zaragoza: Institución Fernando el Católico, 2014), 539–48.

9. These sarcophagi were previously dated to the fifth to seventh century, but most scholars now date them to the fourth century. See Simon Esmonde Cleary, *Rome in the Pyrenees: Lugdunum and the Covnenae from the First Century B.C. to the Seventh Century A.D.* (RMCS; London and New York: Routledge, 2008), 115–19, and the literature cited there. There is ongoing debate as to whether these sarcophagi were produced at an atelier in Arles, or imported from Rome. Scholars have employed various criteria to determine the sarcophagi's provenance: stylistic proximity to (or dissimilarity from) established workshops in Rome, historical records concerning the existence of an Arles workshop, and attempts to determine the source of the marble. The matter remains controversial, but in map 1 the sarcophagi are located in France.

10. On the sarcophagus, see Mostalac Carrillo, "La iconografía," 539–48, with bibliography at 539n2. On the workshop, see 544 and the literature cited in n. 20.

11. Gisela Cantino Wataghin refers to this as the Christian "silence" within Roman visual culture, i.e., the tendency of Christian households to maintain Roman visual identity. Cantino Wataghin, "I primi cristiani, tra *imagines, historiae,* e *pictura*: Spunti di riflessione," *Antiquité tardive* 19 (2011): 13–33.

12. Jaś Elsner, "Inventing Christian Rome: The Role of Early Christian Art," in Catherine Edwards and Greg Woolf, eds., *Rome the Cosmopolis* (Cambridge: Cambridge University Press, 2003), 71–99, quote at 76–77.

13. A famous example is the Projecta Casket. Part of the Esquiline Treasure, a late fourth-century hoard of silver pieces unearthed in 1793 on the Esquiline Hill in Rome, the Projecta Casket is an engraved silver box with scenes including Venus bathing and nude Erotes, as well as an explicitly Christian inscription.

14. An outstanding example of juxtaposition is the Christian sarcophagus (Capitoline Museum no. 150) that portrays the Fall of Man alongside the god Hephaestus in his smithy as part of a creation scene. See Paul Zanker and Björn C. Ewald, *Living with Myths: The Imagery of Roman Sarcophagi*, trans. Julia Slater (OSACR; Oxford: Oxford University Press, 2012), 54, illustration 42; and Dieter Korol, *Die frühchristlichen Wandmalereien aus den Grabbauten in Cimitile/Nola* (JACE 13; Münster: Aschendorffsche, 1987), 72.

15. The shared visual idiom may be the result of the material conditions of production. As Janet Huskinson noted nearly half a century ago, "Many artists who produced such works as sarcophagus reliefs were pagans or Christians trained in workshops that turned out pagan, Christian, 'neutral,' and sometimes Jewish designs to please all customers." Huskinson, "Mythological Figures and Their Significance in Early Christian Art," *Papers of the British School at Rome* 42 (1974): 69.

16. See the discussion of Endymion and Jonah in David L. Balch, "From Endymion in Roman *Domus* to Jonah in Christian Catacombs: From Houses of the Living to Houses of the Dead; Iconography and Religion in Transition," in *Commemorating the Dead: Texts and Artifacts in*

Context—Studies of Roman, Jewish, and Christian Burials, ed. Laurie Brink, OP, and Deborah Green (Berlin: De Gruyter, 2008), 273–302. The iconographic kinship with Endymion was so powerful that "the most popular Old Testament scene depicted by the Early Christian artists was Jonah, lying asleep, naked, under a booth covered by a climbing gourd vine" (the pose of Endymion whom Zeus placed in eternal slumber), and not in the belly of the fish. Bezalel Narkiss, "The Sign of Jonah," *Gesta* 18 (1979): 63. For a broader discussion of this phenomenon, see Mary-Anne Zagdoun, "De quelques thèmes et motifs traditionnels ou païens sur les sarcophages paléochrétiens," *Semitica et classica* 2 (2009): 157–166, and the references at n. 2. It should be underlined that the influence was reciprocal. Jaś Elsner notes, "In the early part of the third century (at least, according to the fourth-century evidence of the *Historia Augusta*), no less a person than the emperor Severus Alexander (222–35) worshipped a very odd mixture of gods in his private shrine: his deified imperial predecessors shared honours with the wise man Apollonius of Tyana as well as Jesus Christ, Abraham, Orpheus, Vergil, Cicero, Achilles, and Alexander the Great!" Elsner, *Imperial Rome and Christian Triumph: The Art of the Roman Empire, AD 100–450* (OHA; Oxford: Oxford University Press, 1998), 219. See also Elsner's discussion of the pagan appropriation of Christian imagery, e.g., the Christ-like image of the infant Dionysus on the Nea Paphos mosaic in Cyprus (220).

17. Hercules is charged with taking a *mēlon*, a Greek word that can refer to other fruit as well as the apple. Early representations of the eleventh labor depict the fruit as a quince (the temple of Zeus at Olympia and the Farnese Hercules—and the earlier work on which it is based; Warburg Iconographic Database 14457 and 12465, respectively), and a citron (Roman numismatic images); see Samuel Tolkowsky, *Hesperides: A History of the Culture and Use of Citrus Fruits* (London: John Bale, Sons & Curnow, 1938), 71–75. However, there is clear evidence that the fruit of the Hesperides was also identified as the apple. The *Deipnosophistai*, a late second-century CE work by Athenaeus of Naucratis, recounts a series of banquets attended by learned guests who discoursed on various topics. Concerning the apple, they report that "Timachidas says in Book IV or the *Dinner Parties* that certain apples are referred to as apples of the Hesperides. Pamphilus says that in Sparta these are served to the gods; they are sweet smelling, but inedible, and are referred to as apples of the Hesperides. Aristocrates, at any rate, says in Book IV of the *History of Sparta*: also apples and what are called the apple trees of the Hesperides." Athenaeus, *The Learned Banqueters*, ed. and trans. S. Douglas Olson (LCL 204; Cambridge, MA: Harvard University Press, 2006), Book III, 82e, 3:457. Athenaeus's banqueters are also familiar with a citron tradition: "Aemilianus claimed that Juba, the king of the Mauritanians, a very learned man, mentioned the citron in his treatise on Libya and asserted that the Libyans referred to it as an apple of Hesperia and that Heracles brought some of these, which were called gold apples because of their appearance, to Greece" (Book III, 83b; Olson, 3:459).

18. Francisco Diez de Velasco argues that the tree of the Hesperides was understood as an *axis mundi* (a claim based in part on the role of Atlas in certain versions of the myth), and that Hercules's entrance into the garden represented a passage into the world of the gods—signs of a deeper thematic affinity between the pagan and biblical tales. See Diez de Velasco, "Marge, axe et centre: Iconographie d'Héraclès, Atlas et l'arbre des Hespérides," in V. Pirenne-Delforge and E. Suárez de la Torre, *Héros et héroïnes dans les mythes et les cultes grecs: Actes du Colloque organisé à l'Université de Vallodolid du 26 au 29 mai 1999* (KS 10; Liège: Centre International d'Étude de la Religion Grecque Antique, 2000), 197–216.

19. The iconographic database of the Warburg Institute (https://iconographic.warburg.sas.ac.uk) offers many scenes of Hercules and Hesperides.

20. See Marion Lawrence, "The Velletri Sarcophagus," *American Journal of Archaeology* 69 (1965): 207–22. Lawrence discusses Hercules and the Apple of the Hesperides at 214, and the two women by the tree ("At the left is another beautifully carved tree in high projection, on either side of which two women stretch their right arms upward towards the fruit.... [The] tree... is certainly not a poplar but closely resembles the apple tree of the left end") at 217. On the iconography of the labors of Hercules, see E. Loeffler, "Lysippos' Labors of Herakles," *Marsyas* 6 (1954): 8–24; and J. Bayet, "Hercule funéraire," *Mélanges d'archéologie et d'histoire* 39 (1921–22): 219–66, and 40 (1923): 19–102. Korol has already noted the iconographic relevance of the Velletri sarcophagus to early Christian Fall of Man scenes, referring specifically to the Mas d'Aire Sarcophagus and the Fall of Man at Dura-Europos; Korol, *Die frühchristlichen Wandmalereien*, 72.

21. There is not a single Fall of Man scene in the *Corpus der byzantinischen Miniaturhandschriften* series: Irmgard Hutter, *Oxford College Libraries* (DB 13; Stuttgart: Anton Hiersemann, 1997); Irmgard Hutter, *Oxford Christ Church* (DB 9; Stuttgart: Anton Hiersemann, 1993); and Irmgard Hutter, *Oxford Bodleian Library* (DB 2; Stuttgart: Anton Hiersemann, 1982); nor, in Axinia Džurova, *Répertoire des manuscrits grecs enlumiés (IXe–Xe s.)* (Sofia: University of Sofia, 2006); nor, again, in Annemarie Weyl Carr, *Byzantine Illumination 1150–1250: The Study of a Provincial Tradition* (SMMI 47; Chicago: University of Chicago Press, 1987).

22. Kurt Weitzmann had identified these Octateuchs as part of a single recension originating in Constantinople, a view later challenged by John Lowden. See Kurt Weitzmann, Massimo Bernabò, and Rita Tarasconi, *The Illustrations in the Manuscripts of the Septuagint*, vol. 2, *Octoteuchs* (Princeton, NJ: Princeton University Press, 1999) (the relevant works are reproduced as plates 84, 85, and 86, respectively); and John Lowden, *The Octateuchs: A Study in Byzantine Manuscript Illumination* (College Park, PA: Penn State University Press, 1992), especially 95–102.

23. There is also a tree in the middle of the composition, but it is visually distinct from the Tree of Knowledge, perhaps a different tree altogether (the Tree of Life?).

24. See Anna Marava-Chatzinicolaou and Christina Toufexi-Paschou, *Catalogue of the Illuminated Byzantine Manuscripts of the National Library of Greece* (Athens: Academy of Athens, 1997), 3, fig. 16.

25. Trapp, "The Iconography of the Fall of Man," 236.

26. See Herbert Kessler, *The Illustrated Bibles from Tours* (SMI 7; Princeton, NJ: Princeton University Press, 1977). An important source for the history of these illuminated manuscripts is the illustration tradition of the Cotton Genesis recension. The Cotton Genesis was a fifth- or sixth-century Greek codex from Alexandria, named for the English collector Robert Cotton (1571–1631). The codex was damaged in a fire, but art historians have identified its illustrations as the model (direct or indirect) for, inter alia, the Grandval Bible, the Bamberg Bible, the Bible of San Paolo fuori le Mura, and the Millstatt Genesis, as well as the post-Carolingian Salerno Antependium, the San Marco mosaics, and the *Histoire Universelle*. See the discussion in Kurt Weitzmann and Herbert L. Kessler, *The Illustrations in Manuscripts of the Septuagint*, vol. 1, *The Cotton Genesis: British Library Codex Cotton Otho B. VI* (Princeton, NJ: Princeton University Press, 1986).

27. Note Kessler's observation that "the fig tree is common to all members of the recension"; Herbert L. Kessler, "*Hic Homo Formatur*: The Genesis Frontispieces of the Carolingian Bibles," *Art Bulletin* 53 (1971): 156.

28. This approach guides the classification of the species in the maps at the end of each section, a determination made on the basis of the image within the broader iconographic environment.

29. John McPhee, *Oranges* (New York: Farrar, Straus and Giroux, 1966), 69.

30. Some scholars claim sweet oranges were introduced earlier, but even they concede that "there was little distinction between sweet and sour oranges in the fourteenth and fifteenth centuries because they were used as a condiment or medicinal agent, not as an eating fruit"; Clarissa Hyman, *Oranges: A Global History* (London: Reaktion, 2013), 16.

31. The golden apple is associated with the apple of discord that the goddess Eris ("discord," "strife") threw into a banquet of the gods as a prize for the most beautiful. Three goddesses, Aphrodite, Hera, and Athena, claimed it for themselves, the ensuing conflict ultimately leading to the Trojan War. The golden apple is also associated with the apple of the Hesperides.

32. Additional examples include the Fall of Man scenes from the Egerton Master (BL Royal 19 D III, fol. 8v) and the Master of the Cité des dames (BL Royal 20 C, IV, fol. 8r), both early fifteenth century.

33. Scholars have offered different explanations for the emergence of this motif. See John K. Bonnell, "The Serpent with a Human Head in Art and in Mystery Play," *American Journal of Archaeology* 21 (1917): 255–91, who argues that the conventions of the mystery plays were instrumental in the emergence and propagation of the motif; Henry A. Kelly, "The Metamorphoses of the Eden Serpent during the Middle Ages and Renaissance," *Viator* 2 (1971): 301–27; more recently, Shulamit Laderman has pointed to a rabbinic wordplay based on the similarity of the Aramaic word for "snake" and the name "Eve" as a possible source; Laderman, "Two Faces of Eve: Polemics and Controversies Viewed through Pictorial Motifs," *Images* 2, no. 1 (2008): 1–20. For an example of the serpent with Adam's visage, see the early fifteenth-century *Life of Christ*, BnF lat. 9586, fol. 3v.

34. Fully dressed: BnF fr. 160, fol. 8v; dragon at Eve's feet: BnF fr. 598, fol. 6v.

35. Ferdinand Werner identifies the fruit as an apple; Werner, *Aulnay de Saintonge und die romanische Skulptur in Westfrankreich* (Worms: Wernersche Verlagsgesellschaft, 1979), 53. It is difficult to ascertain whether this is correct.

36. Franco Júnior ("Between the Fig and the Apple," 3, n5), citing Marcel Durliat, *Pyrénées romanes* (La Pierre-qui-Vire: Zodiac, 1978), 42. I am not certain that the identification is correct.

37. Beatus: BnF lat. 8878, fol. 45r; Latin Bible: BnF lat. 10, fol. 3v; Anchin Bible: Bibliothèque municipale de Douai MS 2, fol. 7r. This last work dates to the middle of the twelfth century, so its inclusion is a slight anachronism.

38. St. Fuscien Psalter: Bibliothèque municipale Amiens MS 19, fol. 7r. These apples, of course, make the identification of round, apple-sized fruits as apples more probable, e.g., those at Aulnay de Saintonge, Neuilly en Donjon, Angers, and the second Fall of Man scene at Cluny.

39. There are few exceptions: the forbidden fruit in the Missal of Corbie Abbey is round and apple-sized but green (Amiens, Bibliothèque municipale 157, fol. 128v); an early fourteenth-century Parisian *Bible historiale* has, perhaps, a large citron (BL Yates Thompson 20, fol. 1r); and in a 1316 manuscript of *L'estoire del Saint Graal* Eve is not holding a fruit, but rather a stalk (BL Add. 10292, fol. 31v).

40. See Samantha Zacher, *Rewriting the Old Testament in Anglo-Saxon Verse: Becoming the Chosen People* (London: Bloomsbury, 2013).

41. C. M. Kauffmann, *Biblical Imagery in Medieval England, 700–1550* (HMSAH 34; Turnhout: Brepols, 2003), 37–39.

42. BL Cotton Claudius B.IV, fol. 7r and Chester Beatty Library W 022, fol. 8v, respectively. On the Hexateuch illuminations, see C. R. Dodwell, "L'originalité iconographique de plusieurs illustrations anglo-saxonnes de l'Ancien Testament," *Cahiers de civilisation médiévale* 56 (1971):

319–28. Kauffmann (*Biblical Imagery*, 67) sees a parallel to this composition in the Carolingian Vivian Bible.

43. Typical examples include the St. Albans Psalter, the Golden Munich Psalter, and the Canterbury Psalter.

44. Morgan M.628, fol. 2r (possibly from Ramsey Abbey, north of Cambridge) and Morgan G.42, fol. 6r, respectively.

45. Fig: BnF fr. 14969, fol. 58v; BL Royal 14 B IX; Walters W.102, fol. 28v; small and round fruit: Morgan M.761, fol. 10r; Morgan M.766, fol. 23v; eschew botanical naturalism: BSB Clm. 835, fol. 8v. Note: The map of England's forbidden fruit iconography appears below, together with Germany and the Low Countries.

46. I have omitted from this survey a number of northern European works that incorporate the Fall of Man as a smaller motif within a larger composition (e.g., Rogier ven der Weyden's "Saint Luke Drawing the Virgin," the Saint Columba Altarpiece triptych, and Albert Bouts's "Annunciation"). The Fall of Man images in these works are not detailed enough to contribute to this analysis.

47. Adam Cohen and Ann Derbes refer to the forbidden fruit as an apple in their study of the doors' Fall of Man iconography (Adam S. Cohen and Anne Derbes, "Bernward and Eve at Hildesheim," *Gesta* 40, no. 1 [2001]: 19–38), and while this possibility cannot be excluded, the fruit has no distinctive apple morphology. The botanical identity of the forbidden fruit is not the focus of Cohen and Derbes's study, and the apple reference may be an aside, as it clearly is when they refer to Eve taking "the apple from the serpent" in the Grandval Bible (22), where the fruit is clearly a fig.

48. Pomegranate psalters: Morgan M.338, fol. 42r and Free Library of Philadelphia, Lewis E M 17:1 to Psalm 97; apple-sized fruit: BSB Clm. 935, fol. 4v (Prayerbook of Hildegard of Bingen), Morgan M.739, fol. 9r; small round fruit: BSB Clm. 14061, fol. 2v and the Gurk Cathedral Fresco (Austria).

49. Meister HL, *The Fall of Man* (1520–30), in Freiburg's Augustiner Museum. On the iconographic context of Meister HL's work, see Ingrid Alexander-Skipnes, "Translating the Northern Model: *Adam and Eve in Paradise* Attributed to Master H.L.," in *The Sides of the North: An Anthology in Honor of Professor Yona Pinson*, ed. Tamar Cholcman and Assaf Pinkus (Newcastle upon Tyne: Cambridge Scholars, 2015), 133–53. Note that Meister HL depicts the forbidden fruit as an apple in the Fall of Man roundel discussed in Megan L. Erickson, "From the Mouths of Babes: Putti as Moralizers in Four Prints by Master H.L." (master's thesis, University of Washington, 2014), 71, figure 7.

50. Among these the Ebstorf Map, the Seitenstetten Gospel Book (Morgan M.808, fol. 196r), and the Grosbois Psalter-Hours (Morgan M.440, fol. 16r).

51. Speculum humanae salvationis: BL Harley 3240, fols. 5r-5v and BL Arundel 120, fols. 4v-5r; stained-glass windows: Choir, window 1, row 2, Parish Church of St. Dionysius, Esslingen; altar decorations: the master of the Berswordt Altar, Neustädter Marienkirche, Bielefeld.

52. As von Erffa notes, in Dürer's etching the Tree of Knowledge has the leaves of a fig but the fruit of an apple (*Ikonoloige der Genesis*, 122). Similar hybrid trees are found in the illustration of the National Library of Greece, MS 211 (pomegranate fruit with grape leaves), the Salerno Antependium, and the Augsburg Psalter. I thank Penny Howell Jolly for alerting me to the significance of this phenomenon (pers. comm.).

53. Of Cranach's Fall of Man works, "today more than fifty paintings are known, and they represent only a small fraction of the works originally produced"; Gunnar Heydenreich, "Adam

and Eve in the Making," in Caroline Campbell, ed., *Temptation in Eden: Lucas Cranach's Adam and Eve* (London: Courtauld Institute of Art Gallery, 2007), 19.

54. A few examples: *The Illustrated Bartsch*, vol. 80, Anonymous, "Belial Showing Solomon Adam and Eve," published 1472; vol. 80, Anonymous, "The Fall of Man," ca. 1473; vol. 84, Anonymous "Adam and Eve in Paradise," published in 1483; vol. 161, Anonymous Artists, "Adam and Eve," 15th century; vol. 85, Anonymous Artists, "The Temptation of Adam and Eve," part of the Buch der Tugend series, 1486; vol. 86, "Adam and Eve," part of the de Claris Mulieribus series, 1488, and so on into the sixteenth century.

55. Padua medallion: Morgan, M.436, fol. 4r; *Postilla*: BnF lat. 364, which has not been digitized but is available for examination at the Bibliothèque nationale. A Book of Hours and Missal (BnF Smith-Lesouëf 22, fol. 89a) may have the apple, but the identification is not certain. Mirandola Book of Hours: BL Add. 50002, fol. 13r; Farnese Hours: Morgan M.69, fol. 27r.

56. Goetz, *Der Feigenbaum*, 34.

57. These include Benedetto Antelami's Fall of Man capital in Parma, the exterior facade of the San Zeno Maggiore in Verona, and Bonnanus of Pisa's bronze doors in the Monreale Cathedral. Italian manuscript illustrations are not numerous, and the forbidden fruit is not always easy to identify (though as a rule it is not an apple). See the Fall of Man scenes in the Monte Cassino Exultet Roll, the Giant Bible from Todi, and the Bible of Santa Maria del Fiore.

58. Padua: Morgan, M.436, fol. 4r and Giusto de' Menabuoi, Baptistery of St. John; Bologna Michele di Matteo Lambertini, *Dream of the Virgin*; Milan: BnF Smith-Lesouëf 22, fol. 89r and BnF lat. 364; Mantua: Andrea Mantegna, Virgin of Victory; Venice: BL Add. 50002, fol. 13r (this may be Padua); Titian, *Fall of Man*; Jacopo Tintoretto, *Adam and Eve*; and Morgan, M.799, fol. 7v. BnF ital. 109 is not clearly an apple, but in any case from Cremona, also in the north. The motif of Madonna and Child with Apple, which portrays baby Jesus holding an apple, is also concentrated in northern Italy, including works by Giovanni Bellini (Venice), Benvenuto Tisi da Garofalo (Ferrara), Luini (Milan), Ambrosius Benson (who is considered part of the Flemish school but was Italian), and several paintings by Carlo Crivelli (Venice).

59. Clovio (Juraj Julije Klović) was trained in the household of Cardinal Marino Grimani, whose family was part of the Venetian patriciate and lived much of his adult life in northern Italy. See Elena Calvillo, "Imitation and Invention in the Service of Rome: Giulio Clovio's Works for Cardinals Marino Grimani and Alessandro Farnese" (PhD diss., The Johns Hopkins University, 2003).

60. See, respectively, Peter Stabel, "Venice and the Low Countries: Commercial Contacts and Intellectual Aspirations," in *Renaissance Venice and the North: Crosscurrents in the Time of Bellini, Dürer, and Titian*, ed. Bernard Aikema and Beverly Louise Brown (New York: Rizzoli, 1999), 31–43; and Bernd Roeck, "Venice and Germany: Commercial Contacts and Intellectual Aspirations," in *Renaissance Venice and the North*, 45–55.

61. Bernard Aikema, "The Lure of the North: Netherlandish Art in Venetian Collections," in *Renaissance Venice and the North*, 82–91. Titian was in Augsburg in 1548 and again in 1550–1551 in the employ of Charles V.

62. Thirteenth century: two illustrations in Biblioteca nazionale di Firenze B. R. 20, fol. 51r and one in Escorial Cod. T.I.1, fol. 88v, both manuscripts of the Cantigas de Santa Maria; fourteenth century: BL Yates Thompson 31, fol. 88r; fifteenth century: painting by the Maestro de Salomón de Fromista; sixteenth century: a cross (Cruz de Humilladero) and a retable (Oñati).

63. Note the Latin phrase *arbor fici*, "fig tree," at the top of the Beatus image.

64. Martina Horn, *Adam-und-Eva-Erzählungen im Bildprogramm kretischer Kirchen: Eine ikonographische und kulturhistorische Objekt- und Bildfindungsanalyse* (BzOO 16; Mainz: Verlag

des Römisch-Germanischen Zentralmuseums, 2020). The image is from the Church of the Metamorphosis in Pandeli near Chandras, Crete. See Horn, *Adam-und-Eva-Erzählungen*, 95–98, and plates 94, 1–2 and 95, 1–2. The other Cretan scenes represent the Tree of Knowledge as either botanically unrealistic, or as a palm tree, and see Horn's summary at 106. My thanks to Gary Rendsburg, who brought this book to my attention.

65. The image appears in Geller, "*The Sea of Tiberias*," figure 5. Figure 4 in the book is a late seventeenth- or early eighteenth-century Bulgarian plinth panel of the expulsion of Adam and Eve that includes a heavenly figure (his head is adorned with a halo, but he is without wings) by a large cluster of grapes. I am not certain how to interpret the presence of the fruit, since the plinth also has a Fall of Man scene that includes a botanically unclear Tree of Knowledge and no representation of the forbidden fruit. I thank Florentina Badalanova Geller for generously sharing these images with me.

66. At the time, Naples was part of the French Angevine kingdom and the earliest of these works is the Anjou Bible. John Lowden discusses the uniquely Angevine iconographic elements in this work (without addressing the identity of the Tree of Knowledge) in his "The Anjou Bible in the Context of Illustrated Bibles," in Lieve Watteeuw and Jan Ven der Stock, eds., *The Anjou Bible, A Royal Manuscript Revealed: Naples 1340* (CIM 18; Paris: Peeters, 2010), 1–25. A number of Latin texts refer to the Tree of Knowledge having *palmes* (genitive: *palmitis*), "young branch, shoot," but the word is easily confused with *palma, palmae*, "palm." Could this error have given rise to the palm iconography? See, for example, Avitus of Vienne (discussed in chapter 2), who describes "the happy young people [Adam and Eve] . . . plucking red apples from a green branch (*palmite*)"; Avitus, *De spiritualis historiae gestis*, 2.139; English translation, Shea, *The Poems*, 183. See also Commodian, *Instructions*, 1.35, which in some manuscripts states that "Belial was [Adam's] tempter by the lust of the palm tree" (Robert Ernest Wallis translation in ANF 4.209), though Poinsotte prefers the reading *plasme* ("creature") to *palmae* ("palm"); Poinsotte, *Commodien, Instructions*, 38, line 2 and the critical apparatus.

67. Morgan M.7, fol. 3r. Not coincidentally, mangos were introduced into Europe in the fifteenth century as part of the Portuguese spice trade.

68. See Snyder, "Jan Van Eyck and Adam's Apple."

Chapter Four

1. "There is little that a modern-day horticulturist could have taught the 1st century A.D. writers Columella, author of *De Re Rustica*, or Pliny the Elder"; Juniper and Mabberley, *The Story of the Apple*, 100.

2. Erika Janik, *Apples: A Global History* (London: Reaktion Books, 2011), 23. "From Burgundy, the Cistercians sent apple varieties to northern and eastern Germany and grafts were sent from Paris to Denmark"; Joan Morgan and Alison Richards, *The New Book of Apples* (London: Ebury, 2003), xi. I thank Natan Paradise of the University of Minnesota for suggesting the relevance of the Cistercians to my argument.

3. Hrabanus Maurus, *De universo* (PL 111.367), quoted in Paolo Squatriti, *Landscape and Change in Early Medieval Italy: Chestnuts, Economy, and Culture* (Cambridge: Cambridge University Press, 2013), 92. See also the grafting-related sources collected in H. Frederic Janson, *Pomona's Harvest: An Illustrated Chronicle of Antiquarian Fruit Literature* (Portland, OR: Timber Press, 1996), 14–27.

4. *Capitulare de villis* §70, in A. Boretius, ed., *Capitularia regnum Francorum* (MGH; Hanover: Hahniani, 1883), 90; English translation, H. R. Loyn and J. Percival, *The Reign of Charlemagne*:

Documents on Carolingian Government and Administration (DMH 2; London: Hodder & Stoughton, 1975), 73.

5. Mirella Levi D'Ancona refers to a single scholarly claim linking the pear and the forbidden fruit, but the author in question "did not give his source"; Levi D'Ancona, *The Garden of the Renaissance: Botanical Symbolism in Italian Painting* (AA 10; Florence: Olschki, 1977), 298. Augustine is tempted to steal pears in Book 2 of the *Confessions,* and the pear is the fruit of seduction in the thirteenth-century Old French *Le roman de la poire* by Thibaut, so the pear was associated with temptation, but not with the forbidden fruit.

6. *Oxford Latin Dictionary,* s.v. "pōmum," 1400. See the discussion above, chapter 2.

7. On semantic narrowing, see Francis Katamba, *English Words: Structure, History, Usage* (New York: Routledge, 2015), 175. Some examples of semantic narrowing in English include *meat,* which earlier meant "food," and only later "edible animal flesh"; *wife,* which earlier meant "woman" and only later "married woman"; *deer* which earlier meant "animal" and only later "a hoofed ruminant"; and *starve,* which earlier meant "to die" and only later "to die of hunger."

8. Alain Rey, *Dictionnaire historique de la langue française* (Paris: Le Robert, 2016), s.v. "pomme," 1573. Wilhelm Meyer-Lübke identifies dialectical reflexes of *malum* that survived into the twentieth century (see Meyer-Lübke, *Romanisches etymologisches Wörterbuch* [Heidelberg: C. Winter, 1911], 5272 and 6645). To these one should add the Provençal wish for an "année pommeuse," presumably a wish for a bountiful year, rather than one blessed specifically with apples. See Adrien Jean Victor Le Roux de Lincy, *Le livre des proverbes français* (Paris: Paulin, 1842), 61.

9. A modern English analogue is the word *melon,* which denotes a broad class of sweet gourds (e.g., the watermelon) and is also used more narrowly to refer to a cantaloupe or honeydew melon.

10. Thus in the Old French Bible, the first full vernacular translation of the Bible, and in the thirteenth-century Guyart des Moulins's *Bible historiale.* See Michel Quereuil, *La Bible française du XIIIe siècle: Édition critique de la Genèse* (PRF 183; Geneva: Droz, 1988), 95 (*arbres portant pomes*); and Mayumi Taguchi, *The Historye of the Patriarks: Edited from Cambridge, St John's College MS G.31; with Parallel Texts of "The Historia Scholastica" and the "Bible Historiale"* (METS 43; Heidelberg: Universitätsverlag Winter, 2010), 12 (*arbres portans pommes*). The *Bible historiale,* a translation of Peter Comestor's *Historia scholastica,* was a very popular text.

11. Tony Hunt, ed., *Le Chant de Chanz* (ANTS 61–62; London: Anglo-Norman Text Society, 2004), line 1564: *Icele poume ad muz de greins.*

12. Hunt, *Le Chant de Chanz,* line 1978. The Vulgate is *fructum pomorum suorum.* The translator does not, however, use *pom* to render Latin *malum.* At Song of Songs 2:3 ("As an apple tree [*sicut malum*] among the trees of the woods"), he writes: "Saint Jerome tells us that there ought to be many clergy / for the *malus* is a tree that produces much fruit" (lines 837–39: *Seint Jeronime nus dist ke mut sout de clergie / Ke malus est un arbre ke mut frutefie*). And the tree of Song of Songs 8:5 ("Under the apple tree [*sub arbore malo*] I awakened you") is *arbre male,* an Anglo-Norman transliteration of the Latin: *Desus la arbre male te ay resuscité / Quey est dunt par le arbre male ici désigné Fors la croyz u Jhesu Crist fu crucifié* ("Under the apple tree I awakened you: For it is there, by the *arbre male* mentioned here for the cross where Jesus Christ was crucified"; line 2679). According to the *Anglo-Norman Dictionary,* these translations of Song of Songs 2:3 and 8:5 are the only two occurrences of *male,* "apple tree," in Anglo-Norman literature, in which case we may dealing with nothing more than a transliteration of the Latin, rather than an organic part of the Anglo-Norman vocabulary.

13. Tony Hunt, *Plant Names of Medieval England* (Cambridge: D. S. Brewer, 1989), 167 and 212. After the introduction of the potato from the Americas into European agriculture, *pomme de terre* came to designate this crop only.

14. *Song of Roland* 29, line 386, in Ian Short, ed., "Part I: The Oxford Version," in *La Chanson de Roland—The Song of Roland: The French Corpus*, ed. Joseph J. Duggan (Turnhout: Brepols, 2005), 126. Old French: *en sa main tint une vermeille pume*. The English translation published in this series renders the Old French as "in his hand he held a bright red apple." See Joseph J. Duggan and Annalee C. Rejhon, trans., *The Song of Roland: Translations of the Versions in Assonance and Rhyme of the "Chanson de Roland"* (Turnhout: Brepols, 2012), 42. Some scholars link Roland's fruit to the forbidden fruit; see Rupert T. Pickens, "Roland's Apple: Truthful and Untruthful Discourse in *La chanson de Roland*," in *Studies in Honor of Hans-Erich Kelle: Medieval French and Occitan Literature and Romance Linguistics*, ed. Rupert T. Pickens (Kalamazoo: Western Michigan University, 1993), 73–80, and the literature cited in n. 5.

15. See Tony Hunt, *Teaching and Learning Latin in Thirteenth-Century England* (Cambridge: D. S. Brewer, 1991), 2:41, §81.

16. Guillaume de Lorris and Jean de Meune, *The Romance of the Rose*, trans. Charles Dahlberg (Princeton, NJ: Princeton University Press, 1995), 49, line 1347. See the entry *pomes* in Joseph R. Danos, *A Concordance of the "Roman de la Rose" of Guillaume de Lorris* (NCSRLL 3; Chapel Hill: University of North Carolina Press, 1975), 185. There is another fruit list that includes apples ("Send them apples, pears, nuts, or cherries, etc.") at line 8207 (Dahlberg, 152), which belongs to the second part of the work, composed by Jean de Meun ca. 1275.

17. "The Ordinances of York," appendix 1 in T. F. Tout, *The Place of the Reign of Edward II in English History* (Manchester: Manchester University Press, 1936), 249. An English version of the ordinances is found in F. J. Furvinal, ed., *Life-Records of Chaucer*, pt. 2 (London: Trübner, 1875), 13. Old French: . . . *pomes, pers, ciris et autrez fruytez qi le dit fruitier purvera*.

18. I have examined discussions of *pomiferum* (including occurrences other than Genesis 1:11) in the following authors: Vigilius, Bishop of Thapsus, 5th century, *Contra Eutychtem* (PL 62.113); Isidore of Seville, 6th–7th century, *Contra Judaeos* (PL 83.532); Bede, *Hexameron* (PL 91.21); Pseudo-Bede, *De sex dierum creatione* (PL 93.212 [2x], 93.217); Pseudo-Bede, *De psalmorum libro exegesis* (PL 93.867; Glorieux, *Pour revaloriser Migne*, 52, identifies the author as Manegold de Lautenbach); Hildefonsus Toletanus(?), *Libellus de corona virginis* (PL 96.305); Rabanus Maurus, *Commentariorum in Genesim* (PL 107.452); Rabanus Maurus, *Commentaria in Ezechielem* (PL 110.1055 [2x]); Rabanus Maurus, *De universo* (PL 111.174); Walafridus Strabo, *Liber Genesis* (PL 113.74; Glorieux, *Pour revaloriser Migne*, 56, identifies the author as Anselm of Laon); Angelomus Luxovensis, *Commentarius in Genesim* (PL 115.129); Johannes Scotus Erigena, *Peri Physeon* (PL 122.704); Hincmarus Rhemensis, *De cavendis vitiis et virtutibus exercendis* (PL 125.924); Remigius Antissiodorensis, *Commentarius in Genesim* (PL 131.56); Petrus Damianus, *Epistola* (PL 144.263); Petrus Damianus, *Liber qui appelatur gratissimus* (PL 145.129); Petrus Damianus, *Expositio mystica historiarum libri geneseos* (PL 145.842); Petrus Damianus, *Liber testimoniorum veteris ac novi testamenti* (PL 145.993); Guibertus S. Mariae de Novigento, *Moralia in Genesin* (PL 156.45, 58); Bruno Astensis, *Expositio in Genesim* (PL 164.152,155); Rupert Tuitiensis, *Commentarium in Genesim* (PL 167.229, 230); Rupert Tuitensis, *De glorificatione trinitatis et processione sancti spiritus* (PL 169.184); Honorius Augustodunensis, *Hexameron* (PL 172.256); Godefridus Admontensis, *Homilia* (PL 174.433, 434); Hugo de S. Victore, *Adnotationes elucidatoriae in pentateuchon* (PL 175.43); Hugo de S. Victore, *De sacramentis Christianae fidei* (PL 176.201–202); Guerricus Igniacensis, *In festo sancti benedicti* (PL 185.106); Petrus Cluniacensis,

Adversus nefandam sectam saracenorum (PL 189.701); Ernaldus Bonaevallis, *Libellus de donis spiritus sancti* (PL 189.1604); Hugo Rothomagensis, *Super fide catholica et oratione dominica* (PL 192.1340); Gerhohus Reicherspergensis, *Commenatrius aureus in psalmos et cantica ferialia* (PL 193.1122, 1140; 194.79); Aelredus Rievallensis, *Sermones de tempore et de sanctis* (*Sermo XXIV*) (PL 195.3501); Hildegardis, *Liber divinorum operum* (PL 197.927, 930, 931); Petrus Comestor, *Historia Scholastica* (PL 198.1059); Petrus Cellensis, *Sermones* (*Sermo XX*) (PL 202.700, 701); Petrus Cellensis, *Liber de panibus* (PL 202.947); Petrus Blesensis, *Sermones* (*Sermo XVII*) (PL 207.608); Sicardus Cremonensis, *De officiis ecclesiasticis summa* (PL 213.327); Innocentius III, *Sermones* (*de poenitentia*) (PL 217.687). None of these sources discuss the lexical meaning of *pomiferum*.

19. Peter Abelard, *Expositio in Hexameron*, 40. Latin: *Et lignum pomiferum. Hoc est arbores fructuosas . . . solet quippe pomum generaliter pro omni arboris fructu intelligi.*

20. Wanda Zemler-Cizewski, in her translation of Abelard's *Hexameron*, renders the Vulgate's *pomiferum* as "apple-bearing." This is plainly not the meaning of the word in Genesis 1:11, but the mistranslation allows her to avoid attributing to Abelard an apparent tautology (something along the lines of "the word *fruit-bearing* should be understood as denoting trees that bear fruit"). See Peter Abelard, *An Exposition on the Six-Day Work*, trans. Wanda Zemler-Cizewski (CCT 8; Turnhout: Brepols, 2011), 61. The confusion generated by the two senses of *pomum* can be seen in Peter Cramer's statement that "the Fall itself—which we have been expecting—comes up first with the mention of apple trees, which really in this case (Abelard explains) means any kind of tree that gives fruit." Peter Cramer, "Abelard on the First Six Days," in *Rethinking Abelard: A Collection of Critical Essays*, ed. Babette S. Hellemans (BSIH 229; Leiden: Brill, 2014), 294.

21. There is some evidence that this shift was already underway in the Latin of Roman Gaul, where *pomum* means "apple" in a number of sources. For example, Marcellus Empiricus, a late fourth- or early fifth-century medical author, perhaps in Bordeaux, prescribes as a remedy for bruises and pain relief a paste made of crushed barley and the rind of a pomegranate or of a *malum*, a word he immediately glosses as "a *pomum* that is eaten," i.e., an apple. Marcellus Empiricus, *De medicamentis liber*, 19.57, in *Marcelli De medicamentis liber*, ed. Georg Helmreich (Leipzig: Teubner, 1889), 185. (Latin: *Mali, id est, pomi quod manducatur, vel etiam Punici corium contusum admixta polenta impositum et livores abolet et dolores sedat.*) Since the recipe calls for either a pomegranate or a *pomum*, it is clear the latter is not the generic term for "fruit," and may have (in the local dialect?) come to mean "apple." The requirement that it be edible excludes crab apples and the like. Marcellus does use *pomum* in the classical sense of "fruit" in other passages, for example, when he writes on "the leaves and fruit (*poma*) of the fig" (*De medicamentis*, 18.8; Helmreich, 178), so it is clear that this meaning has not been altogether superseded. On Marcellus, see P. Geyer, "Spuren gallischen Lateins bei Marcellus Empiricus," in *Archiv für lateinische Lexikographie und Grammatik mit Einschluss des älteren Mittellateins* 8 (1893): 469–81. Additional evidence for *pomum*'s encroaching on *malum* as the primary term for "apple" comes from *Capitulare de Villis*, §70, the section discussed above, which refers to the apple tree as *pomarius*. In classical Latin, *pomarius* is either the adjective "of or used for fruit" or the noun "a fruit seller" (*Oxford Latin Dictionary*, s.v. "pōmārius," 1399), and the shift to "apple tree" is doubtless motivated by the association of *pomum* with the apple. Other possible witnesses include the Latin-Gallic *Glossaire de Vienne* (an eighth-century manuscript of earlier traditions), whose Latin gloss of Gallic *avallo* (usually rendered "apple") is *poma*, rather than *mala*. See Jean-Paul Savignac, *Dictionnaire Français-Gaulois* (Paris: La Différence, 2014), 272 (the evidence of this gloss is not as strong as it first appears, for reasons I will discuss below); and a tenth-century Virgil commentary in which Hippomenes distracts Atalanta with a *pomum*

to win the race (Anatole Boucherie, "Fragment d'un commentaire sur Virgile," *Revue des langues romanes* 6 [1874]: 415–61, esp. 425–26). Whatever the cumulative force of these passages, "apple" is not cited as a regional meaning of *pomum* in J. N. Adams, *The Regional Diversification of Latin, 200 BC–AD 600* (Cambridge: Cambridge University Press, 2007).

22. Robert Grosseteste, *Hexaemeron*, ed. R. C. Dales and S. Gieben (ABMA 6; London: British Academy, 1982), 144 (Chapter 20.1). Latin: *omnis enim arborum fructus nomine pomi comprehenditur*. Christopher Martin assumes that *pomum* here means "apple" and translates the gloss "The fruit of every kind of tree is understood under the name *apple*." See *On the Six Days of Creation*, trans. C. F. J. Martin (ABMA 6[2]; Oxford: Oxford University Press, 1996), 146.

23. Meister Eckhart, *Expositio Libri Genesis*, in *Die lateinischen Werke* 1, ed. and trans. Konrad Weiss (DLW; Stuttgart: W. Kohlhammer, 1964), 252. Latin: *Notandum quod pomum est nomen commune ad omnem fructum*. The emphatic statement that *pomum* can denote also a fig (253; *Ecce igitur quod pomum sit et dicatur ficus*) sets the stage for Eckhart's claim that the forbidden fruit was a fig, noted in chapter 2 above.

24. Alexander Neckam, *De natura rerum libri duo*, ed. Thomas Wright (London: Longman, Roberts and Green, 1863), 174 (Book 1, ch. 77). On Neckam and the historical significance of his work, see Tomaz Zahora, *Nature, Virtue, and the Boundaries of Encyclopedic Knowledge: The Tropological Universe of Alexander Neckam (1157–1217)* (ES 13; Turnhout: Brepols, 2014). Neckam does not call attention to this meaning of *pomum*; it gives every impression of being natural and self-evident to both the author and his presumed audience.

25. Petri Iohannis Olivi, *Expositio Canticum Canticorum*, ed. Johannes Schlageter (CO 2; Grottaferrata [Rome]: College of St. Bonaventure, 1999), 151. Latin: *"Malus" est genus arborum fructiferarum fructus rotundos portantium. . . . Simpliciter tamen dictum magis proprie stat pro "pomo."* Olivi admittedly writes that the *malus* is *fructus . . . pomorum rotundissimorum*, "the fruit that is the roundest of the tree fruit [*pomorum*]," using *pomum* as a generic term for "tree fruit," but this is a quote from the eleventh-century lexicographer Papias in his *Elementarium doctrinae rudimentum* (Venice, 1496), 96b.

26. Schlageter, *Expositio*, 310. Latin: *Sub arbore malo, id est: pomo*.

27. Thomas of Perseigne, *In Cantica Canticorum*, PL 206.808.

28. The *Sinonoma Bartholomei*, a fourteenth-century glossary of medical and botanical nomenclature, lists various plants with *malum* in their name (*malum granatum, malum punicum*, and so on), but notes that *malum* itself normally means *pomum*, "apple." J. L. G. Mowat, ed., *Sinonoma Bartholomei* (AO 1; Oxford: Clarendon Press, 1882), 28. Latin: *Malum quando simpliciter de pomo usuali intelligitur*. See also s.v. "viscus," the Latin term for the pistil, the organ at the center of a flower that receives the pollen, which, we are told, is adapted to various plants: to the pear tree (*piri arboris*), the apple tree (*pomi arboris*), and so on (Mowat, 43). The semantic narrowing of *pomum* may also be reflected in the sign-language handbooks of the Cistercians, who, following the Rule of St. Benedict, sought "to avoid human discourse" and so "[conform] their behavior to an ideal of angelic conduct that actualized in this life their future participation in the heavenly chorus." Scott G. Bruce, *Silence and Sign Language in Medieval Monasticism: The Cluniac Tradition c. 900–1200* (CSMLT [4th series] 68; Cambridge: Cambridge University Press, 2007), 24 and 27, respectively. To help maintain their silence, Cistercians utilized a robust sign language, which novices learned through lexicons containing the terms and corresponding hand movements, editions of which can be found in Walter Jarecki, *Signa loquendi: Die cluniacensischen Signa-Listen eingeleitet und herausgegeben* (SS 4; Baden-Baden: Valentin Koerner, 1981). The original Cluny lexicon, along with the lists of several other monasteries, includes a

sign that denotes "fruit (*signo pomorum*), especially for the pear and the apple (*maxime piri vel mali*)"; Jarecki, 125, §22. The same phrase appears in the handbooks of St. Victor (Jarecki, 238, §39) and Petrus Boherisus (Jarecki, 147, §23), with slight variation in the handbook of Wilhelm von Hirsau (Jarecki, 172, §45). But the Fleury Abbey lexicon contains a sign for pears, and another for *pomum*, with no mention of *malum* (pears: Jarecki, 255, §30; *pomum*: Jarecki, 255, §29). It is unlikely that the Fleury Abbey had signs for "fruit" and "pear," but not "apple"; it is more plausible that *pomum*, which appears alongside the pear, designates the apple (like *malum* and *pirum* at Hirsau). The same division is found at the Cistercian abbey at Bury St. Edmunds (pear: Jarecki, 286, §76; *pomum*: Jarecki, 291, §111).

29. This is certainly the case with authors outside of France. For Albertus Magnus (1193–1280), the great Dominican scholar and bishop of Regensburg, nothing appears to have changed. In his 1260 work *De vegetabilibus* he lists apples (*mala*), pears, and citrus as fruits (*poma*) that have flesh (Book 3, 1.1; Ernest Meyer and Carl Jessen, eds., *De vegetabilibus libri VII* [Berlin: Reimeri, 1867], 166), and see further examples in Book 4, 1.11 (Meyer and Jessen, 367) and Book 4, 1.25 (Meyer and Jessen, 402). So too the thirteenth-century Hebrew-Latin-French dictionary from the Abbey of Ramsey (some fifty miles north of Cambridge), which defines Hebrew *tapuaḥ* as *malus* (citing the verses from Song of Songs), while a generic term like *meged* ("choice fruit," Song 7:13) is a *pomum*, "fruit." See Judith Olszowy-Schlanger, ed., *Dictionnaire hébreu-latin-français de la Bible hébraïque de l'abbaye de Ramsey (XIIIe s.)* (LLMA 4; Turnhout: Brepols, 2008), s.vv. מגד and תפוח. A particularly salient example is the Latin inscription accompanying the Fall of Man scene in the mosaic of the Saint Mark Cathedral in Venice: *hic Eva accipit pomum dat viro suo*, "here Eve accepts the *pomum* and gives it to her husband." Since the fruit in question is a fig, *pomum* clearly means "fruit" ("*Pomum wurde hier, wie auch sonst häufig im mittelalterlichen Latein, für Frucht gesetzt*"; Goetz, *Der Feigenbaum*, 40).

30. The early twelfth-century Franciscan Bartholomeus Anglicus defines the nut as "any *pomum* covered in a hard skin or shell" (Latin: *pomum omne corio vel cortice duro tectum dicitur nux*; a definition that goes back to Isidore of Seville, and ultimately to the Latin author Macrobius); but he also writes that "a few pears appear to be heavier than many apples (*poma*)" (Latin: *pauca pira videntur ponderosiora esse quam multa poma*). See Bartholomeus Anglicus, *De Proprietatibus Rerum* (Heidelberg: Henricus Knoblochtzer, 1488), Book 17, Chapter 108 (unpaginated) and Book 17, Chapter 124, respectively. Alexander Neckam, cited above using *pomum*, "apple," states in the same work that the *ficus Aegyptia* (the sycamore) does not bear many *poma*, i.e., "fruit" (*De natura rerum*, Book 1, ch. 80; Wright edition, 176).

31. Guy Deutscher, *The Unfolding of Language: An Evolutionary Tour of Mankind's Greatest Invention* (New York: Picador, 2006).

32. Michael W. Herren, "Latin and the Vernacular Languages," in *Medieval Latin: An Introduction and Bibliographical Guide*, ed. F. A. C. Mantello and A. G. Rigg (Washington DC: Catholic University of American Press, 1996), 127. One could conceivably argue that the Latin change is, like Old French, the result of a taboo avoidance of *malum*. This is unlikely, for one, because many Latin authors continued to use *malum* in the sense of "apple" during this period. Additionally, the *malum-malum* homonym existed for the better part of a millennium (since the loss of phonemic vowel length in Latin); why would the taboo have kicked in only when it did?

33. Scott Gwara, "Second Language Acquisition and Anglo-Saxon Bilingualism: Negative Transfer and Avoidance in Ælfric Bata's Latin *Colloquia*, c. A.D. 1000," *Viator* 29 (1998): 1–24. Gwara's article contains a detailed and helpful discussion of second-language acquisition as a form of language contact. Bata, a student of Ælfric of Eynsham, was active in the early eleventh century.

34. A calque is a contact-induced semantic shift that aligns the meaning of a native word to the meaning of a corresponding word in another language. For example, the English word *net*, "a meshed material supported by a frame for catching fish, butterflies, etc.," has been used for decades as a synonym for "internet." As a result, the native words for "net" in other languages (Spanish *red*, French *réseau,*, Hebrew *reshet*) have also adopted this meaning.

35. Gwara, "Second Language Acquisition," 12–14. See also Herren's discussion of the Irish word *máel*, which means both "bald" and "servant," and under whose influence Latin *calvus*, "bald," acquired the meaning "servant" in the Latin of Ireland. Herren, "Latin and the Vernacular Languages," 128.

36. David Trotter, "'Stuffed Latin': Vernacular Evidence in Latin Documents," in *Language and Culture in Medieval Britain: The French of England c.1100–c.1500*, ed. Jocelyn Wogan-Browne (York: York Medieval Press, 2009), 153.

37. The importance of phonetic similarity is evident, for example, from the phrase *mano a mano*. Spanish *mano* means "hand," and *mano a mano* is "hand to hand" combat. Due to *mano*'s phonetic similarity to (etymologically unrelated) English *man*, the phrase *mano a mano* is used in English as equivalent to "man to man" (e.g., in the argot of professional wrestling).

38. This interpretation of the edict has been challenged by Richard Wright, who argues that the Council of Tours sought to address Alcuin's relatively recent orthographic reforms that established a single sound for each Latin letter, thereby creating a standard pronunciation of the (Latin) liturgy for churches and congregations across the Carolingian empire. For Wright, then, the edict instructs the clergy not to employ this pronunciation in their sermons, but rather to maintain the generally accepted pronunciation of Latin, which would be fundamentally similar to (or perhaps identical with) the Romance vernaculars. See Richard Wright, "Alcuin's *De Orthographia* and the Council of Tours (A.D. 813)," in his *A Sociophilological Study of Late Latin* (USML 10; Turnhout: Brepols, 2002), 127–46. Even if Wright is correct regarding the situation in 813, most of the material discussed below originates in the twelfth century, by which time the division between Latin and the vernaculars was firmly established.

39. D. L. d'Avray, *The Preaching of the Friars: Sermons Diffused from Paris before 1300* (Oxford: Clarendon Press, 1985), 19.

40. Lay literacy was the result of several connected processes, including the growth of the middle class, increasingly complex requirements of commercial transactions, and the thriving legal profession. For a detailed discussion of the situation in England from the twelfth to the fifteenth century, see M. B. Parkes, "The Literacy of the Laity," in *Literature and Western Civilization: The Medieval World*, ed. D. Daiches and A. K. Thorlby, (London: Aldus, 1973), 555–76, reprinted in M. B. Parkes, *Scribes, Scripts, and Readers: Studies in the Communication, Presentation, and Dissemination of Medieval Texts* (London: Hambledon, 1991), 275–97.

41. Brian Murdoch, *The Medieval Popular Bible: Expansions of Genesis in the Middle Ages* (Cambridge: D.S. Brewer, 2003).

42. On the influence of the *Bible historiale* and its enduring popularity, see Guy Lobrichon, "The Story of a Success: The *Bible Historiale* in French (1295–c. 1500)," in Eyal Poleg and Laura Light, eds., *Form and Function in the Late Medieval Bible* (Leiden: Brill, 2013), 307–32.

43. Clive R. Sneddon, "The Bible in French," in *The New Cambridge History of the Bible*, ed. Richard Marsden and E. Ann Matter (Cambridge: Cambridge University Press, 2002), 256. For an overview, see Lynne Long, "Scriptures in the Vernacular up to 1800," in *A History of Biblical Interpretation*, ed. Alan J. Hauser and Duane Frederick Watson (Grand Rapids, MI: Eerdmans, 2009), 450–81. Determining what counts as vernacular is a matter of convention; at the time of

their composition, the Septuagint, the Aramaic Targums, and the Vulgate were all vernacular translations.

44. Thomas L. Amos, "Preaching and the Sermon in the Carolingian World," in De Ore Domini: *Preacher and Word in the Middle Ages*, ed. Thomas L. Amos, Eugene A. Green, and Beverly Mayne Kinzle (SMC 27; Kalamazoo, MI: Medieval Institute, 1989), 48.

45. Examples of vernacular preaching in monasteries are discussed in Jean Longère, *La predication médiévale* (Paris: Études Augustiniennes, 1983), 164; and Beverly Mayne Kienzle, "The Twelfth-Century Monastic Sermon," in *The Sermon*, ed. Beverly Mayne Kienzle (TSMAO 81–83; Turnhout: Brepols, 2000), 287–88. On the complex relationship between Latin and the vernaculars as languages of preaching more broadly, see Giles Constable, "The Language of Preaching in the Twelfth Century," *Viator* 25 (1994): 131–52.

46. See William H. Campbell, *The Landscape of Pastoral Care in Thirteenth-Century England* (CSMLT 106; Cambridge: Cambridge University Press, 2018), 27.

47. Phyllis Roberts, "The *Ars Praedicandi* and the Medieval Sermon," in *Preacher, Sermon, and Audience in the Middle Ages*, ed. Carolyn Muessig (Leiden: Brill, 2002), 44. Part of the drive to reach the broader public was doctrinal, as both the Waldensians and the Cathars, two groups identified as heretical by the Catholic establishment, "were zealous in their preaching"; d'Avray, *The Preaching of the Friars*, 25.

48. Peter Cantor, a prominent French theologian, could assert that "the practice of Bible study consists in three things: reading, disputation, and preaching"; quoted in Beryl Smalley, *The Study of the Bible in the Middle Ages* (Oxford: Clarendon Press, 1983), 208.

49. For a list of preachers who incorporated biblical commentaries into their sermons, see Jean Longère, *La predication médiévale* (Paris: Études Augustiniennes, 1983), 184.

50. See the discussion in Jennifer F. Schammell, "The Bible on the Stage: The Cultural Foundations of the Mystery Plays and the 'Popular Medieval Bible'" (PhD diss., University of Glasgow, 2005), who focuses on somewhat later English mystery plays.

51. Charles Mazouer, *Le théâtre français du moyen âge* (Paris: Sedes, 1998), 75 ("Pour émouvoir et enseigner un public plus large, le peuple chrétien, il fallait employer sa langue").

52. The most prominent is the Old French Bible (or the Thirteenth-Century Bible); Quereuil, *La Bible française du XIIIe siècle*, 110–13. Old French *fruit* also appears in a twelfth-century translation of Genesis (BnF fr. 6447, with the Fall of Man account at fols. 10b–11a). See the discussion in Paul Meyer, "Notice du ms. Bibl. nat. fr. 6447 (Traduction de divers livres de la Bible.—Légendes de saints)," *Notices et extraits des manuscrits de la Bibliothèque nationale et autres bibliothèques* 35, no. 2 (1896): 435–510. See also *La Bible de Macé de la charité: Genèse, Exode*, ed. J. R. Smeets (Leiden: Leiden University Press, 1967), 19; the Acre Bible, BnF nouvelle acquisitions 1404, fols. 4a–4b; and the *Bible historiale*, where God commands Adam and Eve not to eat *du fruit delarbre* (BAV Barb. lat. 613, 9r). For a survey of Old French translations, see Pierre-Maurice Bogaert, "La Bible française au moyen âge: Des premières traductions aux débuts de l'imprimerie," in *Les Bibles en française: Histoire illustrée du moyen âge à nos jours*, ed. Bogaert (Turnhout: Brepols, 1991), 13–46.

53. Stewart Gregory, ed., *Commentaire en prose sur les psaumes I–XXXV* (London: Modern Humanities, 1990), 73; published online by the École normale supérieure de Lyon in the Base de français médiéval.

54. Jane Henderson, "A Critical Edition of Evrat's Genesis: Creation to the Flood" (PhD diss., University of Toronto, 1977), 167, line 905 (*K'ele eust mangie de la pome*). A detailed description of the manuscript traditions of Evrat's *Genesis* is found in Willy Boers, "La *Genèse* d'Evrat,"

Scriptorium 61 (2007): 74–149. The article does not mention Henderson's dissertation. Boers has produced a new edition of Evrat's translation as his 2002 Leiden University dissertation, which I have not been able to consult.

55. Ina Spiele, *Li romanz de dieu et de sa mere de'Herman de Valenciennes chanoine et prêtre (XIIe siècle)* (PRUL 21; Leiden: Leiden University Press, 1975), *pomier*, 164, lines 32–33; *pome* 166, lines 71, 75, and 94.

56. Gautier de Coinci, *Miracles de Nostre Dame*, ed. Victor Frederic Koenig (Geneva: Droz, 1966), with references to the *pom* at lines 134 and 144; published online by the École normale supérieure of Lyon in the Base de français médiéval. Some of the poems of this early thirteenth-century work were set to music and performed throughout the Middle Ages, disseminating the *pom* vocabulary further.

57. Monika Türk, *"Lucidaire de grant sapientie": Untersuchung und Edition der altfranzösischen Übersetzung 1 des "Elucidarium" von Honorius Augustodunensis* (BZRP 307; Tübingen: Max Niemeyer, 2000). Augustodunensis (whose commentary on the Song of Songs was discussed in chapter 2) wrote the encyclopedic *Elucidarium* as a series of questions and answers, encompassing the principles of Christian faith. The book was immensely popular and was translated into many vernacular languages, including Old Icelandic, Welsh, and Czech. The Old French *pom* usually renders Latin *pomum*, e.g., question 87 ("Was the knowledge of good and evil in [the forbidden fruit]?") is originally *Fuit scientia boni et mali in illo pomo*? (PL 172.1119), and in the Old French translation, *La science de bien et mal fu ele en cele pome?* (Türk, 242); and answer 91 ("The woman ate the forbidden fruit at the sixth hour") is originally *hora sexta mulier formata continuo de vetito pomo praesumpsit* (PL 172.1119), and the Old French translation, *a la siste heure manja la fame la pome* (Türk, 243).

58. Julia C. Szirmai, *La Bible anonyme du MS Paris B.N.F. fr.763* (FT 22; Amsterdam: Rodopi, 1985), line 592.

59. See Mary Coker Joslin, "A Critical Edition of the Genesis of Rogier's *Histoire ancienne* Based on Paris, Bibliotheque Nationale, MS. Fr. 20125" (PhD diss., University of North Carolina, Chapel Hill, 1980), 17 (*por le mangier d'une pome . . . la savor de las pome que li estoit defendue*). "To judge by the number of surviving MSS, mostly of the most expensive quality, this must have been regarded in the later Middle Ages as essential to the library of the average French noble or gentleman with a leaning toward literary culture." David J. A. Ross, "The History of Macedon in the 'Histoire ancienne jusqu'a Cesar': Sources and Compositional Method," *Classica et mediaevalia* 24 (1963): 181, quoted in Joslin, "A Critical Edition," i.

60. Her narrative poem "Yonec" refers to Adam eating the *pumme amere*, which Claire Waters renders "bitter apple." Claire M. Waters, *The Lais of Marie de France: Text and Translation* (Peterborough, ON: Broadview, 2018), 218–19, line 152.

61. See Wolfgang von Emden, ed., *Le Jeu d'Adam* (Edinburgh: Société Rencesvals British Branch, 1996), 15, line 469 and 40, line 476, inter alia. Subsequent vernacular plays avoided the theme of the Fall of Man, on which see Larry S. Crist, "La chute de l'homme sur la scène dans la France du XIIe et du XVe siècle," *Romania* 99, no. 2 (1978): 207–19.

62. G. Raynaud and H. Lemaître, eds., *Le roman de Renart le Contrefait* (Paris: Honoré Champion, 1914), 1:69, lines 6592–93. Old French: *Par orguil et par renardye Fut qu'Adam la pomme menga.*

63. E. De Boer, ed., *"Ovide moralisé": Poème du commencement du quatorzième siècle* (VKAWA 15; Amsterdam: J. Muller, 1915), 248, line 3591. Old French: *Pour le mors de la pome amere.*

64. In addition to the sources already cited, see Pierre Nobel, ed., *Poème anglo-normand sur l'Ancien Testament*, (NBMA 37; Paris: Champion, 1996), 143; Geufroi de Paris's unpublished *Bible des sept estats du monde* (1243) characterizes the forbidden fruit as a *fruit de ce pomier*, "fruit of this apple tree"; BnF fr. 1526, fol. 10b.

65. Tony Hunt, ed., *'Cher Alme': Texts of Anglo-Norman Piety* (MRTS 385; Tempe: Arizona Center for Medieval and Renaissance Studies, 2010), 268; and Maria Colombo Timelli, "Une nouvelle édition du *mors de la pomme*," *Romania* 130, no. 1/2 (2012): 40–73, at 56, lines 79 and 82.

66. W. H. Trethewey, ed., *The French Text of the Ancrene Riwle* (EETS, Original Series 240, London: Oxford University Press, 1958), 95.

67. Henry, Duke of Lancaster, *Livre de seyntz medicines*, ed. Émile Jules François Arnould (Oxford: Anglo-Norman Text Society, 1940), 60; published online by the École normale supérieure of Lyon in the Base de français médiéval.

68. In Evrat's translation of Genesis, *pom* denotes both the forbidden fruit and the fruit of the trees in Genesis 1:11 (Henderson, "A Critical Edition," 142, lines 356–58), a strong indication that he intended the word in the broad sense.

69. In the course of my research I have come across an earlier formulation of this thesis, in Rey, *Dictionnaire historique de la langue française*, s.v. "pomme," 1573: "Dès la première moitié du xiiie s., le mot est employé par allusion biblique au fruit défendu du paradis terrestre, d'abord avec l'ancien sens general de "fruit", avant que la tradition populaire ne l'identifie, pour des raisons linguistiques (sens dominant de pomme), au fruit du pommier."

70. The vernacular-semantics-driven shift to understanding the forbidden fruit as an apple may have motivated some of the scant examples of the *malum* hypothesis. This is possible for Anselm of Laon and Gilbert Foliot and likely for Petrus Riga and Geoffrey of Vinsauf in the early thirteenth century.

71. On the instructions of medieval patrons—and their limits—see Jonathan J. G. Alexander, *Medieval Illuminators and Their Methods of Work* (New Haven, CT: Yale University Press, 1992).

72. The claim that iconography was partially free of ecclesiastical oversight is part of art history's gradual rejection of the romanticized view of the medieval artist as an "anonymous medieval craftsperson piously toiling away in humility and obscurity"; Sherry C. M. Lingquist and Stephen Perkinson, "Artistic Identity in the Late Middle Ages: Forward," *Gesta* 41, no. 1 (2002): 1. For a survey of earlier scholarship and the warring claims concerning medieval artistic freedom, see Walter Cahn, "The Artist as Outlaw and *Apparatchik*," in *The Renaissance of the Twelfth Century*, ed. Stephen K. Scher (Providence: Rhode Island School of Design Museum of Art, 1969), 10–14. On patronage and artistic agency, see Jill Caskey, "Whodunnit? Patronage, the Canon, and the Problematics of Agency in Romanesque and Gothic Art," in *A Companion to Medieval Art: Romanesque and Gothic in Northern Europe*, ed. Conrad Rudolph (New York: Wiley, 2011), 193–212.

73. Manuscript illuminators working prior to the early twelfth century—that is, prior to the most significant iconographic period for this study—are an exception; they tended to be members of religious orders.

74. Margriet Hoogvliet, "Encouraging Lay People to Read the Bible in the French Vernaculars: New Groups of Readers and Textual Communities," *Church History and Religious Culture* 93 (2013): 241.

75. Using the fourteenth- and fifteenth-century wills and inventories of the French (present-day Belgium) town of Tournai, Hoogvliet demonstrates that many laypeople possessed biblical texts, including the local lawyer, tanner, and several women whose occupation is not known.

Later inventories identify individuals of very modest means, including poor widows, as Bible owners. Hoogvliet, "Encouraging Lay People," 267–68.

76. Serge Lusignan emphasizes the role of burgeoning English institutions with strong ties to the royal court in the diffusion of French, e.g., a recently professionalized legal system, parliamentary representation, and professional administrative classes. See Lusignan, "French Language in Contact with English: Social Context and Linguistic Change (Mid-13th–14th Centuries)," in Wogan-Browne, *Language and Culture in Medieval Britain*, 19–30. Richard Ingham places greater weight on the role of the clergy in "The Diffusion of Higher-Status Lexis in Medieval England: The Role of the Clergy," *English Language and Linguistics* 22, no. 2 (2018): 207–24 (part of a special issue devoted to the "mechanisms of French contact influence in Middle English" and edited by Ingham and Olga Timofeeva). French writings occupied a significant place in the literary landscape of England as early as the twelfth century; see Ian Short, "Patrons and Polyglots: French Literature in Twelfth-Century England," in *Anglo-Norman Studies XIV: Proceedings of the Battle Conference*, ed. Marjorie Chibnall (Suffolk: Boydell Press, 1992), 229–50.

77. Albert Baugh and Thomas Cable, *A History of the English Language* (London: Routledge, 2002), 73, quoted in Ingham, "The Diffusion of Higher-Status Lexis," 209.

78. The examples that follow are from A. A. Prins, *French Influence in English Phrasing* (Leiden: Universitaire Pers, 1952), 78–79 (*beforehand*), 87–88 (*by heart*), 98–99 (*come to a head*), and 184 (*instead*).

79. *En lieu de* was both calqued (*instead*) and incorporated (*in lieu of*). See Prins, *French Influence*, 184.

80. See the recent survey of Old French and its influence on Middle High German in René Pérennec and Anton Touber, "Lexik," in *Sprache und Verskunst*, ed. Geert H. M. Claasens, Fritz Peter Knapp, and René Pérennec (GLMF 2; Berlin: De Gruyter, 2014), 107–81, and particularly the subsection on calques (169–81).

81. See the definitions in the *Middle English Dictionary* (https://quod.lib.umich.edu/m/middle-english-dictionary/dictionary). The semantics of Middle English *appel* appear to be continuous with those of Old English *æppel*. The University of Toronto's *Dictionary of Old English* (http://www.doe.utoronto.ca) cites sources that employ the term in the generic sense "fruit," as well as others where it denotes specific fruits: the apple, but also the pomegranate, the date, the quince, and the mulberry.

82. *The Old English Herbarium and Medicina de Quadrupedibus*, ed. H. J. de Vriend (EETS 286; London: Oxford University Press, 1984), 107.80. Middle English: *Þas æpples þat man malum granatum nemneð*.

83. See Forshall and Madden, *The Holy Bible . . . Made from the Latin Vulgate by John Wycliffe*, 1:79. Wycliffe uses *appil* as a standard rendering of *pomum*, but also occasionally for *malum*. In Leviticus 19:23, *applis* translates *poma*; in Exodus 28:34 *piyn appil* translates *malum punicum*, "pomegranate"; but in Isaiah 60:13 *pyne appil tre* translates *pinum*, "pine." In Song of Songs 2:3 (*sicut malum*) the Vulgate's *malum* is *apple*, but in Song of Songs 8:5 (*sub arbore malo*) the lover is awoken under the *pumgranate tre*. See the comment above, chapter 2, note 93.

84. A. R. Littlewood, "The Symbolism of the Apple in Greek and Roman Literature," *Harvard Studies in Classical Philology* 72 (1968): 147–81. In my discussion of *pomum* in the Latin of Gaul, I cited the *Glossaire de Vienne*, where Gallic *avallo* (a cognate of *apple*) is glossed by the Latin *poma*, rather than *mala*. I noted there that this source may not be as relevant as it first appears, and now the reason becomes apparent: if *avallo* (like Middle English *appel* and Middle High German *apfel*) denotes "fruit," then the *poma* gloss is straightforward.

85. *The Early South-English Legendary from Bodleian MS. Laud Misc. 108*, ed. C. Horstmann (EETS, Original Series 87; London: Trübner, 1887), line 1191.

86. W. G. Benham, *The Oath Book or Red Parchment Book of Colchester* (Colchester: Essex Country Office of Standards, 1907), 10.

87. The treatise, from a Trinity College, Cambridge manuscript, was published by Alicia M. Tyssen Amherst in *Archaeologia, Or, Miscellaneous Tracts Relating to Antiquity* (London: Society of Antiquaries of London, 1894): 4:157–72, with the phrase in question occurring at 161, line 15.

88. See the *Mittelhochdeutsches Wörterbuch*, accessible online at http://www.mhdwb-online.de/.

89. Carl Külz und Emma Külz-Trosse, eds., *Das Breslauer Arzneibuch R. 291 der Stadtbibliothek* (Dresden: Friedrich Marschner, 1908), 27. Middle High German: *so nim des cipressen boumes epfel*.

90. Konrad von Megenberg, *Das Buch der Natur: Die erste Naturgeschichte in deutscher Sprache*, ed. Franz Pfeiffer (Stuttgart: Karl Aue, 1861): cedar, 317; orange, 318; pomegranate, 329; monkeys, 158–59.

91. *Liber ordinis rerum: Esse, essencia, glossar*, ed. Peter Schmitt (TuT 5; Tübingen: Niemeyer, 1983): *pomum cedrinum*, 370 (§29), *testa* and *pulpa*, 411 (§39 and §40, respectively, both in the critical apparatus).

92. William Kurrelmeyer, ed., *Die erste deutsche Bibel* (BLVS 243; Tübingen: Literarischer Verein, 1907), 3. The forbidden fruit is *wucher*, another word for "fruit."

93. *Sancta Hildegardis subtilitatum diversarum naturarum creaturarum libri novem*, Book 3, Chapter 1 (PL 197.1215). The *Physica* is composed in Latin, but the names of the fruit trees are in Middle High German.

94. Christian Meyer, ed., *Das Stadtbuch von Augsburg, insbesondere das Stadtrecht vom Jahre 1276* (Augsburg: F. Butsch, 1872), 131.

95. *Ein Buch von guter Speise*, ed. Johann Andreas Schmeller (BLVS 9.2; Stuttgart: Literarischer Verein, 1884), 4. Translation by Alia Atlas at http://www.medievalcookery.com/etexts/buch.html. Middle High German: *Nim gebratene birn und sure epfele und hacke sie kleine*.

96. Megenberg, *Das Buch der Natur*, 15. Middle High German: *wenn diu kindlein fäuht öpfel und pirn ezzent*.

97. Marijke van der Veen, Alistair Hill, and Alexandra Livarda, "The Archaeobotany of Medieval Britain (c. AD 450–1500): Identifying Research Priorities for the 21st Century," *Medieval Archaeology* 57 (2013): 173.

98. *Pear* is from postclassical Latin *pera*, *plum* from Latin *pruna*, *cherry* from popular Latin **ceresia*, *fennel* from popular Latin *fenuculum*, and *cabbage* is a late form of Latin *caput*, "head." *Dill* is Germanic, but the plant was also known as *anet*, from Old French. *Walnut* is also native (non-Latin), but the first element of the word means "foreigner" and is regularly used to denote Celts and Romans. So, while the name *walnut* is etymologically "native," it marks the nut as a foreign crop.

99. *Birn* (pear), *Pflaume* (plum), *Kirsche* (cherry), *Fenchel* (fennel), and *Kohl* or *Kappes* (cabbage) are all ultimately from Latin.

100. I have not undertaken a full analysis of contemporary Dutch sources, though the historical dictionaries available on the Instituut voor de Nederlandse taal website (http://gtb.ivdnt.org/search/) suggest a similar sematic arc. The Old Dutch dictionary (*Oudnederlands Woordenbook 500–1200*) has "fruit" as the base definition of *appel*, with a "possible but more limited" meaning of "apple"; the Early Middle Dutch dictionary (*Vroegmiddelnederlands Woordenboek*

1200–1300) also has "fruit" as its base definition, but the Middle Dutch dictionary (*Middelnederlandsch Woordenboek 1250–1550*) no longer lists the generic "fruit," but only "apple." The Gysseling corpus of thirteenth-century Dutch sources, which serves as the basis for the Early Middle Dutch dictionary, includes a Dutch-Latin lexicon (the Glossarium Bernense of 1240) in which Latin *malum* is identified with *appel* and *malus* with *appelbom* ("apple tree"); it also includes a reference to the forbidden fruit as an *appel*, in Willem van Affligem's thirteenth-century *Sente Lutgart* (*Life of Saint Lutgart*)

101. Like *pom*, they are not the only terms to designate the forbidden fruit. Several Middle English sources use *fruyt* and its variants, including the Wycliffe translation (e.g., to Genesis 3:6: "and she toke of the fruyt of it and she ete" [Forshall and Madden, *The Holy Bible... Made from the Latin Vulgate by John Wycliffe*, 1:83]), while Middle High German Fall of Man narratives often have *obiz* (the progenitor of modern German *Obst*), e.g., Akihiro Hamano, *Die frühmittelhochdeutsche Genesis: Synoptische Ausgabe nach der Wiener, Millstätter und Vorauer Handschrift* (Hermaea 138; Berlin: De Gruyter, 2016), Wiener MS lines 503, 546, 649; and Rudolph von Ems, *Weltchronik*, ed. Gustav Ehrismann (DTM 20; Berlin: Weidmann, 1915), line 366.

102. Some of the relevant sources, presented in rough chronological order, are A. N. Doane, *The Saxon Genesis: An Edition of the West Saxon Genesis B and the Old Saxon Vatican Genesis* (Madison: University of Wisconsin Press, 1991), 223, line 637 (*æppel unsælga*); Ælfric, "On the Greater Litany," in *The Homilies of the Anglo-Saxon Church: The Sermones Chatholici*, ed. and trans. Benjamin Thorpe (London: The Ælfric Society, 1844), 2:330–31; Richard Morris, ed., *Old English Homilies of the Twelfth Century* (EETS 53; London: Trübner, 1873), 35; *The Ormulum*, ed. Robert Holt (Oxford: Clarendon Press, 1878), 2:74, line 12326; *Middle English Sermons Edited from British Museum MS. Royal 18 B*, ed. Woodburn O. Ross (EETS 209; London: Oxford University Press, 1940), 73; J. R. R. Tolkien and N. R. Ker, eds., *The English Text of the Ancrene Riwle, Ancrene Wisse, ed. from MS Corpus Christi College Cambridge 402* (EETS 249; Oxford: Oxford University Press, 1962), §38; the *Cursor Mundi*, with more than two dozen occurrences (N.B.: the Southern Version of the *Cursor Mundi* does not appear to employ the word at all); the *Old Testament History* in the Vernon Manuscript (Bodl Eng. poet. a. 1), fol. 1r, col. B, lines 85 and 108—my thanks to Jim Morey for generously providing me with a transcription of the entire work; Richard Morris, ed., *Legends of the Holy Rood; Symbols of the Passion and Cross-Poems* (EETS 46; London: N. Trübner, 1881), 18 (line 7) and 19 (line 7); Kari Sajavaara, *The Middle English Translations of Robert Grosseteste's "Chateau d'Amour"* (MSNPH 32; Helsinki: Société Neophilologique, 1967), at, e.g., 266 (line 191), 306 (line 1384), 309 (line 1472), all corresponding to *pome* in the original; Murdoch and Tasioulas, *The Apocryphal Lives of Adam and Eve*, lines 71–72; *The Lief of Adam and Eve*, in N. F. Blake, *Middle English Religious Prose* (YMT; London: Edward Arnold, 1972), 107, line 87; M. Konrath, ed., *The Poems of William of Shoreham* (EETS; London: Kegan Paul, Trench, Trübner, 1902), 15, line 800; William Langland, *The Vision of William Concerning Piers the Plowman*, ed. W. W. Skeat (EETS 28; Oxford: Oxford University Press, 1867; reprint 1990), Pass. X, 1:117, line 137; the minstrel song "Adam lay ybounden," in Douglas Gray, "The Medieval Religious Lyric," in *The Blackwell Companion to the Bible in English Literature* ed. Rebecca Lemon et al. (Hoboken, NJ: Wiley-Blackwell, 2009), 77; A. C. Cawley and J. J. Anderson, eds., *Pearl, Cleanness, Patience, Sir Gawain and the Green Knight* (London: J. M. Dent & Sons, 1976), 61, lines 241–42; and Frederick J. Furnivall, ed., *Early English Poems and Lives of Saints (With Those of the Wicked Birds Pilate and Judas)* (Berlin: A. Asher, 1862), 13, line 31. My work on the English sources is indebted to James H. Morey, *Book and Verse: A Guide to Middle English Biblical Literature* (IMS; Urbana: University of Illinois Press, 2009). For a survey

NOTES TO PAGE 74

of English vernacular Bible translations, see Richard Marsden, "The Bible in English," in Marsden and Matter, *The New Cambridge History of the Bible*, 217–37.

103. See *Die deutschen Historienbibeln des Mittelalters*, ed. Johann Friedrich Ludwig Theodor Merzdorf (BLVS 100; Stuttgart: Literarischer Verein, 1870), 1:117; Gustav Ehrismann, ed., *Der Renner von Hugo von Trimberg* (BLVS 247; Tübingen: Literarischer Verein, 1909–11), 1:186; Philipp Strauch, ed., *Der Marner* (Strasbourg: Trübner, 1876), 14 and 16; *Berthold von Regensburg, Vollständige Ausgabe seiner Predigten*, ed. Franz Pfeiffer (Vienna: Wilhelm Braumüller, 1862), 291; Mechthild von Magdeburg, *Das fließende Licht der Gottheit*, ed. Hans Neumann (MTU 100; Munich: Artemis, 1990), 147, line 131; Mary-Bess Halford, *Lutwins' Eva und Adam: Study—Text—Translation* (GAG 401; Göppingen: Kümmerle, 1984), 117, line 475; Konrad von Helmsdorf, *Der Spiegel des menschlichen Heils*, ed. Axel Lindqvist (DTM 31; Berlin, 1924), line 2572; Joseph Eduard Wackernell, ed., *Altdeutsche Passionspiele aus Tirol mit Abhandlungen über ihre Entwicklung, Composition, Quellen, Aufführungen und litterar-historische Stellung* (Graz: K.K. Universitäts Buchdruckerei, 1897), 211, line 3354. For a survey of German Bible translations, see Andrew Colin Gow, "The Bible in Germanic," in Marsden and Matter, *The New Cambridge History of the Bible*, 198–216.

104. *The Historye of the Patriarks*, a fifteenth-century Middle English translation of Peter Comestor's *Historia Scholastica*, refers to the forbidden fruit as an *apple* (Taguchi, *The Historye of the Patriarks*, 33), but also describes the mandrakes Ruben brings Leah in Genesis 30 as *a special kynde of apples named mandrayks*, that is, "a special kind of fruit" (Taguchi, *Historye of the Patriarks*, 161).

105. In the *N-Town Plays*, an English play cycle preserved in a single late fifteenth-century manuscript, God instructs Adam prior to the Fall to freely eat *pepyr, pyan, and swete lycorys . . . appel and pere and gentyl rys* ("pepper, peony, and sweet licorice . . . apple and pear and gentle rice") but to avoid the Tree of Knowledge. Like Bernard of Clairvaux, the *N-Town* author counts the apple among the licit species in the Garden of Eden, which precludes it from being the forbidden fruit. See Douglas Sugano, ed., *The N-Town Plays* (METS; Kalamazoo, MI: Medieval Institute, 2007), Play 2, lines 35–38.

106. I note in passing that it is in this cultural and linguistic setting that we encounter the earliest Hebrew reference to the forbidden fruit as a *tapuaḥ* in the late thirteenth- or early fourteenth-century anti-Christian polemical work *Nizzahon Vetus* or *Nizzahon Yashan*. See David Berger, *The Jewish-Christian Debate in the High Middle Ages: A Critical Edition of the "Nizzahon Vetus"* (JTT 4; Philadelphia: Jewish Publication Society, 1979). In one of the exchanges, the Jewish speaker asks his Christian interlocutor, "How can it even enter your mind that God behaved so cruelly toward Adam, catching him as a result of a minor accusation—the biting of a single *tapuaḥ* [Berger translates: "apple"]—and removing him from both this world and the world to come?" Berger, §228, 218 (Hebrew original at 154). Given the uncertainties surrounding the meaning of *tapuaḥ*, it is not clear that the fruit in question is an apple, but at a minimum the *tapuaḥ* is identified with the forbidden fruit. It is worth noting that the earlier (mid-thirteenth-century) polemical work *Sefer Yosef HaMeqanne*, which Berger identifies as the primary source of *Nizzahon Vetus* (Berger, 35), does not refer to the forbidden fruit as a *tapuaḥ*. See Yosef ben Natan, *Sefer Yosef HaMeqanne*, ed. Judah Rosenthal, (Jerusalem: Meqize Nirdamim, 1970), §8 (35–36) and §84 (79). Subsequent links between the *tapuaḥ* and the forbidden fruit in traditional Jewish writings are surprisingly scarce. I have come across such links in an interpolated passage in a seventeenth- or eighteenth-century manuscript of *Sefer Ha-Razim* ("The Book of Mysteries"), New York, JTS, MS 8117 (*Sefer ha-Razim I und II*, ed. Bill Rebiger and Peter Schäfer [TSAJ 125; Tübingen: Mohr Siebeck, 2009], 1:24), and in the 21st-century responsum of Menashe

Klein (Hakatan), *Mishneh Halakhot* 13, §79, dh: *u-lefi zeh nirah* (2nd ed.; n.p.: Machon Mishneh Halakhot Gedolot, 2000), 119. There are doubtless others, but not as many as one might expect.

107. Isidore, *Etymologies*, 17.7.3, Barney, 342–43. The adjective *matianum* may refer to Matius Calvena, a friend of Cicero's who was an authority on agricultural matters, or it may be a geographic designation, whose meaning is no longer known. Haimo of Auxerre makes an interesting comment in this regard. In his commentary on Song of Songs 7:13 ("The mandrakes give forth fragrance..."), he compares the odor of the fruit (*poma*) of the mandrake to the *pomum matianum*, "which in our country is called *malum*" (*poma ejus optimi sunt odoris, in similitudinem pomi matiani, quod nostri terrae malum vocant*), PL 117.349 (misattributed to Haimo of Halberstadt). The implication is that Haimo is aware that his audience knows the apple by the name *pomum matianum*, but that this terminology is not current in his own "country" or "land" (Auxerre and environs? Burgundy?), where the apple is called *malum*. Though I cannot pursue this question further, Haimo's comment has potentially significant implications for the history of the *matianum/manzana* nomenclature, and for the assumed readership of Haimo's commentary on the Song of Songs.

108. In Aragon, the kingdom that encompasses Catalunya, the 1234 Council of Tarragona that established the basic working of the Spanish Inquisition also declared it illegal to possess books of the Bible, mandating that such books be turned over to the local episcopal authorities for burning. According to Gemma Avenoza, the decree was aimed not at Catalan Bibles but at Occitan translations tied to the Cathars in southern France. All the same, the subsequent centuries saw repeated public burnings of vernacular Bibles, including in Catalan. See Gemma Avenoza, "The Bible in Spanish and Catalan," in Marsden and Matter, *The New Cambridge History of the Bible*, 288–306. See also Pere Casanellas, "Medieval Catalan Translations of the Bible," in *Les veus del sagrat*, ed. Xavier Terrado and Flocel Sabaté (Lleida: Pagès, 2014), 15–34.

109. Peiresc Codex, BnF esp. 2, fol. 2r; Colbert Codex, BnF esp. 5, fol. 1r.

110. Amadeu J. Soberanas and Andreu Rossinyol, eds., *Homilies d'Organyà* (Barcelona: Barcino, 2001), 12. Catalan: (The devil) *li fet mengar lo pom de paradís lo qal Déus li avia vedad*. The medieval Catalan sources were consulted through the *Diccionari de Textos Catalans Antics* database, maintained by the University of Barcelona and Centre de Documentació Ramon Llull.

111. Sources: Montserrat Alegre, ed., *Diàlegs de sant Gregori* (TECCat; Barcelona: Publications of the Abbey of Montserrat, 2006), Book III, chapter 37, page 130. Catalan: *arbres carregatz de poms*. Ausiàs March, *Poesies*, ed. Pere Bohigas, with revisions by Amadeu-J. Soberanas and Noemí Espinàs (Barcelona: Barcino, 2000), 132. Catalan: *Sí com decau la rama e lo pom si la rael de l' arbre hom tallava*. Jordi Bruguera, ed., *Bíblia del segle XIV: Èxode, Levític* (CPB 3; Barcelona: Publications of the Abbey of Montserrat, 2004), Exodus 10:15. Catalan: *E fou manjada tota la herba de la universa terra, e tots los poms dels arbres*.

112. Avenoza, "The Bible in Spanish and Catalan," 290.

113. The manuscripts consulted are Escorial I.i.3 (E3; first half of the fifteenth century), Escorial I.i.4 (E4, aka Santillana; 1400–1430), The Alba Bible (aka the Arragel Bible, 1430), the Ferrara Bible (1553), and the Biblia del Oso (Casiodoro Reina's translation). All are available through the Biblia Medieval database (https://bibliamedieval.es/).

114. Madrid, Biblioteca Nacional de España, MS 816, fol. 2v. Another important Castilian source is the *Fazienda de ultramar*, an early thirteenth-century guide for pilgrims to the Holy Land that contains numerous discussions of biblical history, and exists in a single manuscript (Biblioteca Universitaria de Salamanca, MS 1997). An electronic version, created by David Arbesú Fernández, is available at http://www.hispanicseminary.org/t&c/faz/index.htm. The *Fazienda de ultramar* does not recount the Fall of Man episode.

115. The manuscripts consulted are Escorial I.i.6 (before 1230), Escorial I.i.3, Escorial I.i.5 (first half of fifteenth century), Escorial I.i.4 (Santillana), The Alba Bible, the Ferrara Bible, and the Biblia del Oso (which has *manzano*). All are available through the Biblia Medieval database (https://bibliamedieval.es/).

116. Gonzalo de Berceo, *Los milagros de nuestra señora*, ed. Brian Dutton (London: Tamesis, 1980), 29. Spanish: *Avién y grand abondo de buenas arboledas, milgranos e figueras, peros e manzanedas*. *Manzanedas* is a variant form of *manzanos* ("apple trees"); see José Baró, *Glosario completo de Los milagros de Nuestra Señora de Gonzalo de Berceo* (Boulder, CO: Society of Spanish and Spanish-American Studies, 1987), 132.

117. Pedro M. Cátedra Garcia, *Los sermones en romance del manuscrito 40 (siglo XV) de la Real Colegiata de San Isidoro de León* (Catálogo de la Predicación Hispana 2; Salamanca: Semyr, 2002), 117.

118. I have quoted from the critical edition of the *Cantigas* being prepared under the auspices of Oxford University's Centre for the Study for the Cantigas de Santa Maria: http://csm.mml.ox.ac.uk/pdf/3.pdf.

119. See H. Salvador Martínez, *Alfonxo X, the Learned: A Biography* (SHCT 146; Leiden: Brill, 2010), 73–74.

120. Alfonso's language is probably the reason that three illuminated *Cantigas* manuscripts represent the forbidden fruit as an apple (above, chapter 3, note 63). These are the only works to do so in Spain, and they do not mark the beginning of a broader adoption of this imagery.

121. Lino Leonardi, "The Bible in Italian," in Marsden and Matter, *The New Cambridge History of the Bible*, 268–85.

122. G. Folena and G. L. Mellini, eds., *Bibbia istoriata padovana della fine del Trecento: Pentateuco—Giosuè—Ruth* (Venice: Neri Pozza, 1962), 3.

123. BnF ital. 85, fol. 21v.

124. Bodl Douce 244 (the 1490 Venice edition), to Genesis 3:6 (unpaginated). The author sometimes appears as Malerbi.

125. When the modern state of Italy was founded, in 1861, "the proportion of people who could be said to know 'Italian' . . . could not have been more than 12 percent and may have been as low as 2.5 percent"; Howard Moss, "Language and Italian National Identity," in *The Politics of Italian National Identity: A Multidisciplinary Perspective*, ed. Bruce Anthony Haddock and Gino Bedani (Cardiff: University of Wales Press, 2000), 100.

126. This may be the reason that, as Simon Gaunt notes, "one of the most important regions for the production and transmission of texts in French is Italy, particularly Northern Italy"; Simon Gaunt, "French Literature Abroad: Towards an Alternative History of French Literature," *Interfaces* 1 (2015): 49. French was important in other parts of Italy, too—Naples was under Angevine rule and the Guelf faction gained control of Florence because of its alliance with the Angevine administration. But the French produced in these regions was intended for an audience of native French speakers, whereas northern-Italian French works were written for native speakers of the northern dialects. See Stephen Patrick McCormick, "Remapping the Story: Franco-Italian Epic and Lombardia as a Narrative Community (1250–1441)" (PhD diss., University of Oregon, 2011), 2–3. See also Giuseppina Brunetti, "Un capitol dell'espansione del francese in Italia: Manoscritti e testi a Bologna fra Duecento e Trecento," *Quaderni di filologia romanza dell'Università di Bologna* 17 (2004): 125–59.

127. Giordano da Pisa, *Sul terzo capitolo del Genesi*, ed. C. Marchionni (Florence: Olschki, 1992), 113 (Sermon XIII). Tuscan: *peccoe mangiando lo pomo*. Giordano da Pisa states in Sermon

XII that we do not know the species of the fruit—additional proof that *pomo* is not an apple; Giordano da Pisa, *Sul terzo capitolo*, 111.

128. See *L'ottimo commento della Divina commedia*, ed. Alessandro Torri (Pisa: N. Capurro, 1827–29), 1:11. Tuscan: *Per questo mangio [Adamo] il divietato pomo.*

129. The *Vocabolario* is available online at: http://www.lessicografia.it/index.jsp.

130. See Emil Keller, *Die Reimpredigt des Pietro da Barsegapè: Kritischer Text mit Einleitung, Grammatik und Glossar* (Frauenfeld: Huber, 1901), 67, line 2111. On the forbidden fruit, see, e.g., 35, lines 88 and 114.

131. See Ezio Levi, *Maestro Antonio da Ferrara: Rimatore del secolo XIV* (Rome: Rassegna Nazionale, 1920), 71.

132. Bodl Douce 244 to Song of Songs 8:5. Italian: *sotto larbor del pomo ho te solevata.* The meaning "apple" remained in force for centuries. See Giuseppe Boerio, *Dizionario del dialetto Veneziano* (Venice: Giovanni Cecchini, 1856), s.v. "pomo," 519, who urges readers to recall that the fruit known as *pomo* ("da noi chiamato *Pomo*") is *mela* in Italian; Cletto Arrighi, *Dizionario milanese-italiano* (Milan: Hoepli, 1896), s.v. "pomm," 548.

133. For instance, the "forbidden *pomo*" in the biblical paraphrase housed at the University of Uppsala, Uppsala University Library MS C. 805, fol. 2v.

134. Andrew Pettegree, *The Book in the Renaissance* (New Haven, CT: Yale University Press, 2010), 91.

135. Angela Nuovo, *The Book Trade in the Italian Renaissance* (LWW 26; Leiden: Brill, 2013), 2.

136. Ruth B. Bottigheimer, "Publishing, Print, and Change in the Image of Eve and the Apple, 1470–1570," *Archiv für Reformationsgeschichte* 86 (1995): 202n14. Bottigheimer references Walter H. Achtnich's catalogue of biblical illustrations in Albert Schramm's twenty-volume *Der Bilderschmuck der Frühdrucke*. I have been unable to locate Achtnich's catalogue, but Schramm's collection is available through Heidelberg University's digital library (https://digi.ub.uni-heidelberg.de/diglit/schramm1920ga).

137. "I do not consider it evil to paint such Bible pictures with verses. . . . Indeed, it is impossible to display the Word and work of God too often to the common person"; Martin Luther, introduction to the illustrated *Passional* (1529), quoted in David H. Price, *In the Beginning Was the Image: Art and the Reformation Bible* (Oxford: Oxford University Press, 2020), 86.

Conclusion

1. Jones, Murray, and Murray, *The Oxford Dictionary of Christian Art and Architecture*, 29.

2. Diane Apostolos-Cappadona, s.v. Apple, in *The Encyclopedia of the Bible and Its Reception*, ed. Constance M. Furey, Joel LeMon, et al. (Berlin: De Gruyter, 2009–), vol. 2, col. 522. The claim that the fruit is an apple is indefensible: the serpent is coiled around the fig tree (an unambiguous iconographic marker of the Tree of Knowledge) and hands Eve a small, black fruit, while Adam picks another fruit from the fig tree.

3. Artstor, SSID 13717716. Artstor is one of the most popular digital databases for students of art history. This heading may be influenced by a mistranslation of the Latin inscription to the mosaic, *hic Eva accipit pomum dat viro suo*, "here Eve accepts the *pomum* and gives it to her husband," understanding *pomum* as "apple." On the identification of the fruit as a fig, see Penny Howell Jolly, *Made in God's Image? Eve and Adam in the Genesis Mosaics at San Marco, Venice* (Berkeley: University of California Press, 1997), 44–49.

4. Robert Applebaum, "Eve's and Adam's 'Apple': Horticulture, Taste, and the Flesh of the Forbidden Fruit in Paradise Lost," *Milton Quarterly* 36, no. 4 (2002): 224.

5. Raffaele Garrucci, *Storia della arte cristiana nei primi otto secoli della chiesa* (Prato: Guasti, 1873–81). The work is publicly available through Heidelberg University's digital library (https://digi.ub.uni-heidelberg.de/diglit/garrucci1881bd1).

6. See the discussion in Leder, "*Arbor Scientiae*," 160, with references to earlier scholarship.

7. Garrucci, *Storia della arte cristiana*, vol. 2, pl. 96.1. See also Garrucci's rendering of the forbidden fruit in the Fall of Man scene of the Vienna Genesis in vol. 3, pl. 112.

8. See Robert Ernest Wallis, trans., *The Instructions of Commodianus*, in the very popular Ante-Nicene Fathers series (4.210), who renders *Instructions* 1.35 as "the *pomum* having been tasted, death entered the world" as "the apple . . ."; and see the discussion above, chapter 2, at note 36; Targum to Song of Songs, above chapter 2, note 67; *Jeu d'Adam*, chapter 4, note 61. On the Targum to Song of Songs, see also Philip S. Alexander, *The Targum of Canticles: Translated with a Critical Introduction, Apparatus, and Notes* (AB 17A; Collegeville, MN: The Liturgical Press, 2003). The Targum glosses the *tapuaḥ* in Song of Songs 7:8 ("the scent of your breath is like apples") as claiming that if Daniel is able to withstand his test, and if Hananiah, Mishael, and Azariah withstand theirs, God will redeem Israel and "the names of Daniel, Hananiah, Mishael, and Azariah will be heard throughout all the world, and their scent will spread like the scent of the apples of the Garden of Eden" (Alexander, 183). In his note, Alexander claims that the *tapuaḥ* is a citron, not an apple, and adds: "Implicit here is the identification of the forbidden fruit of Ge 2:17" (Alexander, 183n44). This is improbable. The Targum already linked the *tapuaḥ* with the sweet words of Torah in its gloss of Song of Songs 2:5, and the universal fame of Daniel, Hananiah, Mishael, and Azariah that is likened to the sweet smell of the *tapuaḥ* of Eden is similarly positive. There is no justification for introducing the Fall of Man into this gloss. (Note how Alexander echoes the traditional Fall of Man terminology with the phrase "apples of the Garden of Eden" [Alexander, 183n44], even as he identifies the fruit with the citron, and translates verse 2:3 thus ["Like a citron among the trees of the wood"; Alexander, 99].)

9. John Flood, *Representations of Eve in Antiquity and the English Middle Ages* (RSMRC 9; New York: Routledge, 2011), 78.

Bibliography

Primary Sources

BIBLES, ANCIENT BIBLE TRANSLATIONS, APOCRYPHA,
AND PSEUDEPIGRAPHA

Aberbach, Moses, and Bernard Grossfed. *Targum Onkelos to Genesis: A Critical Analysis Together with an English Translation of the Text*. New York: Ktav, 1982.

Alexander, Philip S. *The Targum of Canticles: Translated with a Critical Introduction, Apparatus, and Notes*. AB 17A. Collegeville, MN: Liturgical Press, 2003.

Bethge, Hans-Gebhard, Bentley Layton, and the Societas Coptica Hierosolymitana, trans. "On the Origin of the World (II, 5 and XIII, 2)." In *The Nag Hammadi Library in English*, edited by James M. Robinson, 170–89. San Francisco: HarperCollins, 1979.

Budge, E. A. Wallis. *Coptic Apocrypha in the Dialect of Upper Egypt*. London: Longmans, 1913.

Charlesworth James H., ed. *The Old Testament Pseudepigrapha*. 2 vols. Garden City, NY: Doubleday, 1982–85.

Dochhorn, Jan. *Die Apokalypse des Mose: Text, Übersetzung, Kommentar*. TSAJ 106. Tübingen: Mohr Siebeck, 2005.

Douay-Rheims Bible. *The Holy Bible Translated from the Latin Vulgate*. Baltimore: John Murphy, 1914.

Elliger, Karl, and Wilhelm Rudolph, eds. *Biblia Hebraica Stuttgartensia*. Stuttgart: Deutsche Bibelgesellschaft, 1998.

Fischer, Bonifatius, ed. *Genesis*. VL 2. Freiburg: Herder Press, 1951.

Folena, G., and G. L. Mellini, eds. *Bibbia istoriata padovana della fine del Trecento: Pentateuco—Giosuè—Ruth*. Venice: Neri Pozza, 1962.

Hanhart, Robert, ed. *Septuaginta*. Stuttgart: Deutsche Bibelgesellschaft, 2006.

Johnson, M. D., trans. *Life of Adam and Eve*. In *The Old Testament Pseudepigrapha*, edited by James H. Charlesworth, 2:249–95. Peabody, MA: Hendrickson, 2010.

Pettorelli, Jean-Pierre, and Jean-Daniel Kaestili, eds. *Vita Latina Adae et Evae*. CCSA 18–19. Turnhout: Brepols, 2012.

Robinson, S. E., trans. *Testament of Adam*. In Charlesworth, *Apocalyptic Literature and Testaments*, 989–94.

Rubinkiewicz, R., trans. "The Apocalypse of Abraham." In Charlesworth, *Apocalyptic Literature and Testaments*, 681–706.

Treat, Jay C. Translation of the Targum to the Song of Songs. http://ccat.sas.upenn.edu/~jtreat/song/targum/.
Tromp, Johannes. *The "Life of Adam and Eve" in Greek: A Critical Edition*. PVTG 6. Leiden: Brill, 2005.
Weber, Robert, and Roger Gryson, eds. *Biblia Sacra Vulgata*. Stuttgart: Deutsche Bibelgesellschaft, 2007.

ANCIENT AND MEDIEVAL SOURCES

Abelard, Peter. *Expositio in Hexameron*. Edited by M. Romig and D. Luscombe. CCCM 15. Turnhout: Brepols, 2004.
Abelard, Peter. *An Exposition on the Six-Day Work*. Translated by Wanda Zemler-Cizewski. CCT 8. Turnhout: Brepols, 2011.
Alan of Lille. *Elucidatio in Cantica Canticorum*. PL 210.51–108.
Albertus Magnus. *De vegetabilibus libri VII*. Edited by Ernest Meyer and Carl Jessen. Berlin: Reimeri, 1867.
Alcuin of York. *Commento al Cantico dei Cantici*. Edited by Rossana E. Guglielmetti. Florence: SISMEL, Edizioni del Galluzzo, 2004.
Alcuin of York. *Questions and Answers on Genesis*. Translated by Sarah van der Pas. In *Questions and Answers on Genesis: Augustine, Ambrosiaster, and Alcuin*, edited by John Litteral. Patristic Bible Commentary. CreateSpace Publishing Platform, 2018.
Ambrose. *De interpellatione Iob et David*. In *S. Ambrosii Opera*, edited by Karl Schenkl, 2:209–96. CSEL 32. Vienna: Tempsky, 1897.
Ambrose. *Homilies of Saint Ambrose on Psalm 118 (119)*. Translated by Íde Ní Riain. Dublin: Halcyon, 1998.
Ambrose. "The Prayer of Job and David." In *Saint Ambrose: Seven Exegetical Works*, translated by Michael P. McHugh, 327–422. FC 65. Washington, DC: Catholic University of America Press, 1972.
Andrew of St. Victor. *Expositio super heptateuchum In Genesim*. Edited by Charles Lohr and Rainer Berndt. CCCM 53. Turnhout: Brepols, 1986.
Angelomus of Luxeuil. *Commentarius in Genesin*. PL 115.107–242.
Angelomus of Luxueil. *Ennarationes in Cantica Canticorum*. PL 115.551–628.
Anselmus Laudunensis. *Enarratio in Canticum Canticorum*. PL 162.1187–1226.
Apponius. *Commentaire sur le Cantique des Cantiques (Explanatio in Canticum Canticorum)*. Translated by Bernard de Vregille and Louis Neyrand. 3 vols. SC 420, 421, 430. Paris: Éditions du Cerf, 1998.
Arnold of Bonneval. *Tractatus de operibus sex dierum*. PL 189.1507–1568.
Athenaeus. *The Learned Banqueters*. Edited and translated by S. Douglas Olson. LCL 204. Cambridge, MA: Harvard University Press, 2006.
Atto of Vercelli. *Epistola prima ad corinthios*. PL 134.287–411.
Augustine. *De Genesi ad litteram*. Edited by Joseph Zycha. CSEL 28.1. Vienna: Hoelder-Pichler-Tempsky, 1894.
Augustine. *The Literal Meaning of Genesis*. Translated by John Hammond Taylor. 2 vols. ACW 41–42. New York: Newman Press, 1982.
Augustine. *Tractates on the Gospel of John, 1–10*. Translated by John W. Rettig. FC 78. Washington, DC: Catholic University of America Press, 1988.

Augustine. *The Works of Saint Augustine: New Testament I and II*. Edited by Boniface Ramsey. Translated by Ronald Teske. WSATTC I/15 and I/16. Hyde Park, NY: New City Press, 2014.
Avitus. *Avit de Vienne, Histoire Spirituelle*. Edited by Nicole Hecquet-Noti. 2 vols. SC 444. Paris: Éditions du Cerf, 1999.
Avitus. *The Fall of Man: De spiritualis historiae gestis libri I–III*. Edited by Daniel J. Nodes. TMLT. Toronto: Centre for Medieval Studies, 1985.
Avitus. *The Poems of Alcimus Ecdicius Avitus*. Translated by George W. Shea. MRTS 172. Tempe: Arizona State University Press, 1997.
Bar Hebraeus. *Barhebraeus' Scholia on the Old Testament: Genesis–II Samuel*. Edited by Martin Sprengling and William Creighton Graham. OIP 13. Chicago: University of Chicago Press, 1931.
Bartholomeus Anglicus. *De Proprietatibus Rerum*. Heidelberg: Henricus Knoblochtzer, 1488.
Bede. *On Genesis*. Translated by Calvin B. Kendall. TTH 48. Liverpool: Liverpool University Press, 2008.
Bede. *The Venerable Bede: On the Song of Songs and Selected Writings*. Translated by Arthur Holder. CWS. New York: Paulist Press, 2011.
Beichner, Paul E. *Aurora Petri Rigae Biblia Versificata*. 2 vols. PMS 19. Notre Dame, IN: University of Notre Dame Press, 1965.
Beleth, Jean. *Summa de ecclesiasticis officiis*. Edited by Herbert Douteil. 2 vols. CCCM 41 and 41A. Turnhout: Brepols, 1976.
Berger, David. *The Jewish-Christian Debate in the High Middle Ages: A Critical Edition of the "Nizzahon Vetus."* JTT 4. Philadelphia: Jewish Publication Society, 1979.
Bernard of Clairvaux. *On the Song of Songs II*. Translated by Killian Walsh. CF 11. Kalamazoo, MI: Cistercian Publications, 1976.
Bernard de Clairvaux. *Sermons sur le Cantique, III*. Edited by Paul Verdeyen and Raffaele Fassetta. SC 452. Paris: Éditions du Cerf, 2000.
Bischoff, Bernhard, and Michael Lapidge. *Biblical Commentaries from the Canterbury School of Theodore and Hadrian*. CSASE 10. Cambridge: Cambridge University Press, 1994.
Bruno of Segni. *Der Hoheliedkommentar und die "Expositio de muliere forte" Brunos von Segni: Einführung, kritische Edition mit synoptischer Übersetzung und Kommentar*. Edited by Ruth Affolter-Nydegger. LSLM 50. Bern: Peter Lang, 2015.
Cantor, Peter. *Glossae super Genesim: Prologus et Capitula 1–3*. Edited by Agneta Sylwan. SGLG 55. Göteborg: Acta Universitatis Gothoburgensis, 1992.
Cellensis, Petrus. *Commentaria in Ruth. Tractatus de tabernaculo*. Edited by G. de Martel. CCCM 54. Turnhout: Brepols, 1983.
Comestor, Petrus. *Scholastica historia: Liber Genesis*. Edited by A. Sylwan. CCCM 191. Turnhout: Brepols, 2005.
Commodian. *Commodien, Instructions*. Edited by Jean-Michel Poinsotte. CUFSL 392. Paris: Les Belles Lettres, 2009.
Commodian. *Instructions*. Translated by Robert Ernest Wallis. In *Fathers of the Third Century*, edited by Alexander Roberts and James Donaldson, 199–220. ANF 4. New York: Christian Literature Publishing, 1885.
Cyprian of Gaul. *Cypriani Galli Poetae Heptateuchos*. Edited by R. Peiper. CSEL 23. Vienna: Tempsky, 1881.
Cyprian of Gaul. *Genesis*. In *Early Christian Latin Poets*, translated by Carolinne White, 100–104. ECF. New York: Routledge, 2002.

Cyril of Scythopolis. *The Lives of the Monks of Palestine*. Translated by R. M. Price. CS 114. Kalamazoo, MI: Cistercian Publications, 1991.
Damian, Peter. *Epistulae*. Edited by Kurt Reindel. 4 vols. MGH. Wiesbaden: Harrassowitz, 1983–93.
Damian, Peter. *Sancti Petri Damiani Sermones*. Edited by Giovanni Lucchesi. CCCM 57. Turnhout: Brepols, 1983.
Díaz y Díaz, Manuel C., ed. *Liber de ordine creaturarum: Un anónimo irlandés del siglo VII*. MUSC 10. Santiago de Compostela: la Universidád de Santiago de Compostela, 1972.
Dove, Mary, ed. *Glossa Ordinaria: In Cantica Canticorum*. CCCM 170. Turnhout: Brepols, 1997.
Durand, Guillaume. *Rationale diuinorum officiorum (libri I–VIII)*. Edited by Anselme Davril and Timothy M. Thibodeau. CCCM 140A. Turnhout: Brepols, 1998.
Eckhart, Meister. *Die lateinischen Werke 1: Prologi, Expositio Libri Genesis, Liber Parabolarum Genesis*. Edited and translated by Konrad Weiss. DLW. Stuttgart: W. Kohlhammer, 1964.
Epiphanius of Salamis. *The Panarion of St. Epiphanius, Bishop of Salamis: Selected Passages*. Translated by Philip R. Amidon. New York: Oxford University Press, 1990.
Freedman, H. *Genesis Rabbah*. 2 vols. London: Soncino, 1939.
Friedlander, Gerald, trans. *Pirkê de Rabbi Eliezer*. New York: Bloch, 1916.
Gallo, Ernest. *The "Poetria Nova" and Its Sources in Early Rhetorical Doctrine*. DPLSM 10. The Hague: Mouton, 1971.
Geoffrey of Auxerre. *Expositio in Cantica Canticorum*. Edited by Ferruccio Gastaldelli. TT 19–20. Rome: Edizioni di storia e letteratura, 1974.
Geoffrey of Vinsauf. *Poetria Nova*. Translated by Margaret F. Nims. MST 49. Toronto: Pontifical Institute of Mediaeval Studies, 2010.
Gilbert of Stanford. *Tractatus super Cantica Canticorum: L'amore di dio nella voce di un monaco del XII secolo*. Edited by Rossana Guglielmetti. PV 16. Florence: Edizioni del Galluzzo, 2002.
Gilbertus Foliot. *Expositio in Cantica Canticorum*. PL 202.1147–1306.
Glorieux, Palémon. "La somme 'Quoniam Homines' d'Alain de Lille." *Archives d'histoire doctrinale et littéraire du moyen âge* 28 (1953): 113–364.
Gregorius Magnus. *Sancti Gregorii Magni . . . in librum Primum Regum qui et Samuelis dicitur*. PL 79.9–470.
Gregory of Nyssa. *Homilies on the Song of Songs*. Translated by Richard A. Norris Jr. WGRW 13. Atlanta: Society of Biblical Literature, 2012.
Guillaume de Deguileville. *Super Cantica Canticorum*. In *Lateinische Hymnendichter des Mittelalters*, edited by Guido Maria Dreves, 361–409. AH 48. Leipzig: Riesland, 1905.
Guillelmus Alvernus. *Sermones de tempore*. Edited by Franco Morenzoni. CCCM 230. Turnhout: Brepols, 2011.
Hammer, Reuven, trans. *Sifre: A Tannaitic Commentary on the Book of Deuteronomy*. YJS 24. New Haven, CT: Yale University Press, 1986.
Hildegard of Bingen. *Liber diuinorum operum*. Edited by Peter Dronke and Albert Derolez. CM 92. Turnhout: Brepols, 1996.
Hildegard of Bingen. *Physica—Sancta Hildegardis subtilitatum diversarum naturarum creaturarum libri novem*. PL 197.1117–1352.
Honorius Augustudeniensis. *Elucidarium*. PL 172.1109–1176.
Honorius Augustodunensis. *Expositio in Cantica Canticorum*. PL 172.347–494.
Honorius of Autun. *The Seal of Blessed Mary*. Translated by Amelia Carr. PTS 18. Toronto: Peregrina, 1991.

BIBLIOGRAPHY

Hrabanus Maurus. *De universo.* PL 111.9–613.
Hugh of St. Cher. *Opera Omnia in Universum Vetus & Novum Testamentum.* Venice, 1703.
Hugh of St. Victor. *Adnotationes . . . in Genesim.* PL 175.29–86.
Hugh of St. Victor. *De sacramentis christianae fidei.* PL 176.
Hugh of St. Victor. *Tractatus Theologicus.* PL 171.1067–1148.
Israelstam, Jacob, and Judah Slotki, trans. *Leviticus Rabbah.* London: Soncino, 1939.
Jarecki, Walter. *Signa loquendi: Die cluniacensischen Signa-Listen eingeleitet und herausgegeben.* SS 4. Baden-Baden: Valentin Koerner, 1981.
Jerome. *Epistle 22 (Ad Eusotchium).* In *The Letters of St. Jerome,* translated by Charles Christopher Mierow, 1:149–50. ACW 33. Westminster, MD: Newman Press, 1963.
Jerome. *Select Letters of St. Jerome.* Translated by F. A. Wright. LCL 262. London: William Heinemann and G. P. Putman's Sons, 1933.
Jerome. *St. Jerome: Commentary on Galatians.* Translated by Andrew Cain. FC 121. Washington, DC: Catholic University of America Press, 2010.
John of Ford. *Iohannes de Forda, Super extremam partem Cantici canticorum sermones cxx.* Edited by E. Mikker and H. Costello. CCCM 17. Turnhout: Brepols, 1970.
John of Ford. *Sermons on the Final Verses of the Song of Songs.* Translated by Wendy Mary Beckett. 7 vols. CF 41–47. Kalamazoo, MI: Cistercian Publications, 1983.
John of Mantua. *Iohannis Mantuani In Cantica canticorum et de Sancta Maria tractatus ad comitissam Matildam.* Edited by Bernard Bischoff and Burkhard Taeger. SpF 19. Freiburg: Universitätverlag, 1973.
Julius, Theodor, and Chanoch Albeck, eds. *Midrasch Bereshit Rabba.* 3 vols. Jerusalem: Wahrmann, 1965.
Lombardus, Petrus. *Commentarius in Psalmos.* PL 191.61–1296.
Loyn, H. R., and J. Percival. *The Reign of Charlemagne: Documents on Carolingian Government and Administration.* DMH 2. London: Hodder & Stoughton, 1975.
Marcellus Empiricus. *Marcelli De medicamentis liber.* Edited by Georg Helmreich. Leipzig: Teubner, 1889.
Martin of Leon. *Sermo Septimus In Septuagesima II.* PL 208.559–607.
Martinus Legionensis. *Sermo Quartus In Natale Domini II.* PL 208.83–550.
Methodius. *The Symposium: A Treatise on Chastity.* Translated by Herbert Musurillo. ACW 27. London: Longmans, Green, 1958.
Mowat, J. L. G., ed. *Sinonoma Bartholomei: A Glossary from a Fourteenth-Century Manuscript in the Library of Pembroke College, Oxford.* AO 1. Oxford: Clarendon Press, 1882.
Neckam, Alexander. *De natura rerum libri duo.* Edited by Thomas Wright. London: Longman, Roberts and Green, 1863.
Nicholas of Lyra. *Biblia cum postillis.* 3 vols. Venice: Franciscus Renner, 1482–83.
Nicholas of Lyra. *The Postilla of Nicholas of Lyra on the Song of Songs.* Translated by James George Kiecker. RTTBS 3. Milwaukee: Marquette University Press, 1998.
Nicholas of Lyra. *Postilla super totam bibliam.* Venice, 1488.
Olivi, Petri Iohannis. *Expositio Canticum Canticorum.* Edited by Johannes Schlageter. CO 2. Grottaferrata [Rome]: College of St. Bonaventure, 1999.
Origen. *Origène: Commentaire sur le Cantique des Cantiques.* Edited by Luc Brésard, Henri Crouzel, and Marcel Borret. SC 376. Paris: Éditions du Cerf, 1992.
Origen. *Origene: Die Kommentierung des Buches Genesis.* Edited by Karin Metzler. OWDÜ 1/1. Berlin: De Gruyter, 218

Origen. *Selecta in Genesim*. PG 12.109.
Papias. *Elementarium doctrinae rudimentum*. Venice, 1496.
Petit, Françoise. *Catenae Graecae in Genesim et in Exodum*. CCSG 15. Turnhout, Brepols 1986.
Petit, Françoise. *La chaîne sur la Genèse: Édition intégrale, chapitres 1 à 3*. TEG 1. Louvain: Peeters, 1991.
Philo. *Concerning Noah's Work as a Planter*. In *Philo*, translated by F. H. Colson and G. H. Whitaker, 3:212–305. LCL 247. Cambridge, MA: Harvard University Press, 1988.
Rabanus Maurus. *Hrabani Mauri Expositio in Matthaeum*. Edited by Bengt Lofstedt. CCCM 174. Turnhout: Brepols, 2000.
Radbertus, Pascasius. *Expositio in lamentationes Hieremiae, libri quinque*. Edited by Beta Paulus. CCCM 85. Turnhout: Brepols, 1988.
Rebiger, Bill, and Peter Schäfer, eds. *Sefer ha-Razim*. 2 vols. TSAJ 125. Tübingen: Mohr Siebeck, 2009.
Remigius of Auxerre. *Expositio super Genesim*. Edited by Burton Van Name Edwards. CCCM 136. Turnhout: Brepols, 1999.
Robert of Tombelaine. *Expositio super Cantica Canticarum*. PL 79.471–549.
Rupert of Deutz. *Commentaria in Evangelium Sancti Johannis*. Edited by Hrabanus Haacke. CCCM 9. Turnhout: Brepols, 1969.
Rupert of Deutz. *De sancta trinitate et operibus eius*. Edited by Rhabanus Maurus Haacke. CCCM 23. Turnhout: Brepols, 1972.
Rupert of Deutz. *Ruperti Tuitiensis: Commentaria in Canticum Canticorum*. Edited by Hrabanus Haacke. CCCM 26. Turnhout: Brepols, 1974.
Schwartz, E., ed. *Kyrillos von kythopolis*. TUGAL IV 49.2. Leipzig: J. C. Hinrichs, 1939.
Stephanus de Borbone. *Tractatus de diuersis materiis praedicabilibus*. Edited by J. Berlioz, D. Ogilvie-David, and C. Ribaucourt. CCCM 124A. Turnhout: Brepols, 2015.
Tertullian. *Adversus Marcionem*. Translated by Ernest Evans. OECT. Oxford: Clarendon Press, 1972.
Tertullian. *Against the Jews*. In *Tertullian*, translated by Geoffrey D. Dunn, 63–104. ECF. New York: Routledge, 2004.
Tertullian. *Against Marcion*. Translated by Peter Holmes. In *Latin Christianity: Its Founder, Tertullian*, edited by Alexander Roberts and James Donaldson, 269–476. ANF 3. New York: Christian Literature Publishing, 1885.
Theodoret of Cyrus. *Questions on Genesis*. PG 80.
Theodoret of Cyrus. *The Questions on the Octateuch: Volume 1, On Genesis and Exodus*. Edited by John Petruccione and Robert Hill. LEC 1. Washington, DC: Catholic University of America Press, 2008.
Theodoret of Cyrus. *Theodoreti Cyrenesis Quaestiones in Octateuchum*. Edited by Natalio Fernández and Angel Sáenz-Badillos. TECC 17. Madrid: Consejo Superior de Investigaciones Cientificas, 1979.
Thomas Aquinas. *Commentary on the Gospel of John: Chapters 1–5*. Translated by Fabian Larcher and James A. Weisheipl. TAT. Washington, DC: Catholic University of America Press, 2010.
Thomas Aquinas. *Quaestiones disputatae*. Edited by R. Spiazzi et al. 2 vols. Rome: Marietti, 1953.
Thomas Aquinas. *Summa Theologiae*. Translated by Edmund Hill, OP. New York: McGraw-Hill and Eyre & Spottiswoode, 1963.
Thomas Aquinas. *Summae Theologiae*. Edited by P. Cramello. Rome: Marietti, 1948.

Thomas Kempis. *Sermones ad novicios regulares*. Vol. 6 of *Opera Omnia*, edited by Michael Josef Pohl. Freiburg: Herder, 1902.

Thomas of Perseigne. *Thomae Cisterciensis Monachi In Cantica Canticorum Eruditissimi Commentarii*. PL 206.9–863.

Traube, Ludovicus, ed. *Poetae latini aevi Carolini*. MGH. Berlin: Weidmann, 1896.

William of Newburgh. *Explanatio Sacri Epithalamii in Matrem Sponsi*. Edited by John Gorman. SpF 6. Freiburg: University Press, 1960.

Williram of Ebersberg. *Williram von Ebersberg Expositio in Cantica Canticorum und das "Commentarium in Cantica Canticorum" Haimos von Auxerre*. Edited and translated by Henrike Lähnemann and Michael Rupp. Berlin: De Gruyter, 2004.

Wolbero of Cologne. *Commentaria vetustissima et profundissima super canticum canticorum Salomonis*. PL 195.1001–1278.

Xíminez de Rada, Roderico. *Roderici Ximenii de Rada Breviarium Historie Catholice (I–IV)*. Edited by Juan Fernández Valverde. CCCM 72A. Brepols: Turnhout, 1992.

Yalqut Shimoni. 2 vols. Jerusalem: n.p., 1975.

Yosef ben Natan. *Sefer Yosef HaMeqanne*. Edited by Judah Rosenthal. Jerusalem: Meqize Nirdamim, 1970.

Zeno of Verona. *Zenonis Veronensis Tractatus*. Edited by Bengt Löfstedt. CCSL 21. Turnhout: Brepols, 1971.

EARLY VERNACULAR SOURCES

Ælfric. "On the Greater Litany." In *The Homilies of the Anglo-Saxon Church: The First Part, Containing the Sermones Catholici or Homelies of Ælfric*, edited and translated by Benjamin Thorpe. 2 vols. London: The Ælfric Society, 1844.

Alegre, Montserrat, ed. *Diàlegs de sant Gregori: Estudi linguistic de la versió catalana de 1340*. TECCat. Barcelona: Publications of the Abbey of Montserrat, 2006.

Atlas, Alia. Translation of *Ein Buch von guter Spise*. http://www.medievalcookery.com/etexts/buch.html.

Benham, W. G., ed. *The Oath Book or Red Parchment Book of Colchester*. Colchester: Essex Country Office of Standards, 1907.

Berceo, Gonzalo de. *Los milagros de nuestra señora*. Edited by Brian Dutton. London: Tamesis, 1980.

Blake, N. F., ed. *Middle English Religious Prose*. YMT. London: Edward Arnold, 1972.

Berthold von Regensburg. *Vollständige Ausgabe seiner Predigten*. Edited by Franz Pfeiffer. Vienna: Wilhelm Braumüller, 1862.

Boucherie, Anatole. "Fragment d'un Commentaire sur Virgile." *Revue des langues romanes* 6 (1874): 415–61.

Browne, Thomas. *Pseudodoxia Epidemica*. London: Edward Dod, 1658.

Bruguera, Jordi, ed. *Bíblia del segle XIV: Èxode, Levític*. CPB 3. Barcelona: Publications of the Abbey of Montserrat, 2004.

Cátedra Garcia, Pedro Manuel. *Los sermones en romance del manuscrito 40 (siglo XV) de la Real Colegitat de San Isidoro de León*. CPH 2. Salamanca: Semyr, 2002.

Cawley, A. C., and J. J. Anderson, eds. *Pearl, Cleanness, Patience, Sir Gawain and the Green Knight*. London: J. M. Dent & Sons, 1976.

De Boer, E., ed. *"Ovide moralisé": Poème du commencement du quatorzième siècle*. 5 vols. VKAWA 15. Amsterdam: J. Muller, 1915.

de Vriend, H. J., ed. *The Old English Herbarium and Medicina de Quadrupedibus*. EETS 286. London: Oxford University Press, 1984.

Doane, A. N., ed. *The Saxon Genesis: An Edition of the West Saxon Genesis B and the Old Saxon Vatican Genesis*. Madison: University of Wisconsin Press, 1991.

Dominguez, Véronique, ed. *Le Jeu d'Adam*. MA 34. Paris: Honoré Champion, 2012.

Duggan, Joseph J., and Annalee C. Rejhon, trans. *The Song of Roland: Translations of the Versions in Assonance and Rhyme of the "Chanson de Roland."* Turnhout: Brepols, 2012.

Ehrismann, Gustav, ed. *Der Renner von Hugo von Trimberg*. 4 vols. BLVS 247. Tübingen: Literarischer Verein, 1909–11.

Emden, Wolfgang von, ed. *Le Jeu d'Adam*. Edinburgh: Société Rencesvals British Branch, 1996.

Folena, G., and G. L. Mellini, eds. *Bibbia istoriata padovana della fine del Trecento: Pentateuco—Giosuè—Ruth*. Venice: Neri Pozza, 1962.

Forshall, Josiah, and Sir Frederic Madden, eds. *The Holy Bible Containing the Old and the New Testaments with the Apocryphal Books in the Earliest English Versions Made from the Latin Vulgate by John Wycliffe and His Followers*. 4 vols. Oxford: Oxford University Press, 1850.

Furnivall, Frederick J., ed. *Early English Poems and Lives of Saints (With Those of the Wicked Birds Pilate and Judas)*. Berlin: A. Asher, 1862.

Gautier de Coinci. *Miracles de Nostre Dame*. Edited by Victor Frederic Koenig. Geneva: Droz, 1966.

Giordano da Pisa. *Sul terzo capitolo del Genesi*. Edited by C. Marchionni. Florence: Olschki, 1992.

Gottfried von Strassburg. *Tristan and Isolde*. Translated by Francis G. Gentry. New York: Continuum, 1988.

Gregory, Stewart, ed. *Commentaire en prose sur les psaumes I–XXXV*. London: Modern Humanities, 1990.

Grosseteste, Robert. *Hexaemeron*. Edited by R. C. Dales and S. Gieben. ABMA 6. London: British Academy, 1982.

Grosseteste, Robert. *On the Six Days of Creation*. Translated by C. F. J. Martin. ABMA 6(2). Oxford: Oxford University Press, 1996.

Halford, Mary-Bess. *Lutwins' Eva und Adam: Study—Text—Translation*. GAG 401. Göppingen: Kümmerle, 1984.

Hamano, Akihiro. *Die frühmittelhochdeutsche Genesis: Synoptische Ausgabe nach der Wiener, Millstätter und Vorauer Handschrift*. Hermaea 138. Berlin: De Gruyter, 2016.

Helmsdorf, Konrad von. *Der Spiegel des menschlichen Heils*. Edited by Axel Lindqvist. DTM 31. Berlin, 1924.

Henderson, Jane. "A Critical Edition of Evrat's Genesis: Creation to the Flood." PhD diss., University of Toronto, 1977.

Henry, Duke of Lancaster. *Livre de seyntz medicines*. Edited by Émile Jules François Arnould. Oxford: Anglo-Norman Text Society, 1940.

Holt, Robert, ed. *The Ormulum*. 2 vols. Oxford: Clarendon Press, 1878.

Horstmann, C., ed. *The Early South-English Legendary from Bodleian MS. Laud Misc. 108*. EETS, Original Series 87. London: Trübner, 1887.

Hunt, Tony, ed. *'Cher Alme': Texts of Anglo-Norman Piety*. MRTS 385. Tempe: Arizona Center for Medieval and Renaissance Studies, 2010.

BIBLIOGRAPHY 161

Hunt, Tony, ed. *Le Chant de Chanz*. ANTS 61–62. London: Anglo-Norman Text Society, 2004.
Isidore. *Etymologies*. Translated by Stephen A. Barney, W. J. Lewis, J. A. Beach, and Oliver Berghof. Cambridge: Cambridge University Press, 2006.
Joslin, Mary Coker. "A Critical Edition of the Genesis of Rogier's *Histoire ancienne* Based on Paris, Bibliotheque Nationale, MS. Fr. 20125." PhD diss., University of North Carolina, Chapel Hill, 1980.
Keller, Emil. *Die Reimpredigt des Pietro da Barsegapè: Kritischer Text mit Einleitung, Grammatik und Glossar*. Frauenfeld: Huber, 1901.
Külz, Carl, and Emma Külz-Trosse, eds. *Das Breslauer Arzneibuch R. 291 der Stadtbibliothek*. Dresden: Friedrich Marschner, 1908.
Kurrelmeyer, William, ed. *Die erste deutsche Bibel*. BLVS 243. Tübingen: Literarischer Verein, 1907.
Langland, William. *The Vision of William Concerning Piers the Plowman*. Edited by W. W. Skeat. 2 vols. EETS 28. Oxford: Oxford University Press, 1867–69.
Levi, Ezio. *Maestro Antonio da Ferrara: Rimatore del secolo XIV*. Rome: Rassegna Nazionale, 1920.
Lorris, Guillaume de, and Jean de Meune. *The Romance of the Rose*. Translated by Charles Dahlberg. Princeton, NJ: Princeton University Press, 1995.
March, Ausiàs. *Poesies*. Edited by Pere Bohigas. Revised by Amadeu-J. Soberanas and Noemí Espinàs. Barcelona: Barcino, 2000.
Mechthild von Magdeburg. *Das fließende Licht der Gottheit*. Edited by Hans Neumann. MTU 100. Munich: Artemis, 1990.
Megenberg, Konrad von. *Das Buch der Natur: Die erste Naturgeschichte in deutscher Sprache*. Edited by Franz Pfeiffer. Stuttgart: Karl Aue, 1861.
Merzdorf, Johann Friedrich Ludwig Theodor. *Die deutschen Historienbibeln des Mittelalters*. BLVS 100. Stuttgart: Literarischer Verein, 1870.
Meyer, Christian, ed. *Das Stadtbuch von Augsburg, insbesondere das Stadtrecht vom Jahre 1276*. Augsburg: F. Butsch, 1872.
Morris, Richard, ed. *Cursor mundi (The cursur o the world): A Northumbrian Poem of the XIVth Century in Four Versions*. EETS 57, 99, 101. London: K. Paul, Trench, Trübner, 1874–93.
Morris, Richard, ed. *Legends of the Holy Rood; Symbols of the Passion and Cross-Poems*. EETS 46. London: N. Trübner, 1881.
Morris, Richard, ed. *Old English Homilies of the Twelfth Century*. EETS 53. London: Trübner, 1873.
Nobel, Pierre. *La Bible d'Acre, Genèse et Exode*. CL. Besançon: Presses universitaires de Franche-Comté, 2006.
Nobel, Pierre, ed. *Poème anglo-normand sur l'Ancien Testament*. NBMA 37. Paris: Champion, 1996.
Peyton, Thomas. *The Glasse of Time, In the First Two Ages*. London: Alsop, 1620.
Quereuil, Michel. *La Bible française du XIIIe siècle: Édition critique de la Genèse*. PRF 183. Geneva: Droz, 1988.
Raynaud, G., and H. Lemaître, eds. *Le roman de Renart le Contrefait*. 2 vols. Paris: Honoré Champion, 1914.
Ross, Woodburn O., ed. *Middle English Sermons Edited from British Museum MS. Royal 18 B. xxiii*. EETS 209. London: Oxford University Press, 1940.
Rudolph von Ems. *Weltchronik*. Edited by Gustav Ehrismann. DTM 20. Berlin: Weidmann, 1915.
Sajavaara, Kari. *The Middle English Translations of Robert Grosseteste's "Chateau d'Amour."* MSNPH 32. Helsinki: Société Neophilologique, 1967.

Schmeller, Johann Andreas, ed. *Ein Buch von gutter Speise*. BLVS 9.2. Stuttgart: Literarischer Verein, 1884).

Schmitt, Peter, ed. *Liber ordinis rerum: Esse, essencia, glossar*. TuT 5. Tübingen: Niemeyer, 1983.

Short, Ian, ed. "Part 1: The Oxford Version." In *La Chanson de Roland—The Song of Roland: The French Corpus*, edited by Joseph J. Duggan. Turnhout: Brepols, 2005.

Smeets, J. R., ed. *La Bible de Macé de la charité: Genèse, Exode*. Leiden: Leiden University Press, 1967.

Soberanas, Amadeu J., and Andreu Rossinyol, eds. *Homilies d'Organyà*. Barcelona: Barcino, 2001.

Spiele, Ina. *Li romanz de dieu et de sa mere de'Herman de Valenciennes chanoine et prêtre (XIIe siècle)*. PRUL 21. Leiden: Leiden University Press, 1975.

Strauch, Philipp, ed. *Der Marner*. Strasbourg: Trübner, 1876.

Sugano, Douglas, ed. *The N-Town Plays*. METS. Kalamazoo, MI: Medieval Institute, 2007.

Szirmai, Julia C., ed. *La Bible anonyme du MS Paris B.N.F. fr.763*. FT 22. Amsterdam: Rodopi, 1985.

Taguchi, Mayumi. *The Historye of the Patriarks: Edited from Cambridge, St John's College MS G.31, with Parallel Texts of "The Historia Scholastica" and the "Bible Historiale."* METS 43. Heidelberg: Universitätsverlag Winter, 2010.

Timelli, Maria Colombo. "Une nouvelle édition du *mors de la pomme*." *Romania* 130, no. 1/2 (2012): 40–73.

Tolkien, J. R. R., and N. R. Ker, eds. *The English Text of the Ancrene Riwle, Ancrene Wisse, ed. from MS Corpus Christi College Cambridge 402*. EETS 249. Oxford: Oxford University Press, 1962.

Torri, Alessandro, ed. *L'ottimo commento della Divina commedia*. 3 vols. Pisa: N. Capurro, 1827–29.

Tout, T. F. *The Place of the Reign of Edward II in English History*. Manchester: Manchester University Press, 1936.

Trethewey, W. H., ed. *The French Text of the Ancrene Riwle*. EETS, Original Series 24. London: Oxford University Press, 1958.

Türk, Monika. *"Lucidaire de grant sapientie": Untersuchung und Edition der altfranzösischen Übersetzung 1 des "Elucidarium" von Honorius Augustodunensis*. BZRP 307. Tübingen: Max Niemeyer, 2000.

Tyssen-Amherst, Alicia M. "On a Fifteenth-Century Treatise on Gardening. By 'Mayster' John Gardner." In *Archaeologia, Or, Miscellaneous Tracts Relating to Antiquity*, 4:157–72. London: Society of Antiquaries of London, 1894.

Wackernell, Joseph Eduard, ed. *Altdeutsche Passionspiele aus Tirol mit Abhandlungen über ihre Entwicklung, Composition, Quellen, Aufführungen und litterar-historische Stellung*. Graz: K.K. Universitäts Buchdruckerei, 1897.

Waters, Claire M. *The Lais of Marie de France: Text and Translation*. Peterborough, ON: Broadview, 2018.

William of Shoreham. *The Poems of William of Shoreham*. Edited by M. Konrath. EETS. London: Kegan Paul, Trench, Trübner, 1902.

MANUSCRIPTS

Florence, Laurentian Library, MS Acquisiti e Doni 121.
Madrid, Biblioteca Nacional de España, MS 816.

Oxford, Bodleian Libraries, MS Douce 244.
Oxford, Bodleian Libraries, MS Eng. poet. a. 1.
Paris, Bibliothèque nationale de France, MS esp. 5.
Paris, Bibliothèque nationale de France, MS esp. 2, 2.
Paris, Bibliothèque nationale de France, MS fr. 1526.
Paris, Bibliothèque nationale de France, MS fr. 6447.
Paris, Bibliothèque nationale de France, MS ital. 85.
Paris, Bibliothèque nationale de France, MS lat. 3832.
Paris, Bibliothèque nationale de France, MS lat. 568.
Paris, Bibliothèque nationale de France, MS nouvelle acquisitions 1404.
Salamanca, Biblioteca Universitaria de Salamanca, MS 1997.
Uppsala, Uppsala University Library, MS C. 805.
Vatican City, Biblioteca Apostolica Vaticana, MS Barb. lat. 613.

Secondary Sources

Adams, J. N. *The Regional Diversification of Latin, 200 BC–AD 600*. Cambridge: Cambridge University Press, 2007.
Aikema, Bernard. "The Lure of the North: Netherlandish Art in Venetian Collections." In Aikema and Brown, *Renaissance Venice and the North*, 82–91.
Aikema, Bernard, and Beverly Louise Brown. eds. *Renaissance Venice and the North: Crosscurrents in the Time of Bellini, Dürer, and Titian*. New York: Rizzoli, 1999.
Alexander, Jonathan J. G. *Medieval Illuminators and Their Methods of Work*. New Haven, CT: Yale University Press, 1992.
Alexander-Skipnes, Ingrid. "Translating the Northern Model: *Adam and Eve in Paradise* Attributed to Master H.L." In *The Sides of the North: An Anthology in Honor of Professor Yona Pinson*, edited by Tamar Cholcman and Assaf Pinkus, 133–53. Newcastle upon Tyne: Cambridge Scholars, 2015.
Alster, Baruch. "Human Love and Its Relationship to Spiritual Love in Jewish Exegesis on the Song of Songs." PhD diss., Bar-Ilan University, 2006.
Amos, Thomas L. "Preaching and the Sermon in the Carolingian World." In *De Ore Domini: Preacher and Word in the Middle Ages*, edited by Thomas L. Amos, Eugene A. Green, and Beverly Mayne Kinzle, 41–60. SMC 27. Kalamazoo, MI: Medieval Institute, 1989.
Andrée, Alexander. "*Sacra Pagina*: Theology and the Bible from the School of Laon to the School of Paris." In *A Companion to Twelfth-Century Schools*, edited by Cédric Giraud, 272–314. BCCT 88. Leiden: Brill, 2020.
Apostolos-Cappadona, Diane. "Apple." In *The Encyclopedia of the Bible and Its Reception*, edited by Constance M. Furey, Joel LeMon, et al., vol. 2, col. 522. Berlin: De Gruyter, 2009–.
Applebaum, Robert. "Eve's and Adam's 'Apple': Horticulture, Taste, and the Flesh of the Forbidden Fruit in Paradise Lost." *Milton Quarterly* 36, no. 4 (2002): 221–39.
Avenoza, Gemma. "The Bible in Spanish and Catalan." In Marsden and Matter, *The Bible*, 288–306.
Bagatti, Bellarmino. "L'iconografia della tentazione de Adamo ed Eva." *Liber Annus* 31 (1981): 217–30.
Balch, David L. "From Endymion in Roman *Domus* to Jonah in Christian Catacombs: From Houses of the Living to Houses of the Dead; Iconography and Religion in Transition." In

Commemorating the Dead: Texts and Artifacts in Context—Studies of Roman, Jewish, and Christian Burials, edited by Laurie Brink, OP, and Deborah Green, 273–302. Berlin: De Gruyter, 2008.

Baró, José. *Glosario completo de Los milagros de Nuestra Señora de Gonzalo de Berceo*. Boulder, CO: Society of Spanish and Spanish-American Studies, 1987.

Baugh, Albert, and Thomas Cable. *A History of the English Language*. London: Routledge, 2002.

Bayet, J. "Hercule funéraire (pl. VII)." *Mélanges d'archéologie et d'histoire* 39 (1921–22): 219–66.

Bayet, J. "Hercule funéraire (suite et fin)." *Mélanges d'archéologie et d'histoire* 40 (1923): 19–102.

Bell, David N. "The Commentary on the Lord's Prayer of Gilbert Foliot." *Recherches de théologie ancienne et médiévale* 56 (1989): 80–101.

Bell, David N. "The Commentary on the Song of Songs of Thomas the Cistercian." *Citeaux: Commentarii cistercienses* 28 (1977): 5–25.

Ben-Sasson, Rivka. "Botanics and Iconography: Images of the *Lulav* and the *Etrog*." *Ars judaica* 8 (2012): 7–22.

Boers, Willy. "La *Genèse* d'Evrat." *Scriptorium* 61 (2007): 74–149.

Bogaert, Pierre-Maurice. "La Bible française au moyen âge: Des premières traductions aux débuts de l'imprimerie." In *Les Bibles en française: Histoire illustrée du moyen âge à nos jours*, edited by Pierre-Maurice Bogaert, 13–46. Turnhout: Brepols, 1991.

Bonnell, John K. "The Serpent with a Human Head in Art and in Mystery Play." *American Journal of Archaeology* 21, no. 3 (1917): 255–91.

Bottigheimer, Ruth B. "Publishing, Print, and Change in the Image of Eve and the Apple, 1470–1570." *Archiv für Reformationsgeschichte* 86 (1995): 199–235.

Bradley, Jill. *"You Shall Surely Not Die": The Concepts of Sin and Death as Expressed in the Manuscript Art of Northwestern Europe c. 800–1200*. LWW 4. Leiden: Brill, 2008.

Brown, George Hardin. "Patristic Pomegranates, from Ambrose and Apponius to Bede." In *Latin Learning and English Lore: Studies in Anglo-Saxon Literature for Michael Lapidge*, edited by Katherine O'Brien O'Keefe and Andy Orchard, 1:132–49. TOE. Toronto: University of Toronto Press, 2005.

Bruce, Scott G. *Silence and Sign Language in Medieval Monasticism: The Cluniac Tradition c. 900–1200*. CSMLT (4th series) 68. Cambridge: Cambridge University Press, 2007.

Brunetti, Giuseppina. "Un capitol dell'espansione del francese in Italia: Manoscritti e testi a Bologna fra Duecento e Trecento in Bologna nel Medio Evo." *Quaderni di filologia romanza dell'Università di Bologna* 17 (2004): 125–59.

Buchheit, Vinzenz. "Augustinus unter dem Feigenbaum (zu *Conf*. VIII)." *Vigiliae christianae* 22, no. 4 (1968): 257–71.

Cahn, Walter. "The Artist as Outlaw and *Apparatchik*." In *The Renaissance of the Twelfth Century*, edited by Stephen K. Scher, 10–14. Providence: Rhode Island School of Design Museum of Art, 1969.

Calvillo, Elena. "Imitation and Invention in the Service of Rome: Giulio Clovio's Works for Cardinals Marino Grimani and Alessandro Farnese." PhD diss., The Johns Hopkins University, 2003.

Campbell, William H. *The Landscape of Pastoral Care in Thirteenth-Century England*. CSMLT 106. Cambridge: Cambridge University Press, 2018.

Carr, Annemarie Weyl. *Byzantine Illumination, 1150–1250: The Study of a Provincial Tradition*. SMMI 47. Chicago: University of Chicago Press, 1987.

Casanellas, Pere. "Medieval Catalan Translations of the Bible." In *Les veus del sagrat*, edited by Xavier Terrado and Flocel Sabaté, 15–34. Lleida: Pagès, 2014.

Caskey, Jill. "Whodunnit? Patronage, the Canon, and the Problematics of Agency in Romanesque and Gothic Art." In *A Companion to Medieval Art: Romanesque and Gothic in Northern Europe*, edited by Conrad Rudolph, 193–212. New York: Wiley, 2011.

Christern-Briesenick, Brigitte. *Frankreich, Algerien, Tunisien*. Compiled by Giuseppe Bovini and Hugo Brendenburg. Vol. 3 of *Repertorium der christlich-antiken Sarkophage*. Mainz: Philipp von Zabern, 2003.

Cleary, Simon Esmonde. *Rome in the Pyrenees: Lugdunum and the Covnenae from the First Century B.C. to the Seventh Century A.D.* RMCS. London: Routledge, 2008.

Cohen, Adam S., and Anne Derbes. "Bernward and Eve at Hildesheim." *Gesta* 40, no. 1 (2001): 19–38.

Constable, Giles. "The Language of Preaching in the Twelfth Century." *Viator* 25 (1994): 131–52.

Cramer, Peter. "Abelard on the First Six Days." In *Rethinking Abelard: A Collection of Critical Essays*, edited by Babette S. Hellemans, 282–97. BSIH 229. Leiden: Brill, 2014.

Crist, Larry S. "La chute de l'homme sur la scène dans la France du XIIe et du XVe siècle." *Romania* 99, no. 2 (1978): 207–19.

D'Ancona, Mirella Levi. *The Garden of the Renaissance: Botanical Symbolism in Italian Painting*. AA 10. Florence: Olschki, 1977.

Danos, Joseph R. *A Concordance of the "Roman de la Rose" of Guillaume de Lorris*. NCSRLL 3. Chapel Hill: University of North Carolina Press, 1975.

d'Avray, D. L. *The Preaching of the Friars: Sermons Diffused from Paris before 1300*. Oxford: Clarendon Press, 1985.

Deichmann, Friedrich Wilhelm. *Rom und Ostia*. Compiled by Giuseppe Bovini and Hugo Brandenburg. Vol. 1 of *Repertorium der christlich-antiken Sarkophage*. Wiesbaden: Franz Steiner, 1967.

de Jonge, Marinus, and Johannes Tromp, *The Life of Adam and Eve and Related Literature*. GAP. Sheffield: Academic Press, 1997.

Deutscher, Guy. *The Unfolding of Language: An Evolutionary Tour of Mankind's Greatest Invention*. New York: Picador, 2006.

Diez de Velasco, Francisco. "Marge, axe et centre: Iconographie d'Héraclès, Atlas et l'arbre des Hespérides." In *Héros et héroïnes dans les mythes et les cultes grecs: Actes du Colloque organisé à l'Université de Vallodolid du 26 au 29 mai 1999*, edited by Vinciane Pirenne-Delforge and Emilio Suárez de la Torre, 197–216. KS 10. Liège: Centre International d'Étude de la Religion Grecque Antique, 2000.

Dodwell, C. R. "L'originalité iconographique de plusieurs illustrations anglo-saxonnes de l'Ancien Testament." *Cahiers de civilisation médiévale* 14, no. 56 (1971): 319–28.

Dresken-Weiland, Jutta. *Italien mit einem Nachtrag Rom und Ostia, Dalmatien, Museen der Welt*. Compiled by Giuseppe Bovini und Hugo Brandenburg. Vol. 2 of *Repertorium der christlich-antiken Sarkophage*. Mainz: Philipp von Zabern, 1998.

Durliat, Marcel. *Pyrénées romanes*. La Pierre-qui-Vire: Zodiac, 1978.

Džurova, Axinia. *Répertoire des manuscrits grecs enlumiés (IXe–Xe s.)*. Sofia: University of Sofia, 2006.

Ego, Beate. "Adam und Eva in Judentum." In *Adam und Eva in Judentum, Christentum und Islam*, edited by Christfried Böttrich, Beate Ego, and Friedmann Eißler, 11–78. JCI. Göttingen: Vandenhoeck & Ruprecht, 2011.

Elsner, Jaś. *Imperial Rome and Christian Triumph: The Art of the Roman Empire, AD 100–450*. OHA. Oxford: Oxford University Press, 1998.

Elsner, Jaś. "Inventing Christian Rome: The Role of Early Christian Art." In *Rome the Cosmopolis*, edited by Catherine Edwards and Greg Woolf, 71–99. Cambridge: Cambridge University Press, 2003.
Erickson, Megan L. "From the Mouths of Babes: Putti as Moralizers in Four Prints by Master H.L." Master's thesis, University of Washington, 2014.
Esche, Sigrid. *Adam und Eva: Sündenfall und Erlösung*. Düsseldorf: L. Schwann, 1957.
Flood, John. *Representations of Eve in Antiquity and the English Middle Ages*. RSMRC 9. New York: Routledge, 2011.
Franco Júnior, Hilário. "Between the Fig and the Apple: Forbidden Fruit in Romanesque Iconography." *Revue de l'histoire des religions* 223, no. 1 (2006): 2–38.
Furvinal, F. J., ed. *Life-Records of Chaucer*. Pt. 2. London: Trübner, 1875.
Garrucci, Raffaele. *Storia della arte cristiana nei primi otto secoli della Chiesa*. Prato: Guasti, 1873–81.
Gaunt, Simon. "French Literature Abroad: Towards an Alternative History of French Literature." *Interfaces* 1 (2015): 25–61.
Geiger, Ari. "A Student and an Opponent: Nicholas of Lyra and His Jewish Sources." In *Nicolas de Lyre: Franciscain du XIVe siècle*, edited by Gilbert Dahan, 167–203. MATM 48. Paris: Institut d'études Augustiniennes, 2011.
Geller, Florentina Badalanova. "The Sea of Tiberias: Between Apocryphal Literature and Oral Tradition." In *The Old Testament Apocrypha in the Slavonic Tradition: Continuity and Diversity*, edited by Lorenzo DiTommaso and Christfried Böttrich, 13–158. TSAJ 140. Tübingen: Mohr Siebeck, 2011.
Geller, Florentina Badalanova. "South Slavic." In *The Bible in Folklore Worldwide*, edited by Eric Ziolkowski, 253–306. HBR 1.1. Berlin: De Gruyter, 2017.
Geyer, Paulus. "Spuren gallischen Lateins bei Marcellus Empiricus." *Archiv für lateinische Lexikographie und Grammatik mit Einschluss des älteren Mittellateins* 8 (1893): 469–81.
Ginzberg, Louis. *Legends of the Jews*. Translated by Henrietta Szold. 7 vols. Philadelphia: Jewish Publication Society, 1909–38.
Giraud, Cédric. "*Lectiones Magistri Anselmi*, les commentaires d'Anselme de Laon sur le Cantique des Cantiques." In *The Multiple Meanings of Scripture: The Role of Exegesis in Early-Christian and Medieval Culture*, edited by I. van t'Spijker. Commentaria 2. Leiden: Brill, 2008.
Glaeske, Keith John. "The Image of Eve in Anglo-Saxon, Middle English, and Old Irish Literature." PhD diss., Catholic University of America, 1997.
Glorieux, Palémon. *Pour revaloriser Migne: Tables rectificatives*. MSR 9. Lille: Facultés catholiques, 1952.
Goetz, Oswald. *Der Feigenbaum in der religiösen Kunst des Abendlandes*. Berlin: Mann, 1965.
Gow, Andrew Colin. "The Bible in Germanic." In Marsden and Matter, *The Bible*, 198–216.
Gray, Douglas. "The Medieval Religious Lyric." In *The Blackwell Companion to the Bible in English Literature*, edited by Rebecca Lemon et al., 76–84. Hoboken, NJ: Wiley-Blackwell, 2009.
Grünbaum, Max. *Neue Beiträge zur semitischen Sagenkunde*. Leiden: Brill, 1893.
Guldan, Ernst. *Eva und Maria: Eine Antithese als Bildmotiv*. Graz: Bohlau, 1966.
Gwara, Scott. "Second Language Acquisition and Anglo-Saxon Bilingualism: Negative Transfer and Avoidance in Ælfric Bata's Latin *Colloquia*, c. A.D. 1000." *Viator* 29 (1998): 1–24.
Hamilton, Victor P. *The Book of Genesis 1–17*. NICOT 1. Grand Rapids, MI: Eerdmans, 1990.
Heisig, Karl. "Woher stammt die Vorstellung vom Paradiesapfel?" *Zeitschrift für die Neutestamentliche Wissenschaft* 44 (1953): 111–18.

Hendel, Ronald S. *Text of Genesis 1–11: Textual Studies and Critical Edition*. Oxford: Oxford University Press, 1998.
Herren, Michael W. "Latin and the Vernacular Languages." In *Medieval Latin: An Introduction and Bibliographical Guide*, edited by F. A. C. Mantello and A. G. Rigg, 122–29. Washington, DC: Catholic University of American Press, 1996.
Heydenreich, Gunnar. "Adam and Eve in the Making." In *Temptation in Eden: Lucas Cranach's Adam and Eve*, edited by Caroline Campbell, 18–33. London: Courtauld Institute of Art Gallery, 2007.
Hoogvliet, Margriet. "Encouraging Lay People to Read the Bible in the French Vernaculars: New Groups of Readers and Textual Communities." *Church History and Religious Culture* 93 (2013): 239–74.
Horn, Martina. *Adam-und-Eva-Erzählungen im Bildprogramm kretischer Kirchen: Eine ikonographische und kulturhistorische Objekt- und Bildfindungsanalyse*. BzOO 16. Mainz: Verlag des Römisch-Germanischen Zentralmuseums, 2020.
Hunt, Tony. *Plant Names of Medieval England*. Cambridge: D. S. Brewer, 1989.
Hunt, Tony. *Teaching and Learning Latin in Thirteenth-Century England*. Cambridge: D. S. Brewer, 1991.
Huskinson, Janet. "Some Pagan Mythological Figures and Their Significance in Early Christian Art." *Papers of the British School at Rome* 42 (1974): 68–97.
Hutter, Irmgard. *Corpus der byzantinischen Miniaturenhandschriften: Oxford, Bodleian Library*. DB 2. Stuttgart: Anton Hiersemann, 1982.
Hutter, Irmgard. *Corpus der byzantinischen Miniaturenhandschriften: Oxford College Libraries*. DB 13. Stuttgart: Anton Hiersemann, 1977.
Hyman, Clarissa. *Oranges: A Global History*. London: Reaktion, 2013.
Ingham, Richard. "The Diffusion of Higher-Status Lexis in Medieval England: The Role of the Clergy." *English Language and Linguistics* 22, no. 2 (2018): 207–24.
Jagić, Vatroslav. "Slavische Beiträge zu biblischen Apocryphen I: Die altkirchenslavischen Texte des Adambuches." In *Denkschriften der Kaiserlichen Akademie der Wissenschafter, Philosophisch-historische Classe*, vol. 42. Vienna: F. Tempsky, 1893.
Janson, H. Frederic. *Pomona's Harvest: An Illustrated Chronicle of Antiquarian Fruit Literature*. Portland, OR: Timber Press, 1996.
Japhet, Sara, and Barry Dov Walfish. *The Way of Lovers: The Oxford Anonymous Commentary on the Song of Songs (Bodleian Library, MS Opp. 625)*. Commentaria 8. Leiden: Brill, 2017.
Jolly, Penny Howell. *Made in God's Image? Eve and Adam in the Genesis Mosaics at San Marco, Venice*. Berkeley: University of California Press, 1997.
Jones, Carolyn E. "*Cursor Mundi* and *Post Peccatum Adae*: A Study of Textual Relationships." PhD diss., University of Miami, 1976.
Juniper, Barrie E., and David J. Mabberley. *The Story of the Apple*. Portland, OR: Timber Press, 2006.
Kannengiesser, Charles. *Handbook of Patristic Exegesis: The Bible in Ancient Christianity*. Leiden: Brill, 2004.
Katamba, Francis. *English Words: Structure, History, Usage*. New York: Routledge, 2015.
Kauffmann, C. M. *Biblical Imagery in Medieval England, 700–1550*. HMSAH 34. Turnhout: Brepols, 2003.
Kelly, Henry A. "The Metamorphoses of the Eden Serpent during the Middle Ages and Renaissance." *Viator* 2 (1971): 301–27.

Kessler, Herbert. *The Illustrated Bibles from Tours*. SMI 7. Princeton, NJ: Princeton University Press, 1977.
Kessler, Herbert L. "*Hic Homo Formatur*: The Genesis Frontispieces of the Carolingian Bibles." *Art Bulletin* 53 (1971): 143–60.
Kienzle, Beverly Mayne. "The Twelfth-Century Monastic Sermon." In *The Sermon*, edited by Beverly Mayne Kienzle, 271–323. TSMAO 81–83. Turnhout: Brepols, 2000.
Klein (Hakatan), Menashe. *Mishneh Halakhot*. N.p.: Machon Mishneh Halakhot Gedolot, 2000.
Klepper, Deeana Copeland. "Nicholas of Lyra and Franciscan Interest in Hebrew Scholarship." In *Nicholas of Lyra: The Senses of Scripture*, edited by Philip D. W. Krey and Lesley Smith, 289–311. SHCT 90. Leiden: Brill, 2000.
Koch, Guntram. *Frühchristliche Sarkophage*. HA. Munich: Beck, 2000.
König, Hildegard. "*Vestigia antiquorum magistrorum sequi*: Wie liest Apponius Origenes?" *Theologische Quartel* 170 (1990): 129–36.
Korol, Dieter. *Die frühchristlichen Wandmalereien aus den Grabbauten in Cimitile/Nola*. JACE 13. Münster: Aschendorffsche, 1987.
Kulik, Alexander. *Retroverting Slavonic Pseudepigrapha: Toward the Original of the Apocalypse of Abraham*. SBLTCS 3. Brill: Leiden, 2005.
Laderman, Shulamit. "Two Faces of Eve: Polemics and Controversies Viewed through Pictorial Motifs." *Images* 2, no. 1 (2008): 1–20.
Lange, Ulrike, and Brigit Kilian, eds. *Ikonographisches Register für das Repertorium christlich-antiken Sarkophage*. Dettelbach: Roll, 1996.
LaVere, Suzanne. *Out of the Cloister: Scholastic Exegesis of the Song of Songs, 1100–1250*. Commentaria 6. Leiden: Brill, 2016.
Lawrence, Marion. "The Velletri Sarcophagus." *American Journal of Archaeology* 69, no. 3 (1965): 207–22.
Leclercq, Jean. "Le commentaire du *Cantique des cantiques* attribué à Anselme de Laon." *Recherches de théologie ancienne et médiévale* 16 (1949): 7–22.
Leder, Hans-Günter. "*Arbor Scientiae*: Die Tradition vom paradiesischen Apfelbaum." *Zeitschrift für die Neutestamentliche Wissenschaft* 52 (1961): 156–89.
Leonardi, Lino. "The Bible in Italian." In Marsden and Matter, *The Bible*, 268–85.
Lingquist, Sherry C. M., and Stephen Perkinson. "Artistic Identity in the Late Middle Ages: Forward." *Gesta* 41, no. 1 (2002): 1–2.
Liphkowitz, Ina. *Words to Eat By: Five Foods and the Culinary History of the English Language*. New York: St. Martin's Press, 2011.
Littlewood, A. R. "The Symbolism of the Apple in Greek and Roman Literature." *Harvard Studies in Classical Philology* 72 (1968): 147–81.
Lobrichon, Guy. "The Story of a Success: The *Bible Historiale* in French (1295–c. 1500)." In *Form and Function in the Late Medieval Bible*, edited by Eyal Poleg and Laura Light, 307–32. Leiden: Brill, 2013.
Lodge, R. Anthony. *Le français: Histoire d'un dialecte devenu langue*. Paris: Fayard, 1993.
Loeffler, E. "Lysippos' Labors of Herakles." *Marsyas* 6 (1954): 8–24.
Long, Lynne. "Scriptures in the Vernacular up to 1800." In *A History of Biblical Interpretation*, edited by Alan J. Hauser and Duane Frederick Watson, 450–81. Grand Rapids, MI: Eerdmans, 2009.
Longère, Jean. *La predication médiévale*. Paris: Études Augustiniennes, 1983.

Lowden, John. "The Anjou Bible in the Context of Illustrated Bibles." In *The Anjou Bible, a Royal Manuscript Revealed: Naples 1340*, edited by Lieve Watteeuw and Jan Ven der Stock, 1–25. CIM 18. Paris: Peeters, 2010.

Lowden, John. *The Octateuchs: A Study in Byzantine Manuscript Illumination*. College Park, PA: Penn State University Press, 1992.

Lusignan, Serge. "French Language in Contact with English: Social Context and Linguistic Change (Mid-13th–14th Centuries)." In Wogan-Browne, *Language and Culture in Medieval Britain*, 19–30.

Malbon, Elizabeth Struthers. *The Iconography of the Sarcophagus of Junius Bassus*. Princeton, NJ: Princeton University Press, 1990.

Marava-Chatzinicolaou, Anna, and Christina Toufexi-Paschou. *Catalogue of the Illuminated Byzantine Manuscripts of the National Library of Greece*. Athens: Academy of Athens, 1997.

Marsden, Richard. "The Bible in English." In Marsden and Matter, *The Bible*, 217–37.

Marsden, Richard, and E. Ann Matter, eds. *The Bible: From 600 to 1450*. Vol. 2 of *The New Cambridge History of the Bible*. Cambridge: Cambridge University Press, 2012.

Martínez, H. Salvador. *Alfonso X, the Learned: A Biography*. SHCT 146. Leiden: Brill, 2010.

Matis, Hanah. *The Song of Songs in the Early Middle Ages*. SHCT 191. Leiden: Brill, 2019.

Matter, E. Ann. "Alcuin's Questions and Answers Text." *Rivista di storia della filosofia* 45, no. 4 (1990): 645–56.

Matter, E. Ann. *The Voice of My Beloved: The Song of Songs in Western Medieval Christianity*. MAS. Philadelphia: University of Pennsylvania Press, 1990.

Mavroska, Vasiliki V. "Adam and Eve in the Western and Byzantine Art of the Middle Ages." PhD diss., Johann Wolfgang Goethe University, 2009.

Mazouer, Charles. *Le théâtre français du moyen âge*. Paris: Sedes, 1998.

McCormick, Stephen Patrick. "Remapping the Story: Franco-Italian Epic and Lombardia as a Narrative Community (1250–1441)." PhD diss., University of Oregon, 2011.

McNally, Robert E. *The Bible in the Early Middle Ages*. Eugene, OR: Wipf and Stock, 2005.

McPhee, John. *Oranges*. New York: Farrar, Straus and Giroux, 1966.

Meyer, Paul. "Notice du ms. Bibl. nat. fr. 6447 (Traduction de divers livres de la Bible. — Légendes de saints)." *Notices et extraits des manuscrits de la Bibliothèque nationale et autres bibliothèques* 35, no. 2 (1896): 435–510.

Montgomery, Holt. "Gilbert Foliot's Commentary on the Song of Songs." Master's thesis, University of North Carolina, Chapel Hill, 1974.

Morey, James H. *Book and Verse: A Guide to Middle English Biblical Literature*. IMS. Urbana: University of Illinois Press, 2009.

Morey, James H. "Peter Comestor, Biblical Paraphrase, and the Medieval Popular Bible." *Speculum* 68, no. 1 (1993): 6–35.

Morgan, Joan, and Alison Richards. *The New Book of Apples: The Definitive Guide to over 2,000 Varieties*. London: Ebury, 2003.

Moss, Howard. "Language and Italian National Identity." In *The Politics of Italian National Identity: A Multidisciplinary Perspective*, edited by Bruce Anthony Haddock and Gino Bedani, 98–123. Cardiff: University of Wales Press, 2000.

Mostalac Carillo, Antonio. "La iconografía del ciclo de Adán y Eva en el sarcófago de la receptio animae de la basílica menor de Santa Engracia (Zaragoza)." In *Miscelánea de estudios en homenaje a Guillermo Fatás Cabeza*, edited by Antonio Duplá Ansuategui, María Victoria

Escribano Paño, Laura Sancho Rocher, and María Angustias Villacampa Rubio, 539–48. Zaragoza: Institución Fernando el Católico, 2014.

Murdoch, Brian. *Adam's Grace: Fall and Redemption in Medieval Literature*. Cambridge: D.S. Brewer, 2000.

Murdoch, Brian. *The Medieval Popular Bible: Expansions of Genesis in the Middle Ages*. Cambridge: D.S. Brewer, 2003.

Murdoch, Brian, and J. A. Tasioulas. *The Apocryphal Lives of Adam and Eve*. EMETS. Exeter: University of Exeter Press, 2002.

Musselman, Lytton John. *Figs, Dates, Laurel, and Myrrh: Plants of the Bible and the Quran*. Portland, OR: Timber Press, 2007.

Narkiss, Bezalel. "The Sign of Jonah." *Gesta* 18, no. 1 (1979): 63–76.

Nickelsburg, George W. E. *1 Enoch 1: A Commentary on the Book of 1 Enoch, Chapters 1–36; 81–108*. Hermeneia. Minneapolis: Fortress Press, 2001.

Noegel, Scott, and Gary Rendsburg. *Solomon's Vineyard: Literary and Linguistic Studies in the Song of Songs*. AIL 1. Atlanta: Society of Biblical Literature, 2009.

Nuovo, Angela. *The Book Trade in the Italian Renaissance*. LWW 26. Leiden: Brill, 2013.

O'Donnell, James J. *Confessions III: Commentary on Books 8–13*. Oxford: Clarendon Press, 1992.

Ovadis, Alyssa. "Abstraction and Concretization of the Fruit of the Tree of Knowledge of Good and Evil as Seen through Biblical Interpretation and Art." Master's thesis, McGill University, 2010.

Parkes, M. B. "The Literacy of the Laity." In *Literature and Western Civilization: The Medieval World*, edited by D. Daiches and A. K. Thorlby, 555–76. London: Aldus, 1973. Reprinted in *Scribes, Scripts, and Readers: Studies in the Communication, Presentation, and Dissemination of Medieval Texts*, edited by M. B. Parkes, 275–97. London: Hambledon, 1991.

Pérennec, René, and Anton Touber. "Lexik." In *Sprache und Verskunst*, edited by Geert H. M. Claasens, Fritz Peter Knapp, and René Pérennec. GLMF 2. Berlin: De Gruyter, 2014.

Pettegree, Andrew. *The Book in the Renaissance*. New Haven, CT: Yale University Press, 2010.

Pickens, Rupert T. "Roland's Apple: Truthful and Untruthful Discourse in *La chanson de Roland*." In *Studies in Honor of Hans-Erich Kelle: Medieval French and Occitan Literature and Romance Linguistics*, edited by Rupert T. Pickens, 73–80. Kalamazoo: Western Michigan University, 1993.

Price, David H. *In the Beginning Was the Image: Art and the Reformation Bible*. Oxford: Oxford University Press, 2020.

Prins, A. A. *French Influence in English Phrasing*. Leiden: Universitaire Pers, 1952.

Randall, Dale. "The Rank and Earthy Background of Certain Physical Symbols in *The Duchess of Malfi*." *Renaissance Drama* 18 (1981): 171–203.

Roberts, Phyllis. "The *Ars Praedicandi* and the Medieval Sermon." In *Preacher, Sermon, and Audience in the Middle Ages*, edited by Carolyn Muessig, 41–62. Leiden: Brill, 2002.

Robinson, Stephen Edward. *The Testament of Adam: An Examination of the Syriac and Greek Traditions*. SBLDS 52. Chico, CA: Scholars Press, 1982.

Roeck, Bernd. "Venice and Germany: Commercial Contacts and Intellectual Aspirations." In Aikema and Brown, *Renaissance Venice and the North*, 45–55.

Ross, David J. A. "The History of Macedon in the 'Histoire ancienne jusqu'à César': Sources and Compositional Method." *Classica et mediaevalia* 24 (1963): 181–231.

Schammell, Jennifer F. "The Bible on the Stage: The Cultural Foundations of the Mystery Plays and the 'Popular Medieval Bible.'" PhD diss, University of Glasgow, 2005.

Short, Ian. "Patrons and Polyglots: French Literature in Twelfth-Century England." In *Anglo-Norman Studies XIV: Proceedings of the Battle Conference*, edited by Marjorie Chibnall, 229–50. Suffolk: Boydell Press, 1992.

Shoulson, Jeffrey S. "The Embrace of the Fig Tree: Sexuality and Creativity in Midrash and in Milton." *ELH* 67 (2000): 873–903.

Smalley, Beryl. *The Study of the Bible in the Middle Ages*. Oxford: Clarendon Press, 1983.

Smith, Lesley. *The "Glossa Ordinaria": The Making of a Medieval Bible Commentary*. Commentaria 3. Leiden: Brill, 2009.

Smyth, Marina. "The Seventh-Century Hiberno-Latin Treatise *Liber de ordine creaturarum*." *Journal of Medieval Latin* 21 (2011): 137–222.

Sneddon, Clive R. "The Bible in French." In Marsden and Matter, *The Bible*, 251–67.

Snyder, James. "Jan Van Eyck and Adam's Apple." *Art Bulletin* 58 (1976): 511–16.

Spicq, Ceslas. *Esquisse d'une histoire de l'exégèse latine au moyen âge*. Paris: Vrin, 1944.

Squatriti, Paolo. *Landscape and Change in Early Medieval Italy: Chestnuts, Economy, and Culture*. Cambridge: Cambridge University Press, 2013.

Stabel, Peter. "Venice and the Low Countries: Commercial Contacts and Intellectual Aspirations." In Aikema and Brown, *Renaissance Venice and the North*, 31–43.

Stone, Michael. *A History of the Literature of Adam and Eve*. EJL 3. Atlanta: Scholars Press, 1992.

Tigchelaar, Eibert J. C. "Eden and Paradise: The Garden Motif in Some Early Jewish Texts (1 Enoch and Other Texts Found at Qumran)." In *Paradise Interpreted: Representations of Biblical Paradise in Judaism and Christianity*, edited by Gerard P. Luttikhuizen, 37–62. TBN 2. Leiden: Brill, 1999.

Tolkowsky, Samuel. *Hesperides: A History of the Culture and Use of Citrus Fruits*. London: John Bale, Sons & Curnow, 1938.

Trapp, J. B. "The Iconography of the Fall of Man." In *Approaches to Paradise Lost: The York Tricentenary Lectures*, edited by C. A. Patrides, 223–65. Toronto: University of Toronto Press, 1968.

Trotter, David. "'Stuffed Latin': Vernacular Evidence in Latin Documents." In Wogan-Browne, *Language and Culture in Medieval Britain*, 153–63.

Väänänen, Veikko. *Introduction au Latin Vulgaire*. MEL 6. Paris: Klincksieck, 1981.

van der Veen, Marijke, Alistair Hill, and Alexandra Livarda. "The Archaeobotany of Medieval Britain (c. AD 450–1500): Identifying Research Priorities for the 21st Century." *Medieval Archaeology* 57 (2013): 151–82.

van Liere, Frans. *An Introduction to the Medieval Bible*. IR. Cambridge: Cambridge University Press, 2014.

von Rad, Gerhard. *Genesis: A Commentary*. OTL. Louisville, KY: Westminster John Knox, 1973.

Wataghin, Gisela Cantino. "I primi cristiani, tra *imagines, historiae,* e *pictura*: Spunti di riflessione." *Antiquité tardive* 19 (2011): 13–34.

Weitzmann, Kurt, Massimo Bernabò, and Rita Tarasconi, *The Illustrations in the Manuscripts of the Septuagint*. Vol. 2, *Octoteuchs*. Princeton, NJ: Princeton University Press, 1999.

Weitzmann, Kurt, and Herbert L. Kessler. *The Illustrations in the Manuscripts of the Septuagint*. Vol. 1, *The Cotton Genesis: British Library Codex Cotton Otho B. VI*. Princeton, NJ: Princeton University Press, 1986.

Werner, Ferdinand. *Aulnay de Saintonge und die romanische Skulptur in Westfrankreich*. Worms: Wernersche Verlagsgesellschaft, 1979.

Wogan-Browne, Jocelyn, ed. *Language and Culture in Medieval Britain: The French of England c.1100–c.1500*. York: York Medieval Press, 2009.

Wright, Richard. "Alcuin's *De Orthographia* and the Council of Tours (A.D. 813)." In *A Sociophilological Study of Late Latin*, 127–46. USML 10. Turnhout: Brepols, 2002.
Zacher, Samantha. *Rewriting the Old Testament in Anglo-Saxon Verse: Becoming the Chosen People*. London: Bloomsbury, 2013.
Zagdoun, Mary-Anne. "De quelques thèmes et motifs traditionnels ou païens sur les sarcophages paléochrétiens." *Semitica et classica* 2 (2009): 157–66.
Zahora, Tomaz. *Nature, Virtue, and the Boundaries of Encyclopedic Knowledge: The Tropological Universe of Alexander Neckam (1157–1217)*. ES 13. Turnhout: Brepols, 2014.
Zanker, Paul, and Björn C. Ewald. *Living with Myths: The Imagery of Roman Sarcophagi*. Translated by Julia Slater. OSACR. Oxford: Oxford University Press, 2012.
Zevit, Ziony. *What Really Happened in the Garden of Eden?* New Haven, CT: Yale University Press, 2013.
Zimmerman, Norbert. *Werkstattgruppen römischer Katakobenmalerei*. JACE 35. Münster: Aschendorff, 2002.
Zohary, Daniel, Maria Hopf, and Ehud Weiss. *Domestication of Plants in the Old World: The Origin and Spread of Domesticated Plants in Southwest Asia, Europe, and the Mediterranean Basin*. OSP. Oxford: Clarendon Press, 2012.

DICTIONARIES AND REFERENCE WORKS

Arrighi, Cletto. *Dizionario milanese-italiano*. Milan: Hoepli, 1896.
BFM—*Base de Français Médiéval*. Lyon: ENS de Lyon. http://txm.ish-lyon.cnrs.fr/bfm/.
Biblia Medieval. https://bibliamedieval.es/.
Boerio, Giuseppe. *Dizionario del dialetto Veneziano*. Venice: Giovanni Cecchini, 1856.
Boretius, A., ed. *Capitularia regum Francorum*. 2 vols. MGH Hanover: Hahniani, 1883.
Diccionari de Textos Catalans Antics. The University of Barcelona and Centre de Documentació Ramon Llull. http://www.ub.edu/diccionari-dtca/.
Dictionary of Old English. University of Toronto. http://www.doe.utoronto.ca.
Glare, P. G. W., ed. *Oxford Latin Dictionary*. Oxford: Oxford University Press, 1968.
Historische woordenboeken Nederlands en Fries. Het Instituut voor de Nederlandse taal. http://gtb.ivdnt.org/search.
Jones, Tom Devonshire, Linda Murray, and Peter Murray, eds. *The Oxford Dictionary of Christian Art and Architecture*. 2nd ed. Oxford: Oxford University Press, 2013.
Le Roux de Lincy, Adrien Jean Victor. *Le livre des proverbes français*. Paris: Paulin, 1842.
Lewis, Charlton, and Charles Short. *A New Latin Dictionary*. Oxford: Clarendon Press, 1891.
Meyer-Lübke, Wilhelm. *Romanisches etymologisches Wörterbuch*. Heidelberg: C. Winter, 1911.
Middle English Dictionary. https://quod.lib.umich.edu/m/middle-english-dictionary/dictionary.
Mittelhochdeutsches Wörterbuch. Mainzer Akademie der Wissenschaften. http://www.mhdwb-online.de/.
Olszowy-Schlanger, Judith, ed. *Dictionnaire hébreu-latin-français de la Bible hébraïque de l'abbaye de Ramsey (XIIIe s.)*. LLMA 4. Turnhout: Brepols, 2008.
Rey, Alain. *Dictionnaire historique de la langue française*. Paris: Le Robert, 2016.
Rothwell, W., S. Gregory, D. A. Trotter, M. Beddow, and Modern Humanities Research Association. *Anglo-Norman Dictionary*. London: Maney Publishing for the Modern Humanities Research Association. 2005.
Savignac, Jean-Paul. *Dictionnaire Français-Gaulois*. Paris: La Différence, 2014.

Schramm, Albert. *Der Bilderschmuck der Frühdrucke.* 20 vols. Leipzig: Deutsches Museum für Buch und Schrift, 1920–37. https://digi.ub.uni-heidelberg.de/diglit/schramm1920ga.

Vocabolario. Lessicografia della Crusca in Rete. http://www.lessicografia.it/index.jsp.

PRINCIPAL DATABASES AND WEBSITES USED IN COLLECTING ICONOGRAPHIC DATA

Bayerische Staatsbibliothek: https://www.bsb-muenchen.de/sammlungen/handschriften/
Biblioteca Apostolica Vaticana: https://digi.vatlib.it/
Bibliothèque nationale de France, Mandragore search engine: http://mandragore.bnf.fr/jsp/rechercheExperte.jsp
Bibliothèque virtuelle des manuscrits médiévaux (BVMM): https://bvmm.irht.cnrs.fr/
Biblissima: https://portail.biblissima.fr/en
Bodleian Digital Collections: https://digital.bodleian.ox.ac.uk/collections/western-medieval-manuscripts/
British Library Digitised Manuscripts: https://www.bl.uk/manuscripts/
Cambridge University Digital Library: https://cudl.lib.cam.ac.uk/
Chester Beatty Library: https://viewer.cbl.ie/viewer/index/
Compostela: The Joining of Heaven and Earth: https://compostela.co.uk/
Corpus Vitrearum (Germany): https://corpusvitrearum.de/
Corpus Vitrearum (Great Britian): https://www.cvma.ac.uk/
Deutsches Archäologisches Institut: https://www.dainst.org/en/dai/meldungen
Digital Scriptorium: https://digital-scriptorium.org/
E-codices: Virtual Manuscript Library of Switzerland: https://www.e-codices.unifr.ch/en
Fitzwilliam Museum: https://fitzmuseum.cam.ac.uk/about-us/collections/illuminated-manuscripts
Free Library of Philadelphia: https://libwww.freelibrary.org/digital/
Harvard Houghton Library: https://library.harvard.edu/libraries/houghton
Huntington Library: https://hdl.huntington.org/
Illustrated Bartsch: https://www.artstor.org/collection/illustrated-bartsch/
Index of Medieval Art: https://theindex.princeton.edu/
Initiale: Catalogue de manuscrits enluminés du Moyen Âge: http://initiale.irht.cnrs.fr/
J. Paul Getty Museum: http://www.getty.edu/art/manuscripts/
Koninklijke Bibliotheek: https://manuscripts.kb.nl/
Koninklijke Bibliotheek van België: https://www.kbr.be/en/collections/manuscripts/
Morgan Library and Museum: http://ica.themorgan.org/
New York Public Library Digital Collections: https://digitalcollections.nypl.org/
Online Stained-Glass Photographic Archive: https://therosewindow.com/pilot/index.htm
Pontificia commissione di archeologia sacra: http://www.archeologiasacra.net/pcas-web/
Städel Museum: https://sammlung.staedelmuseum.de/en
Stan Parry Photography: www.stanparryphotography.com
Walters Library Digital Collection: https://art.thewalters.org/browse/category/manuscripts-and-rare-books/
Warburg Institute Iconographic Database: https://iconographic.warburg.sas.ac.uk/vpc/VPC_search/main_page.php
Württembergische Landesbibliothek: https://digital.wlb-stuttgart.de/start

Index

Page numbers in italics refer to figures.

Abelard, Peter, 20, 66–68, 121n59, 137n20
Abraham, 129n16. *See also* Apocalypse of Abraham
Achilles, 129n16
Achtnich, Walter H., 150n136
Adam and Eve: apocryphal life of, 113n21; clothing depicted, 39; created, 4; disobedience as core transgression, 120n44; and human mortality, 2, 6–7, 17, 24; nakedness covered by fig-leaf aprons, 4, 8–9, 18–20, 39, 113n26, 114n33, 115n36; sin of, 2, 4; as spiritual beings, 115n39. *See also* Fall of Man; Garden of Eden; Genesis, Book of
Adam and Eve (Dürer engraving), xii, 49, *55*, 55–56, 58, 101, 132n52
Ælfric Bata, 68, 139n33
Ælfric of Eynsham, 46, 139n33
æppel/æpple, 72, 144nn81–82, 146n102
agriculture, 148n107; European, 136n13; and iconography, 64. *See also* botany; horticulture
Alan of Lille, 16, 23, 116n10
Alba Bible/Arragel Bible, 148n113, 149n115
Albertinelli, Mariotto, 52, 54, 106
Albertus Magnus, 139n29
Alcuin of York, 2, 18, 23, 26, 37, 121n53, 124n80, 140n38
Alexander the Great, 129n16
Alfonso X (king), 58, 74–75, 149n20
Alster, Baruch, 122n67
Altdorfer, Albrecht, 78, 101, 102
Ambrose, Saint, 15, 22–23, 120n35
Anchin Bible, 41, 92, 131n37
Andrew of St. Victor, 7–8, 16, 20, 122n61
Angelomus of Luxueil, 125n93
Anjou Bible, 104, 134n66

Anselm of Laon, 21–22, 26, 42, 123n76, 123nn72–74, 136n18, 143n70
Antelami, Benedetto, 133n57
apfel (fruit/apple), 73–74, 77, 81, 127n4, 144n84
Aphrodite, 131n31
Apocalypse of Abraham, 112n11; and grape tradition, 5–6
apocrypha, 8–9, 16, 69, 73–74, 108, 113nn20–21, 153
Apollonius of Tyana, 129n16
Apostolos-Cappadona, Diane, 150n2
appel/appil (apple), 72–74, 81, 144n81, 144nn83–84, 145n100, 147n105
apple, vii, 117n22, 134n66; cultivars, 63–64, 111n1, 134n2; European cultivation of, 63; and evil, 2, 12–14, 16, 25–26, 73, 79–80; golden, 32, 39, 129n17, 131n31; as licit species, 11, 16, 24, 75, 147n105; of paradise (banana), 115n2; varieties/cultivars, 63–64, 134n2; word, usage, 66–68, 72–74, 77. See also *apfel* (fruit/apple); *appel/appil* (apple); *avallo* (apple); *malum* (apple/evil); *malus* (apple tree); *manzana/manzano* (apple/apple tree); *mela* (apple); *mēlon* (apple/fruit); *pom* (fruit/apple); *pomme* (apple)
apple tradition: as absent/missing, 1–2, 4–11, 16–17, 20, 37, 51; and affirmation of sin, 21; ascent/rise of, 1–4, 9–28, 42–47, 50–51, 58, 62, 64–68, 77–78, 80, 82–83, 111n1, 147n104, 149n120; and Christ-apple symbolism, 23–24, 79; as de facto forbidden fruit, 11; diffusion of, 71–77, 79, 82–83; extends to present day, 11; forbidden knowledge, as symbol of, 1; in genesis of, 79; iconography, 2, 27–62, 124n80, 127–34nn1–68; inchoate (map), 50; and Latin language, 12–27, 115–27nn1–102; limits of, in Italy and Spain,

INDEX

apple tradition (*cont.*)
 51–61; linguistic and literary rise of, 26–27, 64, 78, 80; as most popular forbidden fruit, 1; and original sin, 22; and print dissemination of, 78; and salvation, 2; scholarly reflection, 79–83, 150–51nn1–9; and sin, affirmation of, 21; and temptation, as symbol of, 1; triumph of, 77–78; vernacular semantics, 2–3, 63–79, 134–50nn1–137; when first appeared, 2
Apponius, 24, 120n35, 125n93
apricot, 20, 72, 122n67
Aramaic Targums. *See* Targums (Aramaic)
Arnold of Bonneval, 16
Artstor (art history database), 80, 150n3
Athena, 131n31
Athenaeus of Naucratis, 129n17
Atlas, 129n18
Augustine, Saint, 2, 15, 17–19, 26, 85, 110, 118n27, 121nn47–48, 135n5
avallo (apple), 137n21, 144n84
Avenoza, Gemma, 148n108
Avitus of Vienne, 13–14, 79, 115n44, 117n15, 127n102, 134n66

Babylonian Talmud, and grape tradition, 7
Baldung, Hans, 78, 101, 102
Bamberg Bible, 37, 91, 130n26
banana, 10, 115n2
Baptistery of San Giovanni, xii, 54, *54*, 104, 105
Baptistery of St. John (Giusto de'Menabuoi), 51–52, 105, 133n58
Bar Hebraeus, 114n36
Bartholomeus Anglicus, 139n30
Baruch, 5–6, 11, 16, 113n20
Beatus of Liebana, 41, 58, 133n63
Beccari, Antonio, 76
Bede, Venerable, 23, 66, 118n28, 120n35
Berceo, Gonzalo de, 74–75
Bernard of Clairvaux, 16–17, 115n44, 120n43, 147n105
Besançon, Jacques de, xi, 94, 95
Bible: commentaries, 1–3, 17–18, 20–22, 26, 66, 68–69, 71, 82, 109, 117n23, 141n49; illuminated/illustrated, 37, 47, 78, 130n26, 134n66; vernacular, 69, 71, 74–75, 120n44, 135n10, 146n101, 148n108. *See also* Genesis, Book of; Hebrew Bible; Septuagint; Song of Songs; Vulgate; *and specific Bible(s) and translations*
Bible historiale, 69, 71, 94, 131n39, 135n10, 140n42, 141n52
Bible of San Lorenzo, 102
Bible of San Millan de la Cogolla, 104
Bible of San Paolo fuori le Mura, 37, 91, 130n26
Bible of Santa Maria del Fiore, 103, 133n57
Biblia del Oso, 148n113, 149n115
Biblia Medieval (database), 148n113, 149n115
biblical apocrypha. *See* apocrypha

biblical pseudepigrapha, 1, 108, 153
Boccaccio, Giovanni, 76
Book of Deuteronomy, and grape tradition, 6
Book of Enoch, 1, 4–5, 112n8
Book of Genesis. *See* Genesis, Book of
Book of Hours (Besançon), xi, 95
Book of Hours (Clovio), xi, 52, 55, 60, 106, 133n55
Book of Hours (Vrelant), xi, 100
Book of Leviticus, 6–7, 15, 118n24, 144n83
Bosch, Hieronymus, 49, 100, 101
botany, 5, 20, 29, 35–36, 41, 47, 51, 58, 67, 111n1, 119n30, 124n80, 127n3, 128n9, 132n45, 132n47, 134nn64–65, 138n28. *See also* agriculture; horticulture
Bottigheimer, Ruth B., 150n136
Brancacci Chapel, Panicale fresco, 54, 105
bread. *See* wheat
Breviarium historie catholice (Ximenez de Rada), 19
Brosamer, Hans, xii, 77, 78
Browne, Thomas, vii, 12, 20, 115nn1–3
Bruno of Segni, 124n80
Bulgaria, 89, 113n20, 134n65
Byzantine art and iconography, 34–37, 90–91
Byzantine Greek sources, 10
Byzantine Octateuchs, 34–36, 91, 130n22

Cabalists, 121n59
cabbage, 73, 145nn98–99
Caedmon Genesis (manuscript), xii, *46*, 95
calques, in semantics, 72, 140n34, 144nn79–80
Cantigas de Santa Maria (Alfonso X), 75, 104, 133n62, 149n118, 149n120
Cantor, Peter, 122n63, 141n48
capitals, xii, 28, 40, *40–43*, 42, 47, 51, 59, 91–93, 97–99, 102–4, 133n57
carvings, xii, 43, 47, *48*, 101
Cassiodorus, 126n94
catacombs, 29, 32–34, *33–34*, *83*, 86, 90–91, 127n5
Catacombs of Marcellinus and Peter (Rome), 29, 32, *33*, 90
Cathars, 141n47, 148n108
Chagall, Marc, 39
Charles the Bald, 37
Chast, Roz, 1
chastity, 9, 18
cherry, 65, 73, 136n16, 145nn98–99
Christianity: and apple symbolism, 23–24, 79; conversion of Jews to, 24; and fig tradition, 9, 26, 127n4; and grape tradition, 7; and iconography, 3, 29–40, 80, 90–91, 127n4, 129n163; Latin, 13; medieval, 3, 20, 22, 26, 69
Chrysostom, John, 37, 91
cibus (food/fruit), 15–16, 24–25, 117–18nn24–25, 118n27, 120n37
Cicero, 129n16, 148n107
Cimitero di S. Gennaro (Napoli), 80

INDEX

Cistercians, 16, 134n2, 138n28
citron/citrus, 9–11, 62, 72, 115n2, 122n67, 129n17, 131n39, 151n9
Clovio, Giulio (Juraj Julije Klović), xi, 52, 55, 60, 106, 133n55, 133n59
Codex Vigilano, 57, 102
Coemeterium Majus (Rome), 29, 90
Cohen, Adam, 132n47
Colbert Codex, 74
Colloquia (Ælfric Bata), 68, 139n33
Columella, 134n1
Comestor, Peter, 20, 66, 69, 122nn61–63, 135n10, 147n104
Commentary on the Six Days of Creation (Hexameron) (Abelard), 20, 66–68, 121n59, 137n20
Commodian, 16, 81, 134n66, 151n8
Confessions (Augustine), 85, 121n48, 135n5
Cornelis van Haarlem, 102
Cotton, Robert, 130n26
Cotton Genesis (manuscript), 130n26
Cramer, Peter, 137n20
Creation and Fall of Man (Albertinelli painting), 52, 54, 106
Crete, Fall of Man scenes, 62, 133n64
cupola mosaics, xii, 81, 104
Cyprian of Gaul, 13–14, 26, 42, 79, 116n8
Cyril of Scythopolis, 10–11

D'Ancona, Mirella Levi, 135n5
Daniel story, 128n7
Dante Alighieri, 76, 81
date: as forbidden fruit, 10–11, 122n67, 144n81; Tree of Knowledge as date palm, 62
death, and Fall of Man, 2, 6–7, 17, 24
Della Robbia, Giovanni, xii, 56, 58, 75, 77, 106
Derbes, Anne, 132n47
devil, 7, 24, 46, 74, 116n12, 148n110. *See also* evil; serpent, in Garden of Eden
Diez de Velasco, Francisco, 129n18
Dochhorn, Jan, 8
Dogmatic Sarcophagus, 29, 90, 128n8
Domenichino, 54, 106
Douay-Rheims Bible, 122n66
Dürer, Albrecht, xi, xii, 49, 55–56, 58, 77–78, 101, 132n52

Eckhart, Meister, 19, 66, 121n55, 138n23
Elsner, Jaś, 30–31, 129n16
Elucidarium (Honorius Augustodunensis), 70, 125n88, 142n57
Enarratio in Canticum Canticorum (Anselm of Laon), 21, 123nn71–73
Encyclopedia of the Bible and Its Reception, The, 80, 150n2
England, iconography in, 2, 28, 45–47, 50, 62, 95–102, 132n45

engravings: Brosamer woodcut, xii, 77, 78; Dürer, xi, xii, 49, 55, 55–56, 58, 101, 132n52
Epiphanius of Salamis (bishop), 7
Esquiline Treasure, 128n13
etymology, 64–65, 68, 140n37, 145n98, 148n107. *See also* semantics
evil, 125n87; and apple, 2, 12–14, 16, 25–26, 73, 79–80; and forbidden fruit, 120n44, 142n57; and gluttony, 24; original sin as, 12; Tree of Knowledge as, 24–25. *See also* devil; *malum* (apple/evil); serpent, in Garden of Eden
Evrat's Genesis (translation), 70–71, 141n54, 143n68

Fall of Man, 1–2, 4–6, 12–13, 20, 23, 45–46, 64, 68, 70–71, 74, 78, 81; as allegory, 114n31; Eve's first-person account of, 8; and human mortality, 2, 6–7, 17, 24; and vernacular plays, avoided in, 142n61. *See also* Adam and Eve; Garden of Eden; Genesis, Book of
Fall of Man (Michelangelo fresco), xi, 54, 80, 106
Fall of Man (van der Goes painting), 49, 100
Fall of Man, French, 2, 39–45, 64, 68–71
Fall of Man, The (Cornelis van Haarlem painting), 102
Fall of Man, The (Meister HL carving), xii, 47, 48, 101, 132n49
Fall of Man scenes. *See* iconography
Farnese, Alessandro, 133n59
Farnese Book of Hours (Clovio), xi, 52, 55, 60, 106, 133n55
fennel, 73, 145nn98–99
Fernández, David Arbesú, 148n114
Fernández Valverde, Juan, 121n57
Fernando X, 60
Ferrara Bible, 148n113, 149n115
fig, 8–10, 17–19, 29, 80, 116n12, 119n32, 121n48, 130n27, 133n63, 150n2; fig-leaf aprons, 4, 8–9, 18–20, 39, 113n26, 114n33, 115n36; and pomegranate, 115n38; and vines, 9, 114n30. *See also* fig tradition
fig tradition, 1–2, 8–11, 17–20, 26, 71, 75–76, 80, 113n26, 114nn32–33, 115n2, 119n32, 122nn61–62, 122n67, 127n4, 128n9, 138n23; antiquity of, 8; in iconography, 29, 33–34, 37–41, 44–45, 47, 50, 54, 58, 60, 64, 127n4; ongoing vitality of, 8–9; and original sin, 18–19; and sexuality, 17–18
Foliot, Gilbert, 22, 26, 124nn77–78, 143n70
forbidden fruit, 2, 4, 9–11, 12, 72, 114n31, 115n2, 127n3, 147n105; accounts of in antiquity, 11; in ancient Jewish and Christian sources, 1, 11; as blameless, 120n44; and chastity, 9; and evil, 120n44, 142n57; in iconography, 27–28, 45, 47, 51, 62, 132n45; and Noah's vine, 113n17. *See also* fig tradition; grape tradition; *malum* (apple/evil); *pom* (fruit/apple); *and specific fruits*
forbidden knowledge, apple as symbol of, 1

France, iconography in, 2, 28, 39–45, 47, 62, 70–71, 91–95, 134n66
French art and literature, 2, 63, 70–72, 74–76, 82–83, 149n126
frescoes, xi–xii, 29, 32, 33–34, 41, 51, 54, 80, 83, 127n5, 132n48
fruit, forbidden. *See* forbidden fruit
fruit, terms, 2–4, 15, 66, 70, 73–76, 80, 119nn30–31, 138n25, 141n52, 144n81; French vernacular, 73–74; German vernacular, 73. *See also cibus* (food/fruit); *karpos* (fruit); *mēlon* (apple/fruit); *obez* (fruit); *peri* (fruit); *pom* (fruit/apple); *pomiferum* (fruit trees); *pomum* (fruit); *poume* (fruit)

Garden of Eden: apples in, 151n9; earliest account of, 4–5; fig tree in, 18; fruit trees in, 4–5, 75; licit species in, 16, 75, 147n105. *See also* Adam and Eve; Fall of Man; Genesis, Book of
Garrucci, Raffaele, xii, 80–82, 151n5, 151n7
Gates of Paradise, Baptistery of San Giovanni, panel doors (Ghiberti), xii, 54, *54*, 105
Gaunt, Simon, 149n126
Geiger, Ari, 124n77, 126n99, 127n101
Genesis, Book of, 1–2, 4, 6, 8–10, 13, 15–22, 32, 37, 45–46, 50–51, 65–68, 70–73, 75–76, 78, 80, 114n31, 143n68; commentaries on, 2, 9–10, 15, 20, 26, 68, 82. *See also* Caedmon Genesis (manuscript); Cotton Genesis (illuminated manuscript); Evrat's Genesis (translation); Fall of Man; Millstatt Genesis; Vienna Genesis
Geoffrey of Auxerre, 23
Geoffrey of Vinsauf, 14–15, 26, 143n70
Germany, iconography in, 2, 28, 47–51, 56, 62, 64, 71, 75, 95–102, 132n45
Ghent Altarpiece (van Eyck), xi, 62, 99
Ghiberti, Lorenzo, xii, 54, 105
Gilbert of Stanford, 124n80
Ginzberg, Louis, 112n6, 114n35
Giordano da Pisa, 76, 149n27, 150n129
Giraud, Cédric, 123n76
Gislebertus of Autun, xii, 39, 92
Giusto de'Menabuoi's Baptistery of St. John, 51–52, 105, 133n58
glazed terracotta (della Robbia), xii, 56, 58, 75, 77, 106
Glossa Ordinaria, 21, 123n72, 123n76
"Gnostic Gospels," and grape tradition, 10
golden apple, 32, 39, 129n17, 131n31
Gottfried von Strassburg, 19
Grandval Bible, 91, 130n26, 132n47. *See also* Moutier-Grandval Bible (manuscript)
grape tradition, 1–2, 4–11; in iconography, 40–41, 44–45, 58, 62, 64, 115n2, 132n52, 134n65; and wine, 6–7, 121n59
Gregory of Nyssa, 9, 114n31

Gregory the Great (Pope Gregory I), 74, 97, 118n29, 125n86
Grimani, Marino, Cardinal, 133n59
Guillaume de Deguileville, 117n18
Guyart des Moulins, 135n10
Gwara, Scott, 68, 139n33

Hadrian, 18
Haimo of Auxerre, 24, 124n83, 126n94, 148n107
Haimo of Halberstadt, 126n94, 148n107
Hamilton, Victor P., 12–13
Hamilton Bible, 104
Hebrew Bible, 1, 13, 25, 45, 70–71, 74–75, 116n13, 117n23. *See also* Song of Songs
Heisig, Karl, 116n8, 117n20, 117n22
Hera, 131n31
Hercules and the Hesperides, 32–33, 129–30nn17–20, 131n31
Hexameron (Abelard), 20, 66–68, 121n59, 137n20
Hildegard of Bingen, 47, 73, 98, 132n48
Histoire Universelle, 94, 104, 130n26
Historia scholastica (Comestor), 20, 69, 122n62, 135n10, 147n104
Homilies d'Organyà, 74
Honorius of Autun, 23, 70, 125n88, 142n57
Hoogvliet, Margriet, 71–72, 143–44nn74–75
Horn, Martina, 62, 133n64
horticulture, 134n1. *See also* agriculture; botany
Hrabanus Maurus (archbishop of Mainz), 63, 118n29, 134n3, 136n18
Hugh of St. Cher, 126n98
Hugh of St. Victor, 15, 20, 66
Huskinson, Janet, 128n15
hybrid fruit trees, 132n52

iconography: 5–6, 10, 28–62, 80, 82, 127–34nn1–68, 151n7; and agriculture, 64; and apple tradition, 2, 27–62, 124n80, 127–34nn1–68; in Crete, 62, 133n64; early Christian, Byzantine, and Carolingian, 29–38, 90–91; in England, 2, 28, 45–47, 50, 62, 95–102, 132n45; figs in, 29, 33–34, 37–41, 44–45, 47, 50, 54, 58, 60, 64, 127n4; forbidden fruit in, 27–28, 45, 47, 51, 62, 132n45; in France, 2, 28, 39–45, 47, 70–71, 91–95, 134n66; in Germany, 2, 28, 47–51, 56, 62, 64, 71, 75, 95–102, 132n45; grapes in, 40–41, 44–45, 58, 62, 64, 115n2, 132n52, 134n65; in Italy, 2, 28, 38, 51–61, 56, 58, 62, 71, 75–77, 102–6, 128n11, 133n58; and linguistics, 76; in Low Countries (Northwestern Europe), 2, 28, 47–51, 56, 71, 75, 95–102, 132n45; and maps, xii, 28, 38, 44–45, 49–51, 55, 58, 60, 89, 130n28, 132n45; medieval, 64, 103, 143n72, 173; and pagan art, 30–33, 127n4, 129n16; and sarcophagi, 29–33, 35, 38, 52; in Spain, 28–29, 31, 51–61, 102–6; and vernacular, 71, 75–78, 139n29, 143n72

INDEX

illuminated manuscripts, xi, xii, 37, 41, 43, 47, 57–58, 58, *61*, 62, 71, 92, 93, 98, 107, 130n26, 133n57, 143n73, 149n120
Illustrated Bartsch, The, 49, 51, 100, 133n54, 173
Inferno (Dante), 76
interdisciplinary scholarship, 3, 82–83
Isidore of Seville, Saint, 18, 66, 74, 102, 139n30
Italian art and iconography, 2, 28, 38, 51–61, 56, 58, 62, 71, 75–77, 102–6, 128n11, 133n58
ivory boxes, xii, 36–37, *37*, 91

James of Kokkinibaphos, 91
Jerome, Saint, 13, 15, 23, 112n4, 119n31, 125n87, 135n12
Jeu d'Adam, 69–71, 81, 142n61
John of Forde, 119n35
John of Mantua, 24–25
Julian of Eclanum, 122n67
Junius Bassus Sarcophagus, xi, 29, *30*, 91, 128n7
Junius 11 manuscript, 46

karpos (fruit), 4, 11
Kessler, Herbert L., 130n27
Kiecker, James George, 126n100
Kokkinibaphos, Jacobus, 37, 91

Langton, Stephen, 123n74
language(s). *See* semantics; vernacular
Last Judgment, The (Bosch), 49, 100, 101
Latin language, and apple tradition, 2, 12–27, 64–65, 67–69, 73, 115–27nn1–102, 138n28, 139n32, 140n38, 145n93
LaVere, Suzanne, 123n72, 123n74
Leviticus Rabbah, and grape tradition, 6–7
Life of Adam and Eve (apocryphal book), 8, 16, 69, 113n22, 119n34
Liphkowitz, Ina, 116n8
literacy, 69, 110, 140n40
Literal Commentary on Genesis (Augustine), 15
Low Countries (Northwestern Europe), iconography in, 2, 28, 47–51, 56, 71, 75–102, 132n45
Lowden, John, 130n22, 134n66
Lucas Cranach the Elder, 49, 78, 102, 132n53
Lucas van Leyden, 78
Lusignan, Serge, 144n76
Luther, Martin, 78, 150n137
Luther Bible (Brosamer), xii, *77*, 78

Maitani, Lorenzo, xii, 52, 104
Malbon, Elizabeth Struthers, 128n7
Malermi, Nicolo, 75–76
Malermi Bible, 75–76
malum (apple/evil), 12–17, 20–26, 65–67, 72–74, 115nn3–4, 116n10, 116n14, 117n15, 117n22, 119n35, 120n37, 123n68, 124n77, 125n93, 126n100, 127n102, 135n8, 135n12, 137n21, 138–39nn28–29, 139n32, 144n83, 144n84, 146n100, 148n107; ambiguity, 13; hypothesis, 2, 13, 17, 20–21, 24, 26, 79–80, 82–83, 120n44, 143n70
malus (apple tree), 12–13, 23, 25, 67, 115n4, 135n12, 138n25, 139n29, 146n100
mandrake, 65, 147n104, 148n107
mango, 62, 134n67
manuscripts. *See* illuminated manuscripts
manzana/manzano (apple/apple tree), 74, 149nn115–16
Marcellus Empiricus, 137n21
Marian homilies manuscript (Kokkinibaphos), 37, 91
Martin, Christopher, 138n22
Martin of Leon, 23
Matius Calvena (Gaius Matius), 148n107
Meir, Samuel ben, Rabbi (Rashbam), 7, 9, 123n67
Meister HL, xii, 47, 48, 101, 132n49
Meister IP, 101–2
mela (apple), 74
mēlon (apple/fruit), 11, 13, 116n10, 129n17
Methodius of Olympus, 9, 114n30
Meyer, Stephenie, 1
Michelangelo, xi, 54, 80, 106
Millstatt Genesis, 98, 130n26
Milton, John, 13, 80, 116n12
minstrel songs, 81
monasticism, 11, 16, 68–73
morphology, 29, 38, 124n77, 132n47
mortality. *See* death, and Fall of Man
mosaics, 34, *36*, 130n26; cupola, xii, *81*, 104
Mostalac Carrillo, Antonio, 128n8
Moutier-Grandval Bible (manuscript), xi, 37. *See also* Grandval Bible
mulberry, 144n81
Murdoch, Brian, 13–15, 69, 113nn21–22, 116n12, 117n19
"Mysteries of Saint John the Apostle and Holy Virgin," 10–11
mystery plays, 131n33, 141n50

Nag Hammadi, and grape tradition, 10, 115nn37–38
nave capitals, xii, *41*, 92
Neckam, Alexander, 67, 138n24, 139n30
Nehemiah, Rabbi, 6
Nicholas of Lyra, 20, 25–26, 51–52, 62, 100, 126nn99–100, 127n101
N-Town Plays, The (Sugano), 147n105

obez (fruit), 73
Octateuchs, Byzantine, 34–36, 91, 130n22
Old Testament History, 86, 146n102
"On the Origin of the World," 10, 115nn37–38
orange, 38–39, 47, 73, 131n30, 145n90

Origen, 7, 13, 116n10
original sin. *See* Fall of Man
Orpheus, 32, 129n16

Padua medallion, 133n55
palm tree, 62, 134n64, 134n66
Panicale, Masolino da, 54, 105
Papias (lexicographer), 138n25
peach, 64–65, 72
pear, 63–67, 72–76, 85, 135n5, 136n16, 138–39nn28–30, 145nn98–99, 147n105
Peiresc Codex, 74
peri (fruit), 4, 119n31
Peyton, Thomas, 121n59
Philo of Alexandria, 11, 114n31
plinth pane/panel, xi, 134n65
plum, 63–64, 73, 145nn98–99
pom (fruit/apple), word, usage, 64–68, 70–74, 73, 135n12, 142n56, 143n68, 146n101. See also *pomme* (apple)
pomegranate: and fig, 115n38; as forbidden fruit, 10, 25–26, 28, 37, 40–47, 58, 64–65, 72–75, 115n38, 117n22, 119n35, 125n93, 127nn100–101, 132n52, 137n21, 144n81, 144n83, 145n90; iconography, 44, 47, 58; psalters, 47, 132n48; symbolism in Christian sources, 120n35; as tree of life, 119n35, 125n93; word, usage, 144n81, 144n83
pomiferum (fruit trees), 15, 65–66, 136–37nn18–20
pomme (apple), 77, 85, 135n8, 143n69. See also *pom* (fruit/apple)
pomum (fruit), 15–16, 23–24, 64–68, 74–76, 81–82, 85, 117n22, 118n29, 119n30, 119n34, 135n6, 135n12, 137–38nn19–25, 138–39nn28–30, 142n57, 144nn83–84, 148n107, 150n3, 150n129, 150nn132–33, 151n8
portal lintel relief (Gislebertus), xii, 39, 92
Post Peccatum Adae, 16, 119n34
poume (fruit), 65
prayerbook, of Hildegard of Bingen, 47, 73, 98, 132n48
Projecta Casket (Esquiline Treasure), 128n13
psalters, 42, 69, 131n38, 132n43, 132n50, 132n52; pomegranate, 47, 132n48
pseudepigrapha, biblical, 1, 108, 153
Pseudodoxia Epidemica (Browne), vii, 12, 20, 115nn1–3
Purgatorio (Dante), 81

Questions and Answers on Genesis (Alcuin of York), 18, 121n53
quince, 5, 65, 72, 122n67, 129n17, 144n81
Quran, Syriac, commentary, and forbidden fruit candidates, 10

Rabanus Maurus (archbishop of Mainz), 63, 118n29, 134n3, 136n18

Rabbinic sources and commentaries, 6–7, 9–10, 114n34; French, 122n67
Rebuke of Adam and Eve, The (Domenichino), 54, 106
Receptio Animae sarcophagus (Zaragoza), xi, 29–30, 33, 37–38, 79, 86, 90
reliefs, 39, 43, 51, 52, 102, 128n15
Remigius of Auxerre, 16, 120n37
Riga, Petrus, 14–15, 26, 143n70
Ripoll Bible, 58, 102
Rizzo, Antonio, xii, 53
Robert of Tombelaine, 23, 125n86
Roberts, Phyllis, 141n47
Roda Bible, 102
Rufinus, 13, 25, 116n10
Rupert of Deutz, 15, 118nn28–29, 124n83
Russia, 61, 64, 89

Sabas the Sanctified, 10–11
Salerno Antependium, xii, 51, *51*, 130n26, 132n52
San Gennaro Catacombs (Naples, Italy), fresco, *83*
San Giovanni Baptistery: mosaic, 104; panel doors, xii, 54, *54*, 105
San Marco mosaics, 130n26
San Zeno Maggiore (Verona), 51, 103, 133n57
sarcophagi, 29–33, *30–32*, *35*, 38, 52, 79, 86, 90, 127n6, 128nn7–10, 128nn14–15, 129n16, 130n20
Satan. *See* devil
"Saxon Genesis" (poem), 73
Scholastica historia. See *Historia scholastica* (Comestor)
Schramm, Albert, 150n136
sculpture (Rizzo), xii, *53*
semantics: and apple tradition, 2–3, 64–68, 71–77, 79, 144n81; and apple's rise as forbidden fruit, 2–3, 63–78, 134–50nn1–137; calques in, 72, 140n34, 144nn79–80; fruit to apple, 64–65; and narrowing, 76, 135n7; rabbinic, 119n31; vernacular, 64–68, 71–77, 82–83, 143n70. *See also* etymology; vernacular
Septuagint, 1, 4, 37, 111n3, 116n10, 140n43
serpent, in Garden of Eden, 1, 4–8, 14–15, 30, 32–33, 35–36, 39, 41, 47, 58, 80, 117n15, 118n25, 131n33, 132n47, 150n2. *See also* devil; evil
Sifre Deuteronomy, and grape tradition, 6
Sistine Chapel (Michelangelo), xi, 54, 80, 106
Slavic art and literature, and grape tradition, 8, 62
Song of Roland, 65, 136n14
Song of Songs, 79, 81–82, 116n10, 117n18, 119n35, 121n57, 122n65, 123n72, 123n74, 124n78, 125n93, 126n98, 126n100, 127n101, 135n12, 139n29, 142n57, 144n83, 151n9; Christian allegorical reading of, 2; commentaries on, 21, 23, 42, 122n67, 123n72, 123n74, 124n83, 148n107; and Fall of Man narrative, 20–26; and Latin apple,

12–13, 16, 19–26; and vernacular apple, 65, 67, 74, 76
Spain, 149n120; apple tradition in iconography of, 28–29, 31, 51–61, 102–6; fig tradition in, 29; and vernacular apple, 66, 74–76, 140n34, 140n37, 148n108, 149n116, 149n120
Speculum humanae salvationis, xii, 47, 49, 49, 94–95, 97, 99–100, 104–5, 132n51
stained glass, xi, 28, 43, 49, 92–93, 97–100, 106, 132n51, 173
St. Clair, Tomb of, sarcophagus, xi, 29, 32, 91, 128n9
St. John Baptistery (Giusto de'Menabuoi), 51–52, 105, 133n58
St. Marcellinus and St. Peter Catacombs. *See* Catacombs of Marcellinus and Peter (Rome)
St. Mark's Cathedral (Venice), cupola mosaic, 81, 104
Storia della arte cristiana (Garrucci), xii, 80–82, 82, 151n5, 151n7

Talmud, Babylonian, and grape tradition, 7
Tam, Rabbenu, 122n67
tapuaḥ, 20, 25–26, 111n1, 122n67, 125n93, 127n101, 139n29, 147n106, 151n9
Targums (Aramaic), 1, 81, 122n67, 140n43, 151n9; Onkelos, 4, 112n5
terracotta, glazed (della Robbia), xii, 56, 58, 75, 77, 106
Tertullian, 23, 114n32, 125n87
Testament of Adam, 8–9, 113–14nn27–28
Theodore (bishop of Canterbury), 18
Theodoret of Cyrus, 9, 114n29
Thomas Aquinas, 2, 15, 18–19, 26, 109
Thomas of Perseigne, 23–24, 67
Tintoretto, Jacopo, 52, 77, 106
Titian, 52, 77, 106, 133n61
Tomb of St. Clair, sarcophagus, xi, 29, 32, 91, 128n9
Tractates on the Gospel of John (Augustine), 17
Trapp, J. B., 28, 37
Tree of Knowledge of Good and Evil, 4, 7, 10–12, 14, 18–19, 23–26, 29–30, 36–37, 39, 46–47, 54, 80, 112n8, 114n36, 125n87, 127n3, 130n23, 132n52, 134nn64–66, 147n105, 150n2; as date palm, 62
Tree of Life, 4, 10, 23, 130n23; pomegranate as, 119n35, 125n93
Tristan (Gottfried von Strassburg), 19
Tromp, Johannes, 8, 113n26
Twilight (Meyer), 1

van der Goes, Hugo, 49, 100
Van Eyck, Jan, xi, 62, 99
Velletri Sarcophagus, 33, 35, 130n20

Venus, 128n13
vernacular: and apple tradition, 2–3, 63–79, 134–50nn1–137; Castilian, 74–75, 122n62, 148n108, 148n114; Dutch, 122n62, 145n100; English, 2–3, 7, 46–47, 68, 72–73, 81, 119n30, 122n62, 135n7, 135n9, 140n34, 140n37, 144n76, 146n101; European, 2–3, 8, 67–68, 75–76, 80, 82–83; and forbidden fruit, 70; French, 2–3, 64–65, 68–76, 81–82, 85, 111n3, 120n44, 122n67, 126n98, 135n5, 135n10, 136n14, 136n17, 139n29, 139n32, 140n34, 141n52, 142n57, 142n59, 143–44nn74–76, 144nn80–82, 144n84, 145n98, 146n101, 146n102, 147n104, 149n126; German, 2–3, 8, 19, 68–69, 71–74, 76–77, 81, 144n80, 144n84, 145n93, 145n98, 146n101, 147n103; Hebrew, 6, 20, 25–26, 111n1, 122n67, 125n93, 127n101, 139n29, 140n34, 147n106, 151n9; and iconography, 71, 143n72; Italian, 74–77, 81, 149nn125–26, 150n132; and Latin, 2, 12–27, 64–65, 67–69, 73, 115–27nn1–102, 138–39n28, 139n32, 140n38, 145n93; plays, 142n61; and preaching in monasteries, 141n45; and second-language acquisition, 139n33; Slavic, 8; sources, 159–62; Spanish, 66, 74–76, 140n34, 140n37, 148n108, 149n116, 149n120. *See also* semantics
Vetus Latina, 110, 112n4
Via Latina Catacomb (Rome), 32–33, 34, 90
Vienna Genesis, 37, 151n7
Virgil, 129n16, 137n21
Vivian Bible, 37, 91, 131n42
von Erffa, Hans Martin, 132n52
Vrelant, Willem, xi, 100
Vulgate, 1, 4, 80, 112n4, 117n24, 119n31, 135n12, 137n20, 140n43, 144n83; and Latin apple, 15, 19–20; and vernacular apple, 65, 67, 70

Waldensians, 141n47
Walsingham Bible, 46, 96
Wataghin, Gisela Cantino, 128n11
wheat, 9–11, 33–34, 114nn35–36
Willem van Affligem, 146n100
wine, and grape as forbidden fruit, 6–7, 121n59
Wolbero of Cologne, 24, 126n95
Wright, Richard, 140n38
Wycliffe, John, 72, 125n93, 144n83, 146n101
Wycliffe Bible, 125n93, 144n83, 146n101

Ximenez de Rada, Rodericus, 19, 121n57

Yalqut Shimoni, 125n93, 127n101

Zemler-Cizewski, Wanda, 137n20, 138n22
Zeno of Verona (bishop), 118n29
Zevit, Ziony, 12–13, 115n4